LENS OF WAR

UnCivil Wars

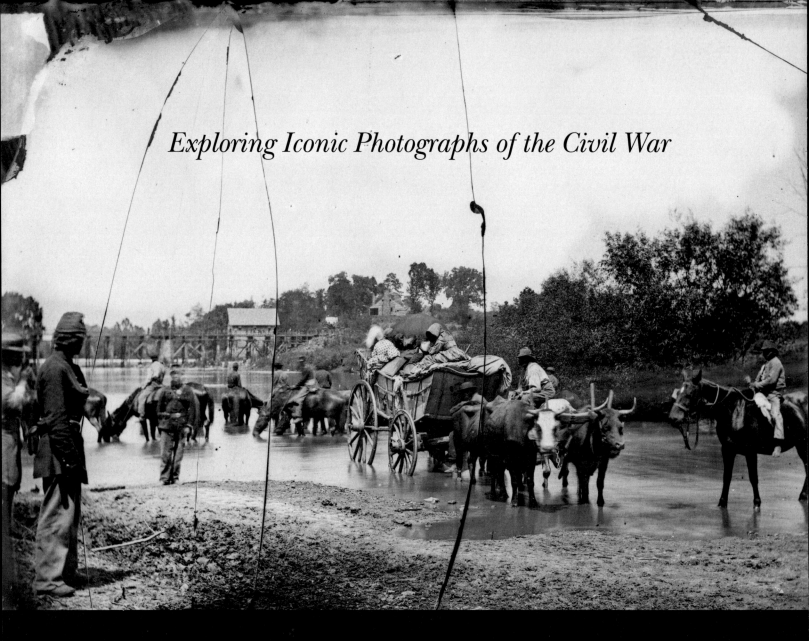

Exploring Iconic Photographs of the Civil War

THE UNIVERSITY OF GEORGIA PRESS ATHENS AND LONDON

LENS OF WAR

5·18

EDITED BY J. MATTHEW GALLMAN AND GARY W. GALLAGHER

Publication of this work was made possible, in part, by a generous gift from the University of Georgia Press Friends Fund.

Designed by Erin Kirk New
Set in ITC New Baskerville and Columbia Titling
Printed and bound by Thomson-Shore
The paper in this book meets the guidelines
for permanence and durability of the Committee on
Production Guidelines for Book Longevity of the
Council on Library Resources.

Most University of Georgia Press titles are
available from popular e-book vendors.

Printed in the United States of America
15 16 17 18 19 c 5 4 3 2 1

Library of Congress Control Number: 2015932512

ISBN-13: 978-0-8203-4810-0 (hardcover)
ISBN-13: 978-0-8203-4811-7 (ebook)

British Library Cataloging-in-Publication Data available

For Eve and Anita, who came to my rescue when my back failed me.

For Will, whose photographs enrich my life.

Contents

LENS OF WAR

Introduction

J. MATTHEW GALLMAN AND GARY W. GALLAGHER

THOSE OF US who are fascinated by the American Civil War—readers, authors, teachers, travelers, public historians, students—arrived at that passion from many paths. This is especially true of the scholars who study the Civil War era in our professional lives. Specialists from across the academic spectrum are drawn to America's great national conflict, both because of the huge impact the war had on our history and because the war's observers and participants left behind a wondrous mass of information in letters, diaries, memoirs, and other literary sources, allowing us to reconstruct their world and experiences. We write about battles, politics, culture, gender roles, emancipation, economic change, art, and dozens of other topics. And because the war holds such fascination for popular audiences, we have the opportunity to share our findings—and the findings of our friends and colleagues—in classrooms and large auditoriums, on battlefields, in museums, and by participating in the occasional television documentary.

Whatever our core concerns, all of us who are drawn to the Civil War profit from the extraordinary photographic record documenting the conflict. The war came in the midst of rapid technological innovation in the world of photography. Shortly after Union and Confederate armies took to the field, an intrepid cohort of entrepreneurial photographers set out to document their movements and the destruction they left in their wake. They traveled with heavy equipment and portable darkrooms, producing glass-plate negatives using a delicate "wet collodion" process that was barely a decade old. The results that survive are stunning in their detail. Meanwhile, many of these same photographers ran highly profitable portrait studios, employing new techniques to produce cheap portraits of celebrities and ordinary soldiers. This was, in many senses, a war that was recorded and understood in photographs.

These early war photographers bequeathed historians an immense number of photographs that preserve the likenesses of participants, take us onto battlefields littered with human and material detritus, into military camps, aboard naval vessels, through ruined cities, and behind the lines in both the United States and the Confederacy. We scrutinize these images, thousands of them published in early works such as Francis Trevelyan Miller's monumental *The Photographic History of the Civil War* and even more now readily available on the Library of Congress's fine web page and in other Internet sources, to uncover truths about the past, and we reproduce them to help explain the Civil War to our

audiences. It is impossible to imagine the study of the Civil War—by students, enthusiasts, or professionals—without this extraordinary photographic evidence.[1]

This is a book about photographs, and about historians. The project began with a very simple observation. People who study the Civil War era spend an enormous amount of energy thinking about and talking about photographs. Yet, we seldom take the photograph as our subject, and we almost never share personal reflections that stray beyond our normal academic writing. We wondered what would happen when scholars of the Civil War era were invited to reflect about photographs and photography in unfamiliar ways. With that in mind, we approached several dozen of our friends and colleagues with a deceptively simple invitation. We asked each of them to select one photograph taken during the Civil War and write about it. The selections were to be very personal and perhaps idiosyncratic. Did they have a photograph that they have always loved? Did a particular image lure them into a deeper engagement with the Civil War? Is there a picture that they regularly turn to in the classroom? Did one picture challenge and excite them? Did they have a favorite portrait of a particular individual? These conversations sometimes occurred over e-mail, but they often began as informal chats over dinner or drinks at conferences all across the academic landscape. We found that Civil War historians love to talk about photographs and were thrilled that so many friends jumped at this opportunity to write and think in new and creative ways.[2]

The essays in this volume describe a wide array of photographs, and they also reflect a fascinating diversity of approaches to the task at hand. Several authors recall how long hours spent gazing at books of Civil War photographs in their youth shaped their own professional identities. Many wonder aloud at the circumstances that shaped a particular image. How were subjects—either living or dead—posed by the photographer? What objects contribute to our overall sense of the moment? One scholar contemplates unexplained shafts of light in an image. Another notes how two sequential images reveal artistic choices. Many explain how a single photograph can reveal a celebrated personality or tease us with unanswered questions about anonymous figures long forgotten. Several scholars chose pictures of the war's destruction. One contributor offers compelling musings about the simple horror in the picture of a fallen horse. Our original invitations gave authors the freedom to adopt whatever degree of scholarly citation they deemed appropriate. Readers will see that the essays reflect a variety of choices in this regard, ranging from no endnotes to detailed accounting for sources and engagement with other historical literature.

Once the images had been selected and the essays submitted, we faced the surprisingly challenging task of imposing some order on these varied pieces. We settled on a simple topical organization: leaders, soldiers, civilians, victims, and places. It is testimony to the richness of these images, and the complexity of the war itself, that fully half of the photographs could have been placed in more than one section. The individual essays speak to each other in myriad ways that would defy a linear organization. This is not a book to be read directly from beginning to end. We hope readers will flip from picture to picture and essay to essay as the mood strikes.

J. Matthew Gallman and Gary W. Gallagher

Serious students of the Civil War will discover many old friends among the pictures, as well as more than a few images that might be unfamiliar. As editors, we did very little nudging when it came to selecting photographs. The lineup of images was almost entirely the result of individual choices. Veteran readers of Civil War literature will find many long-familiar authors among the contributors, but the essayists also include some of the ablest younger historians in the field. Taken together, the photographs suggest something of the range of subjects that the war's photographers selected, and the roster of authors reflects the wide range of scholars who share our passion for the Civil War, and for Civil War photography.

NOTES

1. The foundational published collection of images remains Francis Trevelyan Miller, ed., *The Photographic History of the Civil War*, 10 vols. (New York: Review of Reviews, 1911). The Library of Congress's website "Selected Civil War Photographs," which includes more than 1,100 images, is at http://memory.loc.gov/ammem /cwphtml/cwphome.html. For other important published collections of photographs, see "Suggested Readings" at the end of this book.

2. Our key observation here is that the scholars *in this collection* have spent large amounts of time looking at Civil War photographs and using those images to illustrate lectures and writings, but they rarely have taken photography or photographs as their subject. Other historians have concentrated their professional attention on photography, including Civil War photographs, and scholars from various disciplines have written valuable pieces examining war photography from multiple perspectives. The accompanying bibliographical essay, "Suggested Readings," points readers toward some of the foundational texts in this large literature.

PART 1
LEADERS

The "Gettysburg" Lincoln

The Back Story of a Full-Frontal Photograph

HAROLD HOLZER

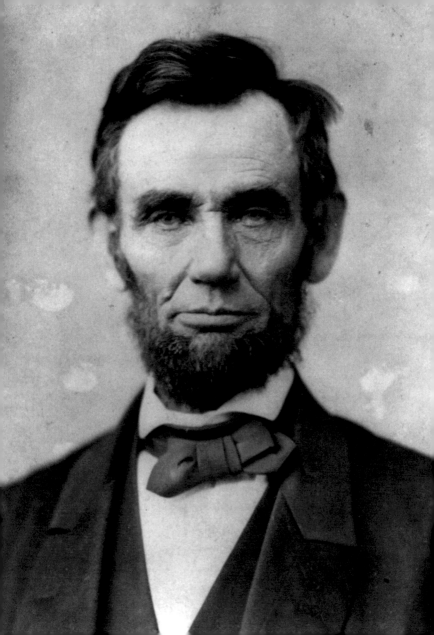

I MUST ADMIT that I no longer remember exactly when I first cast eyes on what ultimately became, and remains, my favorite image of Abraham Lincoln: the intensely revealing, full-face, close-up photograph taken by Alexander Gardner in Washington on November 11, 1863.

For ages, I have thought it must have adorned the dust jacket of the very first Lincoln book I ever owned: Stefan Lorant's *Lincoln: A Picture Story of His Life*. But no, I've recently been reminded that the photograph graced only the 1969 *revised* edition of Lorant's iconic chronology of Lincoln portraits and not the 1957 version that I persuaded my younger sisters to purchase for me as a gift for my bar mitzvah—my thirteenth birthday—in 1962. Much as I treasure that first book, the Lorant original featured an 1861 photograph and not the 1863 image that took my breath away when I first studied it.[1] So perhaps it was the 1969 edition after all, which I purchased for myself at age twenty, the moment it came out, and later brought to Lenox, Massachusetts, to get the author's signature at our first meeting.

It was Lincoln's strange gaze in the portrait that first fascinated me—the right eye a cool, intense gray, staring unblinkingly into the camera, but the left one roving upward in its socket, straying from the viewer for some unfathomable reason, perhaps a medical one, making the subject look mysterious, crafty, tragic, almost otherworldly. At our meeting, my hero Lorant told me he loved the picture, too, and then asked me to conduct a little experiment with him: take a strip of paper and cover half of Lincoln's face at a time, from hairline to chin—and examine one half first, then the other. The startling result: two entirely different men. Viewed alone, Lincoln's left side made him look bemused, his mouth curling into a smile, his eye rolling as if in dismay. Yet the right side showed a hard stare and a frown creasing his countenance. How can a man smile and frown simultaneously in the same photograph? Lorant and I conducted this demonstration, it might be noted, during the first days of the Marfan's syndrome story, when two different medical experts grabbed headlines by contending that Abraham Lincoln had suffered from this debilitating genetic condition, whose symptoms included vertical strabismus—roving eye. But no, Lorant didn't believe it. Lincoln was simply too physically strong to be a Marfan; just look at the wide shoulders and brawny arms in the Gardner photograph. How to explain it, then? Simple, Lorant replied: Lincoln had been kicked in the head by a horse as a child, and was, in his own words, "apparently [*sic*] killed for a time."[2] The concussed boy woke

up eventually, but perhaps the injury had an atrophying effect, causing one side of the mouth to drop, one eye to lurch off heavenward.

From that day forward, I began studying the haunting picture more intensely. And what I have learned since at one level reaffirmed my affection for it. For here was Lincoln at the height of his powers, four months after the twin Union victories at Gettysburg and Vicksburg, and only eight days before he would consecrate the former triumph with the greatest speech of his life, perhaps the greatest in American history. Here was Lincoln before physical decline set in, before the weight peeled off, the face sank, and the sockets under the eyes darkened into bottomless pools. I preferred this Lincoln—the man of astonishing strength—and not the one who slowly wasted away that the nation might live.

Ultimately, my obsession with the portrait inspired me to further research. Why was this particular picture made when it was, along with the companion images created at the same Gardner sitting? And why was the image so ubiquitous in the 1960s, yet apparently so rare in the 1860s? Not for years was I able to find the answers, and with them, to shed some light on the very nature of Civil War iconography—the work of artists in all media, who in fact depended on each other for sources and inspiration. Only then did it become clear: this image was not created by accident, in a void, or without a very specific and long-ignored purpose.

It is always important in studying and understanding early photographs to keep in mind that the experience of posing before the camera in the 1860s was neither casual nor candid. In the age long before official White House photographers, let alone the technologies that made possible anything other than stiffly posed formal exposures, celebrity subjects like Abraham Lincoln (or their advisors, along with the photographers who sought them out to sit) planned their gallery visits in advance, and carefully. Photographers who earned their living making portraits of their clients invited leading politicians, military figures, and theatrical celebrities to pose for them free. They then displayed their results in their waiting rooms to lure additional customers, and mass-produced copies for sale to Americans for their family photograph albums.

The celebrity sitters themselves were well aware of the rationale for their sittings, even the unfailingly modest Abraham Lincoln. In 1860, for example, he made sure to precede his career-altering Cooper Union address with a strategic visit to the New York City studio of Mathew Brady (Gardner's future mentor and employer). The result was an extraordinarily influential portrait, widely reproduced in presidential campaign prints, banners, broadsides, and cartoons. While Lincoln at first dismissed the experience of posing by reverting to home-spun informality—writing, "I was taken to one of the places where they get up such things, and I suppose they got my shaddow [*sic*], and can multiply copies indefinitely"—he later acknowledged, in the photographer's presence, "Brady and the Cooper Union speech made me President."[3]

In other words, there were usually good political reasons for Lincoln to pose for pictures. As president, he did so often and for a purpose. The remark he addressed to Brady about the influence of the Cooper Union portrait, for example, was made when Lincoln sat for a series of pre-presidential photographs after he first arrived in

Washington in late February 1861. The reason for his decision to sit that week seems obvious: he had just slipped into the capital through Baltimore in secret and, some whispered, in disguise, to avoid a rumored assassination plot. Cartoonists had a field day caricaturing the president-elect as a coward sneaking into the capital in a Scotch cap and military cloak, perhaps even Scottish kilt and a feathered tam.[4] Lincoln desperately needed ameliorating, dignified images to supplant this comic assault—and Brady (with Gardner behind the lens) provided just the corrective portraits.

Although Lincoln went on to visit various Washington photographers repeatedly during his four years as president, he was usually invited to do so—by Gardner in August 1863, for example, to help him launch his own independent gallery. How, then, should we interpret a set of photographs made on November 11, 1863? The temptation, into which Stefan Lorant and others not surprisingly fell, was to suppose that the president decided that, in the same spirit that inspired him to Brady's a few hours before he was to orate at Cooper Union three years earlier, the approach of his trip to deliver "a few appropriate remarks" at Gettysburg made mid-November the perfect time to "illustrate" his latest rhetorical effort: to sit for a portrait that would show the country what he looked like as he fulfilled this important assignment.[5]

Of course, this scenario assumes that Lincoln knew in advance that his Gettysburg Address would "live in the annals of the war," as the *Chicago Tribune* later predicted, or that the president would in fact devise such a words-and-image strategy on his own.[6] Alas, as I eventually discovered, he did not. Journalist Noah Brooks

was one of those eyewitnesses to the sitting who inadvertently led later observers astray. Brooks did admit that Lincoln had chosen the date of his Gardner visit coincidentally—"it chanced to be the Sunday before the dedication of the national cemetery at Gettysburg," Brooks wrote, because "Mr. Lincoln carefully explained that he could not go on any other day without interfering with the public business and the photographer's business, to say nothing of his ability to be hindered by curiosity-seekers 'and other seekers' on the way thither." But the Gettysburg association animated Brooks's recollection anyway because the journalist vividly recalled that moments after they left the White House for Gardner's Seventh Street gallery, "The President suddenly remembered that he needed a paper, and, after hurrying back to his office, soon rejoined me with a long envelop [*sic*] in his hand in which he said was an advanced copy of Edward Everett's address to be delivered at the Gettysburg dedication. . . . In the picture which the President gave me, the envelope containing Mr. Everett's oration is seen on the table."[7]

Brooks was onto something. Everett had dispatched a preview copy of the long oration he planned for Gettysburg so the president could review it before writing his own brief remarks. Everett thought Lincoln would not want inadvertently to repeat the messages he had reserved for himself. Indeed, the envelope can be seen on Gardner's prop table in a few of the poses made that day, although it appears that Lincoln never bothered to open it and peruse its contents while he waited for the photographer to reset his plates between poses. Still, Gettysburg seemed to be on everyone's mind that day. Brooks asked Lincoln if he had finished his own

speech. Not yet, the president replied, but it would be brief—"short, short, short," as he put it.[8]

Yet the resulting portraits were not "Gettysburg" photographs—much as subsequent generations wanted them to serve as such, especially after the twentieth-century discovery of a shot made from a distance at the actual November 19 ceremonies, in which the blurred figure of a seated Lincoln, head cast downwards, was barely visible. But if the powerful full-faced portrait I've admired for so long was meant to show his countrymen the way the great man looked on the eve of his dedicatory address, why was it so difficult for his admirers to find copies of the pose at the time it was taken: late 1863? Gardner always mass-produced and widely distributed his latest Lincoln photographs, but not this one. And Lincoln cooperatively posed for Washington's cameramen not to provide prints for his own family album, but to supply fresh poses his admirers could collect for their own. Brady, Gardner, and the others fortunate enough to woo the president to their galleries invariably issued the results in carte de visite form, the rage of the day, and produced thousands of copies for general sale to the public.

Here lay a major problem with the Gettysburg "illustration" theory. What may be the finest of all wartime camera portraits of Abraham Lincoln remained virtually unseen in carte de visite format—and was hardly seen by the public at all—until one A. T. Rice, who later assumed control of the Gardner archive, issued copies in time for the Lincoln centennial in 1909. This was the greatest Lincoln photo never seen. Why, then, did the exquisite poses of November 11 never make it into the hands of these ready pre– and post–Gettysburg

Address customers? Why was "my" superb portrait, in a way, wasted?

A notation made by another eyewitness to the sitting provided the elusive clue. Lincoln's private secretaries, John G. Nicolay and John Hay, were also on the scene at Gardner's that autumn Sunday. Someone among the party—perhaps Lincoln, maybe Gardner, but most likely the staffers—persuaded Lincoln into a rare group pose. "Nico and I immortalized ourselves by having ourselves done in a group with the Presdt.," Hay recorded in his diary. But what he said a few sentences earlier proved the smoking gun. "Went with Mrs Ames to Gardner's gallery & were soon joined by Nico & the Prest. We had a great many pictures taken. Some of the Presdt. the best I have ever seen."[9]

Here, albeit in shorthand, was the explanation my hero Lorant—not to mention pioneer photo historian Frederick Hill Meserve before him, and more recently the outstanding authority Lloyd Ostendorf—had all somehow missed. On November 11, 1863, Lincoln arrived at the Gardner gallery with Nicolay and Brooks. But Hay had gotten there earlier with a "Mrs. Ames" and waited there for the president to arrive. Who was the mystery woman? Hay never explained (his was a diary he never intended to publish, after all), but she is absolutely key to why the photographs were made in the first place and why they were not widely released in the second place. And her presence may also help explain why so many of the Gardner poses that day turned out to be some of "the best" John Hay had ever seen. For she was an artist, and when artists witnessed Lincoln's sessions with photographers, as they did on at least three other occasions before and after November 11, 1863,

Harold Holzer

the results tended to be superior to what the photographers could create on their own.

Sarah Fisher Clampitt Ames (1817–1901) was also an antislavery activist, a wartime nurse in the temporary hospital established in the U.S. Capitol, and the wife of the well-known portrait painter Joseph Ames. So Lincoln, ever grateful to such politically sympathetic volunteers, would have been inclined to cooperate with her. More to the point, she was also what the early historian of Lincoln portraiture Rufus Rockwell Wilson, called "an amateur sculptoress" in her own right who had studied art in Boston and Rome. Where Mrs. Ames had first encountered Lincoln is lost to history, but she may have observed him during one of his visits to the Capitol Building, and sometime during the war began to make sketches of him. At some point she had allegedly accumulated an entire portfolio of drawings of the president, which tragically burned in the fire that consumed Washington, D.C.'s, Patent and Trademark Building.[10]

Somehow—perhaps because her nursing duties brought her in close proximity to influential members of Congress—Sarah Ames secured a lucrative commission to produce a sculpted bust of Lincoln for the U. S. Senate collection. But her sketches were not enough. One can only surmise that, like many artists who had attempted to portray Lincoln from life sittings before her—like Thomas Hicks in Springfield in 1860 and Edward Dalton Marchant in Washington earlier in 1863[11]—she found it difficult to get the president to sit still long enough to make accurate preliminary drawings. Instead, Mrs. Ames turned to the obvious and increasingly popular artistic crutch of photography. Artists were increasingly turning to specially commissioned photos

to augment life sittings.[12] Hicks had persuaded Lincoln to pose for photographer Alexander Hesler in the same Illinois State House building where he was attempting to paint him from life, and Marchant, despite three months of direct access to the president at the White House, felt compelled to turn to a two-year-old Brady Studio pose to supplement his own sittings. What occurred in November 1863 therefore seems obvious: Sarah Ames importuned Lincoln to Gardner's so she could obtain photographic models to aid her in sculpting the marble bust for which she could never hope to get her subject to sit still. So it was that the original of my beloved Lincoln photograph turned out not to be a close-up at all, but in its uncropped state, as Mrs. Ames received it, a head-to-waist portrait that could perfectly suit her as a model for her proposed sculpted bust.

Even with her photographs in hand, Sarah Ames did not rush her sculpture into production. Not until 1868, three years after Lincoln's death, did Congress officially purchase her thirty-six-inch-high draped marble, for the sum of $2,000. Today it sits in a niche outside the Senate deputy majority leader's office, only a few feet from perhaps the most famous life portrait ever done of Lincoln, Francis B. Carpenter's monumental canvas *The First Reading of the Emancipation Proclamation Before the Cabinet*—fashioned, it might be noted, with the aid of yet another set of specially commissioned photographs, this time by Brady's studio, on February 9, 1864.

Washington observer Mary Clemmer Ames—no relation to Sarah or her husband Joseph—saw the bust in the 1870s, around the time the Capitol acquired another work by a sculptress who had tried to capture Lincoln from life: Vinnie Ream's awkward, life-size

standing figure of Lincoln clutching the Emancipation Proclamation. The Ream work caused a sensation when it was unveiled in the Rotunda, but Mary Clemmer Ames thought Sarah Fisher Ames's work "transfixed more of the soul of Lincoln in the brows and eyes of his face than Mrs. Ream has in all the weary outline of her many feet of marble," concluding, "any one who ever saw . . . his living humanity must thank Mrs. Ames for having reflected and transfixed in the brows and eyes of this marble."[13]

By the time I put all the pieces together to solve the puzzle of why Lincoln sat for Gardner on November 11, 1863, and why the astounding result remained so rare for so long, I had devoted much of my own career as a historian of iconography to making similar connections between paintings and photographs, paintings and prints, and even a few sculptures that in turn inspired photographs (including Vinnie Ream's). The mutual interdependence of the pictorial media in the Civil War was fueled by deadline pressures, commercial competition, and lax copyright laws, and where Lincoln was specifically concerned, the busy president's inability to sit still for painters and sculptors. The discovery that one of Lincoln's most productive studio sittings had been requested by, and perhaps even supervised by, an artist in another media was by then no great surprise. Painter George Henry Story had been on hand when Gardner took his photographs of president-elect Lincoln in 1861, and Francis Carpenter no doubt supervised the sittings at Brady's on February 9, 1864.

But the fact that the photograph I had loved so ardently, so viscerally for so long—the picture that inspired me into the field of iconography in the first place—fit so neatly into this mold was the proverbial icing on the cake. Now I could love the Gardner photograph not only because it inspired my lifetime of research but because my lifetime of research finally helped explain the Gardner photograph. Sometimes even the homely face of Lincoln can be a thing of beauty that becomes a joy forever.

NOTES

1. See Stefan Lorant, *Lincoln: A Picture Story of His Life* (New York: Harper & Row, 1952); rev. ed. (New York: Norton, 1969).

2. Autobiography written for John L. Scripps, ca. June 1860, in Abraham Lincoln, *The Collected Works of Abraham Lincoln*, ed. Roy P. Basler, 9 vols. (New Brunswick, N.J.: Rutgers University Press, 1953–55), 4:62 (this collection hereafter cited as *CWL*).

3. Abraham Lincoln to Harvey Eastman, April 7, 1860, in *CWL* 4:39–40; Brady quoted in George Alfred Townsend, "Still Taking Pictures," *New York World*, April 12, 1891.

4. For examples of the cartoons, see Gary L. Bunker, *From Rail-Splitter to Icon: Lincoln's Image in Illustrated Periodicals, 1860–1865* (Kent, Ohio: Kent State University Press, 2001), 92–95; Rufus Rockwell Wilson, *Lincoln in Caricature* (New York: Horizon, 1953), 102–9. For the results of the Gardner sitting, see Charles Hamilton and Lloyd Ostendorf, *Lincoln in Photographs: An Album of Every Known Pose* (Norman: University of Oklahoma Press, 1963), 76–85.

5. For the invitation to deliver "a few appropriate remarks" at Gettysburg, see David Wills to Lincoln, November 2, 1863, Abraham Lincoln Papers, Library of Congress, Washington, D.C.

6. Quoted in Harold Holzer, "'Thrilling Words' or 'Silly Remarks': What the Press Said about the Gettysburg Address," *Lincoln Herald* 90 (Winter 1988): 145.

7. Noah Brooks, quoted in Lorant, *Lincoln: A Picture Story of His Life,* 322–23.

Harold Holzer

8. Ibid.; see also Noah Brooks, *Washington in Lincoln's Time* (New York: Century, 1895), 285–86.

9. John Hay, *Inside Lincoln's White House: The Complete Civil War Diary of John Hay*, ed. Michael Burlingame and John R. Turner Ettlinger (Carbondale: Southern Illinois University Press, 1997), 109.

10. See Rufus Rockwell Wilson, *Lincoln in Portraiture* (New York: Press of the Pioneers, 1935), 179. For Ames's career, see George C. Groce and David H. Wallace, *The New-York Historical Society's Dictionary of Artists in America, 1564–1860* (New Haven, Conn.: Yale University Press, 1957), 8; Charles E. Fairman, *Works of Art in the United States Capitol Building, Including Biographies of the Artists* (Washington, D.C.: GPO, 1913), 7.

11. For these episodes, see Harold Holzer, Mark E. Neely, Jr., and Gabor S. Boritt, *The Lincoln Image: Abraham Lincoln and the Popular Print* (New York: Scribner's Sons, 1984), 43–52, 102–10.

12. For artists' increasing reliance on photography, see Van Deren Coke, *The Painter and the Photograph: From Delacroix to Warhol* (Albuquerque: University of New Mexico Press, 1964).

13. Mary Clemmer Ames, *Ten Years in Washington: Life and Scenes in the National Capital, as a Woman Sees Them* (Hartford, Conn.: Worthington, 1873), 112.

Robert E. Lee and Traveller in Petersburg

ETHAN S. RAFUSE

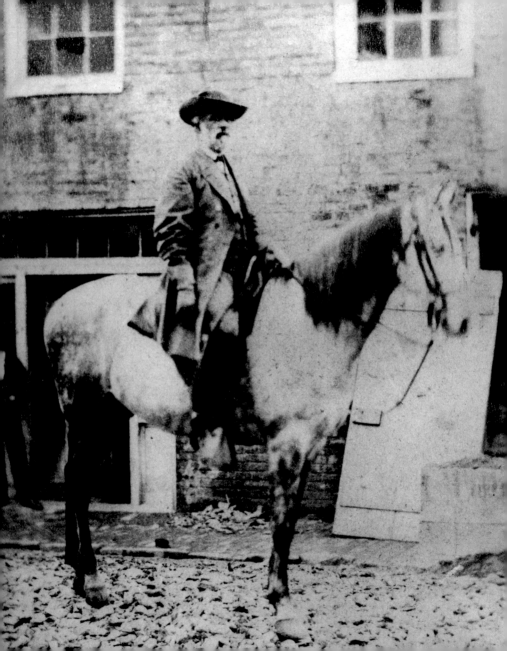

Just as Grant was preparing to move across James River . . . General Lee was maturing his plans for taking the offensive; and, in stating his desire for me to take the initiative with the corps I then commanded, he said: 'We must destroy this army of Grant's before he gets to James River. If he gets there, it will become a siege, and then it will be a mere matter of time.'—JUBAL A. EARLY

———————— •═• ————————

ONE OF THE bleakest environs in which military operations took place during the Civil War was undoubtedly Petersburg, Virginia, during the nine months Ulysses S. Grant and Robert E. Lee battled for control of the Cockade City. For Lee, riding the streets of Petersburg could only have exacerbated the pessimism he felt knowing that Grant and his army had in fact reached the James. Making matters worse, during the months Lee was penned up at Richmond and Petersburg, Union forces ripped the guts out of the rest of the Confederacy, vividly demonstrating the vast imbalance in military power between the North and South. Indeed, as the end approached in March 1865, Lee declared himself unsurprised that the Confederacy was in dire straits. "While the military situation is not favorable," he advised his superiors, "it is not worse than the superior numbers and resources of the enemy justified us in expecting from the beginning.

Indeed, the legitimate military consequences of that superiority have been postponed longer than we had reason to anticipate."[1]

The gloom hanging over the Confederacy during the Petersburg Campaign was clearly evident in a photograph of Lee from the fall of 1864. While the exact moment when it was taken is lost to history, in his study of Lee's photo history Roy Meredith points to leaves that are visible in the photo as compelling evidence that when it was taken, "autumn was well advanced" and concludes it was probably taken in late October or November. Lee is on his famed warhorse Traveller and turned to the right to look directly at the camera. The horse's hooves rest on an unpaved, gravel street. Behind Lee is a building that is clearly the worse for wear.[2]

One must, of course, be wary of reading too much into any particular photograph from the Civil War. Wet-plate photography was a fairly elaborate process that involved equipment that was difficult to transport, required great care in its setting up, and needed subjects to be stationary for several seconds in order for images to be captured. This made photography of battles, troop movements, or any scene in which the activity was such that these conditions could not be achieved all but prohibitive. Moreover, the need to avoid contamination of

the plate after exposure made outdoor photography a particular challenge.

This is one reason this particular photograph of Lee at Petersburg is so remarkable. Unlike the well-known studio photographs of Lee taken during the war, the photo of Lee in Petersburg seems more natural. To be sure, Lee could not help but be conscious of the camera. Yet, the way he looks into it offers a remarkable degree of personal connection between the general and the observer. One gets the impression of having captured Lee in as close to an unguarded moment as 1860s photograph technology allowed, as if the general was making his rounds and the photographer just happened to be standing there, giving Lee (to his slight annoyance) limited time to prepare himself for the camera. In addition, this is the only wartime photo of Lee on horseback. At the time the photo was taken, Traveller was about seven years old and in just the past few months had the experience of being thwarted in his efforts to fulfill his master's desire to rush into the thick of battle by soldiers solicitous of Lee's safety.

Then there is the way the building behind Lee offers compelling testimony to the physical damage the Federals inflicted on Petersburg. Symbolic of the crumbling Confederacy, windows are broken, a door is off its hinges, and debris lies on the ground. Federal shelling of the city during the summer and fall of 1864 did not appreciably affect the course and outcome of military operations, but historian A. Wilson Greene notes it had a profound effect on morale within the city. By the time the photo of Lee was taken, writes Greene, "Almost every edifice in the eastern half of the city had sustained damage. . . . in residential neighborhoods, military camps on both sides of the Appomattox River, and in the city's business district . . . nothing disrupted citizen's lives more severely."[3]

The picture captures Lee not as a vigorous commander who is alert and ready for action but as a weary, though unmistakably dignified and determined man who looks all of his fifty-seven years. There is little evidence of what James Longstreet described as Lee's "'up-and-at-'em' style" of generalship, which was so well captured in a photograph taken in Richmond in early 1863. With his left hand resting on his field sword, his right hand holding a felt hat, both hands in field gloves, long riding boots covering his legs, his field glasses easily accessible, and his eyes looking into the camera lens with a remarkable mixture of intensity, charisma, and eager confidence, that photo impresses on the viewer that they are looking at a great captain who is at or near the zenith of his career and eager to return to the field.[4]

Considering all that Lee had been through by the fall of 1864, the contrast between the two photos is eminently understandable. Commanding an army in the mid-nineteenth century was guaranteed to wear on the hardiest of constitutions. In addition, Lee was further advanced in years than most of the men who exercised army command during the war. (His only real peer in terms of length of service in independent field command was Ulysses S. Grant, who was about fifteen years younger.) Then there was the fact that the circumstances under which Lee exercised command could hardly have been more stressful. When he took command of the Army of Northern Virginia in June 1862, he had to deal with a Union army that was less than ten miles from Richmond, enjoyed considerable superiority in manpower, and was

intent on making the final struggle for the Confederate capital one of trenches and firepower—which Lee was as convinced in 1862 as he would be in 1864 that the Confederates could not win. Lee was able to push the Federals back from the gates of Richmond, but in order to do so had to adopt a bold and risky operational plan, implement it with subordinates whose abilities were often unequal to their responsibilities, and accept such heavy casualties that one could be forgiven for wondering if the whole exercise had been worth it.[5]

The rest of 1862 and 1863 was no easier. Lee repeatedly found himself taking heavy risks and accomplished a great deal, but even victories like Fredericksburg and Chancellorsville left him "depressed" due to the heavy costs they inflicted on his army. Moreover, the almost constant scrambling and improvisation Lee was compelled to engage in placed a heavy strain on a man who found himself battling severe health problems throughout 1863. In March he fell seriously ill, "threatened," he informed his wife, "the doctors thought with some malady which must be dreadful if it resembles its name . . . suffered a good deal of pain in my chest, back, & arms. It came on in paroxysms, was quite sharp." Although Lee managed to endure the months that followed, in late October he confessed to his wife that "I have felt very differently since my attack of last spring, from which I have never recovered."[6]

Indeed, concern about his physical vitality played no little role in Lee's decision after Gettysburg to write to President Jefferson Davis to suggest "the propriety of selecting a new commander for this army." "I sensibly feel," Lee declared, "the growing failure of my bodily strength. I have not yet recovered from the attack I experienced the past spring. I am becoming more and more incapable of exertion, and am thus prevented from making the personal examinations and giving the personal supervision to the operations in the field which I feel to be necessary."[7]

Davis refused to consider a command change and told Lee, "To ask me to substitute you by some one in my judgment more fit to command is to demand an impossibility." Lee soldiered on, but as he watched his army miss what he perceived to be a chance to strike a blow late in 1863, a staff officer heard him wearily exclaim, "I am too old to command this army."[8]

Then came the grueling campaign season of 1864, which saw Grant keep the two armies in almost constant contact with each other. The operations around Spotsylvania Court House especially wore on the combatants, impressing upon them that they were engaged in a "new kind of war," in the words of historian Carol Reardon, one "more brutal, less compromising, less forgiving, seemingly unending." At a critical point in the campaign, Lee himself fell so ill that, although he recovered, one of his staff officers declared afterward "his attack frightened all sickness away from me."[9] By mid-June, Grant had not only inflicted horrific casualties on Lee's army, but also succeeded in putting Lee in the position he had long dreaded, pinned to the defense of Richmond, with the Federals basing their operations on the James River. Grant's position, Lee complained, "is one from which he can attack us at three points, as he may select, & . . . we have not troops sufficient to guard all points."[10]

During the summer and fall of 1864, Lee and his men were able to thwart several attempts by Grant to

Robert E. Lee and Traveller in Petersburg

achieve a decisive victory at Richmond and Petersburg and deliver strong blows at such places as the Jerusalem Plank Road and Hatcher's Run. Yet as artillerist E. Porter Alexander later observed, "Even when we defeated him in his immediate purpose (as we did—almost miraculously, it would seem—for eight long months), yet there was always a bloody price to pay, from our diminishing numbers, for every temporary success, & there always remained more intrenchments to build and to man."[11]

The strain this imposed on Lee was evident in early October when he unsuccessfully attempted to organize a counterattack north of the James. On the evening of October 6, Lee discussed with Alexander his plan and Alexander's role in it. Then, at around 1:30 the following morning, Alexander was finishing his breakfast when Charles Venable of Lee's staff rode up to him and exclaimed, "The Old Man is out here waiting for you & mad enough to bite nails." When Alexander protested Lee had said the previous evening they would not be starting until two, Venable replied, "Yes, two o'clock was the hour he told us all last night, but now he swears he said one. And he scolded everybody & started off all alone, & with scarcely any breakfast, because nothing was ready." When he ran into Lee shortly thereafter, Alexander found that Venable had not exaggerated in his description of the "Old Man's" mood. Lee opened their conversation by stating, Alexander later recalled:

"Good morning, General Alexander. I had hoped to find you waiting in the road for me on my arrival." This was said with the utmost stiffness and formality. "Yes Sir! I was all ready & might have been here just as well, but you told me last night that you'd start at two o'clock,

& it's not near that yet, so I did not hurry." Which I said as good-naturedly & blandly as I knew how. "One o'clock was the hour, Sir, at which I said I would start!" This was said with a very severe emphasis. "I misunderstood you then, General, I thought you said two." "One o'clock, Sir, was the hour!" This was so emphatic that I concluded to let him have the last word, & I said no more."[12]

Lee became further exasperated when, on inquiring as to whether he had procured a guide, Alexander replied that he had presumed the general would provide for that. "Well, Sir, when I was a young man," Lee peevishly replied, "& had a march to make in the morning, I never went to bed until I had procured some citizen of the neighborhood who could conduct me." Lee called to Venable, but the staff officer was talking with another member of the staff and did not hear his commander. Lee then turned to a nearby courier and said, "I will have to ask you to act upon my staff today, for my officers are all disappointing me." It was, Alexander later wrote, "the one time, in all the war, when I saw him apparently harsh & cross."[13]

A few weeks later, Lee took to task another member of his staff. Charged with finding a new location for army headquarters, Walter Taylor selected "a fine house" and prepared a clean room for his commander. When Lee, who took pride in not sparing himself the hardships of active service, saw Taylor's handiwork, his displeasure was manifest. "I firmly believe he concluded," Taylor complained afterward, "I was thinking more of myself than him. . . . It was entirely *too* pleasant for him, for he is never so uncomfortable as when comfortable."[14]

On top of this, the fall of 1864 brought most unwelcome developments in the North. Lee believed Confederate victory hinged on the ability of military operations to erode the will of the Northern public to continue the war. By the time the sun rose on November 6, it was clear that despite Lee's best efforts, the Northern public remained determined to finish the job and confident enough in Lincoln's and Grant's policy of unrelenting war against the Confederacy to give the former a resounding victory at the polls.

By the time he and his army arrived at the gates of Petersburg, Lee had been carrying the burden of army command for over two years without a break. Moreover, from the time he assumed command, he had found himself confronted with the challenge of winning victories with only the thinnest of margins for error and compelled to make high-risk decisions because they were the best of the poor menu of options. "Everything was risky in our war," an associate heard Lee comment in 1870. "He knew oftentimes that he was playing a very bold game, but it was the only possible one."[15]

In the two years after he took command of the Army of Northern Virginia, the man the camera captured in Petersburg played that game very well, earning himself and his army an honored place in American military history. But the war had taken its toll. By the fall of 1864, Lee understood that his bag of tricks was running inexorably closer to empty and the prospects for victory were growing dimmer every day.

And yet . . . it is impossible to look at Lee's face and not see that he remained a proud and determined commander. Indeed, although the prospects for a successful defense of Richmond and Petersburg were bleak in the fall of 1864, there remained much to be determined. How much longer could the defenders of Richmond and Petersburg hold out, and at what cost? Would the seemingly inevitable fall of Richmond and Petersburg in fact mark the end of the war for the Army of Northern Virginia? If not, what would follow? What might the South demand from the North in exchange for laying down its arms? How would the Confederate war and the men who fought it be remembered? As historian Elizabeth Varon observed, Lee was acutely conscious of the importance his words, actions, and example would have on the peace that followed and was determined to secure terms as favorable to his own vision of what the fate of the defeated South should be as possible.[16] With Grant's command securely positioned and free to inexorably grind down the defenders of Richmond and Petersburg, in the fall of 1864 Confederate military defeat indeed appears to have been, as Lee had predicted a few months earlier, "a mere matter of time." Yet the remarkable image of the general one photographer captured during that time made clear that Robert E. Lee was a man who, though unable to hide the toll over two years of command had exacted on his mind and body, keenly understood that he still had much to fight for.

Robert E. Lee and Traveller in Petersburg

NOTES

The epigraph is quoted from Jubal A. Early, "The Campaigns of Gen. Robert E. Lee. An Address . . . before Washington and Lee University, January 19th, 1872," in Gary W. Gallagher, ed., *Lee the Soldier* (Lincoln: University of Nebraska Press, 1995), 6.

1. Robert E. Lee to John C. Breckinridge, March 9, 1865, in Robert E. Lee, *The Wartime Papers of Robert E. Lee*, ed. Clifford Dowdey and Louis H. Manarin (1961; reprint, New York: Da Capo, 1987), 589–90.

2. Roy Meredith, *The Face of Robert E. Lee in Life and Legend* (New York: Scribner's Sons, 1947), 58–59.

3. A. Wilson Greene, *Civil War Petersburg: Confederate City in the Crucible of War* (Charlottesville: University of Virginia Press, 2006), 215, 221.

4. James Longstreet, *From Manassas to Appomattox* (Philadelphia: Lippincott, 1896), 287–88. For this image, see Meredith, *Face of Robert E. Lee*, 41–47.

5. In his report on the Seven Days' Battles, Lee declared, "Under ordinary circumstances the Federal Army should have been destroyed" (Lee, "Battle Report on the Seven Days, March 6, 1863," in Lee, *Wartime Papers*, 221). German military theorist Carl von Clausewitz, whose writings had not been translated into English at the time of the Civil War and thus had no impact on American officers, described the fog and friction Lee documented in his report on the Seven Days as the "ordinary circumstances" of war.

6. Henry Heth to Rev. J. Wm. Jones, June 1877, in J. William Jones and others, eds., *Southern Historical Society Papers*, 52 vols. (1876–1959; Millwood, N.Y.: Kraus Reprint, 1977), 4:153–55; Lee to his wife, April 5, October 28, 1863, in Lee, *Wartime Papers*, 417–28, 616. Douglas Southall Freeman writes of the episode that Lee "had not been sleeping well, and in some way he contracted a serious throat infection which settled into what seems to have been a pericarditis [an inflammation of the sac surrounding the heart caused by an infection]. His arm, his chest, and his back were attacked with sharp paroxysms of pain that suggest even the possibility of an angina [a restriction in blood supply to the heart muscle]" (Douglas Southall Freeman, *R. E. Lee: A Biography*, 4 vols. [New York: Scribner's Sons, 1934–35], 2:502–3).

7. Lee to Jefferson Davis, August 8, 1863, in Lee, *Wartime Papers*, 589–90.

8. Davis to Lee, August 11, 1862, in U.S. War Department, *The War of the Rebellion: A Compilation of the Official Records of the Union and Confederate Armies*, 127 vols., index, and atlas (Washington: GPO, 1880–1901), ser. 1, vol. 29, pt. 2, 639–40; Charles S. Venable, "General Lee in the Wilderness Campaign," in Robert Underwood Johnson and Clarence Clough Buell, eds., *Battles and Leaders of the Civil War*, 4 vols. (New York: Century, 1885–88), 4:240.

9. Carol Reardon, "A Hard Road to Travel: The Impact of Continuous Operations on the Army of the Potomac and the Army of Northern Virginia in May 1864," in Gary W. Gallagher, ed., *The Spotsylvania Campaign* (Chapel Hill: University of North Carolina Press, 1998), 197; Walter Herron Taylor to "Elizabeth S. (Bettie)" Saunders, May 30, 1864, in Walter H. Taylor, *Lee's Adjutant: The Wartime Letters of Colonel Walter Herron Taylor, 1862–1865*, ed. R. Lockwood Taylor (Columbia: University of South Carolina Press, 1995), 164.

10. Lee to Davis, July 23, 1864, in Lee, *Wartime Papers*, 824.

11. Edward Porter Alexander, *Fighting for the Confederacy: The Personal Recollections of General Edward Porter Alexander*, ed. Gary W. Gallagher (Chapel Hill: University of North Carolina Press, 1989), 470–71.

12. Ibid., 479–81.

13. Ibid., 481–82.

14. Taylor to Saunders, November 7, 1864, in Taylor, *Lee's Adjutant*, 203.

15. William Allan, "Memoranda of Conversations with General Robert E. Lee," in Gallagher, ed., *Lee the Soldier*, 17.

16. Elizabeth R. Varon, *Appomattox: Victory, Defeat, and Freedom at the End of the Civil War* (New York: Oxford University Press, 2013).

Ethan S. Rafuse

"It Is Just What It Is and Nothing Else"

Grant after Cold Harbor

JOAN WAUGH

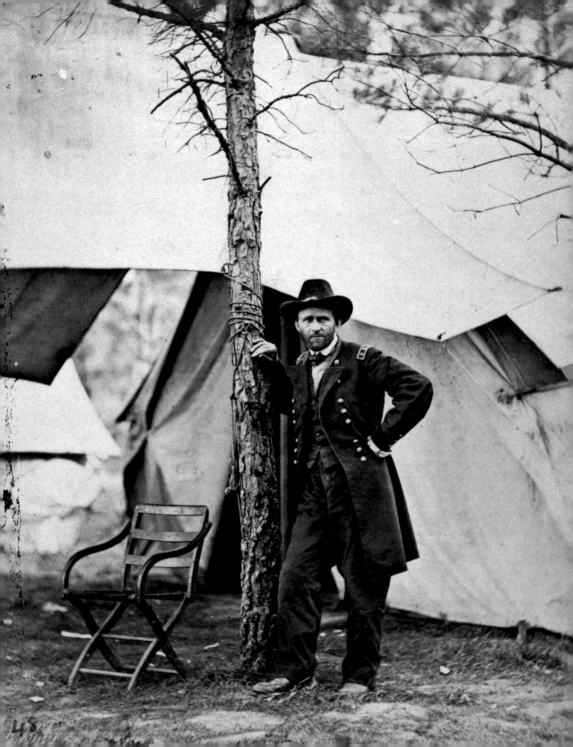

AT THE TIME of the iconic 1864 photograph by Mathew Brady and Company, Ulysses S. Grant was forty-two years old, nearing the height of his military fame and ending a costly, defining military campaign across Virginia. Casual and unaffected, Grant exuded a modest confidence grounded in success and victory. Leaning against a scrawny pine tree in front of his Cold Harbor, Virginia, headquarters tent, he appeared to be anything but the great hero that he already was to the Northern public. When researching my book *U. S. Grant: American Hero, American Myth*, I pondered if Grant himself had "staged" that remarkable photograph or if the renowned Civil War photographer Mathew Brady suggested the pose; either way, the result is a thrilling reversal of the typical military or elite portrait, an uncommon common man leading his troops to a triumphal victory for the United States.

His candid pose, his demeanor, his "cool" appearance seemed strikingly modern, and so was the uniquely nonchalant posture he adopted. How could a picture like this be taken in an era when stuffy, bland portraiture held sway? Even children, uncomfortably perched on chairs or standing stiffly by a table, were not allowed to smile or to exhibit the slightest sign of a mischievous manner. Yet here was arguably the second most important leader in the United States sporting a frown or a scowl, seemingly impatient to get on with his day. He displayed an *actual facial expression*, his hat perched in a rather jaunty manner, his body relaxed yet demonstrating a powerful determination, striking a real attitude!

Grant's exceptional life has prompted more than a few contemporaries and a number of prominent biographers to claim that the "real" Ulysses S. Grant has largely remained invisible to the penetrating eyes of friends, foes, and scholars alike. His inner life, they say, is unknowable. His close wartime comrade put it best for posterity, "Grant's whole character was a mystery," claimed William T. Sherman, "even to himself."[1] While Sherman meant his statement to be interpreted in a complimentary way, others have wondered how in the world such a nonentity who failed at everything, from soldier to businessman to farmer, rose from the bogs of obscurity to the heights of eminence. Was it attributable to dumb luck, a happenstance of being in the right place at the right time? Others, and I count myself among them, looked to his tested character, his fortitude and his intelligence, combined with a weird kind of electric celebrity aura for the answer. General and President Ulysses S. Grant was a relentless military commander whose persona came to embody the "Union Cause" for the war generation. Added to his already impressive résumé after 1868 was a stint as a two-term president

whose administration straddled a transformative era in American history.

The picture taken at Cold Harbor on June 11 or 12, 1864, offered insight and provided clues to the human being who was so famously celebrated and commemorated by massive statues and monuments testifying to his mythic legacy. The photograph illuminated his pride at being a plain, everyday kind of man, free of pretense but still clearly radiating confidence. His swift elevation to fame exemplified the progress possible in the free-labor democracy he was fighting to preserve against an aristocratic-dominated slave republic. This crucial insight into Grant began, and continued for me, with the startling realism of the Brady image. Some cultures fear that a photograph steals the soul; I believe that the camera can capture, however imperfectly, a piece of the soul. For me, this vital piece of visual documentation was complemented by careful readings of *The Personal Memoirs of U. S. Grant* as well as his letters and other materials published in *The Papers of Ulysses S. Grant*. Grant once said that Americans found his writing style familiar, truthful, and compelling because they knew: *"It is just what it is and nothing else."*[2] They knew it, he implied, because they knew *him* so well. His statement also sums up the essence of the Brady photograph. *What it is*, is more than a picture of the slim, compact, slightly stooped man with a neatly trimmed brown beard; it is a snapshot summing up the qualities his contemporaries valued: his tenacity, aggressiveness, modesty, integrity, simplicity, resoluteness, and imperturbability. Somehow, he would win the war. The aggregate of those qualities created the mythic Grant, but it was the testing of them the camera captured on that hot day in Virginia.

Photographers were ever present on the Civil War battlefield, making the conflict the first to be extensively documented by the relatively new technology. Hauntingly realistic photographs of the bloated bodies of dead soldiers and the devastated, blighted landscapes stripped war of romantic notions; at the same time, numerous portraits of generals, politicians, and ordinary men and women offered compelling personal glimpses into the hearts and souls of the individuals who made up the Civil War generation. Mastering the new technology in the 1840s, Brady's innovations shaped and refined the craft of photography. From his well-appointed Manhattan studio, Brady's portraits attracted many rich and prominent clients, but few of them in 1859 would have predicted the impact of the medium for posterity.

When the Civil War began, Brady aimed to photograph the war in its totality—battlefields, encampments, fortifications, cannons, military units, and so on. His keen business sense convinced him that both large profits to his company and a contribution to history could be accomplished by such an ambitious venture. Brady invested his money into realizing his dream, purchasing the necessary equipment and hiring many assistants, including the immensely talented twosome of Alexander Gardner and Timothy H. O'Sullivan. Brady sent teams of field photographers to the battlefields and into the camps. His primary role consisted of managing the huge project from his Washington, D.C., and New York studios. Many, if not most, of the photographs attributed to Brady were actually produced by his most able assistants, such as Gardner and O'Sullivan. Brady's willingness to take credit for other photographers' work

brought him criticism, even though it was a common business practice at the time. Several of his assistants left his employ to establish their own companies. As is well known, Brady's grand scheme ended in ruinous debt, but his company's magnificent photographic history of the Civil War provided generations of Americans with an enduring legacy.

Which brings me back to the pictorial record of Grant that is the subject of this essay. A brief explication of the life and times of Grant up to the second week in June 1864 is necessary to understanding the meaning I am imparting to the photograph in question. One reason mid-nineteenth-century Americans so admired Grant was because of his humble background, which proved, like Abraham Lincoln's, that ordinary individuals could rise to extraordinary heights. In other words, he was just like them, before he was famous, and most believed he never forgot his humble origins. Raised on the Ohio frontier, educated at West Point, veteran of the Mexican War, a dawn-to-dusk, hardworking farmer who built his family a log house, Grant was employed as a clerk in a family-owned leather goods store in Galena, Illinois, when he answered President Lincoln's call for volunteers in that first spring of the American Civil War. Prosperity had thus far eluded him, but like many others, he declared firmly and proudly for the Union.

Grant quickly gained notice in the Western Theater—Tennessee and Mississippi—with a string of victories that included Shiloh, Vicksburg, and Chattanooga. He did not rise to his position without controversy. He suffered attacks on his character and generalship. Charges of alcoholism, incompetence, and a brutal indifference to death dogged him throughout his career and affected his reputation after the war as well. Absorbing all the setbacks and disappointments, Grant displayed great equanimity throughout the war as throughout his life. He accepted the reality of the situation and moved on to the next challenge. The face in the photograph somehow reflected the sum of his past experiences for me, and now I knew, for many who viewed it at the time.

"The art of war is simple enough," Grant is reported to have said. "Find out where your enemy is, get him as soon as you can, and strike him as hard as you can, and keep moving on."[3] Grant's simple but not simplistic aggressiveness in battle appealed to President Lincoln, who kept a close eye on his fellow westerner from the beginning of his winning career. Outwardly quiet and unpretentious, inwardly confident, Grant's style of command was described as practical, flexible, and, above all, decisive. All this contributed to a growing celebrity by late 1863, captured for the record by a foot soldier, "Gen. Grant passed through on the train and the soldiers who have never seen him lined the track and gazed at him as they would a caged animal, crowding as close as they can to the car, sticking their heads in the windows and gawking at him."[4]

A big part of my book research involved many hours poring over the seemingly endless visual representations of a triumphal, perfectly accoutered General Grant, ranging from paintings to sculptures to monuments to photographs. Examining his emergence from 1862 to 1864 as a celebrated warrior-chieftain whose likeness was plastered on innumerable patriotic posters, illustrations, and postcards helped me to understand the country's need for a mythic and heroic general. Although many contemporaries and most historians described

him as unprepossessing and modest, the flood of visual representations engulfing the land highlighted Grant's power, strength, and courage, making him the symbol of a country that fought to remain united, and sustaining the morale of a Northern population buffeted by war. From this time, as Harold Holzer observed, General Grant occupied an "unparalleled place in Civil War iconography."[5]

At President Lincoln's request in March 1864, a newly promoted Lieutenant General Grant devised a national plan for the spring and summer campaign. Grant's strategy involved the movement of all Northern armies at the same time to attack and defeat the Confederates, removing their option of shifting troops around as needed. He stressed his desire to defeat General Robert E. Lee's Army of Northern Virginia while directing major campaigns in Georgia, Virginia's Shenandoah Valley, and Louisiana. The plan drew Lincoln's warm support and raised the hopes of the Northern nation for a quick end to the war. Both the president and his general feared it would not be quick, and they were right. They both knew that while the Confederacy's goal of independence could be achieved by waging limited warfare, the Union's victory required unconditional military victory.

The battles of the six-week Overland Campaign, where Grant's and Lee's armies fought to bloody stalemate across Virginia's countryside, gave rise to the nickname of "butcher" for the general-in-chief whose main strategy seemed to be throwing bodies at the enemy. On May 11, Grant sent a widely published message to Secretary of War Edwin M. Stanton stating, "I propose to fight it out on this line if it takes all summer."[6] His statement rallied a public and a president used to Union commanders who would pull back and stop fighting in the face of battle setbacks, thereby prolonging the war. At the end of May, the Federals reached a crossroads northeast of Richmond called Cold Harbor. The battle began on June 1 with some Union success, with plans to renew the fighting on the next day. Due to complications, the attack was postponed, and on June 3, Grant's massive early morning frontal assault on Confederate lines failed miserably. "I have always regretted the last assault at Cold Harbor was ever made," Grant wrote much later.[7] The campaign's previous battles—the Wilderness, Spotsylvania, and North Anna—were inconclusive, but Cold Harbor was a clear-cut victory for Lee and ended a month of incessant campaigning for both armies. The Union had suffered fifty thousand losses and the Confederacy thirty-two thousand—41 percent of Grant's forces and 50 percent of Lee's. Those losses were terrible for a South unable to replenish its armies, but also a blow for the Northern morale needed to finish the war.

The Overland Campaign was well covered by photographers, including Mathew Brady, who was physically present for some of the time, travelling with the Army of the Potomac. Grant issued Brady a special pass, writing to his wife, Julia, on June 19 that "Brady is with the army and is taking a great many views."[8] For many years, scholars assumed the image was shot at Grant's headquarters in City Point, Virginia, in late June or early July 1864. William Frassanito, one of the leading authorities on Civil War photography, produced evidence that the picture (and three others of Grant and his staff) was instead taken by Brady at Grant's headquarters near Cold Harbor on either June 11 or 12.[9] Thus, it was just

a little over a week after Cold Harbor when the famous portrait was taken. Many historians rightly described this period as a time of low morale for the United States as operations on all the major fronts had failed or were stalemated, including those of Grant's trusted western comrades, General William T. Sherman and General Philip H. Sheridan. In short, the absence of positive developments on the military side made prospects for Lincoln's fall reelection gloomy, to say the least.

Yet the record does not sustain a wholly gloomy outlook, either by the soldiers and citizens of the United States or its leadership, including Lincoln and Grant. Although war weariness rose, major newspapers and journals reported the unwavering approval of many for Grant's strategy, sustaining the support of the Northern armies. Importantly, for General Grant, Cold Harbor was a tactical defeat, but not at all a strategic failure. Here's what Grant possessed that so many Union generals did not—a "buck stops here" mentality. He was responsible for issuing orders costing thousands of lives and the waste and destruction of wide swaths of land. His president shared that responsibility and appreciated Grant's steadfastness. Lincoln remarked of his commander, "It is the dogged pertinacity of Grant that wins."[10] Victory, for Grant, was not only possible, it was eminently probable, just a matter of time, really. Was that expectation in the photograph as well? Yes, I think so! In the days before the photograph was taken Grant decided to stop trying to defeat Lee's army in battle and made plans to cross the James River and head toward Petersburg. Writing on June 9 to Illinois congressman Elihu B. Washburne, Grant remarked, "Every thing is progressing favorably but slowly. All the fight, except

defensive and behind breast works, is taken out of Lee's army. Unless my next move brings on a battle the balance of the campaign will settle down to a siege."[11] If Union troops could capture Petersburg, a vital communications and rail center, nearby Richmond would fall sooner or later. The war would come to an end. The general who was known for never retracing his footsteps braced for success; he did not cower from the consequences of failure.

The Brady photo was swiftly circulated, displayed, republished, and sold. It provided the illustrated cover for the July 16, 1864, issue of *Harper's Weekly*, with the caption "Lieutenant-General Grant at His Head-Quarters (Photographed by Brady)." Although no mention of the picture was found inside, the lead editorial praised the "masterly skill and tenacity of General Grant" and went on to state, "For two months the great battle has been joined. Our armies were never so well led, were never so united and enthusiastic." Mathew Brady's Grant remained one of the most popular representations of the general, and later, a staple in innumerable books, magazines, exhibits, and documentaries. In June 1995, the federal government issued a sheet of twenty thirty-two-cent stamps (those were the days!) depicting Civil War personalities. The image chosen for Grant was the Cold Harbor photograph. Few self-respecting Grant scholars would neglect to include the image either inside their book or for use as an arresting cover, as with H. W. Brands's recently published *The Man Who Saved the Union: Ulysses Grant in War and Peace*.

Mathew Brady did not often dwell on the sentimental or artistic side of taking pictures. He once explained the guiding philosophy behind his craft. "My greatest aim,"

he declared, "has been to advance the art of photography and to make it what I think I have, a great and truthful medium of history."[12] Brady's image of Grant seemed a prime example of a "great and truthful medium" that fascinated me more than any of the numerous paintings, sculptures, cartoons, or other depictions made of him during his storied military career. U. S. Grant emerged from the Civil War a symbol of the new American identity out of the destruction of the old one. His identity, like the reunited country, was born of war, of expanded freedom, of economic prosperity, and of a nationalism and internationalism leavened with democratic ideals. The spare, modest commander captured for posterity by the camera's penetrating eye is gazing toward a brighter future, one that he had an unshakable faith would someday happen.

NOTES

1. William S. McFeely, *Grant: A Biography* (New York: Norton, 1982), 495.

2. Bruce Catton, "U. S. Grant, Man of Letters," *American Heritage* 19 (June 1968): 97–100, 98.

3. John H. Brinton, *Personal Memoirs of John H. Brinton, Major and Surgeon, U.S.V., 1861–1865* (New York: Neale, 1914), 239.

4. Chesley A. Mosman, *The Rough Side of War: The Civil War Journal of Chesley A. Mosman, 1st Lieutenant, Company D 59th Illinois Volunteer Infantry Regiment*, ed. Arnold Gates (Garden City, N.Y.: Basin, 1987), 158.

5. Mark E. Neely Jr. and Harold Holzer, *The Union Image: Popular Prints of the Civil War North* (Chapel Hill: University of North Carolina Press, 2000), 162.

6. Ulysses S. Grant to Edwin M. Stanton, May 11, 1864, in Ulysses S. Grant, *Papers of Ulysses S. Grant*, ed. John Y. Simon and others, 32 volumes to date (Carbondale: Southern Illinois University Press, 1967–), 10:422 (set cited hereafter as *PUSG*).

7. Ulysses S. Grant, *The Personal Memoirs of Ulysses S. Grant*, 2 vols. (New York: Webster, 1885), 2:276.

8. *PUSG*, 11:84–85.

9. William A. Frassanito, *Grant and Lee: The Virginia Campaigns, 1864–1865* (New York: Scribner's Sons, 1983), 172–79.

10. David Herbert Donald, *Lincoln* (New York: Simon and Schuster, 1995), 501.

11. *PUSG*, 11:32.

12. Dorothy M. Kunhardt and Philip B. Kunhardt Jr., *Mathew Brady and His World* (Alexandria, Va.: Time-Life Books, 1977), 65.

Joan Waugh

Jeb Stuart in Full Finery

GARY W. GALLAGHER

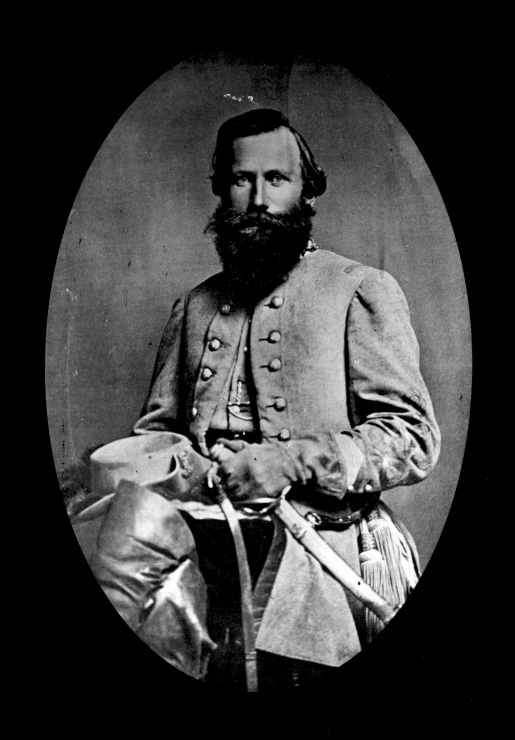

I FIRST GLIMPSED the photograph when I purchased a copy of *The American Heritage Picture History of the Civil War* shortly after its publication in 1960. As a ten-year-old, I found the illustrations in the book captivating, none more so than the full-page reproduction, situated at the beginning of the section on the 1862 Peninsula Campaign, of a portrait of James Ewell Brown "Jeb" Stuart. I never had seen anything quite like this. The young general, luxuriantly bearded and seated with his legs crossed, gazes directly out from the page with eyes that have a startling clarity. Polished boots reach above his knees, the tasseled ends of a sash hang under his left forearm, a gauntleted hand grips the hilt of his saber, and a plume adorns the hat resting on his leg. Smaller details that also caught my eye include a watch chain emerging from the third buttonhole of Stuart's vest, a pin fastening the side of his hat opposite the plume, and braid spiraling up the sleeve of his jacket. I could imagine many figures in the book in modern dress—the clean-shaven John Singleton Mosby, for example, and even the fearsome Radical Republican congressman Thaddeus Stevens, who, to my youthful eye, was a dead ringer for the equally fearsome woman who taught my fifth-grade class at the Carmel school outside Alamosa, Colorado. But not Jeb Stuart, who seemed incontrovertibly anchored in another time and place.[1]

The only information about the photograph credited the Cook Collection at the Valentine Museum—now the Valentine Richmond History Center. I did not know, and would not have cared, that this view of Stuart was not widely disseminated during the war. In the United States, neither *Harper's Weekly* nor *Frank Leslie's Illustrated Newspaper* converted it into a woodcut, and it is unlikely that very many people north of the Potomac and Ohio Rivers saw the image. Neither did many Confederates. On September 27, 1862, the *Southern Illustrated News* printed a crude woodcut almost certainly based on the photograph, though it reversed the pose and showed Stuart only from the waist up, omitting his hat, boots, and saber. Text below the woodcut reads: "Gen. J. E. B. Stuart. From a photograph by D. T. Cowell, Esq." The Valentine Richmond History Center and the Library of Congress cannot confirm Cowell as the photographer or give a specific date for the sitting. The woodcut in the *Southern Illustrated News* suggests that Stuart sat for the photograph early in the war, perhaps at the time of his celebrated first "Ride Around McClellan" in mid-June 1862. Only later in the nineteenth century, when reproductions of the photograph or high-quality engravings appeared in numerous publications, did the most famous image of Stuart reach a substantial audience.[2]

Fascination with the photograph prompted me to look Stuart up in my family's copy of *The Columbia Encyclopedia*. That bulky one-volume reference work provided suggested readings at the end of articles, which led me to Douglas Southall Freeman's *Lee's Lieutenants: A Study in Command*. My grandmother purchased the trilogy for my next birthday, and I was delighted to find that Stuart, as painted by the French artist Charles Hoffbauer in a mural titled *Autumn*, adorned the dust jacket of volume three. Freeman's initial description of Stuart seemed perfectly compatible with the photograph. The celebrated cavalryman, notes Freeman, possessed an "exhibitionist manner, a fondness for spectacular uniforms and theatrical appearance and a vast love of praise," while also demonstrating martial skills that made him one of the Confederacy's military idols.[3]

The literature on Stuart, as it existed in the early 1960s, emerged from Freeman's footnotes and a few other places, and I quickly collected a small shelf of books. Within two years, I worked my way through John W. Thomason Jr.'s *Jeb Stuart*, Henry B. McClellan's *The Life and Campaigns of Major-General J. E. B. Stuart* (in a retitled reprint from Indiana University Press), William Willis Blackford's *War Years with Jeb Stuart*, Burke Davis's *Jeb Stuart: The Last Cavalier*, Heros von Borcke's *Memoirs of the Confederate War for Independence* (Peter Smith's reprint of the 1866 original), John Esten Cooke's *Wearing of the Gray*, and George Cary Eggleston's *A Rebel's Recollections* (the last two also in Indiana reprints).[4]

The photograph often came to mind as I read about Stuart. Thomason seemingly catalogs elements of the image as I first observed it. The general "wore gauntlets of white buckskin, and rode in a gray shell jacket, double-breasted, buttoned back to show a close gray vest," writes Thomason, an officer in the Marine Corps whose grandfather Thomas Jewett Goree, a member of James Longstreet's staff, had told members of the family many stories about Stuart. "His sword," continues Thomason, "was belted over a cavalry sash of golden silk with tasselled ends. . . . His soft, fawn-colored hat was looped up on the right with a gold star, and adorned with a curling ostrich feather." A combination of showman and gifted soldier, concludes Thomason with a flourish, Stuart's "type, the general, charging with his sword out, in the front of battle, is gone from the world. His kind of war has given over to a drab affair of chemistry, propaganda, and mathematics. Never, anywhere, will there be his like again."[5]

Many passages in the books by former Confederate soldiers anticipated Thomason's treatment. Blackford, von Borcke, Cooke, and McClellan all served on Stuart's staff, and while their accounts left no doubt that Stuart excelled at the hard work of commanding cavalry, they also evoked the cavalier trappings so apparent in the photograph. A novelist, Cooke used an engraving of the photograph as his book's frontispiece and tied Stuart directly to a romantic past. "There was about the man a flavour of chivalry and adventure," wrote Cooke in a narrative based in part on observations written in notebooks during the war, "which made him more like a knight of the middle age than a soldier of the prosaic nineteenth century." I had thought no one who looked like Stuart's photograph belonged in the twentieth century; Cooke thought him an anachronism even in the nineteenth. More subdued in his prose than Cooke, Blackford wrote: "General Stuart always dressed well and was well

mounted, and he liked his staff to do the same. In our gray uniforms, cocked felt hats, long black plumes, top boots and polished accoutrements, mounted on superb horses, the General and his staff certainly presented a dashing appearance."[6]

Von Borcke sought to capture the style and presence that left a lasting impression on those who saw Stuart during the war. The Prussian considered Stuart "the model of a dashing cavalry leader" who "delighted in the neighing of the charger and the clangour of the bugle, and . . . had something of Murat's weakness for the vanities of military parade." Resplendent in his "jaunty uniform" and "sitting gracefully on his fine horse," the general "did not fail to attract the notice and admiration of all who saw him ride along." Although von Borcke's allusion to Joachim Murat, the colorful and sometimes reckless cavalry officer who fought under Napoleon, struck no chord with me, the overall tenor of *Memoirs of the Confederate War for Independence* aligned perfectly with the photograph of Stuart.[7]

As I branched out in my reading of materials by the wartime generation, I realized that many works by civilians mirrored those of von Borcke and other members of Stuart's staff in describing a Confederate citizenry entranced by the general's singular persona and appearance. Edward A. Pollard, an editor at the *Richmond Examiner* for much of the war, published *Lee and His Lieutenants* just two years after Appomattox. He pronounced Stuart "the best-remembered figure of the war in Virginia," who, with "his brave troopers," made "magnificent surprises of the enemy, always startling the public with sudden apparitions, and bounding the most distant parts of the chief theatre of war with a luminous track

of romance and adventure." The unmistakable uniform, most notably the "drooping hat, caught up with a star and decorated with an ebon plume; the tall cavalry boots decked with golden spurs; the 'fighting jacket;' . . . were all familiar objects—the popular marks of a famous cavalier." Stuart possessed "a gay careless manner . . . Full of ready jest; always in for a frolic; fond of practical jokes . . . the idol of the country belles who 'followed his feather,' and among whom he distributed complimentary commissions as his 'lieutenants.'"[8]

Pollard's Stuart, with his cavalier's attributes and attention to belles, scarcely seems suited to a modern, mid-nineteenth-century war. Such writings drew me into the company of ex-Confederates who liked to present Robert E. Lee and his high command as a throwback to an earlier, less brutal form of honor-bound warfare. Authors following this interpretive path nourished the idea, so prominent in much Lost Cause literature, that Confederate defeat was inevitable because a chivalric band of brothers stood no chance against the blue-clad juggernaut led by hard-spirited modern soldiers such as U. S. Grant, William Tecumseh Sherman, and Philip H. Sheridan. As Jubal A. Early, one of Lee's corps commanders, put it in a widely disseminated speech from the early 1870s, the Army of Northern Virginia was "gradually worn down by the combined agencies of numbers, steam-power . . . and all the resources of physical science." Northern might "finally produced that exhaustion of our army and resources, and that accumulation of numbers on the other side, which wrought the final disaster." It was almost unfair, I often thought, that the war put Stuart into the field against Philip H. Sheridan's powerful Union Cavalry Corps in 1864—and especially

that one of Sheridan's men mortally wounded Stuart at the battle of Yellow Tavern on May 11 of that year.[9]

Many hours of pouring through pictorial histories of the war revealed that neither Sheridan nor any other Union general left us a photograph comparable to the one of Stuart in full cavalier regalia. George A. Custer doubtless considered himself a cavalier, but some of his self-designed and buffoonish uniforms summon thoughts of bad Halloween costumes or of velvet paintings of dogs in tuxedos. Stuart somehow pulled it off, and it is easy to imagine that poet Stephen Vincent Benét had the photograph in mind as he composed his passage on Stuart in *John Brown's Body*:

> His long black beard is combed like a beauty's hair,
> His slouch hat plumed with a curled black ostrich-feather,
> He wears gold spurs and sits his horse with the seat
> Of a horseman born.
>
> It is Stuart of Laurel Hill,
> 'Beauty' Stuart, the genius of cavalry,
> Reckless, merry, religious, theatrical,
> Lover of gesture, lover of panache,
> With all the actor's grace and the quick, light charm
> That makes the women adore him—a wild cavalier
> Who worships as sober a God as Stonewall Jackson,
> A Rupert who seldom drinks, very often prays,
> Loves his children, singing, fighting, spurs, and his wife.[10]

A visit to Richmond in June 1965 solidified my impressionistic understanding of Stuart as a romantic figure who helped explain Confederate military failure. I went to the Museum of the Confederacy, where I encountered Stuart's plumed hat, sword, and gauntlets—just as they appeared in the photograph. I also first saw Hoffbauer's *Autumn* in person on that trip. One of four heroic-scale works depicting the seasons of the Confederacy, it occupies most of one wall in a large gallery at the Virginia Historical Society (then still popularly known as Battle Abbey). Hoffbauer placed Stuart, who seems to have migrated directly from the wartime photograph to the mural, in the van of his troopers, their sabers unsheathed, galloping up a steep hillside against an unseen enemy. With his plumed hat held aloft and scarlet-lined cape extended, Stuart, framed by trees ablaze with autumnal yellows and oranges, turns in the saddle to urge his men forward. Even as a fourteen-year-old, I knew cavalrymen had become largely irrelevant on major battlefields, so Stuart's strikingly gallant pose struck me as emblematic of purposeful but pointless struggle. The general and his men seemed especially vulnerable, almost superfluous, in a conflict with railroads and ironclads and telegraphic communication (all of which figured in smaller murals in the room), brave individuals on straining mounts in an uphill fight just before the winter of defeat settled across the Confederacy.[11]

The photograph, Hoffbauer's mural, and much of what I had read about Stuart sprang to mind when I first saw *Gone with the Wind*. During the rerelease in 1967, which featured a new 70 mm print, the film came to a local theater in Colorado's San Luis Valley. The text that scrolls up the screen in the first scene, I thought, with its references to a "land of Cavaliers" where "Gallantry took its last bow" and "Knights and their Ladies Fair" played out their final dramatic roles, could have been written with Stuart in mind. Ashley Wilkes's brave but ineffectual character, full of honor-bound rhetoric and dressed much like Stuart with sash and saber, deepened

my impression that cavaliers had no chance to prevail in the war.[12]

By the time I was in high school, my interests in the Civil War had expanded well beyond Stuart, and subsequent reading in undergraduate and graduate school revealed that most former Confederates who wrote about Lee's cavalry chief fit snugly within the Lost Cause tradition. Much of my own writing has dealt with the Lost Cause, countered the notion that United States victory was inevitable, and stressed the importance of understanding the difference between history and memory. In classes, I use myself as an example of someone who began a lifelong

association with the Civil War by steeping myself in writings about Stuart that could form the reading list for an examination of Civil War memory. Yet I never think of Stuart without having the photograph from *The American Heritage Picture History of the Civil War* come to mind. It brings back, however fleetingly, the sense of discovery and satisfaction that fueled my early explorations of the Civil War. That single arresting image served as a point of departure that led me to books, to historic sites, and, eventually, to a career as a historian of the conflict that created Stuart's fame and, just more than three months after his thirty-first birthday, took his life.

NOTES

1. Editors of American Heritage Magazine, *The American Heritage Picture History of the Civil War* (Garden City, N.Y.: Doubleday [for American Heritage Publishing], 1960). The image of Stuart takes up all of page 156. Bruce Catton wrote the engaging text for the book, which observes that Stuart "delighted in gaudy trappings" (157). For several wartime images of Stuart, see William C. Davis, ed., *The Confederate General*, 6 vols. (n.p.: National Historical Society, 1991), 6:20–23.

2. In response to my query about the photograph, a member of the staff at the Valentine Richmond History Center stated that "we have neither a date nor a photographer linked to that particular image" (Kelly Kearney to Gary W. Gallagher, e-mail, August 27, 2013). The Library of Congress's "Selected Civil War Photographs" site dates the image to "between 1860 and 1870" (http://www.loc.gov/pictures/collection/cwp/item/cwp2003004464/PP/). The image received it widest initial attention in Robert Underwood Johnson and Clarence Clough Buel, eds., *Battles and Leaders of the Civil War*, 4 vols. (New York: Century, 1887), 2:582.

3. Douglas Southall Freeman, *Lee's Lieutenants: A Study in Command*, 3 vols. (New York: Scribner's, 1942–44), 1:xlviii. Interestingly, Freeman selected a photograph of Stuart in far less

colorful dress for inclusion in this work. The image is in volume 2, opposite page xxiv.

4. John W. Thomason, Jr., *Jeb Stuart* (New York: Scribner's, 1930); Henry B. McClellan, *The Life and Campaigns of Major-General J. E. B. Stuart* (1885; reprint, titled *I Rode with Jeb Stuart*, Bloomington: Indiana University Press, 1958); William Willis Blackford, *War Years with Jeb Stuart* (New York: Scribner's, 1945); Burke Davis, *Jeb Stuart: The Last Cavalier* (New York: Holt, Rinehart, Winston, 1957); Heros von Borcke, *Memoirs of the Confederate War for Independence*, 2 vols. (1866; reprint, New York: Peter Smith, 1938); John Esten Cooke, *Wearing of the Gray* (1867; reprint, Bloomington: Indiana University Press, 1959); George Cary Eggleston, *A Rebel's Recollections* (1875; reprint, Bloomington: Indiana University Press, 1959).

5. Thomason, *Jeb Stuart*, 2, 15. A talented artist, Thomason created several memorable illustrations of Stuart for the book. On Thomason and his grandfather Goree, see Martha Anne Turner, *The World of Col. John W. Thomason, USMC* (Austin, Tex.: Eakin, 1984), chap. 2. According to Turner, Goree "transmitted to his grandson a love of chivalry and romance" (23).

6. Cooke, *Wearing of the Gray*, 7; Blackford, *War Years with Jeb Stuart*, 93.

Jeb Stuart in Full Finery

7. Von Borcke, *Memoirs of the Confederate War*, 1:22.

8. Edward A. Pollard, *Lee and His Lieutenants; Comprising the Early Life, Public Services, and Campaigns of General Robert E. Lee and His Companions in Arms, with a Record of Their Campaigns and Heroic Deeds* (New York: Treat, 1867), 421–22.

9. Jubal A. Early, *The Campaigns of Gen. Robert E. Lee. An Address by Lieut. General Jubal A. Early, before Washington and Lee University, January 19th, 1872* (Baltimore: John Murphy, 1872), 45, 40, 44, 46.

On the misrepresentation of Lee as a backward-looking soldier caught in a modern war, see my *Lee and His Army in Confederate History* (Chapel Hill: University of North Carolina Press, 2001), 151–90. For a discussion of the development of Stuart's gallant image, see Paul D. Escott, "The Uses of Gallantry: Virginians and the Origins of J. E. B. Stuart's Historical Image," *Virginia Magazine of History and Biography* 103 (January 1995): 47–72.

10. Stephen Vincent Benét, *John Brown's Body* (1927; reprint, New York: American Past series of the Book-of-the-Month Club, 1980), 182–83.

11. On Hoffbauer and his murals, see William M. S. Rasmussen, "Making the Confederate Murals: Studies by Charles Hoffbauer," *Virginia Magazine of History and Biography* 101 (July 1993): 433–56. The murals currently are in the midst of a major restoration. For details about the murals and the restoration, see the website of the Virginia Historical Society, http://www.vahistorical.org/hoffbauer.

12. Screenwriter Ben Hecht wrote the opening text. He had not read Margaret Mitchell's Pulitzer Prize–winning novel, and she was unhappy with the saccharine romanticism of his effort. For a perceptive and readable discussion of this and other aspects of the film, see Molly Haskell, *Frankly, My Dear: "Gone with the Wind" Revisited* (New Haven, Conn.: Yale University Press, 2009); for Hecht's opening, see 29–30.

Gary W. Gallagher

Three Roads to Antietam

George McClellan, Abraham Lincoln, and Alexander Gardner

J. MATTHEW GALLMAN

I HAVE A good friend who is a superb teacher. On occasion he gives workshops to graduate students on approaches to teaching undergraduates. One of his favorite lines is that he teaches a topic best when he has fifty minutes and only really knows about sixty minutes' worth of material on the topic. Thus, he can bring the French Revolution to life for freshmen, largely because he knows (almost) nothing about the French Revolution. The example illustrates some combination of modesty and truth. The truth is that we occasionally teach about topics that have not been the subject of our own research, but if we have read enough and thought enough, perhaps we can be effective teachers while not doing a terrible injustice to truth.

That brings me to George McClellan.

Anyone who teaches a course about the Civil War must come to terms with a handful of colorful characters and important personalities. We each tell our own stories and construct our own courses, but the instructor is duty bound to say something about folks like John Brown, Stephen Douglas, Harriet Beecher Stowe, Frederick Douglass, Abraham Lincoln, Robert E. Lee, and, of course, George B. McClellan. McClellan, like a few other key players, turns up in the semester-long narrative several times in different roles. Those of us charged with engaging students who are occasionally distracted by other matters sometimes turn to entertaining caricature to drive the narrative. We think fondly of George McClellan.

This photograph, taken by Alexander Gardner in the first week of October 1862, records one of the war's most fascinating moments, and it captures something of one of the war's most intriguing relationships. Sixteen days earlier, the Army of the Potomac, under McClellan's command, had faced Confederate General Robert E. Lee and the Army of Northern Virginia on the banks of Antietam Creek. It had been the bloodiest single day of the Civil War. Now Abraham Lincoln had come to visit his commander. And Alexander Gardner was there to record the moment.

As with all good storytelling, the background is important. The classroom version of McClellan's story prior to that moment includes a few crucial points. Before the Civil War, George McClellan was known to be a very smart fellow. He had been a superb student at West Point and had a splendid future ahead of him as a railroad engineer. In the first year of the Civil War, the ambitious Pennsylvanian quickly rose to a position of prominence in the Union military. Northerners embraced him for his military bearing and his ability to turn raw recruits into a well-disciplined army. But as events unfolded, he proved to be an ineffectual commander and eventually

a thorn in President Abraham Lincoln's side. His invasion up the Virginia peninsula to Richmond in the spring of 1862 went poorly. His subsequent failure to act quickly in reinforcing General John Pope and the newly established Army of Virginia drew harsh criticisms from members of Lincoln's inner circle, who felt that the recalcitrant general's actions had bordered on insubordination.

This highly public narrative unfolded alongside a more private written record that now defines our understanding of George McClellan the man. His communications to Abraham Lincoln, his commander in chief, reveal a general too quick to make excuses for his failures and an almost cartoonish egomaniac. He is, in short, a fine target for barbs from the lecturer's podium. (On occasion, when I am in the mood for shameless pandering, I will do a dramatic reading of McClellan's Harrison's Landing Letter, building a bond with my students at the general's expense.) But if his official telegrams and reports suggest a man who is annoying and occasionally insubordinate, the true gems come from McClellan's private correspondence, largely to his wife, Ellen. It is here that we learn how little the general thought of Abraham Lincoln—whom he commonly referred to as "the gorilla"—and his Washington advisors. We do not take kindly to having our national martyrs treated so.

McClellan's path to Antietam has been much examined. After the Army of Northern Virginia defeated Pope at Second Bull Run, Lee struck out north in hopes of delivering a crippling blow to the Union. McClellan, restored to command of the entire army in the East, set out after the invading Rebels with an army of nearly ninety thousand men, far exceeding Lee's fifty-five thousand. His apparent advantage grew considerably when a Union soldier stumbled upon a copy of Lee's campaign plan, dropped by a Confederate officer outside Frederick, Maryland. Lee, outnumbered and in enemy territory, had divided his army into three parts, and McClellan had at least a general sense of where they would be.

Portions of the two armies met near the town of Sharpsburg, Maryland, on September 17, 1862. McClellan, with a much larger force at his disposal, engaged the Confederates with Antietam Creek to their front and the Potomac River to their rear. The Union army hoped to destroy the outnumbered Rebels in a carefully crafted attack on both flanks, but the planned assaults were poorly coordinated, and Lee's army managed to survive a terrible day of fighting. The Army of the Potomac suffered over twelve thousand casualties, and the Confederates lost over ten thousand men killed and wounded. The Battle of Antietam stopped Lee's audacious invasion, but McClellan failed to destroy Lee's army and allowed the Rebels a safe retreat across the Potomac. The result was a tactical victory for the Union army, but hardly the overwhelming success that Abraham Lincoln had imagined. Nonetheless, the victory was momentous enough to provide Lincoln with sufficient context for his public announcement of the preliminary Emancipation Proclamation.[1]

By the fall of 1862, Scottish-born Alexander Gardner had established himself as a skilled photographer and businessman. Six years earlier, an unemployed thirty-five-year-old Gardner had journeyed to New York City to meet Mathew Brady, America's preeminent portrait photographer. Gardner's business acumen and emerging

technical skills helped turn Brady's New York studio and his new Washington, D.C., gallery—which the creative Scotsman ran—into thriving enterprises. With the outbreak of the Civil War, both Brady and Gardner threw themselves into war photography, intent on capturing the war's battlefields and participants. In November 1861, Gardner managed to get himself assigned to General McClellan's staff as a member of the Secret Service, affording him superb access to the general and his command. For much of the next year Gardner traveled with McClellan's army, while regularly returning to oversee the Washington gallery. Like George McClellan, Alexander Gardner was extraordinarily ambitious and self-confident. The Battle of Antietam presented him with enormous professional opportunities.[2]

Within hours after Lee's army abandoned the field at Antietam, Gardner and his men were busily taking powerful images of the dead soldiers and animals strewn across the landscape. For several days they labored, producing seventy images in various formats. Although Gardner was still part of Brady's operation, and thus the photographs were originally published under Brady's name, the pictures of the Antietam dead solidified Gardner's reputation as a great war photographer, setting the stage for his official break with his more famous employer. By the first week in October, the scenes of the Antietam dead were on display at Brady's New York studio. Gardner's Antietam series, particularly his stark images of bloated Confederate bodies strewn across the battlefield, had a profound impact on how Americans considered their Civil War. Oliver Wendell Holmes Jr., the future Supreme Court justice, fought with the Twentieth Massachusetts Infantry at Antietam, receiving a near-fatal neck wound. After viewing Gardner's photographs, a shaken Holmes wrote: "The sight of these pictures is commentary on civilization such as the savage might well triumph to show its missionaries."[3]

As Gardner and his men labored to capture the war's most gruesome details, and Union burial crews went about the grim business of disposing of the dead, George McClellan seemed proud of what he had accomplished. On September 20 he wrote to Ellen, declaring that, "I feel some pride in having with a beaten and demoralized army defeated Lee so utterly, & saved the North so completely. Well—one of these days history will I trust do me justice."[4] Lincoln, in contrast, felt that his general had failed to capitalize on a grand opportunity. The ultimate objective had been the destruction of Lee's army, not merely the end to his invasion. The conflict between the two men seemed to be coming to a head. McClellan privately—and not always so privately—felt that his commander in chief was a fool. Lincoln and his circle of advisors had come to see McClellan as insubordinate and not up to the task.

Two weeks after McClellan wrote to his wife, Abraham Lincoln journeyed to Sharpsburg to tour the battlefield and meet with his troublesome commander. This visit is a useful illustration of Lincoln's managerial style. Whereas some leaders prefer to call subordinates into their offices for meetings—or dressings-down—Lincoln often took the opportunity to visit officers and politicians on their own turf, apparently preferring to get the measure of the man in his familiar environment. (One of Lincoln's most famous visits had been the previous November, when he and Secretary of State William H. Seward dropped in to see McClellan in his Washington

residence when the general was away from home at a wedding. The president and secretary waited patiently in the parlor for an hour, only to learn that McClellan had already returned home and gone to bed without greeting them. Perhaps this visit taught Lincoln more than an extended chat would have.) It was also a remarkable moment, where two extraordinarily powerful men with dramatically different understandings of recent events met face-to-face.

Gardner had already returned to Washington by the time the commander in chief set out to review the troops, but the entrepreneurial photographer got wind of the trip and hurried to the scene. On October 2, the wry president sent Mary Lincoln a short telegram from Harpers Ferry, telling her that "General McClellan and myself are to be photographed tomorrow A.M. by Mr. Gardner if we can sit still long enough. I feel Gen. M. should have no problem on his end, but I may sway in the breeze a bit."[5] On October 3, while Lincoln reviewed the troops and met with his commander, Gardner captured the scene in another twenty-five photographs. Perhaps the most famous of these show the president posing with McClellan and a group of his officers in front of several military tents. Those plates are particularly appealing because they dramatize the height disparity between the two men, a marked difference only enhanced by Lincoln's ubiquitous stovepipe hat. These standing pictures also seem to show a core difference in these two men. McClellan appears as the bantam rooster, almost defiant in his pose; the president seems congenial and relaxed in comparison. Of course one suspects that the pictures illustrate what we believe to be true, rather than revealing any new truth.

Despite the appeal of that outdoor group portrait, I have always preferred Gardner's photograph of McClellan and Lincoln sitting together in a small tent. This photograph of these two great men is distinctive for the moment it captures, but also as a piece of photography. The image has an unusual feel to it, almost as if it is a candid picture of this famous meeting. We see two men sitting in a nicely appointed private space, as observed from outside the general's tent. They could be engaged in a momentous conversation about the future of the war and the nation, or they could be chatting about mundane matters before moving on to the more important issues at hand. In fact, this was not a candid photograph at all, but an orchestrated portrait. The technology of the glass plate negative required the two subjects to hold their poses while the photographer did his work. (This was the context for Lincoln's joke about his immobile general.) Both men were veterans at posing and no doubt knew the drill quite well. Meanwhile, Gardner presumably thought hard about the artifacts that he selected to appear in the scene, perhaps assisted by his subjects. A military belt, sword, and revolver are proudly—but casually—on display. The flag of the United States sits on a table behind Lincoln, with his famed hat resting on it. A folded Confederate battle flag lies on the ground to the left, a testament to the spoils due the victor. Various maps and documents are on display, suggesting an active planning meeting.

Unlike most wartime portraits, Gardner posed McClellan and Lincoln looking at each other face-to-face. The image shows McClellan's eyes, inviting the viewer to imagine what he is thinking as he gazes at the man he casually called "the gorilla." By placing his

camera outside of this private space, Gardner enhanced the sense that we were witnessing an intimate moment between two of the most important men in the Union. Any contemporary viewer with some experience in a photographer's chair would have understood that the two men had to almost freeze themselves in place so that the nuances of expression are really impossible to interpret. But one wonders how many of those viewers—both then and now—accepted the fiction that Gardner's art had produced, and saw this as a candid conversation and not a staged portrait. I probably looked at this picture a hundred times before it occurred to me that it certainly had to have been carefully staged.

Although we do not know precisely what the two were thinking as Gardner produced this wonderful plate, we do have a sense of the broader discussions during this short visit. Lincoln was dissatisfied with McClellan and urged that the Army of the Potomac take the conflict to the Army of Northern Virginia at the first opportunity. McClellan had little respect for his superior's grasp of the difficulties of warfare and was frustrated that he had not garnered the abject praise that he felt his victory deserved. Gardner clearly understood that the moment was momentous.

Whatever Lincoln told McClellan during his brief visit, the president was not pleased with the results. On November 5, he removed General McClellan from command of the Army of the Potomac, replacing him with General Ambrose E. Burnside. An embittered McClellan left the army he had built with such care. For nearly two years McClellan would remain a general without a command. His name periodically cropped up as either a military or political savior, but the Lincoln administration—perhaps recognizing the latter threat—did not send the general back into the field. In 1864 McClellan would be the standard bearer of the Democratic Party, challenging Lincoln once again. As a candidate for president, George McClellan capitalized on his widespread reputation as a moderate prowar Democrat and an immensely popular Union general, before losing in an election that was surely affected by positive events on the battlefield. Here again, history seems to have lost sight of the Democratic candidate's great popularity across much of the North.

The 1864 campaign pitted two men who differed in so many ways, but they shared one thing in common: a love of the camera. In the previous several years each man had sat for numerous portraits in photographers' studios. These images, in turn, had been reproduced for sale as cheap cartes de visite and in all manner of lithographs and other forms. Abraham Lincoln, who was distinctly aware of how Americans connected his image with the Union cause, was certainly by 1864 the most photographed person in the nation, and probably in the world.[6] McClellan had not been photographed as often, but it seems unlikely that any other military or political figure—apart from Lincoln—had sat for many more portraits.[7]

When I look at the studio portraits of these two men, I can imagine that I am learning something about their inner characters. Lincoln ages dramatically. He broods and suffers through four years of national catastrophe and personal tragedy. Yet one can detect an occasional twinkle in his eye and evidence of his famed homespun humor. McClellan's many portraits seem more stiff and formal. In his standing poses he often adopted the

"Napoleon pose," with one hand thrust inside his uniform jacket, seemingly supporting our notion that he was a bit of a martinet. Or maybe in both cases I just see in the photographs what other sources have told me is there.[8]

There is another cluster of studio portraits of George McClellan that are both quite similar and interestingly distinct. I know of seven portraits of him posing with Ellen McClellan. They appear to be from at least three separate sittings. In some he sits on a chair, and in others she takes the seat and he stands over her. He is always in uniform, and she is always extremely well dressed. Several were reproduced for public sale.[9] It is difficult to discern anything about their characters or their relationship from these portraits. Yet it is interesting to note that there are so many of them. One wonders how many married couples sat for so many portraits during the Civil War. Certainly not Abraham and Mary Lincoln.[10]

Truth be told, I have a modest collection of several hundred wartime cartes de visite of prominent civilians. Somewhere along the line I acquired a picture of the McClellans, taken in Brady's studio. In the sixty or so minutes' worth of information I can convey about George McClellan, there is little I know that flatters the man. He was intelligent. He was deeply committed to the Union. He was certainly a man of many fine skills. Yet in the story I tell he becomes a bit of a caricature. And in my defense, I would say that his own words and actions merit that treatment. But when I look at that portrait with Ellen, I am reminded of another truth. George McClellan was deeply devoted to his wife. His published papers reveal that throughout the Civil War he was sending her long letters, often several times a week, and short telegrams when there was no time to write. He shared his thoughts and his feelings with his partner perhaps as much as any public man of his era. Frequently those private and personal messages revealed things about the man that look pretty bad on the printed page. This produces an odd irony. If George and Ellen had been less close as a private couple, perhaps we might like the public man a bit more.

NOTES

1. For an excellent short treatment of the campaign and surrounding events, see James M. McPherson, *Crossroads of Freedom: Antietam* (New York: Oxford University Press, 2002).

2. For biographical material on Gardner, see D. Mark Katz, *Witness to an Era: The Life and Photographs of Alexander Gardner* (New York: Viking Penguin, 1991).

3. Katz, *Witness to an Era*, 47. See also Jeff L. Rosenheim, *Photography and the American Civil War* (New York: Metropolitan Museum of Art, 2013), 7–9; William A. Frassanito, *Antietam: The Photographic Legacy of America's Bloodiest Day* (New York: Scribner's Sons, 1978).

4. George McClellan to Ellen Marcy McClellan, September 20, 1862, quoted in McPherson, *Crossroads of Freedom*, 131.

5. Abraham Lincoln to Mary Todd Lincoln, October 2, 1862, quoted in Rosenheim, *Photography and the American Civil War*, 9. Rosenheim notes that there is some question about whether Lincoln really drafted this note (249n9).

6. One published volume reports that Lincoln sat for photographs on sixty-one separate occasions, yielding 119 separate known surviving photographs (as of 1963). There are roughly fifty surviving studio portraits of Lincoln as president. Alexander Gardner took thirty pictures of Lincoln, making him the most prolific Lincoln

photographer. See Charles Hamilton and Lloyd Ostendorf, *Lincoln in Photographs: An Album of Every Known Pose* (Norman: University of Oklahoma Press, 1963).

7. Historian Robert M. Sandow has a wonderful collection of Civil War photography, with an emphasis on photographs taken of George McClellan. He has identified roughly forty portraits of McClellan and seven of McClellan with Ellen. Not all of these images represent separate visits to the photographer's studio.

8. McClellan is always in uniform in his studio portraits, and of course Lincoln is always in civilian garb. One wonders how much of the difference in impression is communicated by that simple fact.

9. This information comes from an imprecise search of the web, followed by consultation with Bob Sandow.

10. Mr. and Mrs. Lincoln had separate daguerreotypes made on the same occasion in 1846. Hamilton and Ostendorf identify ten other pictures of Mary Lincoln, all taken between 1861 and 1865. But none shows the couple posed together.

The Weird One

Stonewall Jackson's Chancellorsville Portrait

KATHRYN SHIVELY MEIER

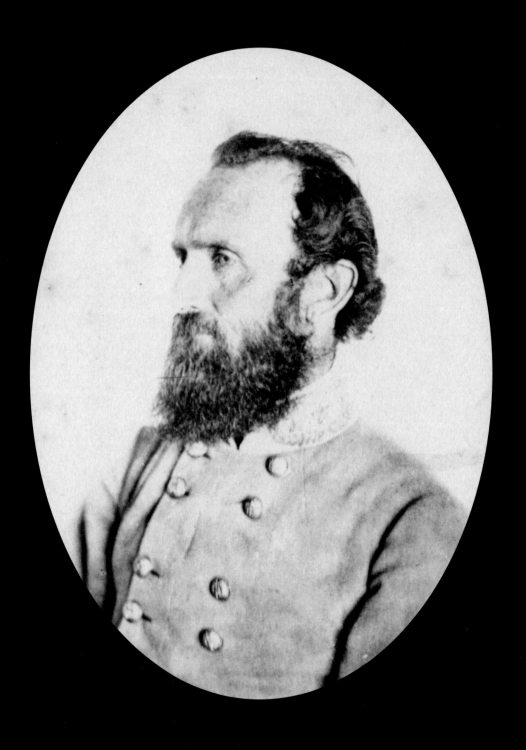

HIS FIXED EYES are pale and colorless, his hairline edges away from youth, his luxuriant beard just brushes the polished button of his lapel and the laureled stars at his collar. Thomas J. "Stonewall" Jackson's brow is creased in a manner that suggests he anticipates that his mortal wounding lurks less than a fortnight hence. But he could not foresee that he would be struck down by friendly fire at the moment of his greatest triumph. No, Jackson frowned in this photograph because, according to his wife, a "strong wind blew in his face" a second before it was snapped.[1]

As a youngster growing up at the foothills of the San Gabriel Mountains in Southern California, I fell in love with the Civil War at least in part because of that photograph of Old Jack, which appeared in my grandfather's 1967 edition of Rossiter Johnson's *Campfires and Battlefields: A Pictorial Narrative of the Civil War.*[2] An extraordinarily kind and gentle man, my grandfather chose to quietly drink away his World War II traumas incurred as a first lieutenant in the army and passed when I was thirteen, before I could muster the courage to ask him about his service. One of the most common questions I get asked as a Civil War historian is how did a Californian get into the Civil War? For someone reared in the drought-dry dust where lakes are reservoirs and cactus grows next to orange-laden trees in December, Virginia's red-clay soil and glossy magnolias are about as alien as Mars. Yet my grandfather bequeathed *Campfires and Battlefields* to my reenactor cousin, and I caught the Civil War bug by accompanying him and his history-loving mother "in the field." When faced with the prospect of my first long-form research paper in high school, it did not even occur to me why I picked the Battle of Chancellorsville. It was simply second nature.

Always exceedingly practical, I went on to major in poetry at the University of California, Berkeley, where I promptly set my fixation on Stonewall Jackson to verse—a poem, I should mention, which is almost entirely wrong in its depiction of Jackson's mortal wounding but steeped in religious mythology. My senior thesis was a meditation on William Faulkner's bewildered men who groped about in the postbellum southern soup for stable identity. I should have realized then that I was doomed. It only took a handful of years more to land at the University of Virginia, studying under Gary Gallagher. When my mentor first described Stonewall Jackson as "The Weird One," some back corner of my brain curled up and settled down permanently at the Civil War hearth. A master's thesis on Chancellorsville and a dissertation-turned-book on the 1862 Shenandoah Valley and Richmond Campaigns followed. Much like the befuddled Union generals Nathaniel P. Banks, John

C. Frémont, and James Shields, every time I attempted to move forward, Stonewall Jackson impeded my advance. I am struck by the probable truth that it is I who is The Weird One.

I am hardly the only person whose curiosity in the Civil War has been piqued by a photograph. Photographs are natural entrees into imagination. Unlike experiencing a piece of written documentary evidence, Civil War images beguile, insinuating a connection with the subject that is falsely intimate, presumptuous, and often utterly convincing. Not so different from Northerners beholding Alexander Gardner's gruesome Antietam images—their first glimpse of the battlefield, brought home to Mathew Brady's New York studio—photographs allow us to believe we are seeing the past as it truly was.

The bond I felt with the picture in my grandfather's book was not unlike mid-nineteenth-century Americans' hunger for images that enabled them to experience proximity with soldiers at the warfront—whether or not they knew them personally—and, when those men perished, to retain a continued connection. Photographs rendered battlefields both public spectacles and intimate parlors: "Every battle-field of the present, as of every war, has its national history. But, besides this, there is a private interest felt by different individuals in these places; for in one a brother fell; in another a lover lost an arm; and in others friends and relatives have fought bravely and come out unhurt." Because the actions of generals had profound impacts on the events that most concerned Americans, "Everybody [became] interested in the exploits of our different generals, and would like to see them personally."[3] As Stonewall Jackson's star rapidly rose in the wake of his celebrated 1862 Shenandoah

Valley campaign, his image marshaled increasing intrigue. The first engraving to appear of Jackson in the *Southern Illustrated News*, on September 13, 1862, did little to diminish the mystery of, for instance, Jackson's facial hair, which had been erroneously described as "short whiskers" in the *Southern Literary Messenger*. The *Illustrated News* engraving bore almost no resemblance to the general, depicting him as soft featured, long of nose, and puffy of cheek.[4]

It was not until November 1862 that Jackson first sat for a portrait at Winchester. As Marylander Colonel Bradley T. Johnson explained, Jackson had "rather pooh-poohed the notion" of being photographed as "weak for a man." Yet when dining with the family of his medical director, Hunter H. McGuire, Jackson met his match in a fourteen-year-old girl. "At the dinner table my little sister got to teasing him about it and he agreed."[5] Despite being notoriously unconcerned with his personal appearance, Jackson had his hair trimmed and even clumsily sewed back on a missing button from his coat while sitting in Nathaniel Routzahn's studio.[6] The resulting photograph was the one Jackson's wife, Mary Anna (just Anna to those who knew her), preferred, as it had "more of the beaming sunlight of his *home-look*," but it failed to convey the general his beleaguered foot soldiers had come to know over the course of their 650-mile trek from May to June 1862 in the Shenandoah Valley campaign.[7] Fanatical and single-minded toward the win, Jackson extracted victories at the expense of his men's health and even his own, apparent in his complete breakdown at the subsequent Seven Days' Battles.[8]

Stonewall Jackson's second portrait—*my* portrait and "the favorite picture with his old soldiers"—was taken in

April 1863, when Anna and her infant daughter, Julia, visited Spotsylvania.[9] After meeting on April 20, 1863, at Guiney's Station, the family, who had not seen each other in over a year, lodged at Thomas Yerby's Belvoir plantation. Quite taken with his daughter's beauty, the general would intermittently hold her up before a mirror, admiring, "Now, Miss Jackson, look at yourself!" While this fatherly devotion made for some contrast with his reputation as the fierce disciplinarian, young Julia was not entirely spared Stonewall's generalship. When she set to crying inconsolably, he ordered his wife, "All hands off!" leaving the babe to kick and scream, picking her up only when she stilled, and replacing her on the bed again when her wailing resumed. According to Anna, "He kept this up until she was completely conquered, and became perfectly quiet in his arms."[10]

Anna, meanwhile, was equally taken by her first real taste of army life. Though her husband spent most daylight hours at his headquarters, he did stop by to show off his new bay horse, Superior. Jackson "galloped away at such a John Gilpin speed that his cap was soon borne off by the velocity; but he did not stop to pick it up. . . . As far as he could be seen, he was flying like the wind—the impersonation of fearlessness and manly vigor." Anna heard tell of women collecting kisses from the most celebrated of all Confederates—Robert E. Lee—and she was thrilled to make the general's acquaintance at Belvoir. Admittedly, she was "somewhat awe-struck at the idea of meeting [him] . . . and descended to the parlor with considerable trepidation; but I was met with a face so kind and *fatherly* . . . I was at once reassured and put at ease."[11]

Those merry nine days were memorialized in the famed Chancellorsville photograph. As usual, Jackson had to be persuaded to sit for his portrait, "which he at first declined; but as he never presented a finer appearance in health and dress," his wife won him over in the end. Jackson wore the frock famed cavalry general J. E. B. Stuart had presented to him as a gift the preceding fall to replace his sun-sapped gray coat, allegedly from which ladies had stripped buttons as souvenirs. D. T. Cowell from the George W. Minnis studio in Richmond posed Jackson in Yerby's main hall, as Anna arranged her husband's hair, "which was unusually long for him, and curled in large ringlets." Just as Cowell was about to capture the scene, a breeze blew in Jackson's face, "causing him to frown, and giving a sternness to his countenance that was not natural," but more "soldierly-looking," Anna recounted.[12]

By the time Anna and Julia prepared to depart on April 29, Union Major General Joseph Hooker's Army of the Potomac had already begun to cross the Rappahannock River, initiating events that would culminate in the Battle of Chancellorsville. As Anna left Belvoir for the station, she watched stretcher bearers lay bloodied soldiers in the plantation's outhouses—her "nearest and only glimpse of the actual horrors of the battle-field."[13] But her foretaste of carnage could not possibly prepare her for the personal loss she would face when she arrived for the second time at Guinea Station, just eight days later.

It was Jackson's mortal wounding at the battle of Chancellorsville and his subsequent death on May 10 that gave the 1863 photograph its eerie cast. On May 2, Jackson's column successfully flanked the Union right via the Orange Turnpike, driving Major General Oliver O. Howard's Eleventh Corps from the field. After nightfall halted the exchange, Jackson, Major

General A. P. Hill, and their staffs reconnoitered across the paths of a number of North Carolinian regiments. When the Thirty-Third North Carolina opened fire on a legitimate Federal threat, the nearby regiments followed suit, presuming the Confederate command to be the enemy. The entire party took a thrashing, and Jackson received three musket balls to the right palm, left shoulder, and left forearm.[14] The grievous left-arm wounds required amputation. Jackson then succumbed to pneumonia, which Hunter treated with cups, mercury, antimony, and opium. Anna arrived to nurse her husband on May 7 but by the tenth informed him there was no hope of his recovery. Jackson expired "quietly," as McGuire recounted, with the alleged words, "Let us cross over the river and rest under the shade of the trees."[15] Renowned in life as exceedingly pious, the parting locution only solidified Jackson as a Christlike sacrifice to The Cause.[16]

There is nothing like death to increase one's celebrity. Perhaps twenty thousand Southerners gathered for Jackson's funeral in Richmond, and the president, cabinet, and governor turned out for his procession.[17] For those who could not view the body, the Chancellorsville photograph, taken little more than a week before Jackson's death, would be recreated throughout the Confederacy. At first there was some confusion as to whether this new image was authentic, given that it bore so little resemblance to the earlier engraving in the *Southern Illustrated News*. But as the origins of the photograph became known, the new likeness grew in popular esteem.[18] Jackson's demise attracted what historian Wallace Hettle has termed "profound soul-searching among Confederate citizens, who viewed the general as a symbol of the righteousness of their cause," while even Northerners lauded his piety and tactical skills.[19]

This was only the beginning of reimagining Jackson and his role in the Confederacy, a process that had interested Americans since the beginning of the war and became simpler now that they had two authentic photographs and their hero lay dead. Jackson has figured prominently in one hundred and fifty years of counterfactual musing over the fate of the Confederacy. If Stonewall had survived, would he have saved the Confederacy? As historian Charles Royster explains this process, "The course of history may have been ineluctable. . . . Yet the multiformity of the war's events and the capriciousness of its destruction invited imagination to defy systems of historical explanation and to change accomplished facts in retrospect—to conceive of a better story."[20] Over time, Jackson's character transmuted to confirm his contrived role as savior. Biographers and the general public began to reenvision the martinet as "humble, simple and confiding as a child."[21] Among historian Gary Gallagher's triad of reasons why Jackson has enjoyed such staying power in the Confederate pantheon—"timing, a hero's death, and a personality that set him apart from his contemporaries"—the notion of Jackson as the quintessential eccentric should not be underestimated.[22] Rapt consumers of Jackson have been amusing themselves with trumped-up tales of his weirdness since the war years; there is hardly a Civil War enthusiast alive who has not pictured the general, arm aloft, sucking a lemon and praising God.[23]

Cutting through the mythology surrounding Jackson is a daunting task, but perhaps most Americans who

behold his iconic image do not long for the truth. The photograph retains that ring of authenticity without the pesky parameters that might prevent us from casting upon it our own desires, much like the watch Quentin Compson's father gave to him in Faulkner's *The Sound and the Fury*: "I give it to you not that you may remember time, but that you might forget it now and then . . . and not spend all of your breath trying to conquer it."[24] Does it follow, then, that the Jackson immortalized in spring of 1863 is simply whoever we want him to be?[25]

On this question, perhaps Julia Jackson deserves the last mention. She accompanied her mother to Washington, D.C., to visit W. W. Corcoran, the philanthropist and art collector, who proudly unveiled a painting reproduced from the Chancellorsville photograph. "As the child stood transfixed before the splendid representation of the father," recalled Mary Anna Jackson, "the dear old man stepped forward, and lifting up the pathetic young face, tenderly kissed her."[26] While the disaster of losing Jackson for the Confederacy has almost certainly been exaggerated, it could not possibly be overstated for his daughter, who, in effect, never knew him. The portrait was, for that moment, a surrogate for her dead father, just as it became a proxy for former Confederates lamenting their defeat, and a portal for me, a young Californian wishing to understand two soldiers from my past.

NOTES

I would like to thank Peter Luebke and Mark Meier for editorial wisdom on this piece, and Ann Neilsen for serving as my repository of forgotten memories.

1. Mary Anna Jackson, *Memoirs of Stonewall Jackson by His Widow, Mary Anna Jackson* (Louisville, Ky.: Prentice, 1895), 414.

2. Rossiter Johnson, *Campfires and Battlefields: A Pictorial Narrative of the Civil War* (1894; reprint, New York: Civil War Press, 1967), 245.

3. "The Battle-Field Brought Home," *New York Evening Post*, July 22, 1862, available at the website Civil War Richmond, http://www.mdgorman.com/Written_Accounts/NYC_Papers/new_york_evening_post_07221862.htm.

4. Mark E. Neely Jr., Harold Holzer, and Gabor S. Boritt, *The Confederate Image: Prints of the Lost Cause* (Chapel Hill: University of North Carolina Press, 1987), 109–10.

5. Jackson, *Memoirs of Stonewall Jackson*, 532–33.

6. Stonewall Jackson, "Winchester photograph," three-quarter pose, 1862 description, VMI Digital Collection, Lexington, Va., http://digitalcollections.vmi.edu/cdm/singleitem/collection/p15821coll7/id/4086/rec/1.

7. Jackson, *Memoirs of Stonewall Jackson*, 413.

8. For an analysis of the effects of Jackson's leadership on his troops in the Shenandoah Valley, see Peter Cozzens, *Shenandoah 1862: Stonewall Jackson's Valley Campaign* (Chapel Hill: University of North Carolina Press, 2008); for the Seven Days' Battles, see Robert K. Krick, "Sleepless in the Saddle: Stonewall Jackson in the Seven Days," in Gary W. Gallagher, ed., *The Richmond Campaign of 1862: The Peninsula and the Seven Days* (Chapel Hill: University of North Carolina Press, 2000), 66–95.

9. Jackson, *Memoirs of Stonewall Jackson*, 413.

10. Ibid., 409–10.

11. Ibid., 412–13.

12. Ibid.

13. Ibid., 416.

14. Robert K. Krick, *The Smoothbore Volley That Doomed the Confederacy: The Death of Stonewall Jackson and Other Chapters on the Army of Northern Virginia* (Baton Rouge: Louisiana State University Press, 2002), 6–19.

15. Hunter McGuire, "Death of Stonewall Jackson," in J. William Jones and others, eds., *Southern Historical Society Papers*, 52 vols. (Richmond, Va.: Southern Historical Society, 1876–1959), 14

(January–December 1886): 162–63. The text is available at the website Stonewall's Surgeon: http://www.huntermcguire.goellnitz.org/jacksondeath.html.

16. For a discussion of contemporary impressions of Jackson's religiosity, see Gary W. Gallagher, "The Making of a Hero and the Persistence of a Legend: Stonewall Jackson during the Civil War and in Popular History," in *Lee and His Generals in War and Memory* (Baton Rouge: Louisiana State University Press, 1998), 117.

17. Wallace Hettle, *Inventing Stonewall Jackson: A Civil War Hero in History and Memory* (Baton Rouge: Louisiana State University Press, 2011), 21.

18. Neely, Holzer, and Boritt, *Confederate Image*, 111–12.

19. Hettle, *Inventing Stonewall Jackson*, 22. For more on the popular reception of Jackson's death in the United States and the Confederacy, see Gallagher, "The Making of a Hero," 104, and Charles Royster, *The Destructive War: William Tecumseh Sherman, Stonewall Jackson, and the Americans* (New York: Knopf, 1991), 213.

20. Royster, *Destructive War*, 213.

21. Neely, Holzer, and Boritt, *Confederate Image*, 113.

22. Gallagher, "The Making of a Hero," 117. Gallagher ranks Jackson's successful military record as most important to his deification.

23. Hettle, *Inventing Stonewall Jackson*, 53–54.

24. William Faulkner, *The Sound and the Fury* (1929; reprint, New York: Vintage, 1984), 76.

25. Wallace Hettle would suggest that, at the very least, what we want Jackson to be is worth studying; he writes "memories, stories, and myths can in themselves be significant aids in understanding important historical questions" (*Inventing Stonewall Jackson*, 4.)

26. Jackson, *Memoirs of Stonewall Jackson*, 414.

uliar Genius of William Tecumseh S

JOSEPH T. GLATTHAAR

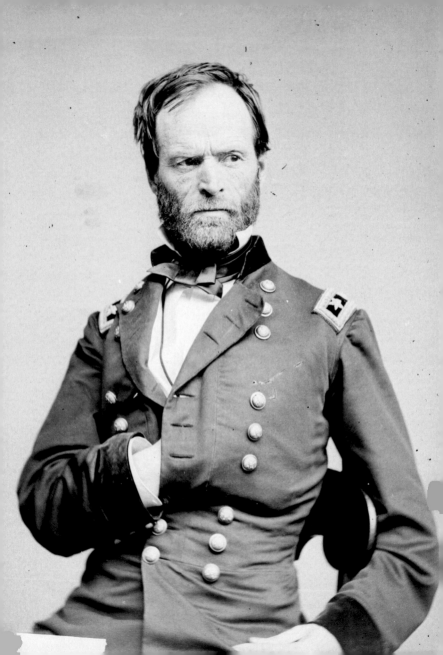

OF ALL the fascinating people who were a part of the Civil War, none intrigues me more than William Tecumseh Sherman. My first glimpse of this photograph by Mathew Brady was in 1963. I was six years old, and my older brother received *The Golden Book of the Civil War*, adapted for "Young Readers" from *The American Heritage Picture History of the Civil War* by Bruce Catton, for Christmas that year. I pored over the pages so many times that it soon became my very own, and I still have the beaten-up copy today.

At the time I thought Sherman was a maniac. His stern, intense gaze, disheveled hair, and generally unmilitary appearance conjured images of a scary and perhaps crazy person. Many Southerners then and now might agree with my youthful assessment. I preferred the quiet, relaxed confidence of Ulysses S. Grant leaning against a pine tree outside his tent (see the essay by Joan Waugh in this volume); the handsome, dignified, almost serene Robert E. Lee outside his Richmond home just after the war's end; or the photograph of a seemingly fit, rested, clean-shaven Abraham Lincoln in 1860, contrasted on the next page with a crease-faced, sunken-eyed, beaten-down Lincoln in 1865, demonstrating how the war had aged the sixteenth president.[1]

Over the next five or six years I continued to read on the Civil War. Grant remained my favorite, but I also gained a keen interest in the orphaned boy who became a great general, Thomas Jonathan Jackson. By ten or twelve, however, I abandoned my Civil War readings for sports and other pursuits.

Not until my senior year in college did my interest in the Civil War revive. I took a class on the Civil War my winter term and the next semester wrote my senior thesis on Grant's Vicksburg Campaign. Based on primary sources including the *Official Records*, Grant's memoirs, and Sherman's memoirs, the project vindicated my childhood opinion of Grant as a great commander.[2] It also instilled a newfound respect for Sherman. The communications between Grant and Sherman were so clear and direct, and they sang each other's praises so enthusiastically in their memoirs that Sherman rose dramatically in my esteem. During a year between college graduation and the start of my graduate education, I worked full-time but still managed to read some fifty Civil War–era books, including Grant's and Sherman's memoirs in their entirety. I continued my work in the Civil War with a master's thesis on Hood's Tennessee Campaign, which involved Sherman somewhat. My dissertation, however, came back to Sherman in an odd way.

One day I was poking around manuscript collections at the State Historical Society of Wisconsin when I found a diary by Captain George B. McMillan of the

Sixteenth Wisconsin Infantry. It dawned on me that a study of Sherman's march to Savannah and through the Carolinas from the perspective of the Union soldiers who executed it, the Confederate troops who opposed it, and the civilians who endured it might provide some extraordinary insights in the rise and fall of morale on the opposing sides. After researching all three perspectives, I decided that the evidence from Sherman's army was so preponderant that the dissertation needed to focus on it. I would use civilians' and Confederate soldiers' evidence for a more accurate depiction of the conduct of Sherman and his army.

As I researched it quickly became apparent that Sherman's soldiers idolized their commander. On the one hand, they could identify with him and his values. Sherman was born and raised in Ohio. His father passed away when he was young, and his mother, saddled with too many children and no income, had to place "Cump" in the home of a family friend, Thomas Ewing. Even though Ewing became a U.S. senator and cabinet member, Sherman never took on any airs. At West Point he was known for superb academics and unmilitary deportment, which reduced his class rank from fourth to sixth.

His soldiers loved him for his distaste of spit and polish, as the photograph suggests. Sherman's uncombed hair and ruffled appearance reflected his soldiers' image of their commander. The only difference was that in the photograph he wore a uniform coat with rank, whereas on the campaign he preferred more comfortable attire. One soldier noted, "His dress is as unassuming as the man. A field officer's coat without rank, low canvassed belt, hat with cord and none on his pants." He then concluded, "There is not a thing of the military in his appearance." A semiliterate soldier expressed his affection for Sherman when he wrote his wife, "It is an honor to enney man to have ben on this last campaign with Sherman you se him a riding a long you would think that he was somb oald plow jogger his head bent a little to one side with an oald stub of a sigar in his mouth." On the march or around the campfire, he could discuss the quality of Georgia soil or the most technical aspects of logistics. Having traveled widely himself, Sherman liked to think that he knew someone in common with just about every officer and enlisted man in his army. Another soldier commented that he would customarily walk with his hands in his pants pockets and "talk good earnest common-sense with the person nearest to him, regardless of rank." Rank was not royalty with Sherman, and he conveyed that message to subordinates through his actions. The fact that soldiers referred to Sherman in private and in his presence as "Uncle Billy" indicates the degree of comfort and respect they had for him.[3]

Like his soldiers, Sherman learned from his wartime experience. He and his men shared the same views on the most expeditious means of winning the war, by taking the war to the enemy and their home front.

On the other hand, this affection would not have lasted long if Sherman did not serve as an effective leader. His gaze in the photograph suggests a burning intensity, someone who is deep in thought and extremely focused on a goal. Soldiers marveled at his vast knowledge of military matters and his approach to warfare that took the war to the enemy and preserved their lives. He marched his army right through the heart of Georgia and the Carolinas and suffered relatively light

casualties in the process. His intention was to break the enemy's will to resist Union authority. As he wrote to Major General George H. Thomas in October 1864, "I propose to demonstrate the vulnerability of the South, and make its inhabitants feel that war and individual ruin are synonymous terms." As his men marched, they fed themselves largely off the countryside. With each step Sherman's soldiers took, their faith in themselves, their commander, and ultimate victory soared. They waded their way through the lengthy swamps of South Carolina and somehow managed to emerge in a great position to strike at Columbia, the state's capital. "It is wonderful what confidence this army has in Sherman," another soldier wrote. "Every man seems to think the idea of these Rebels being able to do us any harm is perfectly preposterous."[4] His penetrating stare much reflected the way he bored right through the heart of the Confederacy.

At the same time, my youthful fear based on the photograph that Sherman was a crazy man was not all that wrong. In the winter of 1861–62, the strain of command and the lack of supplies and other equipment exhausted Sherman to the point that he may have suffered a breakdown. He went home to recuperate; word circulated that he had gone crazy, and a newspaper claimed he was insane. Sherman himself admitted later that had he not had children who would have suffered a horrible stigma, he would have committed suicide. His subsequent performance as a general, though, won over his soldiers. "We all have great Confidence in Sherman," wrote a soldier to loved ones at home. "Although he was pronounced Crazy at one time, I wish all Generals were afflicted as he is."[5]

More importantly, Sherman instilled fear in the Rebels. His campaigns sought to demonstrate to Confederate troops and civilians that their armies could no longer protect their people. It had both a physical and a psychological component to the Savannah and Carolinas Campaigns. As Sherman explained to Grant, "Even without a battle, the results operating upon the minds of sensible men would produce fruits more than compensating for expense, trouble, and risk." Confederates who opposed Sherman's march soon lost heart. They had no way of halting his juggernaut. A Georgian wrote his wife after New Year's, "When we begin and let reason have its sway as to the probable future of events of our country there is nothing to make one come to any other conclusion than that all is lost." An Alabama private revealed in January 1865, "our soldiers are very much disheartened and the most of them say we are whipped." A South Carolinian went even further: "Our affairs are, apparently, hopeless. Nothing but Divine interposition can save us from subjugation."[6]

The campaign also took its toll on civilians. An Iowan wrote, "Nearly all of them had the greatest horror of Yankees." A Minnesotan concurred, describing citizens as "scared out of their wits by the Yanks." As Sherman's army neared Columbia, South Carolina, Emma LeConte's mother fainted from worry and fear. Thousands upon thousands fled their homes rather than face Sherman's "hoards," whether they resided in Georgia, South Carolina, or North Carolina. No doubt, quite a number of Sherman's soldiers behaved badly, especially in South Carolina. In Georgia and North Carolina they took food and destroyed anything of military value. Robberies and sexual assaults occurred but

were not condoned. In South Carolina, however, soldiers deliberately burned down homes and towns and plundered substantially.[7]

The impact on the former Confederacy, though, was astounding. Massive desertions in the Confederate ranks occurred, as soldiers returned to look after loved ones. Matters became so severe that Lee wrote the governor of North Carolina as Sherman was about to invade that state, urging him to boost morale at home. Letters from loved ones were leading to an epidemic of desertions in Lee's army. As my mentor and friend, the late, great Frank E. Vandiver said to me, "Communities from Texas to Virginia swear that Sherman's army marched through them." While he said it with a wry smile, the point was clear: Sherman's army left a monumental impact on the psyche of Southerners. Sherman in the photograph looks like a man who could punish his enemies that way and not think twice about it.

It was not until my year teaching at the U.S. Army War College that I learned to appreciate Sherman's bizarre genius fully. I taught an elective course called "Command Relationships in the Civil War," and among my groups for study were Grant and Sherman, and Grant, Sherman, and Admiral David Dixon Porter. I issued packets of primary documents, the officers conducted additional research, and we discussed each of the various relationships over a short semester. I began to see how Sherman developed his ideas for a raiding strategy in conjunction with Grant, and how progressive Sherman was with joint (army-navy) operations. At one point in the semester, after reading various written communications by Sherman, one of my colonels jumped up and said, "There isn't an officer in the U.S. Army today who can write a better op [operational] order than this." Conversations with Jay Luvaas, a brilliant military historian on faculty at the Army War College, reinforced my high regard for Sherman.[8]

Despite his strong racial attitudes, Sherman extended decisions with regard to freedmen to their logical conclusion. In other words, he was slowly working through his powerful cultural bias against blacks. When Secretary of War Edwin M. Stanton informed Sherman that he needed to raise black units and have them serve in his army, Sherman responded that you must realize that if you place them in the army you must give them the right to vote. Later, when the War Department decided to have black regiments in the U.S. Army, Sherman balked. If the army were to have black troops, they needed to be treated the same as white soldiers, and units should be integrated. It took the United States government eighty years to catch up with Sherman!

The more I have thought about that photograph of Sherman, the more I realize that it reflects his odd genius. While most of us attempt to narrow problems down to their most essential elements, Sherman had the kind of mind that grasped them in all complexity. Once, in comparing himself to Grant during a conversation with James Harrison Wilson, Sherman asserted that he was smarter and better read than Grant, but Grant had him beat in his firmness to formulate and execute decisions. "I am more nervous than he is," he told Wilson. "I am more likely to change my orders or countermarch my command than he is." Although Sherman proved to be an outstanding army group commander, he doubted

himself and his decisions. Perhaps it was because he viewed problems in all their complexity that he was constantly attempting to weigh various factors to formulate and apply a sound solution. His brilliant, penetrating mind, his capacity to force through a plan that would punish citizens and soldiers alike but in the end save lives, and his ability to identify with his volunteers (despite much prejudice toward them early in the war) reflected his greatest strengths as a commander. All of that is evident to me in the photograph.[9]

NOTES

1. Bruce Catton, *The Golden Book of the Civil War*, adapted by Charles Flato (New York: Golden Press, 1963), 173, 204–5, 209.

2. U.S. War Department, *The War of the Rebellion: A Compilation of the Official Records of the Union and Confederate Armies*, 127 vols., index, and atlas (Washington: GPO, 1880–1901) [set hereafter cited as *OR*]; Ulysses S. Grant, *Personal Memoirs*, 2 vols. (New York: Webster, 1885); William T. Sherman, *Memoirs of W. T. Sherman by Himself*, 2 vols. (New York: Webster, 1891).

3. Joseph T. Glatthaar, *The March to the Sea and Beyond: Sherman's Troops in the Savannah and Carolinas Campaigns* (New York: New York University Press, 1985), 16.

4. William Tecumseh Sherman to Thomas, October 20, 1864, in *OR*, vol. 39, pt. 3, 377–78; Glatthaar, *March to the Sea*, 16.

5. Glatthaar, *March to the Sea*, 16; John F. Marszalek, *Sherman: A Soldier's Passion for Order* (New York: Free Press, 1993), 163–66.

6. Sherman to U. S. Grant, November 6, 1864, in *OR*, vol. 39, pt. 3, 659–60; John Johnson to Ell, January 3, 1865, John A. Johnson Papers, Georgia Department of Archives and History, Atlanta; John Cotton to Wife, January 20, 1865, in John W. Cotton, *Yours Till Death: Civil War Letters of John W. Cotton*, ed. Lucille Griffith (University: University of Alabama Press, 1951), 125; Robert Gourdin to Sister, December 26, 1864, Gourdin-Young Papers, Emory University, Atlanta, Georgia.

7. Glatthaar, *March to the Sea*, 70, 134–55.

8. The statement, as I recall, was by Colonel Howard McMillan.

9. Joseph T. Glatthaar, *Partners in Command: The Relationships between Leaders in the Civil War* (New York: Free Press, 1994), 138.

PART 2
SOLDIERS

Looking at War

Union Soldiers in the Peninsula Campaign

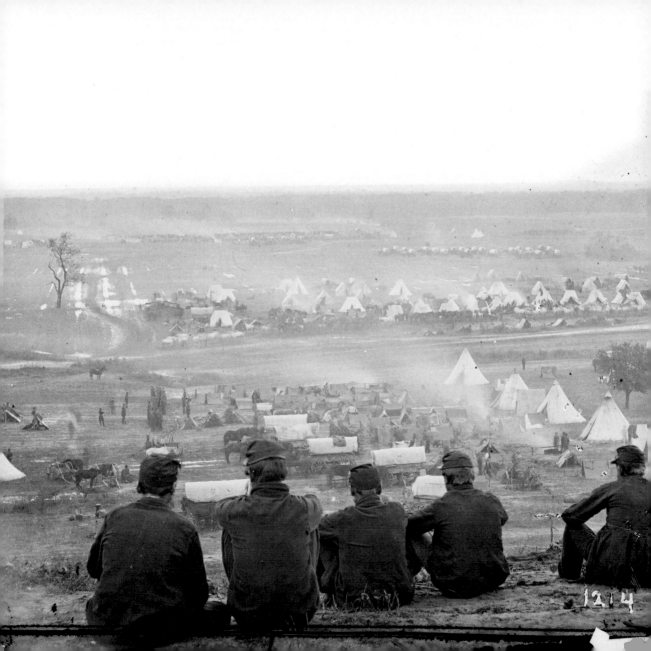

THE CIVIL WAR usually comes to us through stories. Whether read, heard, seen, or enacted, stories carry us into the pivotal and dramatic moments of the conflict. But for participants, most of the Civil War, like all wars, consisted of waiting. Soldiers waited through the long muddy season when animals and wagons could not travel Southern roads. They waited for officers to execute or respond to attacks. Civilians waited endlessly for news of the war and reports of wounded and killed. Abraham Lincoln waited out much of the war in the telegraph office across from the White House. James Gibson's photograph of Union soldiers during the Peninsula Campaign in May 1862 allows the viewer to wait as well. The men over whose shoulders we look are staged here, but the position was a natural and inevitable one for every soldier—waiting for a new season, a new battle, a new event that would create meaning.

If we hope to understand the Civil War, we must understand soldiers' perspectives—after all, they were the ones who fought the war. The Union men in James Gibson's photograph gathered on a hill overlooking Cumberland Landing, just above where Virginia's Pamunkey River flows into the York River. Gibson did not note the date, but it probably fell in mid-May 1862, as Major General George B. McClellan's forces moved up the York before heading west toward Richmond along the line of the York River Railroad. By this point in the war, soldiers did not merely wait. They anticipated. The arrogant hope that one side or the other would concede evaporated after news the preceding month about the Battle of Shiloh, where twenty-four thousand soldiers fell in two days of fighting. Now, enlisted men understood the purpose of all the preparation and material in front of them. The easy confidence that characterized much of 1861 yielded to the grim, determined pose embodied by these soldiers. Among these five men, some probably sat imagining their own deaths.

John Keats's "Ode on a Grecian Urn," another creation of the nineteenth century, captures the emotional power of anticipation, which can be more real and more lasting than the actual event. In his poem, Keats celebrates the lovers who do not consummate, the leaves forever green, and the music forever new. Gibson's photograph pauses men on the verge of action as well—young, healthy, whole. But if anticipation can be good for lovers, it must more often be bad for fighters. Some soldiers on this march expressed great confidence in their ability to repulse the Confederates and end the secessionist threat to the Union. But many others were skeptical.

Gibson staged his photo in a way that immerses viewers in soldiers' perspectives and so offers us an opportunity

to consider several aspects of their experience. Though not as well known as Mathew Brady (whose Washington, D.C., studio he helped manage for a time) or Alexander Gardner, Gibson provided an invaluable record of the Peninsula Campaign. He traveled through the region from April into June, photographing Union positions and material, the siege of Yorktown, and many individual soldiers.[1] Choosing to photograph soldiers from behind and to use them as a literal frame through which viewers see the landscape liberates us from the conventions of portraits at the time. The stiff formality required by exposure times that mars so many wartime images is absent here. The soldiers are at once humanized by their humble pose and dehumanized because we do not see their faces. This was a tension that every enlisted man struggled against in the war.

Viewing the soldiers in the foreground from behind rather than head on suggests the interchangeability of the already monstrous Union military machine; we do not need to see faces because these particular men will not survive the conflict. They are, literally, uniformed men waiting to take their place in battle. As the conflict extended in time and scale, soldiers easily became abstractions to all but their families. Newspapers carried battle reports that summarized casualties by the thousands. The Union army in 1862 was already an organization larger than anything seen earlier in North America. The prewar U.S. Army contained 15,000 men. By the end of the Civil War, 2.2 million men had served in the Union army.

At the same time, the photograph's composition roots us in the war's human dimension. The soldiers in the foreground become the yardstick by which to measure the scene they observe. The individual pieces of military equipment spread out across the landscape are person-sized—tents, blankets, muskets, and coats. No "Flying Fortresses" or aircraft carriers dominate the landscape. The other natural feature that stands at odds with our image of the Civil War as a modern, industrialized conflict is the profusion of animals. Although the foreground focuses on men, the middle of the picture reveals the presence of dozens of horses. Even more important than the presumed camaraderie among the men on the hill is the intimacy of men and animals on the plain below. Horses appear in all manner of action— eating, resting, corralled, yoked to wagons, saddled and ready to be ridden. Railroads played an important role in moving men and supplies, but the Civil War moved on animal and human power. The hoof and foot, not the iron rail, carried the war. Managing and supplying the animals that moved the armies required even more elaborate systems than their mechanized counterparts. Both the North and South organized huge procurement networks to obtain the fodder and equipment to support their animals. Mobile blacksmiths moved with the armies, shoeing horses and repairing equipment. It was no coincidence that the men who commanded Union and Confederate armies were themselves expert horsemen who at times demonstrated more compassion for the animals than the men they commanded.

By giving us only the backs of these young men to orient ourselves, Gibson forced us to consider the scene they watched. The uniformity of their dress, including the signature kepis worn by Union soldiers, suggests the regimentation of the army. Unlike the undersupplied Confederate army, within which men wore all manner

of headgear, McClellan's Army of the Potomac drew upon a vast procurement system to outfit and equip its soldiers. Although little can be seen of the men in the photo, their easy pose suggests both young men and enlisted personnel (officers did not sit flat on the ground). These were the men who fought the war.

From their perch, they observed the transition toward what historian Allan Nevins called "the organized war."[2] During the conflict, each side established the systems that define modern warfare. Departments, divisions, and bureaus multiplied; agents, clerks, directors, and inspectors proliferated. Many critical posts were often filled by men who had recently worked within the railroad companies and commercial banks that pioneered business bureaucracy. That expertise allowed the North to conduct the war through what we would today call a public-private partnership. Andrew Carnegie, for instance, worked in the War Department helping organize Union army train schedules and telegraph lines. This was war on a grand scale, and Gibson's image clearly conveys one small slice of what these men would have seen. The best modern history of the campaign describes the profusion of goods at the next Pamunkey River landing: "Acres of boxes and barrels and crates holding rations and ammunition and supplies and equipment of every sort covered the landing. There were wagon parks and artillery parks and great piles of baled forage."[3]

Despite the scale of organization visible, the photo emphasizes the utilitarian nature of nineteenth-century warfare. The homelike infrastructure of today's military is absent. Soldiers lived in dirt and mud. For many men, the microbial threat proved lethal. Dysentery and other diseases flourished in the camps. And soldiers who returned from battles with wounds faced special danger from infection in an age just before the medical breakthroughs of Louis Pasteur, Joseph Lister, and others. Soldiers developed their own understandings of the relationship between hygiene and health, but these were hardly foolproof.[4] Every soldier contended with heat, cold, moisture, contaminated water, spoiled food, and innumerable vermin and pests. These threats multiplied and waged war on soldiers in camp, leaving some to fear rest more than the march. "What I dread most in the service is getting sick in camp," one wrote. "I fear if I was to get bad sick in camp it would kill me."[5]

Even if the aggregate picture of the Union camp reveals broad organization, a closer look reveals the physical disarray that characterized Civil War armies. Tents open in different directions, and many have overcoats or blankets thrown over them. By the midpoint of the campaign, McClellan commanded more than 100,000 soldiers and a large but indeterminate number of noncombatants. In 1860, Virginia's largest city was Richmond, with 37,910 residents—a number that by the summer of 1862 probably had doubled. The Army of the Potomac thus represented not just a mobile city but a marching metropolis significantly larger than the state capital (only New Orleans among all Confederate cities had a larger population than the Army of the Potomac). And it was a special kind of city—nearly all male, young, and armed. Civil War camps offered every opportunity for trouble that worried parents and spouses could imagine—gambling, alcohol, prostitution, crime, and fighting. The armies tried to impose order (though none organized military police systems of the sort that characterize modern armies), and some officers proved

uniquely effective at rooting out threats. For the most part, however, soldiers had to find their own way through the temptations and dangers of camp life. "The army is the worst place in the world to learn bad habbits of all kinds," noted a Michigan soldier. "There is several men in this Regt when they enlisted they were nice respectable men and belonged to the Church of God, but now were are they? they are ruined men."[6] Even men who entered the army with firm wills found the tedium of camp life could draw them into risky behavior. There was only so much time a man could spend contemplating the army as a great engine of war.

As much as Gibson's photo reveals about the experience of Civil War soldiering, it obscures a great deal as well. The soldiers' lofty vantage point gives an impression that they had transcended the moment, but this interpretation belies the chaos and terror that defined the war for so many participants. The tension here points to another contradiction that defined the life of both Union and Confederate soldiers: the calm and orderly nature of camp life contrasted with the horror and violence of battle. Soldiers spent most of their army life in camp or on the march. Here, they joined what a Massachusetts man on the Peninsula Campaign called "the Army of nothing and nobody, Head Quarters nowhere." Writing to his wife, he advised that she "take blank and divide by ten and you have my shadow that I am forced to call my life."[7] Camp life, as Gibson's photo reveals, was characterized by tedious repetition: drill, domestic chores, and simple waiting. Battles, on the other hand, left many soldiers bewildered by their unpredictable violence. Veterans grew accustomed to this life lived in extremes, but few relished it.

Gibson's photo also presents soldiers as the masters of all they survey, but they were not the only actors in the war. The families these men left behind at home played a key role as supporters or opponents of the war. Both the Union and Confederacy functioned as democracies (if only imperfect predecessors of our modern system), and in order to maintain the war, they needed the support of citizens. And soldiers needed the support of their families. Commanders on both sides worried that discouraging letters from home would sap the morale of their troops. In the spring of 1862, many soldiers were approaching the end of a year's service. Volunteers' initial expectations that they would be home in time for the fall harvest in 1861 had been cruelly swept away by continued Confederate resistance and the massive reorganization undertaken in the Army of the Potomac in late 1861 and early 1862. Soldiers yearned to rejoin their families, and some slipped away on unauthorized leaves. As a result, both armies tightened discipline in early 1862 and launched rhetorical campaigns that explained desertion as disloyalty.

Like all photographs, the image at Cumberland Landing freezes its subjects in time, but for the previous month, Union soldiers had been in motion on the Peninsula. Most arrived in early April when McClellan ferried his troops by steamer to Fort Monroe. Their journey toward Richmond brought them into intimate contact with Confederate civilians, none too happy to see them. White Virginians greeted the occupiers with "steely glares and icy hatred," spurred on by local newspapers that encouraged civilians to "die with dignity and glory, but . . . never live to be slaves."[8] Most Northern soldiers seem to have given little thought to

being occupiers before they arrived in the South. Like Lincoln and Seward, many expected that they would be treated as liberators, especially by non-slaveholders in the region. That they were not came as a rude surprise.[9]

The most important aspect of the war that lay just outside the camera's range at Cumberland Landing was emancipation. It happened not far away, but few Civil War photographers chronicled it. The Union's initial large-scale experience with ad hoc emancipation by the army occurred during the Peninsula Campaign.[10] Soldiers first encountered the brewing slave rebellion when they stopped to ask directions from black Southerners. They rarely asked white Virginians but implicitly trusted slaves and free blacks to support the Union. Army scouts gathered much of their military intelligence in this manner. Then, as the army made its way up the Peninsula and masters fled, enslaved people took the chance to run. "Slaves took any opportunity, no matter how unexpected, to flee into Union lines," as one historian explains, "leaving plows standing in the fields and taking off with neither a hat nor a coat when the chance to join a band of Yankees presented itself."[11] It is entirely possible, probably likely, that some of the men feeding animals in the picture's background or tending cooking fires among the tents were recent additions to the Union army, former slaves now balancing precariously on the cusp of freedom.

The men gathered for James Gibson's photograph were poised on the verge of a great change in the war and in U.S. history. George McClellan anticipated that the coming battle (what would later be called Seven Pines) would be "one of the great historical battles of the world."[12] But he had as little idea of where the war was headed as his men gathered at Cumberland Landing. Where emancipation would lead, no one could say, but its coming marked a signal change in history. The soldiers' inability to see this future points up the singularity of the moment and the contingency of war. Their concerns for the future would have been both personal and political: Would the next battle bring their death? Would it end the war? Preserve the Union? Bring emancipation? "What men or gods are these?" Keats asked in his poem. They chase and love and yet hang suspended in time. So also for Gibson's soldiers, just men gathered as an army in a hostile land, changing the world as gods might.

NOTES

1. Garry E. Adelman, "Documentary Photography Comes of Age on the Peninsula," Civil War Preservation Trust, www.civilwar.org/battlefields/gainesmill/documentary-photography-comes.html, accessed September 16, 2013.

2. Allan Nevins, *The War for the Union: The Organized War, 1863–1864* (New York: Scribner's Sons, 1971).

3. Stephen B. Sears, *To the Gates of Richmond: The Peninsula Campaign* (New York: Ticknor & Fields, 1992), 104.

4. Kathryn Shively Meier, *Nature's Civil War: Common Soldiers and the Environment in 1862 Virginia* (Chapel Hill: University of North Carolina Press, 2013).

5. Quoted in ibid., 15.

6. Quoted in Bell Irvin Wiley, *The Life of Billy Yank: The Common Soldier of the Union* (1952; reprint, Baton Rouge: Louisiana State University Press, 1995), 247.

7. Quoted in Meier, *Nature's Civil War*, 62.

8. Quoted in James Marten, "A Feeling of Restless Anxiety: Loyalty and Race in the Peninsula Campaign and Beyond," in Gary W. Gallagher, *The Richmond Campaign of 1862* (Chapel Hill: University of North Carolina Press, 2000), 126–27.

9. For a useful exploration of the process of occupation, see Stephen V. Ash, *When the Yankees Came: Chaos and Conflict in the Occupied South* (Chapel Hill: University of North Carolina Press, 1995).

10. On emancipation during McClellan's campaign, see Glenn David Brasher, *The Peninsula Campaign and the Necessity of Emancipation* (Chapel Hill: University of North Carolina Press, 2012).

11. Marten, "A Feeling of Restless Anxiety," 134.

12. Quoted in Sears, *To the Gates of Richmond*, 106.

Aaron Sheehan-Dean

Cary Robinson's Last Christmas

EMORY M. THOMAS

Cary Robinson
The Vineyard
Killed in Our War
— Por X 306

I KNEW Cary Robinson's name long before I saw his photograph. I "met" Robinson in the course of conducting research for my biography of Robert E. Lee. Two young women—girls, really—from Richmond wanted to spend Christmas in 1863 with Robinson, himself only twenty years old.

But at the time, December 1863, Robinson was serving in the Army of Northern Virginia, which was defending Richmond and the Confederacy against George G. Meade's Army of the Potomac. Soldiers could not simply salute someone and toddle off to sing Christmas carols with two teen-aged girls.

So the girls did what seemed to them the logical thing to do. They wrote a note to the commander in chief of Cary Robinson's army, General Robert E. Lee. Here is what they said: "We the undersigned write this little note to you our beloved Gen. to ask a little favor of you which if it is in your power to grant we trust you will. We want Private Cary Robinson of Com. G., 6th V[irginia Infantry], Mahone's Brig. to spend his Christmas with us, and if you will grant him a furlough for this purpose we will pay you back in thanks and love and kisses."

The two young women signed themselves "your two little friends." They were Lucy Minnegerode and Lou Haxall, respectively the daughter of the rector of St. Paul's Episcopal Church in Richmond and the daughter of a very prominent Richmond family made wealthy by flour milling. Lee knew them, likely from social occasions during his rare visits to Richmond during the war. And Lee attended St. Paul's Church, along with Jefferson Davis and other prominent Confederates. St. Paul's was as close as possible to a "state church" in the Confederate capital.

When I first read the letter of his "little friends" to Lee, I was principally concerned with Lee and his circumstances. Indeed, Lee's circumstances in December of 1863 make quite a story in themselves.

During the previous spring, Lee had suffered what was likely some form of cardiovascular event—a stroke or a heart attack, most probably the onset of angina. In late March, he complained of a "heavy cold," and a week later, on April 3, 1863, he changed the adjective to "violent." He blamed his illness on a recent sojourn in Richmond and overheated houses. Lee's physicians became concerned, so concerned that they "ordered" the commanding general to leave his headquarters and to take to a bed. Lee did not return to his family in Richmond, but instead took refuge in a spare room of a family living on a farm nearby. He took his hired African American body servant Perry with him and maintained contact with his headquarters while his army was in "winter quarters" near Fredericksburg, Virginia.

He was not happy. Lee was essentially a shy person, and he was skeptical of physicians and medicines. He wrote

to one of his daughters, with tongue firmly in cheek, "You know how pleased I am at the presence of strangers, what a cheerful mood their company produces. Imagine then the expression of my face and the merry times I have." During his convalescence, his doctors "have been tapping me, all over like an old steam boiler" and treating him with "a complete saturation of my system with quinine." Ultimately Lee's physicians diagnosed him as suffering from rheumatism and/or an inflammation of the pericardium (the membrane enclosing the heart). Actually Lee suffered from something more serious, perhaps atherosclerosis (constriction of blood flow in his arteries) and angina pectoris.

Lee lived in his convalescent space for over two weeks; he returned to his headquarters on April 16, confessing to his wife, Mary, that he was "feeble & worthless & can do but little." He felt "oppressed by what I have to undergo for the first time in my life." On April 11, his pulse rate still had been "about 90."

Of course, Lee did carry out what he "had to undergo." He carried out his command quite successfully. He dared greatly and won what many consider his greatest victory at Chancellorsville, then dared some more at Gettysburg and lost. Lee continued to campaign during the fall of 1863, but his ambitious strategies came to not much more than frustration at Bristoe Station and Mine Run.

And Lee continued to suffer from the cardiovascular event from the spring of 1863. "I have felt very differently since my attack of last spring, from which I have never recovered," he wrote to his wife on October 24, 1863. Very late in his life, he still lamented that "first attack in front of Fredericksburg." Nevertheless, Lee soldiered on, and he accomplished great things in the war and after, despite his infirmity.

Beside his own ailments in late 1863, Lee was compelled to concern himself with the declining health of his wife, Mary. Her arthritis had progressed to the point at which she had to exchange her crutches for a wheelchair. During the summer of 1863, Lee had to arrange for a private railroad car to transport Mary Lee to Mountain Springs in search of relief from her pains. By Christmas 1863, she was back in Richmond (where Lee had advised her not to be), living in a rented house with two of her daughters.

Lee did not like the house, principally because there was no room for his daughter-in-law Charlotte Wickham Lee, called "Chass" by members of the family. She was the wife of Lee's second son, William Henry Fitzhugh, who went by "Rooney" and had been wounded at the Battle of Brandy Station and was being held captive by the Federals at Fort Lafayette, New York. So Lee had both his son and daughter-in-law about whom to worry. A brief visit with Chass "oppressed" him "with sorrowful forebodings," and soon after Lee's visit Chass died.

During the war Lee had lost large amounts of invested money, along with personal and real property. He confided to his oldest son Custis, "I have nothing now not in the hands of enemy, except for $5,000 in Confederate States bonds . . . and $5,000 or $8,000 in N.C. bonds." He added, "I own three horses, a watch, my apparel and camp equipage. You know the condition of the estates of your grandfather [George Washington Parke Custis]. They are either in the hands of enemy or beyond my reach. The negroes have been liberated, everything swept off . . . houses, fences, etc., all gone. The land alone remains a waste."

The war was trending poorly. Lee likely realized but could never admit that Gettysburg had been his last chance to win the war the way that he wanted to win it—in one decisive campaign.

Moreover, Lee had every reason to believe that he was about to lose his army. Battles in the Western Theater of the war were not going well. General Braxton Bragg had suffered a horrendous defeat before Chattanooga at Missionary Ridge, and it had become quite clear that Bragg was no longer fit to command the Army of Tennessee. Rumor had it that Confederate president Jefferson Davis intended to send Lee to Dalton, Georgia, to command the Confederacy's other main army. Lee did not want this to happen. He feared that his health could not sustain the challenge. He had been sending subordinates with whom he could not get along to the Army of Tennessee for some time. He certainly did not want to go to command these people. Now he received a summons to go to Richmond to meet with President Davis. When he left his headquarters, he wrote a note to J. E. B. Stuart, who led the army's cavalry: "I am called to Richmond this morning by the President. I presume the rest will follow. My heart will always remain with this Army."

As it happened, Lee proved able to dodge command of the Army of Tennessee. He met with Davis and proposed P. G. T. Beauregard for the command. He knew that Davis despised Beauregard, and predictably Davis rejected Lee's suggestion. Then Lee nominated Joseph E. Johnston, a senior general with whom Davis also had feuded for a long time. Davis acceded to Johnston's appointment, which had probably been Lee's wish from the beginning.

The point of this long litany of laments is simple. Oppressed with significant woes—personal, private, and public—Lee did not have time, and should not have had the temperament, to deal with the "little favor" requested of him by his "two little friends."

But he did.

Lee received the "little note" on the same day that he received his summons to meet with Davis in Richmond. He carried the note with him, and after he had worked his machinations on the president, he responded. He wrote to Robinson, whom he knew had recently suffered the death of a brother. And he wrote to Lucy Minnegerode and Lou Haxall:

> I rec'd the morning I left camp your joint request for permission to Mr. Cary Robinson to visit you on Xmas, and gave authority for his doing so, provided circumstances permitted. Deeply sympathizing with him in his recent affliction it gave me great pleasure to extend to him the opportunity of seeing you, but I fear I was influenced by the *bribe* held out to me, and I will punish myself by not going to claim the thanks and love and kisses promised me. You know the self denial this will cost me. I fear too I shall be obliged to submit your letter to Congress, that our Legislators may know the temptations to which poor soldiers are exposed, and in their wisdom devise some means of counteracting its influence. They may know that bribery and corruption is stalking boldly over the land, but may not be aware that the fairest and sweetest are engaged in its practice.

Not only did Lee rise above his trials and take the time to write a letter to one of his thousands of soldiers. He also wrote to his "two little friends," and he

introduced humor to the exchange with his reference to the "bribe" of "thanks and love and kisses." For some time, I have told this story to classes, clubs, and other audiences. I think it is my favorite Lee story because it illustrates the depth of his character and his capacity to laugh at life.

In the course of assembling material for an "album" about Lee, I asked Bryan Clark Green, then curator of photographs at the Virginia Historical Society, to try to locate a picture of a number of people, among them Cary Robinson. The photo reproduced here is in the society's collections among the Robinson Family Papers.

I find the photograph arresting, haunting, and fascinating. Initially, I thought Robinson looked scared, at least startled. Later, I have come to see the photo with its label, "Killed in Our War," as incredibly poignant. Robinson is innocence incarnate. At what or whom is he looking? He is too young to be in "Our War." Robinson represents the waste of wars.

I have discovered that Cary Robinson, born in Richmond on November 9, 1843, was the son of Conway Robinson, who was an eminent legal scholar and author of a famous tome about the practice of law. Cary attended Mr. Turner's School in Richmond and then enrolled in Columbia College (later George Washington University) after his family moved to the District of Columbia in 1858. Cary and his younger brother William—"Willie"— had to cross enemy (Federal) lines in order to enlist in the Confederate army. At that time in 1861, Cary was eighteen years old and Willie was sixteen. Willie was eighteen when he died on October 14, 1863, of wounds sustained at Bristoe Station.

Cary Robinson was killed near the Boydton Plank Road on October 27, 1864. His obituary appeared in the *Richmond Examiner*. One of his comrades wrote of him:

[H]e always desired to die at the head of the old brigade . . . splendid in his dauntless bravery, genial in his temper, full of innocent mirth, rarely gifted in mind . . . softened & enabled by a sweet spirit of Christian love & faith . . . the cause has lost a chivalrous & courageous defender, society a refined and accomplished gentleman, and the service of Christ, on earth, a faithful and loving disciple. . . . [H]e once said, . . . his noble boyish face illuminated by the beauty of holiness, 'if God sees fit to take me I am perfectly contented' . . . [H]e has received his promotion into the noblest army of martyrs.

On the day Cary Robinson died, Robert E. Lee reported, in part to the secretary of war, "[T]he attack . . . upon the enemy on the Boydton Plank Road . . . was made by three (3) brigades under General Mahone Mahone captured four hundred (400) prisoners, three (3) stands of colors, and six (6) pieces of artillery. . . . [D]uring the night the enemy retired from the Boydton Road, leaving his wounded and more than two hundred and fifty (250) dead on the field."

The Christmas that Cary Robinson spent in the company of Lucy Minnegerode and Lou Haxall was his last. His photograph reproduced here is a remarkable parable.

RESEARCH NOTE

This essay is based upon material in my *Robert E. Lee: A Biography* (New York: Norton, 1995) and *Robert E. Lee: An Album* (New York: Norton, 2000), the Robinson Family Papers at the Virginia Historical Society in Richmond, and the obituary of Cary Robinson in the *Richmond Examiner*, November 3, 1864.

Three Confederates at Gettysburg

BROOKS D. SIMPSON

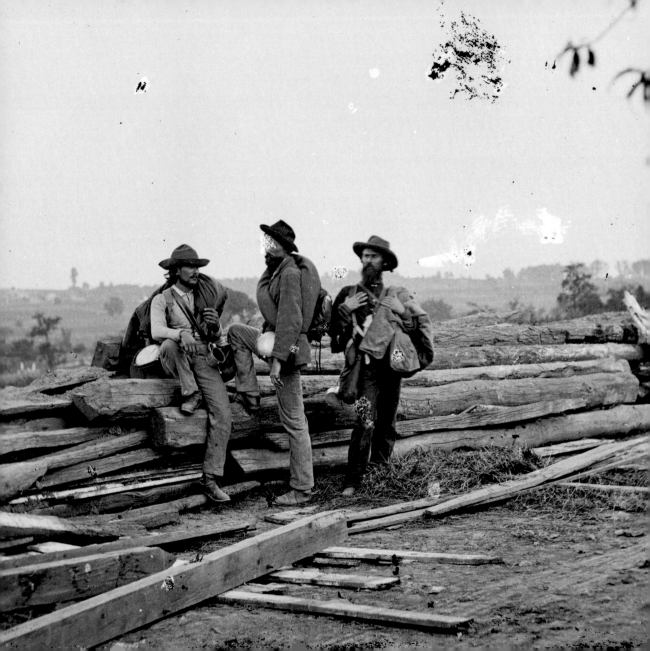

THERE THEY STAND, perhaps the three most recognizable Confederate soldiers of the American Civil War. Who are they? No one really knows. Various attempts to identify them have fallen short of telling us for sure who they were. Where are they? They are west of the town of Gettysburg, standing along Seminary Ridge, at the Lutheran Seminary, not far from General Lee's headquarters. What day was it taken? Most probably the image was captured on July 15, 1863, by Mathew Brady or an assistant. What do we see when we look at the image? That depends.

It was once common to view the average Confederate soldier as a man called to fight to protect his home, his family, and his state. Those men fought hard, long, and well, were loyal to the cause, struggled with worn clothing and what might pass for shoes if they were lucky, with a lean, hungry look in their eyes that might be explained in part by the fact that they were underfed. They stand here in sharp contrast to the men who attempt to reenact their experiences some 150 years later, who show signs of a healthy appetite, comfortable living, and sufficient resources to buy their own weapons, uniform, and equipment instead of relying on items captured or stripped from the dead.

A closer look disturbs first impressions. First, we know that these men are prisoners of war. Undoubtedly, the photograph we see was courtesy of their captors, who stood aside for a few minutes. The men also look somewhat better dressed and equipped than we might have expected. Given that they are at Gettysburg, their shoes attract special notice. After all, according to the story, the Confederates advanced on Gettysburg along the pike that ran just north of where this image was taken on the morning of July 1 to see if they could get some shoes for their foot-weary infantrymen. True, there was no shoe factory in the town, but there were some shoemakers and tanneries. Yet these shoes look as if they have been put to good use for some time. Moreover, if the date for this image is July 15, then we are talking about three stragglers or deserters who were still near Gettysburg some eleven days after the Army of Northern Virginia began its retreat (one may assume that the breastworks captured in the image may well have been constructed on July 4, after elements of Richard S. Ewell's Second Corps pulled back from their positions opposite East Cemetery Hill and Culp's Hill). That would tell us that perhaps these men were not among Lee's finest, at least not that July.[1]

Thanks to recent research, we know a little more about the men who formed the Army of Northern Virginia. Joseph T. Glatthaar's admirable study of that army concludes that over a third of the men who enlisted in 1861

either owned slaves or were members of a slave-owning family, with another 10 percent living in slaveholding households. That percentage increased slightly among 1862 enlistees before sliding back among those men who joined the ranks in 1863 and 1864.[2] This suggests that defending home, family, and a way of life also involved defending slavery for many of these men; we also know that most non-slaveholders, especially those who benefited in various ways from the existence of the peculiar institution or who feared the impact of emancipation on their lives, had little quarrel with slavery. Given the world in which they lived, one could not expect things to be different. Slavery made the South distinct, and defending it made sense in 1861. That some people today have trouble with that notion suggests more about themselves than about the reality of the past.

I confess that I thought very little about these questions when I first stumbled across this image. Either my father or grandmother had provided me with a souvenir of a trip to Gettysburg years before—a booklet containing human-interest stories of the battle. It was my first Gettysburg book. I recall poring over it time and again, looking at the images and reading the text. Yes, the photographs of the battlefield and its heroes were captivating, but so were the postwar photographs, some of which showed a much more open field than was the case until recently. Those images reflected the copyright date of the booklet—1927—as well as an image of the battle that pitted brother against brother in a war where everyone fought for what they believed, and slavery was but a footnote that concealed the experience of African Americans, enslaved and free. Outside of a picture of several sisters who served as nurses and the ubiquitous

Jennie Wade, women were nearly absent from the booklet, as were male civilians, aside from the cranky hero John Burns.[3]

I first visited Gettysburg in 1967 and went again in 1974: then, starting in 1978, I visited with increasing frequency. The first time was a family trip, one designed primarily around my interests, as my sister will tell you (she's never recovered from her visit to Jennie Wade's house). In turn I've taken my wife and daughters there several times. My interests varied, even as they evolved. For various reasons, they tended to focus on the officers and men of the Army of the Potomac, including two ancestors whose regiments fought on Little Round Top and Culp's Hill. Yes, I thought about the Confederates, but primarily in terms of the men who directed operations and led men into combat, from Robert E. Lee down to brigade commanders. As for the Confederate soldier, I knew little beyond what the conventional wisdom held—that they were mostly non-slaveholders who fought for Southern independence in large part to protect a society that was grounded in the institution of slavery. I accepted that they were determined fighters who more than held their own on the field of battle.

That conventional wisdom is still true, but it is also incomplete. Over time, I developed a more sophisticated notion of how Confederate soldiers went to war in 1861, only to watch as more and more soldiers started slipping away from the ranks from 1862 through the spring of 1865. Some men grew dispirited; some had taken enough; others decided that if they had gone to war to protect their homes and families, they now had to leave the army if they were to meet those responsibilities. Definitions of duty were always changing, and

sometimes they conflicted. Desertion was not necessarily dishonorable, even if it eroded Confederate military manpower; however, it was one of the ways Ulysses S. Grant wore away Confederate resources.

Moreover, whether they were stragglers or deserters, these three Confederates standing on Seminary Ridge were also prisoners of war. Photographed after the Army of Northern Virginia retreated across the Potomac River, they were destined to go elsewhere. Normally, they could expect to find themselves sent to a prison camp, then returned to the very army they had left in Pennsylvania as part of an exchange of prisoners. But even as these men posed for the photographer, word was spreading that Secretary of War Edwin M. Stanton had ordered a halt to such exchanges, citing problems with how the Confederates were observing the protocol associated with the prisoner of war cartel. Before long, Confederate authorities would unilaterally release men paroled at Vicksburg while refusing to include black Union prisoners of war in future exchanges. By year's end the entire system had collapsed, and during 1864 men on both sides languished in prison camps before the Confederates relented on the matter of exchanging black prisoners in early 1865. Exchanges were few and far between and extremely limited, so we do not know what happened to these three men and whether they were caught up in the collapse.

I did not make all of these discoveries on my own. In 1975, William A. Frassanito's *Gettysburg: A Journey in Time* appeared. I immediately picked up a copy. Frassanito had spent a great deal of time figuring out the location of various iconic photographic images of the battlefield taken in the wake of the battle, sometimes within

days. Much of what Frassanito uncovered, especially the notion that the famed image of a sharpshooter's last rest at Devil's Den was staged, has since become part of the standard understanding of the story. So did his ability to locate where and when the photograph under discussion was taken. I confess that this book, as well as Frassanito's subsequent work and the investigations of Garry Adelman, Tim Smith, and others, still engages me, leading me to look at these images as I never quite had before.

So what should I make of this Confederate threesome? Truth to tell, I gave them very little extended thought. Although I visited Gettysburg more than any other Civil War battlefield, I hesitated to write anything on the battle until I felt I had something interesting and different to say about it. Aside from a few short essays and a battlefield guide I cowrote with Mark Grimsley, I remained mostly silent for years. It made no sense to write something unless one had something new to say or something that could help others understand what had happened. I was far more engrossed in learning details of the action at Little Round Top and Culp's Hill and locating where my ancestors' regiments marched and fought. I visited monuments, walked the fields and through the woods, watched as the National Park Service restored the ground to something resembling its wartime appearance, and often stayed at a friend's house on Fairfield Road just west of Willoughby Run. I enjoyed giving tours of the field and discussing command decisions. When it came to key points of the battlefield, I tended to look at things from the perspective of the Union defenders, although I did make the trek from Seminary Ridge to Cemetery Ridge several times,

noting the swales and slopes and occasionally pondering what the Confederate attackers were thinking and feeling.

This changed somewhat when I met my wife. On our first date she announced that she was busily engaged in doing genealogical research on her family and had come across a Confederate ancestor from North Carolina who had been wounded during the assault of July 3. I mentioned that I had some ancestors who were also present at the battle who fought on the other side. She wondered whether they might have exchanged fire with her ancestor at Gettysburg. As she had no idea what I did for a living, she was a bit taken aback when I said that I was sure that was highly unlikely. After all, how could I know? Explanations given, I became interested in this Confederate, who, like our three Confederates in the photograph, soon made his way to a prison camp, having been captured during Lee's retreat the same week when the photograph was taken. The next summer I walked her through an area recently reclaimed from commercial development along the Emmitsburg Road and suggested that the ground in front of us may well have been where her ancestor was wounded in what I now know to call the Pettigrew-Trimble-Pickett assault. She fell quiet and looked over the field in front of us. Tears began to well up in her eyes. After a few moments, she turned and walked away.

Since that moment, I've taken more of an interest in the Confederate soldier. Along with several students from Arizona State's Barrett, the Honors College, I walked the route his Tar Heel regiment followed that July 3 (it is a far different walk than the usual well-trodden path followed by Pickett's men). I realized that he arrived at Gettysburg on July 1, just a short distance south of the ridge where the three Confederate prisoners posed just over two weeks later. And on July 3, 2013, while I chose to stand by the Brian farm with Peter Carmichael and Ian Isherwood of Gettysburg College, I looked to see how those North Carolinians, far less popular than the three brigades of Pickett's Virginians, made their way eastward toward Cemetery Ridge as the National Park Service led nine groups across those fields.

I've also arrived at the point where I can now address Gettysburg as a historian better than I could have before. The story of the battle and the campaign lies at the intersection of war, politics, and society. No, it was not the decisive battle of the war, nor was it the high-water mark of the Confederacy. But that need not ruin the drama of the story or the desire to tell it in such a way that it goes beyond the usual names or familiar places. Moreover, with more and more being written about less and less, there's an opportunity to bring that material together and reduce it to a manageable size so that the average visitor wanting to learn more can find a point of departure.

I still don't know very much about those three Confederates who posed for Mathew Brady or one of his associates on July 15. I don't know why they lost touch with their comrades or why they found themselves on the wrong side of the Potomac River and South Mountain in midsummer. Nor do I know what fate awaited them. In each case it's a matter of what might have been . . . which, when you think about it, is what so much of Gettysburg is about. But nowadays I look closer at their faces, their

eyes looking off into the distance in different directions, showing no signs of defeat as they proudly posed by the breastworks. True, they might well be deserters or stragglers, but they refused to give any hint of that as they stood still for the camera as the wet plate captured their image. Yes, I notice they are well dressed with decent shoes and seemingly sufficient accoutrements. But there's something else going on there. I might question what they believed in, but it sure looks as if they believed it . . . or at least once did.

NOTES

1. See William A. Frassanito, *Gettysburg: A Journey in Time* (New York: Scribner's Sons, 1975), 70–71; see also Thomas J. Desjardins, *These Honored Dead: How the Story of Gettysburg Shaped American Memory* (New York: Da Capo, 2003), 120–21.

2. Joseph T. Glatthaar, *General Lee's Army: From Victory to Collapse* (New York: Free Press, 2008), 19–21, 203–4, 359.

3. Herbert L. Grimm, Paul R. Roy, and George Rose, *Human Interest Stories of the Three Days' Battles at Gettysburg* (Gettysburg: Times and News Publishing, 1927).

Three Confederates at Gettysburg

Champ Ferguson

DANIEL E. SUTHERLAND

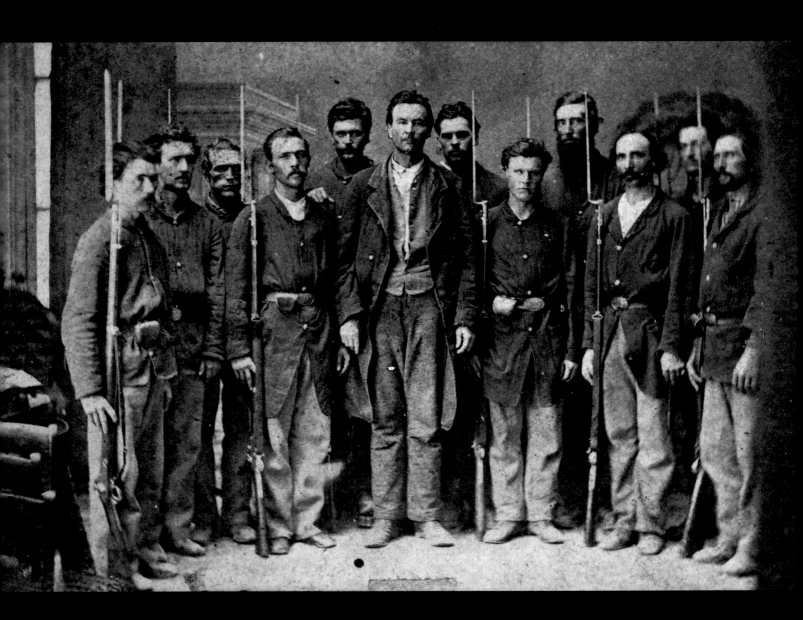

CONFEDERATE GUERRILLAS may well and truly be called the invisible men of the Civil War. The most effective of them were neither seen nor heard until they sprang from cover. More stealthily still, they went unseen as they derailed trains, blew up bridges, and cut telegraph lines. They left an equally faint footprint on the written records of the war. The vast majority signed no enlistment papers or discharge papers, are not identified on muster rolls, in medical files, or in after-action reports, and filed no pension applications. Only a few wrote letters or kept diaries, so that the most reliable information about their personal lives, motivations, and wartime activities comes from the trial transcripts of captured guerrillas who faced military tribunals.

The same holds true for the photographic record. While drawings of guerrilla raids and portraits of a few guerrilla leaders appeared in the North's illustrated newspapers, we have nothing like the tens of thousands of photographic images generated by the conventional armies and navies or the civilians of North and South. Here and there one comes across a photo of the carnage left by a guerrilla raid (a wrecked train, a scuttled riverboat), but there are no wartime pictures of the fields where they fought, of their encampments, few even of captured guerrillas or the corpses of dead ones.

As it happens, the two best-known groups of irregulars, John S. Mosby's Partisan Rangers (the Forty-Third Battalion Virginia Cavalry) and William Clarke Quantrill's band of guerrillas, left the largest number of wartime portraits, but even that sampling, given the hundreds of men who served with Mosby and Quantrill, is rather small. More commonly, surviving photographs of guerrillas are postwar portraits of old men. Their images will not be found in the Library of Congress, National Archives, or even local historical societies. Rather, they remain the preserve of families, handed down by ancestors who may or may not have known what role their ex-guerrillas played in the war.

Of this, I can bear personal testimony. I had been writing about Civil War guerrillas for more than a few years before I learned that my great-great-grandfather had been one of them. William "Billy" Sutherland, a year shy of forty years old when the war started, was married with seven children. He owned about 400 acres of land but no slaves in what is now Dickenson County, in southwest Virginia, on the Kentucky line. He was also the local blacksmith, a lay Baptist preacher, and a crack shot. In all this, Billy was a fairly typical guerrilla, most of whom were respectable, law-abiding citizens, not much different from soldiers in the ranks. If anything, they were older, better educated, more prosperous, and

more prominent in their communities than were common soldiers.

Billy did not enter the war until the spring of 1862, when the Virginia legislature formed a state militia to help defend communities beyond the reach of Confederate armies. He became the orderly sergeant for Company B, Second Regiment Virginia State Line, raised in the so-called Sandy Basin, near the Clinch River. By 1864, as rivalries and resentments grew between Rebels and Unionists in his neighborhood, the company had morphed into a partisan band, the only way that Billy and his friends believed they could protect their families and maintain their property. This, too, was a familiar pattern as men who might have served in the conventional army decided that Confederate independence came second to the survival of their communities.

Yet Billy Sutherland did not pose for a photograph during the war. Even had the means been at hand in his isolated rural community, he would have seen no need for picture taking, no reason to commemorate his role in the war. When he sat for his photograph, it was well after the conflict, his face framed by a pure white beard and equally white hair. By then, he had served as a county constable, deputy sheriff, and member of the board of supervisors, far better reasons to be photographed, he would say, than military service. He died in 1909, at age eighty-seven.

Champ Ferguson was photographed after the war, too, though not nearly so long after as Billy Sutherland and under very different circumstances. They were about the same age, Champ being just a few months older than Billy. Champ also had a family, though a smaller one than Billy's brood. He, too, farmed about 400 acres, although he also owned three slaves. He grew up not very far west of Billy, in south-central Kentucky, so close, in fact, that it is conceivable their paths crossed during the war. But while Champ, like many people in his part of the rural South, had a strong religious bent, he was no lay preacher. Instead, he had a reputation as a violent man, even a bully, and he was fond of liquor. When Champ entered the war in late 1861, it was not from a sense of patriotism but because he had killed two Kentucky Unionists. He was a guerrilla from the start, and a deadly one. Arrested and tried by a military commission at the end of the war, he was accused of having murdered at least fifty-three people. He was hanged on October 20, 1865.

There are four postwar photographs of Champ, taken not decades after the conflict but during the summer and autumn of 1865, while he was on trial in Nashville, Tennessee. Two of the images show Champ by himself, although each conveys a different sense of the man. In one picture, he looks subdued, rather tired, the broad shoulders of his tall, strongly built frame slumping slightly as he sits in a chair. The other portrait shows a more resolute man, eyes slightly narrowed, jaw firmly set, facial muscles taut. In a third picture, he stands beside one of his guards, but it is the fourth photograph, featured here, that is most intriguing. It is the only known photograph to show a single captured guerrilla and multiple guards. Indeed, it is rare enough to see photographs of any prisoner of war, guerrilla or soldier, with armed guards present. And so many of them! Eleven men to guard a single prisoner? And one with such a kindly, good-natured face? What is it all about?

Daniel E. Sutherland

This photograph and two others were probably taken on August 22, midway through Ferguson's trial, which began in July. They were the work of Cyril C. Hughes, one of twelve photographers listed in the 1865 Nashville city directory (the city also had a portrait painter known for his ability to "color" photographs "in any known style"). The *Nashville Dispatch* mentions just one photograph being taken on August 22, very likely, from the wording of the announcement, the image of a seated, tranquil Champ. Yet that picture and the two of Ferguson under guard were clearly made in the same place and at the same time, as confirmed by their identical backgrounds.

Who took the fourth photograph, of the solemn-looking Ferguson, is less certain. It could have been the work of Hughes, but on September 3, the *Nashville Union* announced, "Splendid photographs of Champ Ferguson for sale at the Gallery of the Cumberland." This gallery happened to be owned by a competitor of Hughes, A. Samuel Morse, and was known to serve virtually as a "Branch of Hd. Qrs" for the Army of the Cumberland, which then occupied the city. Given the gallery's close association with the Federals and the fact that the *Union*, unlike the *Dispatch*, was a Republican-leaning newspaper, Morse would have been inclined to make Ferguson look unsympathetic. In saying that he was selling splendid "photographs" of the prisoner, the *Union* probably did not mean to suggest that more than one image had been taken, only that copies were available. This interpretation is reinforced by the editor's comment that Morse had produced an "accurate likeness of this noted personage." In any event, the fourth picture is the only one in which the background

cannot be discerned, and it is lighted differently than the others.

Interestingly, too, the three photographs attributed to Hughes were not made at the prison. As noted, a common background—portions of a painted backdrop—can be seen in all three of them. In the group portrait, the top of a tree is visible in the upper-right corner, and fairly comfortable-looking chairs are aligned on the left-hand side. If Ferguson was in fact escorted from the prison to the photographer's studio, then perhaps eleven guards *were* necessary, although the *Dispatch* reported that ten soldiers with loaded rifles and fixed bayonets daily escorted him from the prison to the court. One suspects, as well, that Hughes must have had a personal connection with either the prison warden or an influential army officer, someone with the authority to let the prisoner visit his studio, which was some distance from the prison. Then too, perhaps money exchanged hands.

Ferguson's guards were drawn from the Ninth Michigan Infantry Regiment, and their role is important for interpreting the photograph. Neither in the picture nor in their personal interactions with Ferguson did the guards betray any sign of disliking, let alone fearing, their charge. The same impression is conveyed in the photograph of Ferguson with a single guard, the man to his immediate right in the group portrait. Rather than standing at attention with his rifle, as the guards do in the ensemble, this lone soldier leans casually on his weapon while his left hand rests in a friendly way on Ferguson's shoulder. Virtually all reports of the Ninth's association with the prisoner suggest this same goodwill. "He converses freely with the guards," reported the

Dispatch, "and wears a pleading smile at times that leaves the visitors at the court-room to form a mild opinion of his *personale.* The handcuffs are not used in taking him to and from the courthouse, which apparently gratifies him, as he has a deadly horror of manacles."

Given Ferguson's reputation as a stone-cold killer, this treatment of him is remarkable. A possible explanation is that the Ninth Michigan had not encountered very many guerrillas during the war and so did not fully grasp the murderous nature of men like Ferguson. The Ninth had its baptism of fire at the Battle of Stones River, to be followed by the Tullahoma, Chickamauga, and Atlanta Campaigns. Unlike Union soldiers who regularly engaged guerrillas, they had not seen any of their fellows shot from ambush, hanging from tree limbs, or lying dead (sometimes mutilated) in the road. Nor had they encountered the civilian victims of men like Ferguson.

Another explanation could be Ferguson's health, which went into a steep decline after a couple of weeks in prison. A steady diet of crackers, meat, and coffee caused severe diarrhea and a corresponding weight loss of thirty pounds. He grew so weak that by the time of the August 22 photographs his guards had to convey him between the prison and the court in a hack. His condition probably helps, as well, to explain his benign appearance in those photographs. Ferguson's health did not start to improve until shortly before the Ninth Michigan was mustered out of service in mid-September. It would, then, have been fairly easy for the guards to sympathize with a fellow so incapacitated, especially since few people thought he could escape the gallows.

The guards may also have succumbed to Ferguson's own friendly nature and the aura of celebrity that surrounded him. "He is calm, and evinces an extraordinary firmness at all times," reported the *Dispatch* toward the end of July. His "demeanor," the same paper reported in September, was "genteel and modest." Admirers in the courtroom and in the streets also made known their sympathies. Indeed, the judge advocate who prosecuted the case was taken aback by this unseemly attitude. "Were he a philanthropist and benefactor of mankind," the army lawyer observed sarcastically, "surrounded on all sides with evidence of good deeds, instead of a man covered in human gore . . . the evidence of the sympathy and admiration of certain parties could not have been more plain or marked."

One must assume that Hughes, even as a Northerner who had moved to Nashville from New York in 1855, also thought Ferguson a fine fellow. He clearly had the option of posing him as a dangerous character. Instead, even with a phalanx of armed men watching over him, the placid expression on Ferguson's face and the demeanor of the guards makes the guerrilla chief look anything but a hardened criminal. Indeed, by exaggerating the danger presented by Ferguson, Hughes gives the tableau an almost comedic dimension.

Still, not everyone was ready to be wooed. The *Nashville Union,* for instance, in describing Ferguson's "fierce appearance," dwelled on his "dark penetrating eyes which look[ed] as though they were little accustomed to tears." His face, their reporter hinted, betrayed "signs of pretty free drinking" and had the "hectic flush of a consumptive." None of these traits can be seen in the photographs taken by Hughes, which may explain why *Harper's Weekly,* in publishing the picture of Ferguson and his guards as a woodcut on September 23 (also attributing

it to Hughes), changed it substantially. First, they gave Ferguson a heavy beard and darkened his countenance. They also made his guards look more wary. Rather than crowding around the prisoner, essentially standing *beside* him, they more clearly *surrounded* him, while also keeping their distance from this dangerous-looking felon.

Nonetheless, the majority of Nashville newspapers offered a sympathetic portrait of the man in the dock. A reporter for the *Nashville Dispatch* noted the courteous way in which Ferguson greeted him when interviewed in his claustrophobic cell (reportedly three by twelve feet) at the state penitentiary. His manner was "cordial," said the journalist, who also commented on how Ferguson suffered from the restrictions placed on visits by his wife and daughter. However, the prisoner did not betray a guilty conscience and seemed in every respect to be a man falsely accused. "I am wakeful, and have dreams, but they are not unpleasant," Ferguson told his visitor. "My mind is cheerful and I do not grieve or fret as you suppose."

The photograph verifies all this. Ferguson, though clearly larger and stronger than any of the men around him, looks to be a gentle soul. He is a farmer, dressed in a farmer's garb. A newspaper description of his attire offered details missing from the black-and-white photograph. "A coarse, heavy rusty sack coat covers his broad shoulders," went this report, "while a checked flannel shirt and dark blue pants with his half heavy boots all pretty well worn, make up the balance of his wardrobe." His slightly quizzical expression makes him look intelligent, too, far too intelligent, and one would think too compassionate, to have committed the bloody deeds charged to him.

When, in the end, the military commission condemned him to death, numerous people asked President Andrew Johnson to commute the sentence to imprisonment. Even the prison warden expressed sympathy for him, and some people believed that Ferguson would somehow be allowed to escape before his day of reckoning. Ferguson himself wrote to Johnson, who, ironically enough, as the military governor of Tennessee in 1862–64, had been one of the guerrilla's most bitter opponents. "I only ask that my life may be spared," he now told Johnson, "and will humbly submit to such other punishment as you in your clemency may deem fit." He noted that most former guerrilla leaders who survived the war, with few exceptions, had all been pardoned. "I beg you, in your goodness to save my life!" he concluded. "Your power is great, and I feel that your heart is warm."

When a reporter from the *Dispatch* interviewed him on the day before his execution, Ferguson seemed to have been cheered by a final visit by his wife and daughter and the ministrations of a Presbyterian clergyman. "[He] firmly believes in a future world and merciful God," the journalist surmised, again softening Ferguson's fearsome reputation and casting doubt on the severity of the court's verdict. On the scaffold, too, he stood tall and erect. "He met death in a brave spirit and unflinching determination to die game," reported the *Dispatch*, whose reporter "never saw a man maintain such nerve to the end."

Although he had evaded the question once his trial began, Champ Ferguson believed he would be acquitted. Only after the verdict had been returned and his appeals denied did the reality of his situation take hold.

Not until the morning of his execution would he tell a reporter, "The Court was bound to convict me. My counsel did well, but it was useless, for every point of law in my favor was overruled." Yet even then, he expressed no remorse or shame for his wartime career. Shortly before his execution, he justified his bloody deeds to a reporter from the *Dispatch*. "I was a Southern man at the start. I am yet, and will die a Rebel," he declared defiantly. "I believe I was right in all I did. . . . I committed my deeds in a cool and deliberate manner. I killed a good many men, of course; I don't deny that, but I never killed a man whom I did not know was seeking my life."

Which brings us to the meaning of this photograph. Other guerrillas, facing military tribunals during the war, had either defied the authorities or justified their careers in similar terms, and still others, having survived the war, would claim the same high ground in writing their reminiscences or in postwar correspondence. One of Billy Sutherland's grandsons, Elihu J. Sutherland, in recording the memories of people in the Sandy Basin, heard much the same story. So while Ferguson was the most notorious Rebel guerrilla to face justice after the war, and the only one to be legally executed, his last testament evoked the self-image such men had always had of themselves and their role in the war.

Ferguson's photographs perpetuated that image, and in ways even more potent and lasting than his words. Scholars have written much in recent years about how "memory" has shaped our impressions of the Civil War, most often by pointing to how postwar reminiscences and early histories of the conflict sanitized its suffering and carnage by creating a mythical, romanticized war. Photographs may play that same role, and not only, as one might suppose, in portraits of aging guerrillas. Naturally, those pictures make the men look harmless. It is impossible to imagine Uncle Billy toting a shotgun, burning bridges, or stealing horses. But how much more powerful are the photographs of Champ Ferguson, taken even as he confronted the consequences of his murderous career. Who is this gentle-looking man that he should be accompanied by armed guards? Surely, this is not the cold-blooded killer who was hanged at Nashville. And if he was counted among the worst of the Rebel guerrillas, then how bad a bunch could they have been after all?

Daniel E. Sutherland

Who Are They?

CAROL REARDON

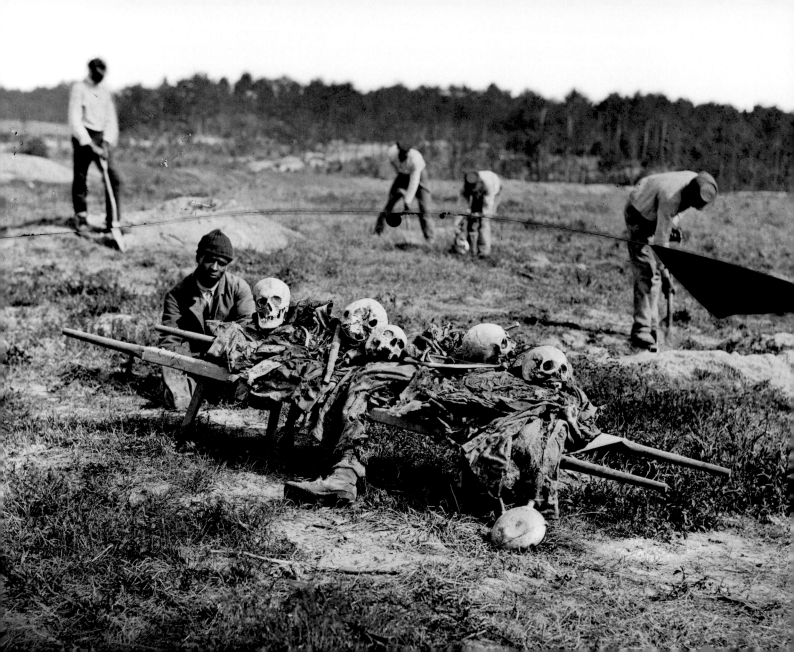

THE SKULLS. The empty eye sockets. The single shod foot seemingly unattached to any one specific set of bones piled on the canvas stretcher. The unreadable expression on the face of the African American man, possibly a soldier from a United States Colored Troops (USCT) regiment, sitting next to the mortal remains of his onetime brothers in arms. The disquieting process of disinterring the dead continuing uninterrupted in the background. How can such a scene fail both to repulse and command attention?

I first saw that photo while in elementary school as I leafed through one of my first Civil War books. It fascinated more than frightened, since I grew up in a family that fully understood that every war—even one that ended in victory for a good cause—exacted a human cost. In March 1945, German antiaircraft fire shot down the B-17 copiloted by my uncle, my mother's older brother. Although this happened a good number of years before my birth, I learned at an early age how my grandparents received a telegram informing them that their older son was listed as "missing," and how it took two years to change his status to "killed in action." As a family, we visited his grave—he is buried with most of his crew—at Zachary Taylor National Cemetery in Louisville, Kentucky. My father, a World War II veteran, participated actively in our local Veterans of Foreign Wars post, and my brother and I grew up in a home that observed Memorial Day in very respectful and reflective ways.

At least my parents found closure for their wartime losses. But what about the families of those soldiers whose stark skulls stare out from that photograph? The caption on the picture reads simply, "Cold Harbor, Va. African Americans collecting bones of soldiers killed in the battle." Who were these men? What were their names? Did the activities depicted here satisfy Drew Gilpin Faust's eloquent descriptions of the effort of Civil War soldiers to provide the fallen with "the dignity of an individual and indentifiable grave"?[1] Did their families ever know what happened to them?

These questions intruded frequently when, as part of the research for a recent project, I delved deeply into the applications for Union soldiers' "widow's pensions." Today's generations would consider these "pensions" to be survivor benefits. During July 1862, partly in belated acknowledgment that the Civil War would be neither brief nor inexpensive in blood and treasure, Congress passed a bill to provide financial support to many classes of individuals whose lives had been upended by the conflict. Despite the name frequently given to these payouts, far more than widows could be eligible for "widow's pensions." Soldiers discharged for wounds or other physical

disabilities that prevented them from supporting themselves could apply for these pensions. So could dependent mothers (the initial legislation made no mention of dependent fathers), orphans under the age of sixteen, and even dependent sisters whose deceased older brothers had served as head of the family. The monthly stipend did not stretch very far; a disabled private or the survivors of deceased enlisted men received only $8; a colonel's widow or dependent mother got $30. At least during the war years, a new widow got no additional financial support from the federal government for the fatherless children she now had to raise alone.

The application process for these funds was complicated. Bereaved families of little means had no time to mourn, since the initiative for supplying the required documentation to prove marriages, births, soldier muster records, and other information rested entirely with them. The clerks in the Department of the Interior who administered the pension system regularly rejected claims they deemed incomplete. Even a cursory reading through the Civil War survivor-benefit applications made me expand my questions about the white skulls in that photograph. In addition to "Who are you?" I now wonder, "What happened to your family?"

Perhaps one of those skulls belonged to Private Jefferson Cupp, a member of Company A, Seventh West Virginia Infantry. Jefferson, the son of Susannah Cupp—she never married his father—grew up in the small town of Muddy Creek, where he farmed his grandfather's land. Jefferson Cupp was twenty years old in July 1861 when he enlisted in the Union army for a term of three years. His hardy constitution contributed to his steady performance as a soldier. He frequently sent home some of his pay, and during the winter of 1863–64, when Secretary of War Edwin M. Stanton invited three-year regiments to "veteranize" and serve until the end of the war, Private Cupp reenlisted. On June 3, 1863, at Cold Harbor, however, the soldier's life ended. A Confederate bullet pierced his head and killed him instantly. How long did it take for the sad news to reach Muddy Creek, where, despite her anguish, Susannah Cupp tried to make a go of it without her son's financial support? She enjoyed little success hiring out her own labor. Her father, John, nearing eighty and a pensioner from the War of 1812, could offer no additional support.

Thus, Susannah began the process of applying for survivor benefits in August 1864. She required the help of a Morgantown attorney, for Susannah was illiterate and could not complete the paperwork for a dependent mother's pension. The attorney obtained confirmation from the Adjutant General's Office of Jefferson's enlistment and his death in battle. He crossed out the spaces for verification of Susannah's marriage to Jefferson's father, stating bluntly that she had never married him. He also attested to her loyalty to the Union and obtained a sworn statement that Jefferson left neither a wife nor minor children with a stronger claim to this pension. Two "trustworthy" local residents who had known the Cupp family for over fifteen years attested in affidavits that Jefferson had worked his grandfather's farm for at least five years before his enlistment and all the money for their crops went to support the family. In February 1866, about eighteen months after she applied, she received final approval for her $8 monthly stipend. It hardly made up for the loss of her son, laid to rest in Grave 37, Section B, of the Cold Harbor National

Cemetery by burial crews such as that depicted in this photograph.[2]

Or perhaps one of those sets of empty eyes belonged to William Dusick, a private in Company A, Twenty-Fourth Michigan Infantry. His parents, Maria and Wenzel Dusick, had been married by a Catholic priest in September 1842 back in Bohemia—shortly after William's birth, as it happened—and the growing family came to the United States well before the Civil War broke out. William's father established himself in Detroit as a cabinetmaker before moving the family to Ypsilanti. He taught his trade to William, who, even as a teenager, began perfecting new techniques by working with skilled craftsmen in other furniture-making shops. His initiative allowed him to provide his parents with $6 or $7 each week. When Colonel Henry A. Morrow began recruiting the Twenty-Fourth Michigan in July 1862 in answer to Lincoln's call for "300,000 more," twenty-year-old William Dusick signed the roll. He formally mustered in on August 13, 1862, and regularly sent home a portion of his pay. Private Dusick stood in ranks when the Twenty-Fourth Michigan entered Herbst's Woods on July 1, 1863, at Gettysburg, and he numbered among the regiment's severe casualties in that fight. Restored to the ranks by the spring of 1864, he participated in the hard fighting at the Wilderness and Spotsylvania. On June 3 at Cold Harbor, as his regimental history recorded it, "two men in the Twenty-fourth were killed by the enemy's sharpshooters. One William Dusick, had gone out a few feet in front of the breastworks and just as he turned to come in, he was shot in the back and fell dead. There his body lay till nightfall, it being certain death to go for it before dark. The place was a veritable

'Hell's Half Acre' as the boys called it."[3] The photograph certainly suggests the veracity of that label.

Back in Ypsilanti, Maria Dusick, now age forty-nine, and Wenzel, in increasingly ill health, pondered a future without the support of their eldest child. In 1866, Maria began the process of applying for a widow's pension. From the start, she ran into difficulties. Because she and Wenzel had wed in Bohemia, they had no official documentation validating their marriage. A local judge signed an affidavit averring that "it is not customary in Bohemia and the other parts of Germany to give Marriage Certificates, as all Marriages are put on the record of the church." That seemed to satisfy the pension bureau clerks—not always the case, as other files with correspondence from American consulates in Berlin, Dublin, London, and elsewhere attest—and the Dusicks cleared that hurdle. A local physician documented Wenzel's "dyspepsia and general debility" to verify his claim that he could not support himself and his wife. In October 1867, the $8 monthly pension was approved. With such limited funds, Maria and Wenzel likely never traveled to the Cold Harbor National Cemetery to view the final resting place of Private William Dusick in Grave 46, Section C.[4]

Hostile battle lines previously had crossed the same ground over which the two armies clashed at Cold Harbor. Back on June 27, 1862, Robert E. Lee and George B. McClellan had clashed in the Battle of Gaines's Mill, their lines perpendicular to those taken up by the armies in 1864. Soldiers digging trenches in 1864 sometimes ran across the graves of soldiers buried two years earlier. Thus, not all the remains on that stretcher may be soldiers who fell at Cold Harbor. Perhaps, indeed,

one of those skeletons is that of Private Daniel Reardon (sometimes spelled Riordan or Rieorden) of Company K, Ninth Massachusetts Infantry. (Within the regiment, he was known as "Daniel Reardon 2nd" because two men in his company bore the same name.) While Cupp and Dusick were very young single men, still supporting aging parents, Reardon was a mature man who enlisted on June 11, 1861, at age thirty-three, and marched to war leaving behind a wife and three children. He and Catharine Gorman Reardon had married in Trawley, Ireland, in August 1849, just before immigrating to the United States and settling in Randolph, Massachusetts. The Reardons became the parents of three girls: Mary in 1854, Catharine in 1856, and Hannah (or, perhaps, Joanna) in 1860. On the banks of the Chickahominy River during the Seven Days' Battles, when a Confederate frontal assault broke the Ninth Massachusetts's battle line, Private Daniel Reardon 2nd fell dead.

Back home in Randolph, Catharine learned of her husband's fate not from any official military source but from "letters from the regt. and newspaper reports." In November 1862, she applied for survivor benefits. Like Maria Dusick, Catharine could not produce a marriage certificate, but the tight Irish community around Boston produced two witnesses who could supply acceptable affidavits of her marriage to Daniel Reardon. Her church produced baptismal records to certify the births of the three girls. Like the Dusicks and Susannah Cupp, she swore that she had never participated in any action that might have been construed as support for the rebellion. She received approval of her $8 monthly pension in May 1863. When the law was amended in 1866 to provide additional support for minor children, she applied for and received an extra $2 for each of the three girls, payment ending always on the day before each child's sixteenth birthday. She never remarried and continued to receive her payment until her death in 1896, all the while signing each document that came her way with her mark; she, like Susannah Cupp, had never learned to write.[5]

Of course, nothing in the original caption specifies that these haunting skulls belong only to Northern soldiers. On other Virginia battlefields, similar burial crews like that depicted here found Union and Confederate dead intermixed and buried them all. Thus, perhaps one set of these haunting eyes belonged to Sergeant Major Luther Wolfe. A twenty-three-year-old clerk in Charlottesville when he first enlisted in May 1861, Wolfe joined Company B of the Nineteenth Virginia Infantry. He mustered in for one year on May 12 in Culpeper, sworn in by Colonel John Bowie Strange, his regimental commander. Wolfe did not take well to military life at first, and his early record is dotted with frequent absences to the hospital. Still, he reenlisted for two years on February 9, 1862, his term of service now extended to "the war." He stood in ranks and suffered a slight wound at the battle of Second Manassas in August 1862, but he apparently missed the Pennsylvania Campaign in June–July 1863 due to illness. As a consequence, he did not participate in his regiment's most famous action at Gettysburg—Pickett's Charge. Perhaps the Nineteenth Virginia's heavy casualties there help to explain why Wolfe won promotion to regimental sergeant major that summer. He held that rank for less than a year because he, too, fell on June 3 at Cold Harbor. Survivors of Confederate soldiers killed in battle could not apply for

a federal pension, but they might submit a claim for any back pay due. Wolfe's compiled service record shows no evidence that anyone filed a claim in his name.[6]

All four of these young men died abrupt and violent deaths in the prime of their lives. In time, however, even the bloodletting of Cold Harbor that provided the setting for this 1865 photo would be shunted aside in the name of national reconciliation. At the dedication of Pennsylvania's memorial in the Cold Harbor National Cemetery in 1909, the Honorable Henry M. Foote intoned, "It was here upon that fateful day in June, 45 years ago" that Pennsylvanians, "together with others from different states, met the valorous host of Lee, and in that fearful carnage scores of those heroes on both sides gave to the cause, which each beheld as right, full measure of their heroic devotion."[7] Would those whose remains rested on that stretcher—or their families back home—have agreed?

NOTES

1. Drew Gilpin Faust, *This Republic of Suffering: Death and the American Civil War* (New York: Knopf, 2008), 76.

2. Pension Application, Susannah Cupp for Private Jefferson Cupp, accessed at www.Fold3.com (subscription required), September, 8, 2013; U. S. Quartermaster's Department, *Roll of Honor: Names of Soldiers Who Died in Defense of the American Union, Interred in the National Cemeteries*, vol. 15 (Washington: GPO, 1868), 158 [hereafter cited as *Roll of Honor*].

3. O. B. Curtis, *History of the 24th Michigan of the Iron Brigade, Known as the Detroit and Wayne County Regiment* (1891; reprint, Gaithersburg, Md.: Olde Soldier Books, 1988), 257–58.

4. Pension Application, Maria Dusick for Private William Dusick, accessed at www.Fold3.com, September 8, 2013; *Roll of Honor*, 165.

5. Pension Application, Catharine Reardon for Private Daniel Reardon, accessed at www.Fold3.com, September 8, 2013; Daniel George Macnamara, *The History of the Ninth Regiment, Massachusetts Volunteer Infantry, June, 1861–June, 1864* (1899; reprint, with introduction by Christian G. Samito, New York: Fordham University Press, 2000), 535.

6. Compiled Service Record, Luther Wolfe, Nineteenth Virginia Infantry, accessed at www.Fold3.com, September 8, 2013.

7. [Pennsylvania Cold Harbor Memorial Commission], *Pennsylvania at Cold Harbor, Virginia: Ceremonies at the Dedication of the Monument Erected by the Commonwealth of Pennsylvania in the National Cemetery at Cold Harbor, Virginia* (Harrisburg, Pa.: Aughinbaugh, 1912), 45.

PART 3
CIVILIANS

A Family in Camp

CAROLINE E. JANNEY

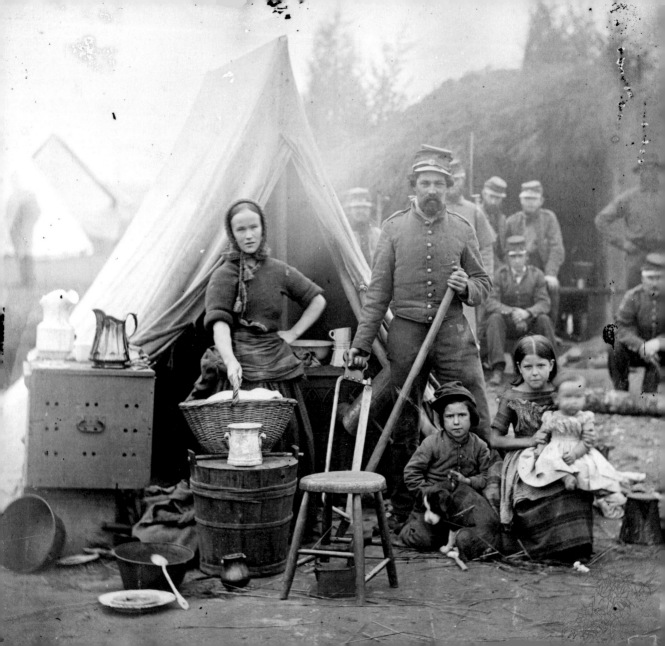

EACH SEMESTER while preparing lectures for my courses, I find myself spending hours searching for the perfect image. As I comb through my collection of photography books and the ever-expanding online databases, I find scores, if not hundreds of new images to use. But inevitably, whether for my Civil War, women's history, or even the survey of U.S. history class, I find that I include this photograph in at least one lecture. Much of the appeal of this image lies in the fact that it captures so many different aspects of the war: photography early in the conflict, the material culture of camp life, and the role of women. With seemingly endless details to explore, it beckons to be examined closely—perhaps with a magnifying glass or in today's digital form with the "zoom" function. It invites imaginative speculation about who these people might have been, why they were there, and how the war altered not only their lives but also those of millions of other soldiers and their families over four long years.

What we know with any certainty about the photograph comes from the caption provided by the Library of Congress: "Tent life of the 31st Penn. Inf. (later, 82d Penn. Inf.) at Queen's farm, vicinity of Fort Slocum." The descriptive text indicates the photograph was taken in 1861.[1] But the image and its caption beget more questions than they answer: Who were these individuals?

Was this a husband and wife along with their children? If so, why was the whole family in camp? How long had they been there? And perhaps on a more trivial note, did they bring the dog with them, or did they acquire it while in camp?

In August 1861, the Thirty-First Pennsylvania Infantry (designated the Eighty-Second Pennsylvania after the Battle of Fair Oaks) organized in Philadelphia, nine of the companies originating from the City of Brotherly Love and a tenth, Company B, hailing from Pittsburgh. A fair number of the soldiers were foreign born, having fought in the French and British armies. Many of the men, especially the officers, had already joined the Union effort in April, enlisting after Lincoln's initial call for three-month volunteers only to commit themselves to another three years after the disastrous Union routing at Manassas. Arriving in Washington, the soldiers found themselves assigned to the outskirts of Fort Slocum, one of the many forts constructed that summer to protect the capital. On property owned by the Queen family in the rear of a line of earthworks, the men engaged in the monotony of camp life. "We are constantly engaged on the fortifications near here, cutting, clearing, digging &c and there is work enough for our brigade there all winter," Lieutenant Charles L. Davis wrote his mother early in November. But it was drilling

that occupied most of the regiment's time. "We drill in the morn from 6½ to 7½," he explained. "Battalion drill from 9 to 11 o ck & every fine afternoon brigade drill from 1 to 4 o ck & when not we drill by comp[any] in skirmishing. We are daily becoming more proficient & will soon be equipped in blue fitting us admirably for the field when we take it."[2]

At some point either late that fall or early in 1862 (the regiment was ordered to Manassas Junction and eventually toward Richmond in March), a crew of Mathew Brady's operatives arrived to photograph the camp. Judging from the thick knitted sweater and head scarf the woman is wearing and the absence of long sleeves on the girl, it appears to have been a cool though not frigid day, perhaps late autumn. Photographs taken of the camp from a distance suggest as much, showing trees barren of leaves.[3]

While this image might seem candid, another plate reveals the extent to which it was posed. In the alternate photograph, the featured soldier holds only a hacksaw, the woman is gazing down at her basket, the children are not looking at the camera but talking to the youngest child, a black man along with two other soldiers look on in the distance, there are fewer household objects visible, and other tools are haphazardly displayed, such as an ax next to a pile of firewood. By the time the photographer was ready to take the second image, everyone is looking at the camera, the woman has her hand on her hip, the soldier is holding another tool, a stool has been placed in the foreground, more household implements have been displayed or arranged differently (whether at the urging of the photographer or by the choice of the subjects it is unclear), the young boy has coaxed a

dog into his lap, four more soldiers have gathered in the background, and the black man has been moved to the right, just out of focus (again, was this the choice of the photographer?). This was not just a random camp scene that the photographer stumbled upon; instead, it was a calculated and posed image.[4]

This brings us to perhaps the most obvious aspect of the photograph: a young woman along with her small children in an army camp. Such was not nearly as unusual as we might expect. In fact, women—and their children—had long found their way to the front lines. During the Revolutionary War, for example, wives of officers, such as Martha Washington, often spent winters in encampments, where they helped boost morale or served as hostesses for dinner parties. Thousands of less prominent women attached themselves to both the British and Continental Armies. Their presence, however, was not always welcome. George Washington famously complained that "the multitude of women . . . especially those who are pregnant, or have children are a clog upon every movement." Frustrated that the women refused to obey his order that they march at the rear of the army rather than ride on the baggage wagons, Washington insisted his officers "use every reasonable method . . . to rid of all such as are not absolutely necessary." But as Washington and others well knew, many of these women proved integral if not necessary. They laundered and mended clothes, cooked, cared for the sick and wounded, and even helped reduce the number of desertions in the ranks.[5]

Thousands of women were likewise a visible and important part of Civil War camps. The wife of one Union soldier famously noted that the 1862 winter

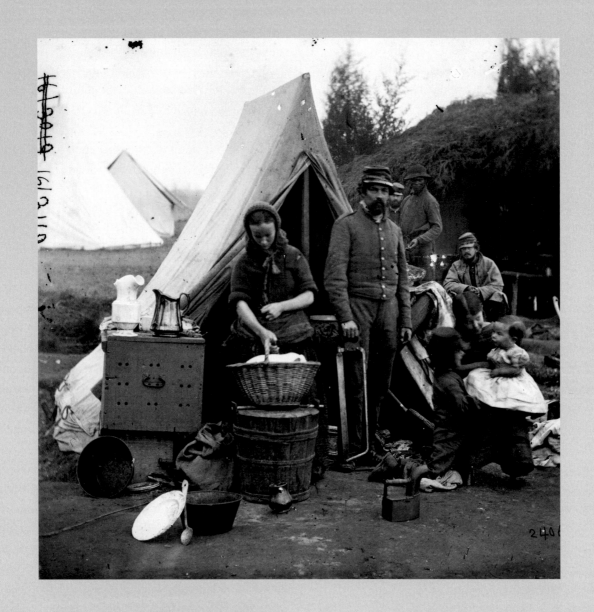

camp of the Army of the Potomac was "teeming with women"—women from a variety of backgrounds and with diverse motives for being there.[6] Officers on both sides invited their wives to visit them in camp, especially during the winter months, when there was no active campaigning. Some became regular fixtures in camp, including Julia Grant, who accompanied her husband whenever possible throughout the war, though such women were likely to live in nearby residences rather than "in the barracks." Other women found themselves in both Confederate and Union camps as nurses, some in official capacities such as Dorothea Dix's Nursing Corps, and others, such as Susie King Taylor, in less official roles.[7] And although their numbers were never as great as the term "camp follower" might imply, there were likewise those women who gravitated toward the army to ply their trade as prostitutes.[8]

The woman in this photograph, however, was not the wife of an officer there to enjoy the occasional military ball, nor was she a member of the nursing corps. Instead, like many others (we have no way of knowing exactly how many), she was most likely the wife of an enlisted man. In the early days of the war, such women ventured to camp for the same reason as the officers' wives: to be close to their husbands, share in the excitement, or take care of a wounded or sick husband or son. But many of these women may have followed their menfolk out of necessity rather than adventure or commitment to the cause. Women who failed to secure support from relief boards or who had no kinship networks on which to lean when their husbands marched off to war occasionally joined their spouses as regimental cooks, matrons, or laundresses. Both Union and Confederate armies allocated domestic-service positions to each regiment, opening the way for women who needed extra income to follow their husbands to the front.[9]

But these posts were often unstable and unpredictable. Some women accompanied their husbands when the regiments were ordered to the front, while others were banned from doing so. Such orders could have devastating effects on women, stranding them far from home. One Union soldier recalled encountering a young Irish woman who had followed her husband from Pittsburgh, only to be abandoned in Washington when the regiment moved into Virginia. "She was but poorly thinly clad she & an infant some nine or ten months old in her arms, both mother & child shivering & crying with the cold," he wrote in the fall of 1862. "Such cases are not rare," he continued, "I know of many of [sic] Irish women that have shared the privations and hardships of a winter in camp with their husbands that are now drove back alone to their homes."[10] Despite such circumstances, one historian has speculated that working-class and immigrant women in the North might have preferred life in the camps to the uncertainties of life on the home front without a male breadwinner.[11]

Such may very well have been the circumstances that led the wife of this Thirty-First Pennsylvania soldier to camp. Like most of the soldiers in the regiment, he was probably from Philadelphia and perhaps even foreign born. His wife might too have been an immigrant with little or no family to support her once her husband marched off to war. Even had she wanted to accompany him without dragging their children to the front lines, the youngest of whom looks to be two years old or younger, she most likely would not have had any family

to watch over them. His occupation might likewise have shaped her decision to join him. The fine-toothed saw he holds appears to be that of a butcher.[12] If this was the case, it is likely that his wife had aided his work prior to the war and would continue to do so in camp.

Even if she did not assist with butchering, the household implements surrounding her suggest that this woman played an essential role in the camp of the Thirty-First Pennsylvania. The pitchers, bowls, and spoons all indicate that she most likely cooked for the men (as perhaps did the African American man in the background of the unstaged photograph).[13] The basket and coal-steam iron situated beneath the stool in the posed photograph suggest that she probably did the bulk of the laundry—cleaning, darning, and even pressing everything from socks to havelocks. At the first sign of illness (more than two-thirds of Civil War soldiers' deaths were because of disease), she might have cared for the sick soldier, trying her best to nurse him back to good health. And she probably performed this labor not only for her husband but also for the entire regiment.

The presence of women in camps, however, could both create tensions and lead to anxieties for many wives. Living in the encampment, eating rations, and being subject to the whim of the army left more than a few desiring to return home.[14] Others, especially single women who served as nurses, found their characters under scrutiny as rumors of improper relations between the young women and surgeons reached the home front.[15] Even well-respected officers' wives found that brief visits to camp could have long-term consequences—a fact Confederate general William Dorsey Pender's wife, Fanny, learned only too well. She visited

camp three times between April 1861 and his death at Gettysburg in July 1863, but left each time pregnant. When she informed him that she wanted to see him but feared another pregnancy, he replied that if "you do not want children you will have to remain away from me, and hereafter when you come to me I shall know that you want another baby."[16]

Men had equally mixed feelings about women in camp. Some believed the camps were not a fit place for women given what one soldier described as the "talk, songs, and everything not good for them 2 hear." Others felt that women's presence hampered the very aspects that made camp life bearable: drinking, cursing, card playing, and other so-called immoral behaviors.[17] Confederate general Jubal A. Early, a lifelong bachelor, complained throughout the war about the presence of women in camp, especially that of John B. Gordon's wife, reportedly once saying, "I wish the Yankees would capture Mrs. Gordon and hold her until the war is over." Like others', his objections were not to Mrs. Gordon alone. Instead, he warned of the potential discontent officers' wives might generate among the men in the ranks who could not bring their wives to camp. Union general John A. Logan informed his wife, Mary, that he not only believed camp an improper place for "nice ladies," but he also worried that her presence would prompt other officers to request the presence of their wives—a potential logistical nightmare.[18] Most of the 30 percent of Union soldiers who were married, however, had neither the pleasure nor dread of their wives in camp.

Nor did most soldiers have to worry about the safety of their children in Civil War camp. Most children, especially those from the North, were safely tucked away from

A Family in Camp

the battlefield. But some did occasionally make their way into camps. Many of these youngsters were family members of senior officers, including the Grant children and the daughter of General John A. Rawlins.[19] White Southern children might venture into camps or onto battlefields near their homes to explore, while former slave children often found themselves near the front lines in so-called contraband camps.[20] The children of working-class Northern women who joined regiments out of necessity, however, often had no choice but to join their mothers in camp. Older children would most likely have been expected to assist with chores. We might imagine that the daughter in this photograph helped her mother with the laundry and cared for the youngest child, who appears to be approximately two years old. The son may have gathered kindling for fires and performed other simple tasks around camp. With his kepi perched atop his head, it does not take much to imagine him playing soldier—marching alongside the men as they drilled, shouldering a stick turned musket. These children might have provided a welcome diversion for soldiers so far from home, bringing a touch of domestic joy to the encampment. But it is just as likely that they proved to be a source of heartache for men who desperately missed their own families back in Pennsylvania.

Whatever the men in camp felt about these particular youngsters, images of children during the war proved quite popular. Photographers captured children picnicking beside a Confederate torpedo boat, watching soldiers at Sudley Ford on the Bull Run battlefield, and visiting soldiers' quarters at Corinth and City Point. Magazines such as *Harper's Weekly* and *Frank Leslie's Illustrated Newspaper* included both Union and Confederate children in sketches of troops marching off to battle, tearful good-byes with fathers, and besieged residents in Vicksburg and Fredericksburg. It was not merely that children proved to be great subjects. Rather, as historian James Marten has observed, both Northerners and Southerners often invoked children as the inspiration for fighting. It was their honor, the future of their nation (be it slaveholding or free) that was at stake. They would bear the cost as orphans of soldiers who failed to return home.[21] This camp scene, then, could serve a symbolic role on the Northern home front. These soldiers were fighting not for an abstract principle of "union" or "liberty," but for the families of every Union soldier.

Canines were likewise a popular feature in wartime photographs. There are numerous images showcasing the Union armies' canine companions, including those of Rufus Ingalls's spotted "coach dog" and several of George Custer's beloved setter Rose.[22] It is unclear whether the puppy in this photograph belonged to the family—or to anyone in particular. The children may have brought the young dog from home, or it may have been a stray that the children coerced into camp with some extra food. Perhaps it was not the family's dog but that of the entire company or regiment. It was common during the war for units to select dogs (and on occasion birds, raccoons, bears, and even a badger) as mascots that would serve as an inspiration for the troops. A brindle Staffordshire bull terrier known as Sallie accompanied the Eleventh Pennsylvania Infantry from the time she was a four-week-old pup until her untimely death in February 1865 at Hatcher's Run. Decades later, the men memorialized her in their regimental monument

at Gettysburg. The 102nd Pennsylvania selected Jack, a brown and white bull terrier, as its mascot. Members of the unit claimed that the terrier understood bugle calls and stood guard over the regiment's dead and wounded after battles.[23]

Whomever it belonged to, the photographer may have believed that including the dog would reflect the notion of the camp as a home away from home. Or he may have recognized that it would emphasize the idea that the war was about family. Or perhaps he simply liked dogs. Whatever his rationale, including the dog in the second "staged" photograph has the effect of making the harsh reality of war, even in an image focused upon a family, seem more sentimental.

I am drawn to this photograph time and time again because it offers an endless source of contemplation and emotional appeal. I cannot help but be fascinated by the myriad details, from the ceramic pitchers that seem out of place in a military encampment to the hole in the woman's sweater that suggests her humble origins. But it also leaves me with more questions than it answers: Was it viewed during the war, or did it become popular only after Appomattox? If it was seen by the public during the war, what was the reaction? What became of this family? Did the soldier survive? Did the young woman and the children move with the regiment when it headed to the Virginia peninsula? Did they manage to avoid the devastating camp diseases? If the children survived, how did their wartime experiences shape their adult lives?[24] We will never know. Even so, their image serves as a poignant reminder of how far-reaching the war was even from the outset, how intimately it affected families—even Union families ostensibly far from the front lines—and how families in turn affected the Civil War.

NOTES

1. American Memory Project (online), Library of Congress.

2. Samuel P. Bates, *History of the Pennsylvania Volunteers, 1861–1865,* 5 vols. (Harrisburg: Singerly, 1868–1871), 2:1202–3; Wayne C. Temple, ed., "A Signal Officer with Grant: The Letters of Captain Charles L. Davis," *Civil War History* 7 (December 1961):428–37.

3. A search of the Library of Congress's American Memory Project reveals at least three other images most likely taken at or around the same time. These images include a distant view of the camp, a sergeant and officer of the Thirty-First (later Eighty-Second) Pennsylvania, and a group of officers.

4. Robert Wilson, *Mathew Brady: Portraits of a Nation* (New York: Bloomsbury usa, 2013), 91–93.

5. Carol Berkin, *Revolutionary Mothers: Women and the Struggle for American Independence* (2004; reprint, New York: Vintage, 2006), 50–66, 68–71 (quotations on 55, 56).

6. Quoted in Nina Silber, *Daughters of the Union: Northern Women Fight the Civil War* (Cambridge, Mass.: Harvard University Press, 2005), 93.

7. For more on nursing, see Jane E. Schultz, *Women at the Front: Hospital Workers in Civil War America* (Chapel Hill: University of North Carolina Press, 2004).

8. Ibid., 93, 107; John Y. Simon, "A Marriage Tested by War: Ulysses and Julia Grant," in Carol K. Bleser and Lesley J. Gordon eds., *Intimate Strategies of the Civil War: Military Commanders and Their Wives* (New York: Oxford University Press, 2001), 127–37; Mary Elizabeth Massey, *Bonnet Brigades: American Women and the Civil War* (New York: Knopf, 1966), 65–66. Simon notes that "Few officers were as frequently accompanied by their families as Grant" (127). Although the notion that most camp followers were prostitutes is a misconception, prostitution did flourish during the war, especially

in cities. On at least two occasions, Union commanders attempted to regulate the practice to curtail venereal disease. For more on this, see Stephen V. Ash, *When the Yankees Came: Conflict and Chaos in the Occupied South, 1861–1865* (Chapel Hill: University of North Carolina Press, 1995), 79, 85–86.

9. Judith Giesberg, *Army at Home: Women and the Civil War on the Northern Home Front* (Chapel Hill: University of North Carolina Press, 2009), 53; Schultz, *Women at the Front*, 55–56. Schultz points out that regimental women tended to be married to soldiers in the ranks, but there were occasionally widows who sought the positions.

10. Quoted in Schultz, *Women at the Front*, 56.

11. Giesberg, *Army at Home*, 50–51, 54. Although some Northern cities and states offered aid to soldiers' dependents in order to fill the ranks and meet their quotas, Giesberg notes that such fiscal support was not as readily available as many men might have assumed when they marched off with their regiments. For many the stigma of applying for poor relief, however much deserved, was enough to keep them from seeking aid. Others loathed the harsh scrutiny of a woman's morality (and thus deservedness) from the upper- and middle-class neighbors who doled out the assistance. The pension system likewise assisted soldiers' wives and created more oversight of women's behavior by the state. For more on how the pension laws enhanced the paternalistic role of the state, see Silber, *Daughters of the Union*, 83–84.

12. For images of similar saws used for butchering, see the website Urban Remains: Antique American Architectural Artifacts, http ://www.urbanremainschicago.com/original-19th-century -oversized-antique-american-union-stock-yard-butcher-saw -with-opposing-handles.html (accessed August 30, 2013).

13. Lieutenant Charles L. Davis's letter of November 5, 1861, notes that "We have a very good cook but I am sorry to say he is about to leave us—feels homesick & being colored is afraid to go over into Va." (Temple, "A Signal Officer," 430).

14. Silber, *Daughters of the Union*, 93–96.

15. Ibid., 114–15; Schultz, *Women at the Front*, 50–54.

16. Massey, *Bonnet Brigades*, 68–69.

17. Silber, *Daughters of the Union*, 93–96 (quotation on 96); Giesberg, *Army at Home*, 53.

18. Massey, *Bonnet Brigades*, 66–68 (quotation on 68); John Brown Gordon, *Reminiscences of the Civil War* (1903; reprint, with an introduction by Ralph Lowell Eckert, Baton Rouge: Louisiana State University Press, 1993), 91, 157–58, 316–19.

19. James Marten, *The Children's War* (Chapel Hill: University of North Carolina Press, 1998), 103. For a photograph of Grant and his son Jesse outside of Petersburg in 1865, see Benson J. Lossing, *Mathew Brady's Illustrated History of the Civil War with His War Photographs and Paintings by Military Artists* (Avenel, N.J.: Gramercy, 1994), 7. For a photograph of Rawlins's family at Grant's headquarters in City Point, Va., see the American Memory Project, Library of Congress. For other photographs of children in camp with officers, see Lossing, *Mathew Brady's Illustrated History*, 29, 189, 331.

20. Marten, *Children's War*, 107–8. For a discussion of contraband camps and children, see Jim Downs, *Sick from Freedom: African-American Illness and Suffering during the Civil War and Reconstruction* (New York: Oxford University Press, 2012).

21. Marten, *Children's War*, 5, 11, 21, 104; Lossing, *Mathew Brady's Illustrated History*, 218. For an image of African American children, see the American Memory Project, Library of Congress.

22. For examples of images, see Lossing, *Mathew Brady's Illustrated History*, 265, 277, 287, and American Memory Project, Library of Congress.

23. Anne Palagruto, *Civil War Dogs and the Men Who Loved Them* (N.p.: Create Space Independent Publishing Platform, 2008).

24. For a look at the effect of the war on children as adults, see Marten, *Children's War*, chapter 6.

What's in a Face

Annie Etheridge Hooks and Civil Work

JANE E. SCHULTZ

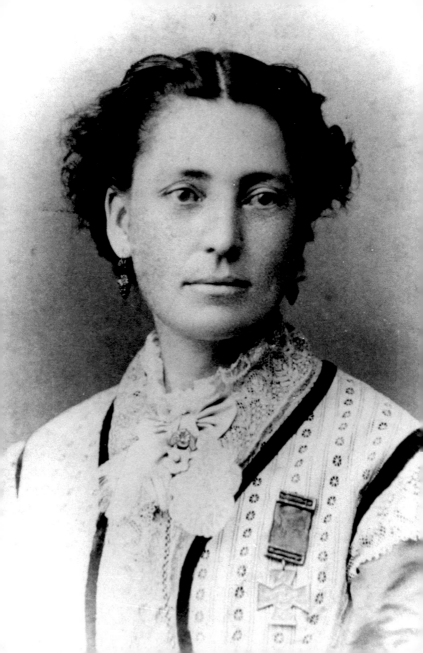

THE FIRST published image of Annie Etheridge was not a photograph but an engraving that appeared in Linus P. Brockett and Mary C. Vaughan's 1867 commemorative volume, *Woman's Work in the Civil War*. Embodied heroically—an image that called to mind nineteenth-century statuary depicting Liberty—Etheridge rides sidesaddle upon a rearing white steed surrounded by musket-bearing soldiers amid the din of battle. Begloved, slouch-capped, and holding aloft the colors on a standard, Etheridge looks off to the heavens while soldiers tip their caps and fix their adoring eyes on her. One man, prostrate presumably from a battle wound, beckons to her, as if his supplication might alter the heavenward direction of her gaze. The engraving affirms the iconic status that Etheridge had achieved by the end of the war and that compilers like Frank Moore and Brockett and Vaughan were quick to exploit in the postwar publishing bonanza.[1]

A photographic portrait was made around the same time, while Etheridge was still in her twenties. Like an American Mona Lisa, Etheridge's gaze is enigmatic—prim and seductive at the same time. The far-off look of the eyes and the glimmer of a smile are fitting emblems of this blacksmith's daughter's elusive history and identity. As a person who crossed state lines, marriages, gender assignments, and war duties, Lorinda Anna Blair Kellogg Etheridge Hooks represents the multiplicity of Americans who waged civil war when a more simplistic and oppositional schematic dominated the national racial imaginary. The racial script of the Civil War charged Northern white men to fight in the name of Union and on behalf of Southern black bondsmen, despite the more complex racial makeup of the nation in 1860, where Hispanic, Asian, Native American, and multiracial peoples also congregated.[2] Easier to comprehend a polarized map of race than the more layered racial landscape of 1860 or 1865, Americans who had known Etheridge during the war beheld a woman of "bronze" or "sunburned" complexion, whose features rendered her legible only as a person of European descent.[3] If she were biracial or even triracial, those identities were submerged under the fetching affect of the photo and invisible to those viewing the image.

In this early portrait of Annie Etheridge, I see the facial characteristics of Native America: high cheekbones, forehead and bridge of the nose in a straight line, mouth and jaw set in determination. A soldier who saw her at Chancellorsville in 1863 remarked at Etheridge's "dark, expressive eyes," "clear-cut face," and "firm mouth." Others observed her "wrapped in her blanket" and "sleep[ing] upon the ground"—images that would have brought to mind the domestic accoutrements of

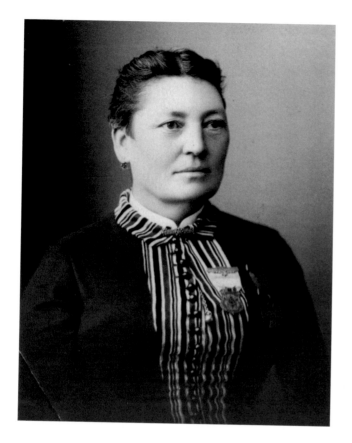

betrays the tendency to feminize Etheridge as a bird or insect instead of the solid, physically fit woman she evidently was.[6]

A later photograph of "Gentle Annie," as she was known in the Army of the Potomac—one taken in the 1880s, when Etheridge was in her forties—makes an even stronger case for the possibility of Native American blood. Cheekbones more pronounced and eyes nearing the almond shape of native peoples on the North American continent. In the eighteenth and nineteenth centuries, Michigan, where Etheridge was born and raised, was a wilderness inhabited by tribes like the Ojibwa and Ottawa, and Michigan diarists note that homesteading journeys featured interactions with local tribal peoples.[7] The poet Baamewaawaagizhigokwe, aka Jane Johnston Schoolcraft—the daughter of an Irish commercial trader and an Ojibwa mother—grew up in Michigan Territory, speaking her native language in addition to French and English, and she is thought to be the first Native American poet who wrote both in Ojibwa and English. An etching of her—the only extant likeness—pictures her in European garb and Empire coif with a fair complexion and facial features that look European, especially if one does not expect to see a different provenance.[8] Given this evidence and the inevitability of mixed-race partnerships, it is not far-fetched to imagine that Etheridge's bloodline had similar characteristics.

tribal life in addition to those of the seasoned infantryman.[4] Etheridge drew no wages as *fille du régiment*, but officers supplied her with a horse, saddlebags full of lint, bandages, and basic medicaments, and a pair of pistols in case she needed them. Life on horseback seems not to have fazed her in the least, and this regimental daughter's "vigorous constitution" allowed her to perform physical feats and endure exposure to shot and shell that lesser men could not tolerate.[5] The "flitting from one soldier to another as he lay bleeding or dying on the ground," described by one compiler in the 1890s,

In both portraits from the 1860s and 1880s, Etheridge sports the Kearny Cross for bravery, with which General David Bell Birney honored her after the Battle of Chancellorsville in May 1863. General Philip Kearny himself communicated two days before his death at

What's in a Face

Chantilly that he intended to make Etheridge an honorary sergeant of the Third Michigan Infantry, but the promotion never materialized. Although Frank Moore, compiler of *Women of the War: Their Heroism and Self-Sacrifice*, speaks of the promotion as a fait accompli, Brockett and Vaughan, whose tribute to heroic women of the war was published a few months later, corrected the error with a veiled criticism of Moore: "Annie never received the appointment, as has been erroneously asserted."[9]

The features of Etheridge's dress, ornamentation, and laurels do not in themselves substantiate a case for mixed racial heritage. More compelling in establishing the ambiguity of Etheridge's racial background was her own claim in her 1886 pension deposition that she was "of Dutch descent." Etheridge might or might not have known about any mixed-race heritage in her family lineage, but in an era when full-blooded European descent was prized and "half-breed" was a term that stigmatized biracial Native Americans (similar to "mulatto" for mixed-race African Americans), those who could pass as white readily did so. If a biracial person could convince others that she was a pure-blooded American of European descent, then she had better chances of achieving economic and social success. It is not hard to imagine that mixed-race people would have chosen to pass, if indeed it offered the possibility of greater socioeconomic access.

We do not know in fact whether Etheridge had any Native American blood. Etheridge's antecedents were, at best, mysterious; her mother and father, Cynthia and John, are unknown to us through any surviving family documents. Born in Detroit in 1839, Etheridge, née Blair, was the eldest of three children. Eleven in 1850,

a younger sister was six and a younger brother, four.[10] The Blairs left for Wisconsin sometime after 1850, hoping to raise themselves out of poverty. According to Etheridge's own postwar testimony in a pension application, she was raised "in ease and luxury" until her father was bankrupted.[11] There is much hearsay about what happened to Etheridge between 1850 and the start of the war. Some accounts aver that John Blair returned to Michigan and that his daughter traveled from Wisconsin to visit him periodically, including right after the war, when he was reportedly ill. Others mention an early marriage to David Kellogg of Michigan but no account of the dissolution.[12] A second marriage to James Etheridge in 1860, when Annie was twenty-one, apparently ended in his death or his desertion. James is rumored to have enlisted in the Second Michigan Infantry in 1861, whereupon Annie followed him to war and found work in the regiment, like many other working-class women, doing laundry, cooking, and caring for the sick. Though the Second Michigan did indeed enlist a private named James Etheridge, not a single soldier's account mentions that Annie had a husband. What does this mean? That it was a marriage that ended in abandonment? That James deserted? That Annie wanted to keep the shadowy details of her past from public view?

Postwar commemorative volumes are at odds on Etheridge's marital status. Frank Moore's 1866 *Women of the War* does not touch the subject, using the polite default of "Miss" in his references to her. He quotes a poem penned by an anonymous soldier laureate entitled "To Miss Anna Etheridge, the Heroine of the War," in which Etheridge's virginal and pious qualities are emphasized: "Hail, dauntless maid! whose shadowy

form, / Borne like a sunbeam on the air, / Swept by amid the battle storm," and "Hail, angel! whose diviner spell / Charmed dying heroes with her prayer, / Stanching their wounds amid the knell / Of death, destruction, and despair."[13] In Moore's volume, the sketch of Amy Morris Bradley, a plainspoken Mainer best known for bringing order to the Convalescent Camp outside Washington, refers to Annie as "Mrs. Etheridge," identifying her as a matron, not a maid. Moore, who based his sketch of Nurse Bradley on her diary and voluminous correspondence, also notes that in August 1862, as the Peninsula Campaign wound down and where she and Etheridge had served on transport vessels, "she lost the aid of one of the most efficient of her coworkers, Mrs. Etheridge, who returned to the regiment in which her husband was enlisted."[14] Military and pension records shed no light on whether her return to the Second Michigan was prompted by a husband who was still with the regiment. Presumably her married title was a detail adduced by Bradley, not by Etheridge, and Moore failed to reconcile the contradiction, either because he failed to notice it or thought better of entering the sensitive territory of marital address when representing the war years of an unattached woman who lived among men.

Brockett and Vaughan appear to have been just as inconsistent in this matter. Their sketch of Etheridge in *Woman's Work* is titled "*Mrs.* Annie Etheridge" (emphasis added), yet in their account of Amy Morris Bradley earlier in the volume—Moore and Brockett and Vaughan included many of the same female subjects in their two volumes—they refer to Etheridge as "Miss." What we learn from both of the postwar accounts is that the question of marital status was a flash point for female relief workers. It was customary and a sign of respect to assume that a woman was a miss unless she had a visible husband. Etheridge did not, and no one to date has been able to find any divorce or death records for James Etheridge or David Kellogg. What is potentially more illuminating is that in the titles of their accounts of individual women, Moore and Brockett and Vaughan use neither "Mrs." nor "Miss" for women whose class status is uncertain or, worse, below middle class. In Moore's book, we have titles like "Miss Amy M. Bradley" and "Anna Etheridge"; in Brockett and Vaughan's, elite New York sisters are called "The Misses Woolsey," whereas Bradley, whose father was a cobbler, goes without a title. That Moore considered Bradley a "Miss" and Brockett and Vaughan did not suggests further slippage in how postwar commentators classified their female subjects.

Critical readers of nineteenth-century primary sources are familiar with the coded language of class, race, ethnicity, and gender that assigned elite, purebred whites to lady-hood and those whose antecedents could not be traced to something less than respectability. When Moore referred to Irish immigrant Bridget Divers of the First Michigan Cavalry as "not prepossessing or attractive" in personal appearance, with a "strong and brown" hand and the "heart that beats under her plain cassock . . . as full of womanly tenderness as that of any princess in purple velvet," it is likely that he tried to compensate for her lack of pedigree by showing fastidious concern for conduct that identified Divers as a working-class woman.[15] The dilemma that has haunted me for the twenty years I have looked at Etheridge's wartime photo is how it was possible for "Gentle Annie" to be accepted as a woman in the ranks, a kind of woman

warrior like Divers, whose respectability was never questioned. When middle-class citizens assailed women who "unsexed" themselves by cross-dressing or claiming men's roles for themselves, was it simply that Etheridge's dress and demeanor were so unassailably feminine and virginal that she was neither disparaged as an assertive bluestocking nor targeted as a sexually available woman? How did Etheridge emerge from the war with body and reputation intact? As Daniel Crotty, a color sergeant in the Third Michigan Infantry opined, Etheridge was "one woman in a million," but not simply because she worked in the field during the Army of the Potomac's most desperate battles.[16] To my mind, this superlative characterizes her march through the pages of Civil War history without so much as a blot or insult.

We do not know—and most likely never will—if Etheridge was sexually active during the war, but we do know that the soldiers, officers, and relief workers who mention seeing her spoke of her virtue in reverential terms and of her bravery and "coolness" under fire. Though not a virgin, Etheridge might as well have been, according to soldiers who were charmed by her Madonna-like bearing. Several mentioned that any man in the regiment (the Second Michigan, the Third, and later the consolidated Fifth) would have come to her aid had anyone tried her virtue. Daniel Crotty extolled, "Any man in the regiment would die in her defense, should anyone cast a reproach on her fair name and character. All believe her to be one of the truest of women"— that is, "true" in the antiquated sense of honest, meaning that Etheridge presented herself as virtuous, unlike women who followed regiments to provide sexual services.[17] Another maintained that "the soldiers held her in the highest esteem, not one of whom but would have periled his life in her defense."[18] Playing on her sense of deference and modesty, Philadelphia nurse Mary Morris Husband, who did not meet Etheridge until after the Battle of Cold Harbor in 1864 but had heard of her legendary exploits, found her "very reticent, with a reserve & apparent pride of manner toward strangers which was uncommon in her position," with "conduct . . . ever free from reproach."[19] The woman who could demonstrate virtuous modesty, vulnerability, and backbone enough to withstand enemy fire won praise because it was a challenge to perform all of these roles at the same time.

The legend of Annie Etheridge gained girth and momentum during the war years and after because of her quick accommodation to a soldier's life, her ability to maintain composure in the heat of battle, and her reputation for shaming shirkers. The idiosyncrasies of her service—provisioning men in combat, dragging wounded out of the range of fire, lifting others onto her pony for evacuation, putting herself at risk of wounding, sleeping on the ground in encampments, nursing the sick, and still wearing her best dress for Sunday religious meetings—make it difficult to label Etheridge.[20] Surely she was more than the standard relief worker, according to testimonials from diverse witnesses. Lieutenant Charles Mattocks of the Seventeenth Maine Infantry, for example, observed her at Chancellorsville "in the very front" of the battle, assisting the wounded "where few surgeons dared show themselves."[21] The inference is that Etheridge was even more courageous than male superiors. A veteran of more than thirty battles (First and Second Bull Run, Antietam, Fredericksburg, Chancellorsville, and

Gettysburg among them), Etheridge was the subject of reports that placed her in the midst of the fray, exposing herself to great danger. Without clues to her motivation, one wonders what compelled her to serve where she was so likely to be wounded or killed. Etheridge showed uncommon bravery, regardless of gender, but what other factors were at work here? Was it pure love of country possibly motivated by an inherent sense of disenfranchisement stemming from ethnic inheritance—the wish to demonstrate one's Americanness where it had been previously erased or denied? Was Etheridge careless of her life, given what might have been disgraced womanhood from an earlier chapter? Might she intentionally have put herself in the line of fire because she felt that her life was worthless, that she somehow deserved to sacrifice herself for the Union? Might she even have believed that her gender assignment was simply a mistake?

Clearly, these are speculations, the bête noire of evidentiary history, but it is important to consider these possible narratives, the range of meanings that might have illuminated Etheridge's actions in light of the informational vacuum that characterizes her self-presentation. What turns up consistently in others' stories about her are narrow escapes despite her proximity to exploding munitions. In each case, we see the motif of Etheridge's deliverance coupled with the death of the soldier standing next to her. As she helped a wounded private of the Seventh New York Infantry to the rear during Second Bull Run, a shell fragment hit him and instantly "tore him to pieces under her very hands." Eight months later at Chancellorsville, as she exhorted entrenched soldiers to "do [their] duty and whip the Rebels," a cowardly officer is said to have sheltered himself behind her: "A Minié ball whizzing by her entered the officer's body, and he fell a corpse against her." A later ball grazed her hand and pierced her skirt, though she was not seriously hurt. At the Wilderness in May 1864, an orderly in conversation with Etheridge was struck and immediately killed by Rebel fire. In an October 1864 skirmish near Hatcher's Run, despite a surgeon's warning that she was directly in the line of fire, she remained at her post to assist with water, lint, and bandages. When the regiment's young drummer stopped to talk to her, "a ball struck him, and he fell against her and then to the ground, dead." Even after this fusillade, Etheridge is said to have faced a Confederate battery as she retreated, unscathed.[22] A religious person might have read this evidence as a cosmic sign of Etheridge's inviolability; a more superstitious one might have observed, given the swift justice meted out to her interlocutors, that it would be well to avoid making her acquaintance altogether. Surely this narrative motif (where Etheridge provided a model of valor and was saved despite the fate of those in juxtaposition) was embellished and perfected as it made the circuit of the encampments.

According to a friend from the Department of the Interior, where she would later secure positions in the Patent and Treasury Offices, Etheridge planned to translate her wartime celebrity into a lucrative publishing contract. The friend wrote Frank Moore that Etheridge "has manuscripts from which might be compiled a work of considerable extent and of intense interest, for which she has already rec'd several liberal offers Should she decide to write a work herself for publication it would not be policy for her, as you will appreciate, to

allow others to publish compilations from her manuscripts forestalling the publication of her own work."[23]

Although aware of her bankability, of her potential to exploit her celebrity, "Gentle Annie" never managed to convert her story into cash, probably because, according to one source, she worked in her government office more than twelve hours per day. In 1870, Etheridge married Charles E. Hooks, an amputee veteran of the Seventh Connecticut Infantry. By 1878, government bureaucrats pressured Etheridge to turn over her job to someone more in need of the wages—a nineteenth-century form of Rosie the Riveter syndrome. GAR veterans, in defense of "our Anna," were incensed that a woman who cost the army nothing but contributed mightily was being dishonored in this way. "Her noble deeds in the dark days of the war," read their petition, "entitles her to a place in Government employ as long as she lives. This would be but a small return for the service she has rendered the country." Still her fierce champions, the soldiers did not succeed in their plea, leaving Etheridge and her one-armed husband to live on a pittance from 1878 forward. The censuses of 1880 and 1900 show the couple living at 115 Sixth Street S.E., a modest address near the federal navy yard where Charles Hooks was employed as a night watchman and Annie kept house. In 1886, in the midst of unprecedented federal expansion of the military pension system, she applied for aid by special act of Congress. She noted, not without irony, that "I received no compensation whatever during the war for any services—they were given entirely at 'the front' and most amid the hardships and dangers of the battlefield. In this receiving none (not even what the soldiers received), I was obliged to expend for personal expenses in living—clothing, some even in transportation—though *that* it was expected I would be furnished.[24] How, such verbiage alluded, was it possible that a grateful nation could turn a deaf ear to one who had served so selflessly, and a woman at that? A pension for $25 per month was ultimately approved in 1887, fully five years before Congress legislated the Army Nurses' Pension Act, which granted eligible applicants $12 monthly pensions, roughly the same amount that military nurses had received, along with a ration, thirty years earlier.

Annie Etheridge Hooks remains an enigma, though I am convinced, in perusing her image one hundred years after her death, that her story is far more complex than we have yet imagined.[25] All that remains of "Gentle Annie," aside from a grave marker at Arlington National Cemetery, are two photographs taken approximately twenty years apart and stories of her valor. Clearly the power of her legend did little to shelter her in later years. Comrades occasionally took up a collection for her, and she did draw a nurse's pension for twenty-six years. Her petition for a widow's pension after the death of Charles Hooks in 1910 suggests that she lacked the means to live a comfortable life, and she died alone, without children or family or much notice from the admirers who for decades had fueled her celebrity as "the great heroine of so many campaigns and battles."[26] Much was made of Etheridge's femininity by war witnesses—her polite demeanor, her prudence, her unobtrusiveness—but given her familiarity with the life of soldiers, a life that she too lived, one cannot help but wonder whether such comments were assurances rhetorically intended to head off doubters. In both portraits, Etheridge wears dangly earrings and dresses according to the fashion of

the day—perhaps in response to critics who disapproved of a woman's competing with men on their own turf. It is precisely because her motives may continue to elude us that we must consider the multiple lives that she, like other nineteenth-century workingwomen, might have lived. A multiracial, multiethnic "soup" had been brewing in the New World since the late fifteenth century, but during the Civil War, the construction of a black-white racial opposition and the illegibility of a more nuanced American racial reality were conveniences to more easily prosecute the war's political objectives. Annie Etheridge Hooks performed military, domestic, and civil work in a way that transcended gender and racial assignments, striving to achieve a martial ideal. Saying little about her past was one way to maintain personal power in a society whose reaction to more information could well have created suspicion and damaged her credibility. Instead, she held firm to the mission.

NOTES

1. The image appears in Linus P. Brockett and Mary C. Vaughan, *Woman's Work in the Civil War: A Record of Heroism, Patriotism, and Patience* (Philadelphia: Zeigler, McCurdy, 1867), opposite 747.

2. See Sarah T. Lahey's "Fragmenting the Nation: Ethnic and Minority Literatures of the Civil War" (PhD diss., Northwestern University, 2011), which argues that binary representations of race in the wartime United States were a rhetorical convenience constructed to more easily advance the sectional conflict.

3. Daniel G. Crotty of the Third Michigan Infantry is one who describes Etheridge's "beautiful bronze face." Cornelia Hancock commented of Etheridge that "she looks as sunburned as any soldiers." It can be inferred that exposure to the elements for four years had tanned Etheridge's skin, but the bronzing of her complexion might also suggest a more complex racial heritage; see Crotty, *Four Years Campaigning in the Army of the Potomac* (Grand Rapids, Mich.: Dygert Brothers, 1874), 204; Hancock, *Letters of a Civil War Nurse*, ed. Henrietta Stratton Jaquette (Lincoln: University of Nebraska Press, 1998), 105.

4. See Robert G. Carter, *Four Brothers in Blue; or, Sunshine and Shadows of the War of the Rebellion* (Washington, D.C.: Gibson Brothers, 1913), quoted in Eileen Conklin, *Women at Gettysburg* (Gettysburg, Pa.: Thomas, 1993), 96; Elizabeth D. Leonard, *All the Daring of the Soldier: Women of the Civil War Armies* (New York: Norton, 1995), 109; John W. Haley, *The Rebel Yell and the Yankee Hurrah: The Civil War Journal of a Maine Volunteer*, ed. Ruth L. Silliker (Camden, Me.: Down East, 1985), 79; and soldier's testimony from the Etheridge pension, quoted in Conklin, *Women at Gettysburg*, 94.

5. From a description in the *Detroit Advertiser and Tribune*, February 16, 1863, quoted in Leonard, *All the Daring*, 106.

6. Mary Gardner Holland, *Our Army Nurses* (Boston: Lounsbery, Nichols, and Worth, 1897), 597.

7. In particular, Caroline M. Kirkland, who traveled from Geneva, New York, to Michigan in 1835 and ultimately founded the frontier town of Pinkney, wrote of the Native Americans she met en route in her satirical memoir, *A New Home—Who'll Follow? or, Glimpses of Western Life* (New York: Francis and Francis, 1839).

8. See Margaret Noori, "Bicultural before There Was a Word for It," *Women's Review of Books* 25 (March/April 2008):7–9.

9. Frank Moore, *Women of the War: Their Heroism and Self-Sacrifice* (Hartford, Conn.: Scranton, 1866), 514; Brockett and Vaughan, *Woman's Work*, 749.

10. The 1850 census reveals that John Blair was born in New York and Cynthia Blair in Massachusetts. Etheridge's sister was named Maria, and her brother, Edwin.

11. See, for example, Brockett and Vaughan, *Woman's Work*, 747.

12. See, for example, Conklin, *Women at Gettysburg*, 102.

13. Moore, *Women of the War*, 517–18.

14. Ibid., 432.

15. Ibid., 112.

16. Crotty, *Four Years Campaigning*, 57.

17. Ibid., 57–58.

18. Holland, *Our Army Nurses*, 598.

19. Mary Morris Husband to Frank Moore, January 30, 1866, Frank Moore Papers, Perkins Library Special Collections, Duke University, Durham, North Carolina (repository hereafter cited as DU).

20. Crotty, *Four Years Campaigning*, 171.

21. Charles Mattocks, *Unspoiled Heart: The Journal of Charles Mattocks of the 17th Maine*, ed. Philip N. Racine (Knoxville: University of Tennessee Press, 1994), 30.

22. Brockett and Vaughan, *Woman's Work*, 748–50, 752; Moore, *Women of the War*, 515.

23. C. S. Shepherd to Frank Moore, February 22, 1866, Frank Moore Papers, DU.

24. Etheridge pension, Exhibit M, quoted in Conklin, *Women at Gettysburg*, 103–4.

25. Etheridge died in Washington, D.C., on January 23, 1913.

26. Crotty, *Four Years Campaigning*, 57.

Jane E. Schultz

Refugee Camp at Helena, Arkansas, 1863

THAVOLIA GLYMPH

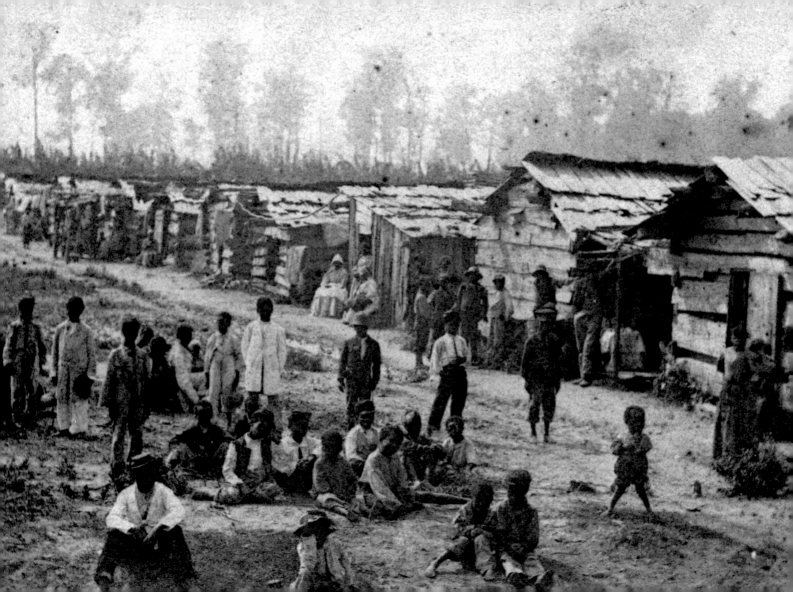

THE CIVIL WAR was a defining moment in the history of the United States that generated scores upon scores of documents—public and private—on whose authority tens of thousands of books continue to be published. The impressive interest in the war attests to its enduring power both as a symbol of the principles upon which the nation was founded and the nation's future that victory soundly rejected. No less today than during and immediately following the war, the diaries, letters, government and military documents, newspaper accounts, and records of private agencies engaged in alleviating the suffering of soldiers and civilians, as well as the work of visual artists, have the power to move us—to inspire, sadden, or even disgust. Photographic and other visual images are especially powerful in this way to do critical intellectual and political work. Photographs of soldiers and their families taken before heading off to war, of men lying dead on a battlefield, of widows in mourning attire or women and children on the road fleeing the path of armies, and of the ruins of plantations and cities left behind powerfully convey the war's cost in ways narratives cannot. After the war, this visual record played an integral part in the work of remembering and reconstructing a divided nation. They helped Americans make sense of what had happened. Pictures of Union prisoners of war

(which the Federal government paid to have made), for example, helped Northerners keep alive memories of the war's human toll and, for some, memories of its most lofty goals. Americans on both sides of the divide treasured cartes de viste of loved ones lost, fueling a booming business in the duplication and packaging of images for commemorative books after the war.

Then as now, photographs seemed to make the war's meaning and its costs more intelligible if not fully comprehensible. This was no less true for African Americans. Historian Nell Painter's work on Sojourner Truth highlights the ways in which black abolitionists like Truth and Frederick Douglass understood the power of portraiture, the authority of self-possession it conveyed. During the war, black people just out of slavery and possessing none of the recognition that accrued to men and women like Douglass and Truth stepped forward to have their portraits made. One thinks, for example, of the extraordinary portrait of an unidentified black soldier, his wife, and two daughters in the Liljenquist Family Collection of Civil War Photographs at the Library of Congress. Portraits black people themselves commissioned are some of the most powerful images of African Americans taken during the war. Like white soldiers, black soldiers stood in line at photographers' booths for a likeness to send home to a parent, wife, lover, or friend. The

sesquicentennial commemorations, which often high-light the impact of all these types of images, reflect in part an "enduring obsession with the war."[1]

More often than not, however, slaves and former slaves did not commission or endorse the portraits and other images that date from the war. These images largely capture black people in moments of becoming free—men, women, and children in flight to Union lines, men in the moment of transformation from slave to soldier, or freedpeople arrayed before plantation slave cabins—the involuntary subjects of a photographer's camera lens. But even here, black people become subjects in a way they had not been before. The refugee camp that is the subject of this essay falls into the latter category.

This photograph of a refugee camp at Helena, Arkansas, was taken in 1863 by Thomas W. Bankes, one of the war's less well-known photographers.[2] It is similar in some ways to other photographs in which black people are subjects. It is also in important respects strikingly different from more popular and better-known images that depict African American refugees in the process of becoming free, such as the famous photograph from 1862 of slaves crossing the Rappahannock River to free-dom. Bankes's photograph of a refugee camp inhabits a different space and fills a critical gap in the images most available to us today. Even the most evocative of Civil War images of slaves in flight and "contraband" camps fail to capture the experience of black refugees as vividly and poignantly. Here, then, is a visual record in line with contemporary narratives that describe refugee camps and the conditions within them.[3]

Bankes's photograph of one of several refugee camps at Helena, Arkansas, is one of the most arresting images of the war I have encountered. It offers a rare depiction of a refugee camp dramatically at odds with the views of "contraband" camps most familiar to scholars and the general public, such as the one at Arlington, Virginia, which has been widely disseminated in books and arti-cles on the Civil War. The best-known images portray neat cabins or tents arrayed in orderly fashion that sug-gest places of stability amid the storm of war. We know, of course, that even these places were sites of great pain and suffering, that just beyond the range of the camera lens lay evidence of the dislocation of black people's lives attendant to their flight and resettlement. Static images of slaves who did not flee because the flight of slavehold-ers had cleared a path for them to remain similarly belie the troubled ground on which they too began building free lives—often in the presence of Northern teachers and agents of freedmen's aid societies who came to help but brought with them disabling views about black peo-ple and their humanity.

Bankes's photograph of refugees at Helena reflects some of these problems. The way in which the people are posed, and their attire, gives the image the kind of static quality found in most wartime photographs of freedpeople. Numerous indicators suggest that it was staged rather than a random shot taken on a random day. Yet it is also strikingly different. The dislocation and harms attendant to black refugee life are more dis-cernible, much more apparent to the eye, more front and center. The world that lies just beyond the frame in other photographs is, in a sense, directly before our eyes. The image commands attention as a record of the price black people paid for freedom, of the unfold-ing of freedom in the midst of the humanitarian crisis

that accompanied slavery's destruction, a record often overlooked.

Bankes forces the viewer to confront the reality of refugee camps on American soil during the Civil War—to see, that is, on the ground of the nineteenth century United States an institution that we typically associate with the twentieth and twenty-first centuries and as something that happened or happens to people in other places. The photograph thus inscribes onto the history of the U.S. Civil War a narrative less well known and helps us to think about its place in the larger history of refugees and refugee camps. It invites us to remember that contemporaries—newspaper correspondents, U.S. Sanitary commissioners, government agents, and military commanders—called places like the Helena camp "refugee," not "contraband" camps. This photograph helps us to better understand why.

For most Americans, images of civilian hardship and suffering typically bring to mind Southern Unionist and Confederate women, not black women and children refugees. To be sure, Civil War sesquicentennial commemorations have made sites of black suffering such as the battlefields on which black soldiers fell and "contraband" camps more familiar to the general public. Still, as a rule we neither associate Civil War suffering, death, and destruction with enslaved women and children nor make the refugee camps in which many lived and died part of the larger story of the war's human toll. The power of Bankes's achievement lies in the insight it provides into that toll.

First, there are the children, the most vulnerable of noncombatants in any war, who dominate the foreground of Bankes's photograph. A woman holding a baby sits in their midst, and in the background other women sit in front of shanty housing. This led me to wonder about Bankes's motivation in taking the photograph. Perhaps his intent was to present a positive portrait of black children and women in freedom. The children smile and appear happy despite the grim surroundings. They are presented not as they would have come to the camp.

Black refugees from slavery invariably reached Union lines in rags. By 1863, the only clothing they possessed likely suffered from as much as two years of wear. In the Mississippi Valley, where the photograph was taken, the annual allotments of clothing had long since ceased for most slaves. In Bankes's photograph, the people wear "new" and, in some cases, rather fancy attire. Though shoeless, the young boys sport nice jackets, vests, and ties; some wear full suits. The women, no longer almost naked in the worn and tattered dresses in which they generally arrived, are attired in clean clothing and fresh aprons. Northern freedmen's aid societies and the U.S. Sanitary Commission entered freedmen's aid work in the Mississippi Valley later than they did along the East Coast, but clothing the refugees had become a major thrust of their efforts. The new clothing had arrived in boxes from the Midwest and the Northeast, collected by the U.S. Sanitary Commission and its sole female agent at Helena in 1863, Maria Mann.[4] In addition to dispensing clothing gathered by the Sanitary Commission, Mann had devoted much of her time to soliciting clothing and food for the refugees at Helena through direct personal appeals to family and friends back east. She encouraged them to send even homemade sheets and blankets, as she had a refugee "sewing

Refugee Camp at Helena, Arkansas, 1863

woman" who could convert them into dresses and other items of clothing.

But if Bankes's goal was to present a positive image of black refugees—the kind of image that could be effective, perhaps, in soliciting more support from Northerners—the shanties in the background mount a landscape of refusal. From a visual point of view, they provide both a competing and a complementary narrative to the "happy" children and women at ease. On the one hand, the shanties are evidence of loss and neglect. On the other, these bleak homes mark enslaved people's determination to make new lives in freedom. Constructed of planks of varied size with gaping spaces between them, sporting windows without panes and ramshackle side porches designed perhaps to afford some little refuge from the heat, cold, rain, and snow, the shanties exhibit all the telltale signs of hurried and haphazard construction. They portray nothing less than a refugee camp of the kind familiar to our eyes today.

In quarters "void of comfort or decency," in Maria Mann's words, sickness and disease incubated. The camera does not capture the effects of vector-born diseases such as malaria, typhoid fever, chronic diarrhea carried by rotten meat, and blood-sucking fleas, mosquitoes, lice, biting flies, mites, and ticks, but we know they are there. The animal carcasses that littered the ground near the camps, which manuscript sources document, are also not visible. It is possible to imagine, however, how the cold and snow of the late winter of 1863, followed by early spring flooding, would have penetrated the shanties' open spaces that counted for windows and the gaping holes in the walls, and how this would have made the dirt floors a muddy, diseased mess. The town of Helena proper, itself a "sickly, pestilential, crowded post" with grounds covered with "carcasses, filth & decay," could offer little respite.

This image, thus, interests me both for what it reveals and what it covers over. It raises certain questions about emancipation's unfolding in refugee camps where environmental disasters became the face of political ones. Women and children sickened with smallpox shortly after arriving in the camps, and dysentery took the lives of the young and old. We can imagine, too, that separated from enslaved women midwives, pregnant women miscarried more often and died in childbirth more frequently, and that the number of stillbirths and infant mortality increased. Scholars have yet to do the work that would yield demographic data to address these kinds of questions conclusively, but manuscript sources provide some insight.

Orphans were no doubt among the children in Bankes's photograph, as were refugees arriving with already compromised health. Manuscript sources suggest a growing population of orphaned black children whose mothers had died in childbirth, at the hands of the enemy, or from disease—like the pregnant woman with two children, ages six and two, who made it to Helena only to die soon after. Her two-year old died quickly thereafter, rendering her six-year-old child an orphan.

In the end, I do not know what motivated Bankes to take this particular photograph. While the scene appears staged, I do not know why he may have staged it. I cannot say with authority why the children are so prominently featured or what work, if any, he intended the

row of shanties that dominate the background to do. Yet I find it intriguing to consider that he could have taken a picture of the children and left the shanties out of the frame entirely. The larger body of Bankes's work, particularly other photographs he took in Helena before moving to Little Rock at the end of 1863, is suggestive, however. Bankes appears to have had a specific interest in documenting the war's environmental toll. He took several pictures, for example, documenting the devastation that resulted from the 1863 spring floods. Seen from this perspective, the juxtaposition of well-dressed refugees against the background of the crumbling shanties appears less accidental and more a deliberate move on his part.

After weeks or months of planning their escape, or perhaps only days, enslaved people who made it safely to Helena and similar Civil War camps after Union occupation had reason to celebrate and to fight to survive. They had made it through territory patrolled by Confederate soldiers, endured hunger, sometimes left loved ones or friends behind, and seen traveling companions perish and fall by the wayside, laid low by exhaustion, hunger, disease, or Confederate scouts and guerrilla forces. Those who made their way to Helena had come in small and large groups, and some alone. Among them were soldiers' wives, families, fiancées, and lovers who followed the men to Helena when it became a major recruiting station for black soldiers. Most saw Union lines as offering the best hope for freedom and protection against angry slaveholders and the Confederate army.

Like all refugee camps that became gathering places for black people during the Civil War (as, indeed, is the case with refugee camps today), the one at Helena was at once a place of despair and death *and* a site of refuge and hope and the making of freedom. Many who made their way to Helena knew that death was imminent but preferred to die in the quasi freedom of a refugee camp life than to die in slavery. Many suffered and perished, but former slaves' faith in a new world in the making was also on view. In the midst of devastation, they married and reconstituted families, tried to make a living and gain literacy. In the spring of 1863, for instance, former slaves Sallie Williams and William Anderson got married in the camp of the Forty-Sixth United States Colored Infantry at Helena.

Bankes's photograph fills an important void in the visual imagery of the Civil War and raises new questions and lines of inquiry. It makes it possible to "see" the coming of freedom from a different angle, one that affected tens of thousands of black women, children, and the elderly—and also to look at images with which we are most familiar in new ways. In 1862, when Alexander Gardner set up shop in Washington, D.C., in competition with his former employer, Mathew Brady, he placed large signs over the front and side of his new business. The largest read, "Views of the War." Bankes's photograph adds to that well-used phrase a view of the war rarely photographed.[5]

Finally, we can be sure that the women and children in Bankes's photograph were fooled neither by the used clothes they wore nor by the tableau created by Bankes's arrangement of their bodies. They knew the camp as a place of death and a place of hope. The clothesline tacked across the front of the shanties was a small testament to the hope that remained.

Refugee Camp at Helena, Arkansas, 1863

NOTES

1. Quotation from Jeff L. Rosenheim, *Photography and the American Civil War* (New York: Metropolitan Museum of Art, 2013), 147.

2. Born in England, Thomas W. Bankes came to the United States in the 1850s and set up shop in Helena around 1860. He continued to earn his living as a photographer after the war in Little Rock (U.S. Census, 1st Ward, Little Rock, Pulaski County, 1870). Bankes's photograph of the refugee camp is in RG 3323-06-12, Nebraska State Historical Society, Lincoln. My thanks to Linda Hein, reference assistant, and Dell Darling, in digital imaging, for their assistance in providing copies of the photograph and for permission to publish it.

3. A recent find by Martha Jones of a sketch of washerwomen is a rare exception; see Martha S. Jones, "Emancipation Encounters: The Meaning of Freedom from the Pages of Civil War Sketchbooks," *Journal of the Civil War Era* 3 (December 2013): 387–402.

4. Maria Mann Letters, Papers of Mary Tyler Peabody Mann [Mrs. Horace Mann], Manuscript Division, Library of Congress.

5. Rosenheim, *Photography and the American Civil War*, 26.

Finding a New War in an Old Image

SUSAN EVA O'DONOVAN

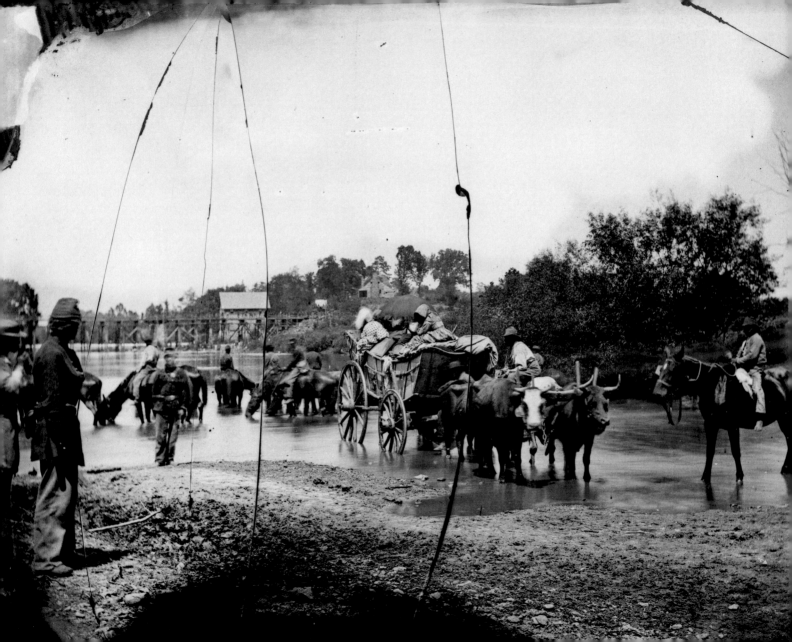

IN MID-AUGUST 1862, shortly before the Second Battle of Bull Run, one of the photographers on Mathew Brady's staff captured what has become one of the most ubiquitous and heavily used images of the Civil War era: a photograph of five African Americans crossing the Rappahannock River near present-day Remington, Virginia. The photographer, Timothy H. O'Sullivan eventually left Brady's employ, joining another prominent wartime photographer, Alexander Gardner, but the picture O'Sullivan took on a hot summer day shortly after the Battle of Cedar Mountain and shortly before Union and Confederate forces collided for a second time at Manassas invites viewers to reconsider our more popular understandings about the war, its combatants, and especially the process by which a war for Union came to be a war against slavery.[1]

At first glance, O'Sullivan's picture seems uncomplicated and straightforward, but on further examination, intriguing information can be extracted from just beneath the surface, information that points the viewer to a deeper story about slavery and war and African Americans' role in both. Central to the image is a party of five African Americans and their heavily laden wagon, caught by the photographer's camera just as they were emerging from the river onto a flat sandy bank. In the background, we can see a mill of some sort, a house and outbuildings nestled above the river among some trees, a trestle bridge on what was then the Orange and Alexandria Railroad, and just over the shoulder of one of the women on the wagon, a corner of the head and hat of a mounted figure. In between the bridge and the African Americans with their wagon stands a group of Union soldiers who have stopped their horses in the river in order to give the thirsty animals a chance to drink. None of the soldiers seem at all interested in O'Sullivan and his camera or in the African Americans with whom they are sharing the river. The soldiers' attention is on one another and their horses. Not so in the case of the African Americans.

That attentiveness is especially visible in the figure of the teenage boy. Off to the right of the image, the wagon and the rest of his party separating him from the soldiers, the boy drapes casually over his horse's bare back, his legs not even long enough for his own bare feet to reach the bottom of the horse's barrel. Instead of gripping the reins, which are wound loosely around the horse's neck, the boy holds nothing but the end of a rope, perhaps a tie rope of the kind commonly used by today's trail riders. A soft, rolled-brimmed hat shields his head and face from the sun, and the rest of his wardrobe consists of long, light-colored pants and a jacket that recalls military design. His is a casual look and a confident bearing: a

boy at home on top of a horse. Except that there's more to this story. Notice how the boy keeps the wagon and its four large oxen between him and the soldiers, his horse oriented in such a way that he has his back to no one in the picture. This is a boy who is careful. He's also not too sure about O'Sullivan. Thus, while his horse faces the wagon and, past it, the soldiers, the boy's eyes are on O'Sullivan. It is a posture that is simultaneously deferential and curious, self-aware and self-protective, the posture adopted by people who are forced to live by their wits in societies in which power is stacked steeply against them. The boy wears subordination like a cloak, using it to hide a mind that, from the intensity with which he discreetly examines the cameraman, yearns otherwise.

That's not quite the case with the two adult men. If they once wore subordination, they had discarded it by the time O'Sullivan found them on the Rappahannock River. Occupying positions that announce a close and possessive relationship with the wagon, its contents, and the animals that pulled it, one of the older men sits on the tongue, just in front of the wagon box, his shod feet dangling above the water, his left arm resting on the hip of the rear off ox. The other man is seated sideways on the rear near ox, a picture of relaxation with his forearms resting comfortably on his thighs, his feet dangling between the two rear oxen. These are men who know oxen, know wagons, and know their way around both. Handling a four-hitch team is nothing new to these men, likewise the business of fording a river. There is trust, familiarity, and confidence in their positions and posture. This is especially true of the man seated on the one ox. He is either a very proficient driver, experienced enough to successfully handle a team of unfamiliar oxen,

or he has been working closely with this team for quite some time.[2] Nothing in his attitude suggests that what he is doing is new to either man or beast. Furthermore, as captains of a terrestrial ship, and a large one at that, neither man projects the timidity and subordination of the boy on the horse. The one on the wagon tongue stares openly at O'Sullivan, unconcerned, evidently, that anyone might object to such obvious study. The other man, the one sitting on the ox, ignores O'Sullivan and the soldiers altogether, leaving the viewer with the impression that he is unimpressed by either the photographer sweating over his camera or the soldiers with their horses. It is a posture that evokes extreme confidence, one born of many miles chalked up successfully on many roads through many and varied social and physical terrains. He's a man who has seen a lot, done a lot, and survived a lot. He is unruffled in a time of war: at peace with his oxen, at peace with himself, and at peace with his surroundings to a degree not yet achieved by the boy on the horse.

Then there are the two women who sit nestled atop the baggage that fills the wagon. On close examination, the woman on the right is resting her chin in her left hand, eyes cast downward and further shadowed by the brim of her bonnet. Her companion has her back to the camera, and it is impossible to tell from the picture what she might be looking at, if she is looking at anything at all. That neither woman is openly interested in their immediate surroundings can be interpreted in a number of ways. Perhaps they are sick and exhausted, worn out by travel. Perhaps they trust the two teamsters, confident that they won't lead the group into danger. Perhaps they are trying their best to be invisible, not wanting to

draw the soldiers' or O'Sullivan's attention. Perhaps it is a combination of all three and possibly more.

Despite the interpretive difficulties presented by the two women, they do share something in common with the men in their group. None of the party appears connected to the soldiers by anything but physical proximity. No looks are exchanged between white people and black. With a single exception, no one in the two groups (soldiers and African American refugees) faces each other, and in the case of the exception—the teenager to the right—the wagon and team provide a visual and physical barrier between the boy on the horse and the boys in blue. One gets the impression that O'Sullivan captured two images inside one when he set up his camera on the banks of the Rappahannock. The soldiers comprise one image, the African Americans the other. Moreover, that O'Sullivan caught them in one shot while crossing the same stream at the same time may be nothing more than a practical matter of timing and safety: after all, who knew better than enslaved travelers the kind of dangers a river ford can present. Limited by nature to certain locations, river crossings are an ideal location not only for photographers hoping for a powerful image; they are also ideal locations for ambushes by bandits or warring armies. Wagons can get bogged down in sandy bottoms, livestock can become stuck in the mud, and if the water is deep enough or swift enough, people can drown. Given the weight of the wagon and the fact that there were only two adult men in the party, it would be sensible for all of these reasons that the African Americans cross in the company of Union soldiers. It simply makes sense: a convergence of convenience.

It is a reading that also makes sense given what we now know about enslaved Americans in the Civil War era. Over the past thirty or forty years, scholars have come to recognize that status (being enslaved) had no bearing on intellectual capacity or political awareness or personal ideology. In other words, being a slave in practice had little relationship to slavery in the abstract. There was nothing socially or politically dead about those on whom the Confederacy pinned its hopes for the future. Indeed, as W. E. B. Du Bois tried to impress upon historians in the early part of the twentieth century, one can argue that the Confederacy formed in direct response to a growing rumble from beneath slaveholders' feet, and certainly scholarship on the war years has documented the vital role slaves played in pushing Abraham Lincoln and his constituency into an increasingly antislavery stance.[3]

That O'Sullivan took this image in August 1862 tells us something just as important. Slaves did not need a president's permission—or even encouragement—to act in the name of freedom. In fact, enslaved Americans had been acting to undermine, destabilize, and destroy slavery long in advance of Lincoln's birth, never mind the proclamation he issued on January 1, 1863. Even without taking into account the myriad ways in which the enslaved had worked to undermine slaveholders' power from the very beginning, it is clear from the historical record that they stepped up their game as sectional relations deteriorated. Whether they followed the lead of the eight men who arrived at Florida's Fort Pickens to claim their liberty, an event that took place a full month before the fall of Fort Sumter, or organized friends into an informal reading club in order to stay

abreast of current and political events, or took the more dramatic and drastic action of rising up in rebellion—slaves were well ahead of the rest of the nation when it came to the politics of slavery and freedom.[4] Once the conflict broke out in earnest, what had begun tentatively and in piecemeal fashion became epidemic. Across the Confederacy, but especially in places proximate to Union forces and Union lines, slaves launched a more general assault in pursuit of their own visions of freedom. Much of what we might term the slaves' war manifested itself in human movement of the kind O'Sullivan captured with his camera. Beginning as a trickle, first black men but soon whole families made their way across enemy ground and through Union lines. By early summer, self-liberating slaves were crossing into Union lines by the dozens and hundreds. Two years later, in May 1863, the Union officer responsible for supervising black fugitives at Virginia's Fort Monroe estimated that ten thousand former slaves had come under his control. It was a groundswell action that caught the Northern nation and its leaders by surprise. It was also an action that changed the course of the war. Under increasing and unrelenting pressure from people like those O'Sullivan fixed in national memory, field commanders, policy makers, and a president soon found themselves forced to grapple at last with the problem of slavery; the nation's slaves would have it no other way. Said one young soldier when asked about the influx of slavery's chief enemies: "[The fugitives] followed us and we could not stop them." By 1864, an estimated four hundred thousand men, women, and children had liberated themselves by means of movement, and the number would continue to climb.[5]

What is also in evidence in the historical record, and which O'Sullivan likewise caught with his camera, is that the enslaved were the masters of their own minds and ideas. No mere mimics of Northern sensibilities, dupes of hegemonic slaveholders, or simply bewildered flotsam and jetsam of war, pushed hither and yon by forces beyond their control, enslaved Americans acted in ways that advanced what was most meaningful to them. Possessed of their own ideas, aspirations, and expectations—bodies of knowledge that had been generations in the making—the understandings that informed enslaved people's responses to the war were, like all ideologies, the product of very particular and personal circumstances. Since there was never a single slave experience, it stands to reason that there was never a single slave's politics, ideology, or sense of self, and as was the case with free Americans of any generation, those who weighed their options as war swept a nation, made their decisions for deeply personal and individual reasons.

The most visible result of this ideological diversity can be seen in the demography of flight. Only a fractional number of the nation's slaves (10 percent by 1864) judged the risks of flight acceptably low, at least compared to the cost of staying put. Moreover, a shared decision to move against slavery by moving their feet (as opposed to going on strike or otherwise sabotaging Confederate efforts) was no guarantee that the wartime fugitives shared other political sensibilities. Joseph Harris, for example, joined in the war against slavery in order to secure his family's future, which in his mind included securing educational opportunities for his children. "[I]t is beter for them then to be their Surveing a mistes," he

explained to his commanding officer.[6] Spottswood Rice, who had been enslaved in Missouri, fought to end slavery wherever it might be, indicting in no uncertain terms the president's cautious policies when he exclaimed in a letter written to the woman who continued to hold one of his daughters, "wo be to Copperhood rabbels and to the Slaveholding rebels for we don't expect to leave them there root neor branch."[7] An anonymous writer in New Orleans spoke just as bluntly about the need to make emancipation universal, but then went on to warn that any alliance between white Northerners and black Southerners was strictly provisional, a necessity of war and nothing else. Indeed, the "Colored Man" explained, "there are three things to fight for and two races of people divided into three Classes one wants negro Slaves the other the union the other Liberty So liberty must take the day nothing Shorter."[8]

Recognizing that individual slaves acted for reasons strictly their own helps us to better understand why O'Sullivan saw just one wagon through his camera on that hot August day. The slaves' war was a personal war, one waged for deeply idiosyncratic reasons and in the absence of a supreme commander. The multiplicity of those reasons served to splinter the slaves into a thousand small armies, all of which, like the group whose photograph structures this essay, made their own way, on their own terms, to a future of their own imagining.

Timothy O'Sullivan probably had no idea what he captured with his camera that summer day, midway through the Civil War. But with the advantages of the perspective and insights wrought by time and a rich historical record, a twenty-first-century audience can see beyond the surface of O'Sullivan's enduring image to catch an important glimpse of a different war, one fought by those who have too often been dismissed as historical bystanders. The details, of course, have always been present in the image, just as slaves were always a part of a war that dramatically remade a nation. The challenge is to see what's on the page and to read, as anthropologist Ann Stoler has advised, with (not against) the archival grain.

NOTES

1. Rick Dingus, *The Photographic Artifacts of Timothy O'Sullivan* (Albuquerque: University of New Mexico Press, 1982), 2.

2. "Near" and "off" refer to the left side and right side, respectively, of a team as viewed while looking forward from a seat at the front of a wagon. When working with an ox team, the driver positions himself at the outside hip of the near ox and uses voice commands (notice the absence of reins in the image) to effect changes of speed and direction. This suggests further that the seated man is also the driver of this team. For general information about ox husbandry, see Drew Conroy, *Oxen: A Teamster's Guide to Raising, Training, Driving, and Showing*, 2nd ed. (North Adams, Mass.: Story, 2008).

3. W. E. B. Du Bois, *Black Reconstruction in America: An Essay Toward a History of the Part Which Black Folk Played in the Attempt to Reconstruct Democracy in America, 1860–1880* (New York: Harcourt, Brace, 1935), chap. 4.

4. For examples of slaves' articulating and acting on their own political sensibilities, see A. J. Slemmer to Lt. Col. L. Thomas, March 18, 1861, in U.S. War Department, *The War of the Rebellion: A Compilation of the Official Records of the Union and Confederate Armies*, 127 vols., index, and atlas (Washington, D.C.: GPO, 1880–1901), ser. 2, vol. 1, 750; the biography of H. H. Holloway, Houston Hartsfield Holloway Papers, Manuscript Division, Library of Congress;

Finding a New War in an Old Image

Frederick Law Olmsted, *A Journey in the Seaboard States, with Remarks on Their Economy* (New York: Dix & Edwards, 1856), 676–86; William Webb, *The History of William Webb, Composed by Himself* (Detroit: Egbert Hoekstra, 1873); transcription of the trial record in the case *Commonwealth v. Sam (a slave)*, Mecklenburg County, May 21, 1861, Executive Papers of Governor John Letcher, Pardons, May 1861, Acc. 36787, State Government Records Collection, Record Group 2, Library of Virginia, Richmond.

5. Excerpt of Benjamin F. Butler to Lieutenant General Scott, May 27, 1861, in Ira Berlin, Barbara J. Fields, Thavolia Glymph, Joseph P. Reidy, and Leslie S. Rowland, eds., *The Destruction of Slavery* (Cambridge: Cambridge University Press, 1985), 70–72; excerpts from testimony of Captain C. B. Wilder before the American Freedmen's Inquiry Commission, May 9, 1863, in ibid., 88–90; Steven Hahn, *The Political Worlds of Slavery and Freedom* (Cambridge, Mass.: Harvard University Press, 2009), 61.

6. First Sergeant Joseph J. Harris to General Ullman, December 27, 1864, in Ira Berlin, Joseph P. Reidy, and Leslie S. Rowland, eds., *The Black Military Experience* (Cambridge: Cambridge University Press, 1982), 691–92.

7. Spotswood Rice to Kittey Diggs, [September 3, 1864], enclosed in F. W. Diggs to General Rosecrans, September 10, 1864, in ibid., 689–90.

8. Statement of a Colored man, [Sept.? 1863], in ibid., 153–56.

Susan Eva O'Donovan

PART 4
VICTIMS

My Dead Confederate

JAMES MARTEN

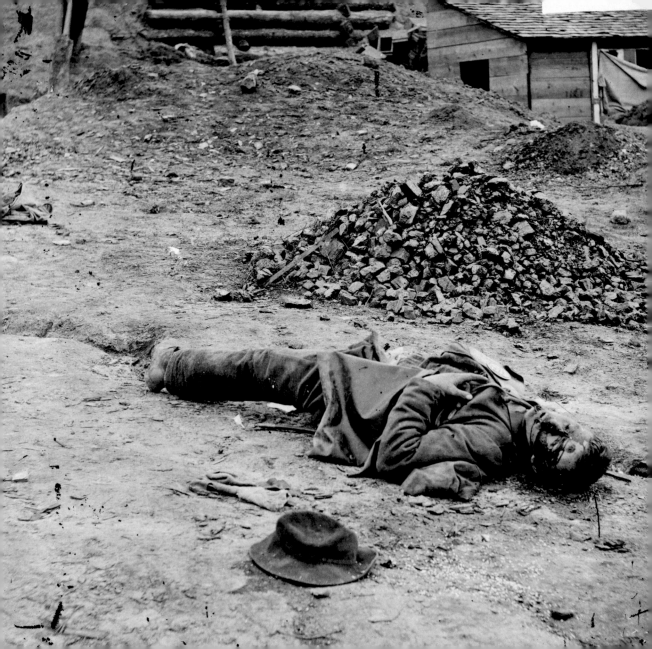

FOR MOST of my life I have been haunted by a single image from the Civil War: this photograph of a dead Confederate soldier. I was ten or eleven, living in a tiny town in South Dakota. My sister and I took piano lessons from a Mrs. Harris in the slightly less tiny town up the road, and while waiting for her to finish, I would explore the contents of a bookshelf that apparently belonged to Mrs. Harris's husband. He was superintendent of schools and a history buff. The book I kept going back to was a big coffee-table book, I think on Abraham Lincoln. It was filled with what I know now to be classic photographs by Mathew Brady and others, including this well-known shot taken after the fall of Petersburg. I knew a fair amount about the war by then. I was a Bruce Catton man, and around this time my family took a trip that revolved entirely around my interests, including a memorable couple of days in Gettysburg and my first and only visits to Ford's Theater and the Petersen House in Washington.

I was and still am rather squeamish about filmed and photographed violence, so it is a little surprising that I kept turning to that photo. Or perhaps it isn't.

The photograph is a perfectly realized image of death. Unlike the clumps of torn and rumpled bodies that litter some of the famous photographs of battlefield dead, this one lies alone on hard-packed dirt, like so much rubble.

Indeed, the background is dominated by a pile of broken bricks and stones, with rock-strewn earth rising away from the body. One article suggests that this might be dirt from a newly opened grave. Some sort of structure made of raw boards—a makeshift hospital, perhaps, or an ammunition shack, with a torn sheet flapping in a rough window or door—adds to the desolation.[1]

The composition of the photograph, the isolation of a single casualty, highlights the loneliness of dying. No other evidence of humans is visible; no one has looted the body, no one has taken him away for burial. He is forgotten, ignored, abandoned.

Yet the place must have been teeming with tens of thousands of Union soldiers marching and waiting and milling about quite near the death scene, hundreds of other dead and dying and maimed comrades, and dozens of reporters and photographers. This boy—he seems very young, with perhaps just a hint of whisker—died, after all, during one of the key moments in the war's final weeks. Even as he ate his last rough meal and slept fitfully during the night before what he could not know would be his last battle—even as he died—all of the immortal events of the collapse of Lee's army at Petersburg played out: from the fall of Fort Mahone, where this boy apparently fought, to the dramatic messenger reporting to President Jefferson Davis that the

capital would soon fall, to the hurried and catastrophic evacuation of Richmond.

Perhaps he was a recent recruit; his nondescript uniform seems almost new, and he wears shoes—he's not ragged or barefoot, as so many Confederates are said to have been by 1865. There is no weapon in sight, although something resembling a scabbard is partially visible under his back; an ammunition haversack stamped with a big "us" is slung over his shoulder. The only other objects in the scene are a hat and an unidentifiable piece of cloth, which at first glance seems to be a pair of gloves, but on closer inspection seems simply to be a rag.

He doesn't seem to have suffered. A shell fragment juts from between his eyes; the blood lies thickly on his face where it flowed from the wound, nose, and mouth. Darkened soil beneath his head suggests more blood, indicating he probably died where he was photographed. He does not seem to have torn at his clothes in agony or dug his heels into the ground in his death throes. Perhaps he really did die one version of the "good death"—quick, without suffering—for which soldiers prayed. If so, it also wasn't the "good death" that Victorians sought, a chance to say good-bye, to get right with God, to be comforted by friends or comrades as the light faded. If "dying was an art," as Drew Faust suggests, this boy's death was no masterpiece. In the confusion of the retreat, it's unlikely that anyone took down the details of his death that could be shared later in a tender and reassuring letter to his family. Indeed, it's unlikely that his body would have been identified at all. He would not only have died alone, but would rest forever in a grave full of unidentified soldiers. This, too, was a fear of

nineteenth-century Americans, as Faust points out, but with his comrades in retreat—or killed, like him—there would have been no choice.[2]

This young Rebel died more than two years after Mathew Brady famously introduced New Yorkers to the human costs of war in his 1862 exhibit "The Dead of Antietam." "Mr. Brady has done something to bring home to us the terrible reality and earnestness of war," the *New York Times* commented in an oft-quoted passage. "If he has not brought bodies and laid them in our dooryards and along the streets, he has done something very like it."[3]

The *Times* pointed out a fact no less heartrending for its obviousness: no amount of "photographic skill" could capture the invisible figures in these ragged tableaux of dead soldiers, the "widows and orphans, torn form the bosom of their natural protectors." This boy, of course, left a family somewhere. He looks too young to have had sons and daughters, but he was somebody's son, perhaps someone's sweetheart, and his absence would be felt at holidays and family dinners for the rest of their lives. His features are clear enough that they reflect the "terrible distinctness" of Brady's photos, commented upon by the *Times* reporter, who imagined a viewer bending close to a photograph and actually recognizing a husband or son or other loved one.[4]

The circumstances of seeing this photograph over and over—it could not have been more than two or three years after the end of the Civil War centennial, which I have always imagined inspired my interest in the war—colors my memory with a sepia-toned nostalgia fitting a childhood recollection. But a historian needs a clearer view of what exactly he or she is looking at. We actually

know a lot about the photographer and the moment in which he encountered the dead Confederate. Thomas C. Roche had worked for a time for Brady, but was lured away in 1864 by his former employer, the New York photographer and entrepreneur H. T. Anthony, to make stereographic views of the war. His photographs are not as famous as Brady's, but he was well known among his mates and had a reputation as a fearless seeker of great shots. Miller's famous *Photographic History of the Civil War* refers to Roche as an "indefatigable worker." He was also fearless. A colleague told a story of Roche's exploits during the weeks leading up to the fall of Petersburg. While taking pictures of the Union fortifications at Dutch Gap Canal, Confederate shells began falling all around. After one exploded within a few rods of Roche, "shaking the dust from his head and camera," the photographer strode over to the shallow crater left by the shell and exposed his last plate "as coolly as if there was no danger, and as if working in a country barn-yard." When asked if he wasn't afraid, he blithely explained that "two shots never fell in the same place." While visiting a friend during the buildup for the final push on Petersburg, he heard the opening bombardment. "The ball has opened," he declared, "I must be off!" and soon his wagon rattled off into a night filled with the "rumbling of artillery, the clatter of cavalry, the tramp of infantry, the shrieking of locomotives." The friend saw Roche the next morning after the Confederates had fled, "on the ramparts with scores of negatives . . . that will in truth teach coming generations that war is a terrible reality."[5]

Roche rushed into the fallen Confederate bastion of Fort Mahone, hot on the heels of the victorious Yankees, apparently elated to find plenty of material for his gruesome stereotypes. According to one historian, Roche's work on the day of the fall of Petersburg was the seventh and last time that dead Civil War soldiers were photographed. He took twenty-two stereographic slides, several of which feature our young dead man (a number of which can be seen on the Library of Congress website). Like many photographers of the war, he probably added some props—almost certainly the hat and, in other shots, an artillerymen's ramrod. He photographed the boy from three or four angles, moved the ramrod at least once, and in one picture added another body, a man in a vest and shirtsleeves with his face turned away from the camera. A recent *Civil War Times* article has revealed that, rather than being the dead Yankee soldier that everyone thought it was, the "body" was actually a perfectly healthy African American man, perhaps Roche's teamster, who appears in a different photograph taken around the same time. In fact, the photograph provided "evidence" for the suggestion made in recent years that there were actually "black Confederates" fighting in Lee's army.[6]

The story of Roche's efforts to make the best possible picture out of tragedy, to make reality seem more real, I suppose, provides a dose of reality to the otherwise emotional, not to say ethereal, description of a photograph that once meant a great deal to me. But I want to end with a reflection on why this photograph might have resonated with me in the late 1960s and has stayed with me for over forty years.

A less famous passage at the beginning of the *New York Times* article suggested that the many thousands of New Yorkers who every day passed blithely past Brady's Broadway studio, unaware and uncaring about the

display of dead Yankees inside would "jostle less carelessly down the great thoroughfare, saunter less at their ease, were a few dripping bodies, fresh from the field, laid along the pavement. There would be a gathering up of skirts and a careful picking of way; conversation would be less lively, and the general air of pedestrians more subdued." The point, of course, was that these Northern civilians could easily ignore the carnage being committed on their behalf a few hundred miles away.[7]

This particular picture of this particular dead boy was my "The Dead at Antietam." I was a Civil War buff through and through, spending my time reading about the war and even writing little stories and drawing elaborate pictures of Civil War battles, the bloodier the better. My squeamishness was tempered with a mysterious fascination. Although I certainly could not have articulated it at the time, I sensed then and know now that I was engaging in a kind of war voyeurism every time I peeked at that book about Lincoln.

Faust and others have commented on the dehumanization of soldiers who witnessed so much death, and such bloody deaths, and who fatalistically considered their inevitable mortality. Historians undergo a similar hardening process, I suppose. Our profession requires a certain detachment, and one eventually gets used to reading accounts of bullets falling like hail, entire lines of battle swept away by storms of canister, of survivors being able to walk from one side of a battlefield to another on the bodies of dead soldiers. I don't practice military history, but in a book about children during the Civil War, and in other works about children in other conflicts, I found myself considering stories of children and youth coming in harm's way and suffering and dying as civilians and soldiers alike as potent pieces of evidence, as points to be made. One of my favorite sections of that book explored the use of imagery of drummer boys in wartime writing for children and adults alike. Nothing could beat the idea of preteens enthusiastically volunteering for duty and dying in carrying it out as a propaganda item; if these children were brave and loyal and steady enough to risk and give their lives, then how could any adult resist his country's call? Pictures and poems about these boys, who were probably not much younger than the subject of Roche's photograph, were common enough to be considered a genre of wartime writing. I feature it every time I speak on children during the war; my well-practiced line about a little girl announcing to her mother that she wanted to grow up to be "dead drummer boy" always gets a nice murmur of laughter.[8]

But there is an uneasy undercurrent to that laughter—and to my telling that story over and over. We know we're finding humor in perhaps the darkest corner imaginable. Child soldiers are nothing to laugh about in the early twenty-first century; they never have been. And we, I, cannot stop thinking about them.

On a whole different level, the world that swirled around me in the late 1960s might help explain my weekly pilgrimage to that book and this picture. I did not realize until I was studying the picture again, placing it in its various contexts, that perhaps it had been a safe way for me to work out my fears and fascination with the idea of war. I didn't turn eighteen until after the draft ended, although in 1967 or 1968 I had no idea whether I would end up in the army, let alone Vietnam. I don't recall actually worrying about it very much, but it would certainly have been on my mind. I eagerly read

articles in the newspaper or in *Look* magazine about the war and still remember a kind of nervous excitement about reading about this oh-so-real war—which could be witnessed in living color on TV or in magazines—and perhaps the black-and-white photograph to which I was drawn became a way for me to link my growing interest in a long-ago conflict with an all too real war that might have worried me a bit.

I stayed safely at home and in a little less than two decades became a historian. Roche kept on working with Anthony after the war, taking many pictures of the West, developing photographic technology, and coauthoring a book on the technical aspects of photography that went through at least six editions.[9]

Our dead boy's life ended when a piece of metal sliced into his forehead that chaotic April morning in 1865. Considering the timing and circumstances of his demise, it is easy to call his one of the more useless deaths of the war. But it is never useless to remind oneself of the truest of all truisms: that the war to which one has dedicated a professional life—and much of a preprofessional childhood—was littered with similar rumpled, bloody bodies. And that each of those bodies represented a loss, a family torn asunder, a future never realized.

NOTES

1. David Lowe and Philip Shiman, "Substitute for a Corpse," *Civil War Times* 49 (December 2010):40–41.

2. Drew Gilpin Faust, *This Republic of Suffering: Death and the American Civil War* (New York: Random House, 2008), 6, 103–36.

3. *New York Times*, October 20, 1862.

4. Ibid.

5. Francis Trevelyan Miller, ed., *The Photographic History of the Civil War*, 10 vols. (New York: Review of Reviews, 1911): 1:42; A. J. Russell, "Photographic Reminiscences of the late War," *Anthony's Photographic Bulletin* 13 (July 1882): 212–13.

6. Robert Wilson, *Mathew Brady: Portraits of a Nation* (New York: Bloomsbury, 2013), 141; Lowe and Shiman, "Substitute for a Corpse," 40–41. Leslie Madsen-Brooks dismisses this and other similar "proofs" of the presence of African American Confederates in "'I nevertheless am a historian': Digital Historical Practice and Malpractice around Black Confederate Soldiers," *Writing History in the Digital Age* (Spring 2012 version), http://writinghistory. trincoll.edu/crowdsourcing/madsen-brooks-2012-spring (accessed September 4, 2013).

7. *New York Times*, October 20, 1862.

8. For samples of this genre of writing, see James Marten, ed., *Lessons of War: The Civil War in Children's Magazines* (Wilmington, Del.: Scholarly Resources, 1999), 107–20.

9. T. C. Roche and H. T. Anthony, *How to Make Photographs: A Manual for Amateurs* (New York: Anthony, 1886).

Andrew J. Russell and the
Stone Wall at Fredericksburg

EARL J. HESS

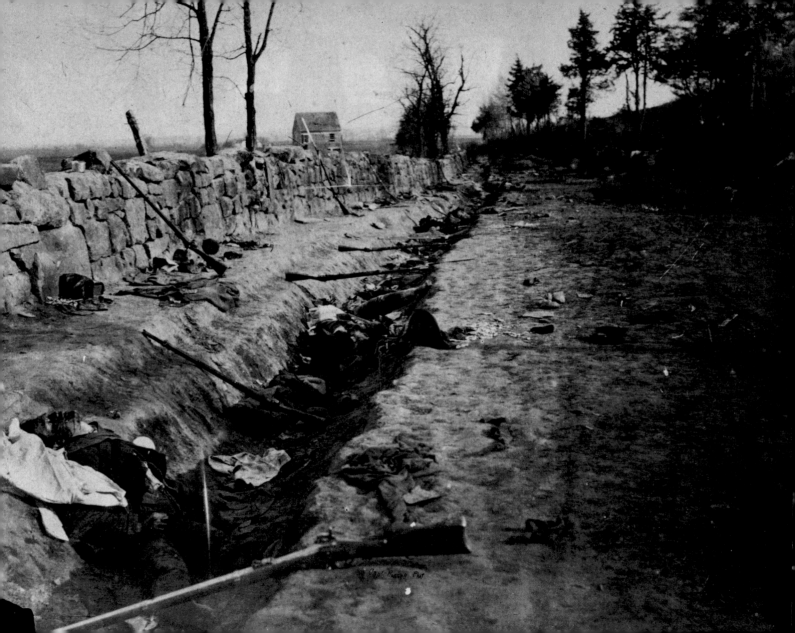

LESS THAN twenty-four hours after the fighting stopped, a photographer set up his equipment and exposed one of the most haunting photographs to emerge from the Civil War. It is a unique image. While most photographs of Civil War battlefields were taken one or two days after the fighting, this one was exposed literally within a handful of hours after the killing stopped. Moreover, the ground taken would be given up before the end of the day. The photographer captured a moment in the Battle of Chancellorsville, depicting one small part of the field after it was taken and before it was abandoned to the enemy.

This photograph can tell us a great deal about combat in the Civil War, but it warrants examination for what it hides as well as for what it shows. Aspects of terrain, the care of the wounded, and the experience of combat all are open to us if we take a technical approach to the photograph. The image is also open to a meta-material approach if we choose to adopt one.

The scene depicts the area just behind the stone retaining wall that shouldered the eastern side of a road running along the foot of Marye's Heights west of Fredericksburg, Virginia. This area had already seen a great battle only four and a half months before this photograph was exposed. On December 13, 1862,

Confederate soldiers crouching behind the wall had shot down thousands of attacking Union troops. The Federal effort in the battle of Fredericksburg had produced thirteen thousand casualties and no results remotely worth the human cost.

But that had been Major General Ambrose E. Burnside's effort. Replaced by Major General Joseph Hooker, the Union Army of the Potomac pursued a different plan in late April 1863. Hooker flanked the strong position on the heights west of Fredericksburg, held by General Robert E. Lee's Army of Northern Virginia, and crossed the Rappahannock and Rapidan Rivers well upstream of the city. Lee left Major General Jubal A. Early and part of his army to hold the heights and took the rest to battle Hooker near the crossroads known as Chancellorsville, about a dozen miles west of Fredericksburg.

Lee audaciously attacked on the evening of May 2, 1863. Under Lieutenant General Thomas J. "Stonewall" Jackson, the Confederates flanked Hooker's right and rolled it up before night put an end to the fighting. Darkness contributed to the accidental shooting of Jackson by his troops. But Lee continued the attacks early on the morning of May 3, resulting in a bruising fight around the crossroads as Union troops fought desperately to retain their position.

Receiving word of Hooker's plight, Major General John Sedgwick tried to provide support. Left in command of the Sixth Corps at Fredericksburg, Sedgwick decided to attack the heights and draw Confederate strength from Hooker. He might even be successful, in which case his men could advance west to Hooker's aid. Unlike December 13, the Confederates held the heights with a small force and were vulnerable.

Sedgwick advanced along the Plank Road, which led westward from Fredericksburg toward the high ground. He formed his right wing north of the road in a mix of columns and lines. His left wing, located south of the Plank Road, aimed directly at the northern stretch of the stone wall at the foot of Marye's Heights. The left wing consisted of a line of infantry composed of the Sixth Maine, Thirty-First New York, and the Twenty-Third Pennsylvania, with the Fifth Wisconsin ahead as skirmishers. The stone wall was then held by only eight companies of the Eighteenth Mississippi Infantry, reinforced by a few men of the Twenty-First Mississippi Infantry. The mismatch of strength boded well for the Federals— four regiments against a little more than one—but the ground to be covered was open.

When the Federals moved out that morning, the right wing suffered a good deal from artillery fire. The left wing, however, braved heavy musketry and surged ahead. It crested the stone wall, engaged in hand-to-hand combat with the Mississippians, and then drove the Confederates away by about 12:30 p.m. Sedgwick lost about 1,000 men in the attack. The Confederates suffered about 475 casualties, more than one-third of the number engaged. The blue-coated survivors of this encounter at the wall moved westward in pursuit of the Confederates as the entire heights fell into Union hands. Sedgwick moved his troops a few miles west before encountering a blocking force Lee had placed at Salem Church to keep the two Federal wings separated.

For the rest of May 3 and throughout the morning of May 4, the battlefield along the wall was silent but littered with the human and material debris of war. It was an opportunity too good for a photographic artist to pass up. Captain Andrew J. Russell, an avid artist and photographer, took advantage of it. Born in New York State on March 20, 1829, he had grown up in Nunda and developed an interest in landscape painting. One of his efforts turned up at an art gallery in upstate New York in 1996. Titled *View of Bath NY from the West*, Russell had painted it for Robert Van Valkenburg in October 1859. Another Russell painting appeared in 2000. Titled *Cayuga Lake from Pumkin Hill, 1856*, it depicted the town of Aurora, New York. There is a naïveté to the landscapes that is appealing. But Russell also became interested in photography. In fact, he used photographs as an aid to his paintings, working up the canvas image based on photographs that he took. Russell also moved to New York City to pursue his interest further by working in a studio.

The war interrupted Russell's career. At first he painted a diorama about the issues of the day to inspire support for the Union cause. But Russell waited until Abraham Lincoln's call for three hundred thousand more troops in the summer of 1862 before enlisting. In fact, he organized a company that became part of the 141st New York Infantry and served as its captain. In March 1863, Russell was detached for special duty with the U.S. Military Railroad as a photographer. His

job was primarily to document the work of Union logistics officers by exposing images of the facilities they built and used. He worked directly under the famous railroad man Herman Haupt.

As a necessary part of his work, Russell obtained an eleven-by-fourteen-inch camera and negative box from the firm of Philp and Solomon in Washington, D.C. The equipment arrived on March 25, 1863, in time for Russell to use it during the Chancellorsville Campaign. Taking the camera across the Rappahannock River on the morning of May 4, in company with his boss, Haupt, Russell began to explore the scene of battle. He found the stone wall, set up his camera, and exposed the view before moving on to take other photographs that afternoon.

What can we learn from this photograph? Be aware of the point made by Alan Trachtenberg in the journal *Representations* in 1985 that historic photographs can show us much, but what they *do not* show us can be just as important. Before we discuss what can be seen here, let us contemplate what is not depicted. First, there are no live men in the view. All the Union and Confederate soldiers who were capable of moving have already left by the time Russell reached this spot. This was mostly due to the fact that the tempo of the battle demanded rapid movement westward. There could be no dawdling to clean up the contested field at leisure. Long before the time Russell exposed his wet plate, the Federals who captured the stone wall had moved closer to Salem Church.

Also, there are no wounded men in this photograph. They were taken off the field very quickly, compared to many other Civil War battles. There typically were three or four times as many men wounded in combat as killed, so one can assume that dozens of wounded soldiers littered the ground within the space now covered by Russell's viewfinder. Enough time has elapsed for helping hands to get all the wounded away, Union and Confederate alike. But one can detect evidence of that process. Look closely at the top of the stone wall and you can see a tin cup. It is highly unlikely that cup was on the wall during the battle. It must have been used by an uninjured man to offer water to a wounded soldier, and then placed on top of the wall for convenience, only to be forgotten.

What *does* the photograph show us? Our first interest is the depiction of battlefield death. Altogether, about a hundred photographs were exposed on Civil War battlefields to depict the dead. The majority of those photographs were exposed on fields in the East, with only a handful in the West. Also, there is much evidence of manipulation by photographers. Some of them asked living soldiers to fake the dead by lying down and pretending to be killed. It is relatively easy to detect this, for these men were not bloated or bloody.

Russell certainly was not guilty of this fakery. The bodies here are not bloated because he came upon them before the natural process of decay had brought forth that kind of evidence. At least one of the bodies seen here is quite bloody. It all looks starkly real.

But Russell probably was guilty of another kind of fakery widely practiced by Civil War photographers— arranging the décor of the battlefield. Other cameramen placed abandoned muskets in graceful lines to compose the image (making an interesting visual contrast of linearity compared to the crumpled remains of

humans). There are simply too many muskets in this view that seem to be neatly laid across the ditch or leaning up against the stone wall to be circumstantial. Russell probably did it out of a sense of trying to make an interesting or ordered scene. Everything else seems to be scattered about in the photograph, giving the appearance of happenstance, of having been dropped while the owners were preoccupied with other, more important things, and left where they fell. Only the muskets seem to be part of an attempt to arrange the décor of the view.

The dead bodies also seem to be lying in situ, no attempt to rearrange them for effect. One can enlarge the photograph on the computer screen and see much more than is readily apparent to the eye. There are at least four bodies in the photograph. Interestingly they all lie within or just outside the drainage ditch skirting the eastern edge of the road.

The first body, in the left foreground, is the most visible and the most saddening. Despite Russell's formal caption for the photograph, this fallen soldier might have been a Federal rather than a Confederate, given the dark hue of the uniform. He lies on his back in the ditch; in fact, the upper body lies outside the ditch. His eyes are open and his face is covered with blood. The lower part of his body is crumpled badly inside the ditch. Blood seems also to stain his clothes. He paid the ultimate price of his exposure to combat and might well have suffered a good deal before dying.

At first glance it is not easy to see the other bodies, but the second one is discernible upon enlargement. He appears to be a Mississippian, for a hat lies near him. Federal soldiers in the East tended to wear kepis (and there is one lying several feet away in the roadbed),

while Confederates more often wore wide-brimmed hats. Whether U.S. or C.S., this soldier lies more peacefully, with no apparent bloodstains or evidence of trauma. What looks like the swollen leg of a man is just behind him. I have always been bothered by the sight of this leg; it looks almost inhuman, like a leg of meat in a butcher's window. Enlargement fails to enlighten me as to what exactly it is. If truly the leg of a man, I wonder if he suffered horribly before dying.

In the third cluster within the ditch, one can see the form of at least one dead body with enlargement of the image. But the rest is not easily identifiable. The fourth body is different from the previous three. It is quite some distance from Russell's spot, and one can see it more clearly upon enlargement. The body is stiffly laid out, with arms crossed, and mostly lying outside the ditch toward the heights. It is possible loving hands laid out this man, some friend or relative serving in his regiment. Whether he was a Union or Confederate soldier is impossible to say.

There is much more than four bodies lying in the ditch.

Clearly discernible upon enlargement is a cartridge box. A bayonet is stuck into the ground next to the second body (the one that probably is a Confederate soldier). It is not attached to a musket. There are many blankets and a bayonet scabbard. And there are the rifle muskets lying across the ditch.

Much material also lies between the ditch and the stone wall. Before noticing it, we should consider the wall itself. It was made of fairly large stones, neatly fitted together, even though a few of the stones have fallen down. After all, the Federals in effect scaled the wall or

jumped over it during their assault. Note also the wall would go up to about a man's waist, providing a good shelter for troops to repel an assault upon the foot of Marye's Heights. Russell's view looks south; there is a two-story house in the distance, outside the wall.

Among the items lying near the wall, there is a knapsack, blankets, canteens. One can see what appears to be a large book or newspaper, though it may be a white cotton haversack. The inevitable rifle-muskets, carefully stacked to lean against the stones, are there too.

This photograph has always impressed me. Not only does it reveal a great deal about combat, but it has two fascinating features that provoke a different kind of examination. There are two unexplained streaks of brilliant light in the view. One appears vertically in the left foreground. In fact, it crosses the leg of the first body, the one with the bloody face and the upward stare. The other is less obviously visible, but upon enlargement you can see that it is a complex bit of light in the midground of the image and centered against the stone wall. This second image has a long horizontal line, and five shorter lines emanating from the center of that horizontal line.

How does one explain these two instances of brilliant light? If you want to think technically, you can dismiss them as the sun glinting off the burnished steel of the many muskets that lay about. But I have never seen lights like these in other Civil War battlefield photographs, no matter how many muskets lay about.

If we forget the technical and consider the sublime, we can recall the long tradition of belief in spirit photographs that has been part of the history of photography ever since the technology was invented nearly two hundred years ago. The idea is that the souls of the departed can manifest in photographs as points or streaks of light, and sometimes with lights appearing as shapes roughly resembling human form. In addition, the trauma of World War I produced a good deal of speculation on the particular aspects of battlefield death. The idea here is that, dying violently, the souls of departed soldiers often linger at the scene in a confused state before moving on. The twentieth century is filled with literature on this subject.

Both lights in Russell's photograph are intense. The vertical streak in the foreground has its lower end close to a musket, but near the musket the light is less intense, which would be unlikely if it was glinting from the gun itself. The more elaborate one in the midground has no connection to any musket, and it shoots off in different directions. The lights do not appear to have been superimposed by the photographer as an afterthought, and they do not seem to be clearly caused by something that is material within the view of Russell's camera. If one saw this sort of phenomenon in many other Civil War photographs, it would be easy enough to dismiss it as possibly caused by the camera lens. But these emanations of light remain an intriguing source of thought and wonder to me.

SOURCES

Boylan, Grace Duffie. *Thy Son Liveth: Messages from a Soldier to His Mother.* Boston: Little, Brown, 1919.

Finger Lakes Artists. "Alfred J. Russell." www.jsuttongallery.com/artists-pages/andrew-j-russell, accessed May 4, 2013.

Haupt, Herman. *Reminiscences of General Herman Haupt.* Milwaukee, Wis.: Wright and Joys, 1901.

Hess, Earl J. "A Terrible Fascination: The Portrayal of Combat in the Civil War Media." In *An Uncommon Time: The Civil War and the Northern Home Front*, edited by Paul A. Cimbala and Randall M. Miller, 1–26. New York: Fordham University Press, 2002.

Martin, Joel, and Patricia Romanowski. *Love beyond Life: The Healing Power of After-Death Communications.* New York: Dell, 1997.

Sears, Stephen W. *Chancellorsville.* Boston: Houghton Mifflin, 1996.

Trachtenberg, Alan. "Albums of War: On Reading Civil War Photographs." *Representations* 9 (Winter 1985): 1–32.

Williams, Susan E. "'Richmond Again Taken': Reappraising the Brady Legend through Photographs by Andrew J. Russell." *Virginia Magazine of History and Biography* 110 (2002): 437–60.

Earl J. Hess

"A Harvest of Death"

Negative by Timothy O'Sullivan, Positive by Alexander Gardner

STEPHEN CUSHMAN

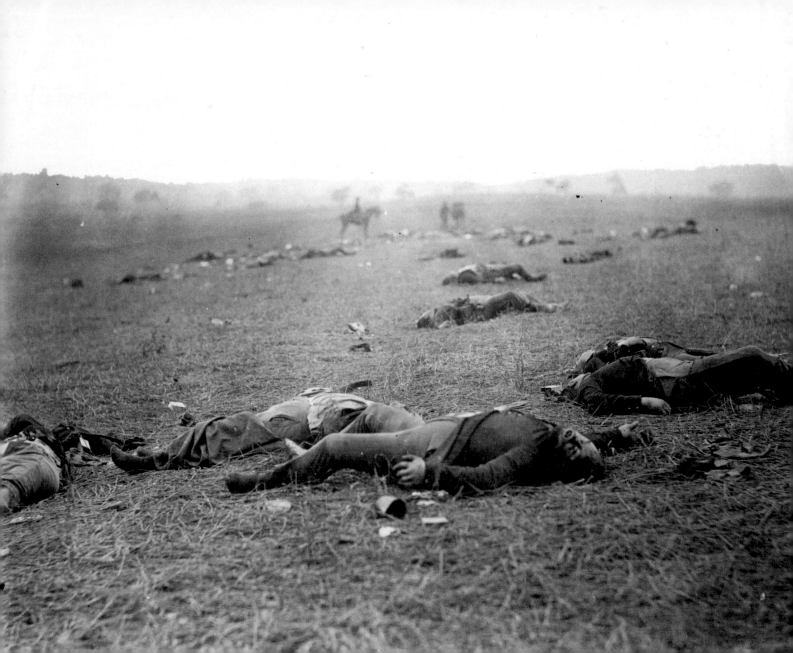

Mortua quin etiam iungebat corpora vivis
componens manibusque manibus atque oribus ora,
tormenti genus, et sanie taboque fluentis
complexu in misero longa sic morte necabat.

Indeed, he even yoked dead bodies to the living,
Putting together hands with hands and mouths with mouths,
A kind of torture, running with both corrupted blood and putrid matter,
He thus killed with a long death in a wretched embrace.

—VIRGIL, *Aeneid* 8:485–88

———— ◆ ————

Devilish! WHAT BETTER WORD to describe the macabre sadism of King Mezentius, who tortured the living by binding them to the dead, as recounted with horror to Aeneas by old King Evander? But the word is not Evander's; it is Alexander Gardner's, and it appears, italicized, in the moralizing caption that accompanies this famous photograph in his *Photographic Sketch Book of the War* (1865–66).[1] Taken at Gettysburg by Timothy H. O'Sullivan on July 5, 1863, and developed by Gardner, the photograph, according to the tireless detective work and "considered guess" of William A. Frassanito, shows the bodies of U.S. soldiers from the Third Corps, "situated somewhere in the open fields on the southern extreme of the field, near the Rose farm and close to the Emmitsburg Road."[2] Gardner's caption

belongs to the ancient rhetorical convention *ekphrasis*, a verbal mode of describing visual images, often works of art, in extensive detail, one that includes Virgil's description of the shield of Aeneas, made for him by Vulcan, and Virgil's much earlier model, Homer's description in the *Iliad* of the shield of Achilles, forged for him by Hephaestos. Gardner may or may not have been thinking specifically of these classical precursors, but the full sentence, which opens the second paragraph of his caption, shows clearly that he had both description and the ancient world in mind: "A battle has been often the subject of elaborate description; but it can be described in one simple word, *devilish!* and the distorted dead recall the ancient legends of men torn in pieces by the savage wantonness of fiends."

In this sentence Gardner worked to frame O'Sullivan's image of five shoeless corpses in the foreground, four of them supine and the fifth lying on its right side, against the overlapping backdrops of epic and the supernatural. But there are other words for the cartoonish minstrelsy of the fattened lips of the foremost corpse, caught in the midst of rounding to chant an exaggerated OM, words less sensational, less moralizing: "If the process continues unabated, all of the features described continue in their scourge of the corpse such that, when fully developed into a state of severe decomposition, the

169

body will be extremely bloated (having the appearance of someone who is morbidly obese), the skin will be dark brown/green and greasy with skin slippage and blister formation, and there will be abundant purge fluid At this stage, the eyes are frequently bulging out of their sockets, the lips are swollen and bulging, and the tongue is often protruding from the mouth."[3] In their respective ways, Gardner's *Sketch Book* and a contemporary textbook in forensic pathology, from which this passage is taken, both represent commercial ventures. In their respective ways, Gardner's *Sketch Book* and the textbook can fascinate and repel the uninitiated layperson simultaneously, whether or not that layperson has seen a battlefield in the days following a battle or has visited a so-called body farm such as the University of Tennessee Anthropological Research Facility, established to study human decomposition in various settings, a few miles from downtown Knoxville.

But though the forensic textbook, abundantly illustrated, may grip attention and stir response in the uninitiated, while it also earns money for author and publisher, its primary aims are not to stimulate and to satisfy an appetite for images of corpses. When he arrived in Gettysburg, with O'Sullivan and James F. Gibson two days after the end of the battle, these were Gardner's primary aims, aims encouraged by the success of the photographs of the dead at Sharpsburg-Antietam in September 1862, taken by Gardner and Gibson, and exhibited the next month at Mathew Brady's gallery in New York. Someone going into that exhibit, "The Dead of Antietam," in October 1862 would have been looking at photographs of, as Frassanito has put it, "the first battlefield in American history to be covered by cameramen before the dead had been buried."[4] Face-to-face with the photographs on Brady's walls, that 1862 visitor could not have known many of the later images now housed in the visual archive of my mind's eye, among the most compelling of which are the black-and-white pictures of prone bodies half-buried in sand at the waterline of a Normandy beach. Nevertheless, that 1862 viewer and I share something crucial: for him or for her, the photographs of bodies made at the Dunker Church or along the Hagerstown Pike had the power of priority. They were the first such photographs he or she had ever seen, and the same is true of me, six years old during the centennial of Sharpsburg-Antietam, turning the pages of the recently published *American Heritage Picture History of the Civil War* (1960).[5] For both of us, the sight of these photographs precipitated something like a fall from naïve ignorance into troubling knowledge, from innocence into experience, and neither of us would find the world the same.

A fall is a fall, and there can be a self-absorbed myopia in claiming that one's own tumble is longer or more dramatic than anyone else's. But unlike some of the first viewers of "The Dead of Antietam," or many of their contemporaries throughout North America, my six-year-old self had had no experience of seeing dead bodies laid out at home, thanks to twentieth-century mortuary practices that whisked the dead away to funeral homes for timely embalming or cremation, or of seeing them photographed according to the aesthetic conventions of nineteenth-century postmortem photography. For me it was not simply a matter of seeing the first dead soldiers I had ever seen; it was one of seeing my first human dead at all.

Stephen Cushman

When and where I first saw "A Harvest of Death" I cannot remember. It does not appear in the *American Heritage Picture History*; the dead of Gettysburg are represented there only by Gardner's famous Devil's Den sharpshooter (titled in the *Sketch Book* "The Home of a Rebel Sharpshooter, Gettysburg") and O'Sullivan's photograph of Confederate bodies gathered, according to Frassanito, at the southwestern edge of the Rose Woods and mistakenly identified in the *American Heritage Picture History*, and many other places, as members of the Twenty-Fourth Michigan Infantry, Iron Brigade, Army of the Potomac.[6] If Frassanito's considered guess is correct, then the dead Confederates photographed by O'Sullivan at the edge of the Rose Woods lay in approximately the same part of the Gettysburg battlefield as the soldiers he photographed in "A Harvest of Death," which may not have been my first look at dead bodies but was my first look, or certainly my fullest one, at something else. And notwithstanding all the photographs of human wreckage from other wars I have seen since, it remains, for me, the most harrowing image of that something else.

When Gardner set out for Gettysburg, he set out to photograph dead bodies because "The Dead of Antietam" had been such a success. Fair enough. This entrepreneurial undertaking may strike some as little more than war profiteering of an uncomfortably predatory kind, but it takes two to make a profit, and we cannot censure Gardner for the desires of his audience. Forty-five years after Gettysburg, the narrator of E. M. Forster's *Room with a View* (1908) commented wryly, with reference to the eagerness of the fictional Reverend Eager for details of a murder in Florence, on "the ghoulish fashion in which respectable people will nibble after

blood."[7] It is for each member of Gardner's audience to decide whether or not Forster's satire includes him or her. More to the point here is the recognition that one can photograph dead bodies in many ways, and one can photograph many kinds of dead bodies. In "A Harvest of Death"—one could be justified in conjecturing that this is the reason the editors of the *American Heritage Picture History* omitted the photograph—O'Sullivan and Gardner crossed a line. Theirs is not simply a photograph of dead bodies; it is a photograph of a decomposing body, well along in the process.

Photographs of dead soldiers on Civil War battlefields blend two pictorial genres that originate with painting: landscape and portraiture. Both Gardner's "Home of a Rebel Sharpshooter, Gettysburg" and O'Sullivan's "A Harvest of Death" draw on the conventions of these two genres. But there the similarity ends. In the case of "Rebel Sharpshooter," with the body and other items shamelessly rearranged, as Frassanito has shown, the representation of the handsome young man, who in death appears to have fallen asleep, repeated familiar aspects of many peaceful, attractive images of the dead found in contemporary postmortem photographs.[8] "A Harvest of Death" did not. It put on display—more relentlessly than any other photograph in "The Dead of Antietam" or in the *Sketch Book* or among images made by Nicholas Brown at Battery Robinett, Corinth, Mississippi on October 4, 1862, or by Gardner and O'Sullivan at Spotsylvania on May 20, 1864, or by Thomas Roche at Petersburg on April 3, 1865—the effects of decomposition described in the textbook on forensic pathology.[9]

"Death is the mother of beauty," intones Wallace Stevens's 1915 poem "Sunday Morning," by which he

could have meant several things, among them that mortality is what causes human beings to produce beauty, for example, in the form of art, or that mortality is the necessary condition for human recognition and appreciation of beauty because beauty depends on transience and if we did not die, our experience of things that please us most deeply would not be transient, nor would the things themselves, should they happen to be other living beings, who do not return like sunsets or seasons.[10] In the case of photographic images of Civil War dead, beauty is complicated and difficult. Certainly, Gardner achieved a kind of beauty in "The Home of a Rebel Sharpshooter, Gettysburg," even if his accompanying caption pushes the image toward sentimentality and even if the fakery behind the photography raises disconcerting questions about whether journalistic documentation should be fraternizing with artistic manipulation. In the case of photographs not so immediately soothing or reassuring, such as those made at Sharpsburg-Antietam along the Hagerstown Pike, beauty may reside for some beholders in the contrasting textures of their black-and-white color blindness, or in the formal composition that uses a fence and a wheel-rutted road to establish visual axes that frame the bodies, or in larger contexts of narratives about self-sacrifice and heroism. But if there is anything beautiful in O'Sullivan's composition about decomposition, and maybe some will find it in the background that stretches away into the blurred indistinctness of trees on the horizon behind a mounted figure, perhaps an officer in charge of the burial party who doubles as War or Death, horsemen of the Apocalypse, it does not reside in the bloated body, face, and lips of the figure in the foreground.

Death may be the mother of beauty, but decomposition is the mother of disgust and revulsion. No matter how completely one may accept the fact of one's own mortality or that of a loved one, it is a rare person who can accept with equanimity the image of oneself or that loved one as an oozing pile of meat left to rot in the sun. My literal version of Virgil's word *taboque* in the epigraph above renders it as "and putrid matter," but other translators of his Latin have opted for such alternatives as "putrefaction," "poison," "gore and slime."[11] None of these options captures, however, the immediate, palpable specifics. Neither does O'Sullivan's black-and-white image, which gives us the uncanniness of a world from which all color has leached, as it masks repulsive odors and mutes the crazed sound track of thousands of flies seeing to bodies in sultry July. Not even the forensic pathology textbook offers up these details; they must be, and for many viewers will be, supplied by the imagination.

Beyond disgust and revulsion lies the stuff of deep taboo. Ever since *Homo neanderthalensis* first began to bury the dead, at least one hundred thousand years ago and perhaps as many as three hundred thousand, the timely disposal of dead bodies has figured prominently in behavior that links preserving the health of the living to the origins of religious ritual. The withholding of that timely disposal, either deliberately or unavoidably, is an abomination and the plot engine that drives many of our oldest stories. In Sophocles's *Antigone* (probably first performed around 441 or 442 B.C.E.), for example, Antigone is determined to bury the body of her brother Polyneices, also a casualty of civil war, rather than leave it on the battlefield as carrion for scavengers. As she

defiantly declares to Creon, in Elizabeth Wyckoff's translation, "But if I left that corpse, my mother's son, / dead and unburied I'd have cause to grieve / as now I grieve not."[12] Before and after *Antigone*, Homer's and Virgil's epics included encounters with shades in the underworld who have left behind them unburied or unburned bodies in the world above and who petition for quick righting of this primal wrong.

Traveling north on the Emmitsburg Road, Gardner, O'Sullivan, and Gibson came upon bodies that would be buried soon, but in choosing to photograph the decomposing soldier from the angle they used, in effect they denied him burial, keeping him forever above ground. Even more devilishly, like King Mezentius, who is eventually killed by Aeneas, Gardner has bound us to this unburied, decomposing soldier for as long as copies of the photograph exist and as long as there are people to look at it. Not only the object of his photograph is *devilish!*; so is the photograph itself, which manages to knot a forceful appeal to unseemly nibbling after ghoulish sensations with a kind of ongoing visual torment, *tormenti genus*, in Virgil's phrasing. The photograph traffics in taboo and the forbidden, and as Freud's theory of jokes would have it, taboo and the forbidden lie at the root of our joking. Consider a moment early in Tony Horwitz's *Confederates in the Attic* (1998), when the oddly talented reenactor Robert Lee Hodge is called on to "do the bloat": "Hodge clutched his stomach and crumpled to the ground. His belly swelled grotesquely, his hands curled, his cheeks puffed out, his mouth contorted in a rictus of pain and astonishment. It was a flawless counterfeit of the bloated corpses photographed at Antietam and Gettysburg that I'd so often stared at as a child."[13]

A flawless counterfeit? Probably not, unless Hodge's talents encompass the faking of skin color and texture, not to mention the purging of fluids, detailed by the forensic pathology textbook; not unless he also has mastered the imitation of smell. That Hodge, like Horwitz, is knowingly treading on taboo and the forbidden becomes immediately clear with the punch line that follows in the next two sentences: "Hodge lept to his feet and smiled. 'It's an ice-breaker at parties,' he said." The incongruity here invites the relief of a chuckle or laugh, a wry nod to black humor. It is a clever narrative moment, as Horwitz uses Hodge's icebreaker to break the ice with his own readers at the outset, to set the tone for handling difficult material with a light touch.

But a question raised by Hodge's counterfeiting of photographic counterfeiting of bodies of soldiers killed in combat is profound and, for some, troubling: When is it not all right to make an image of something? The question cuts to the heart of debates about pornography, whether sexual or violent; it underlies Plato's expulsion of poets from his ideal republic for making imitations of immoral actions; and it hovers over the foundations of monotheistic religions that emerged in the eastern Mediterranean observing the second commandment of Exodus 20:4, rendered by King James's translators as "Thou shalt not make unto thee any graven image, or any likeness of any thing that is in heaven above, or that is in the earth beneath, or that is in the water under the earth."

In a democracy, however imperfect, ethical imperatives implied by debates about pornography or Plato's *Republic* or the second commandment must accommodate ethical imperatives about freedom of information

and citizens' rights, even duties, to know the truth, or some version of the truth, especially when it comes to voting in elections that will affect the making of war. Although he did not justify the making of "A Harvest of Death" explicitly in these terms, Gardner closed his caption for the photograph with statements underlining what he understood to be the ethics behind it: "Such a picture conveys a useful moral: It shows the blank horror and reality of war, in opposition to its pageantry. Here are the dreadful details! Let them aid in preventing such another calamity falling upon the nation." With this final paragraph, Gardner commended the photograph as a cautionary tale, a kind of visual prophylaxis against future rippings of the social fabric.

All kinds of cynical responses can bubble up at this moment, beginning with those pointing out that this piece of moral edification would cost someone buying it in 1865 or 1866 the tidy sum of $150. Then there is the whole matter of Gardner's identification of the dead soldiers as "rebels," when in fact they are U.S. soldiers, subsequently presented, as Frassanito has shown, from another angle, "roughly 135° clockwise," in the very next plate, titled "Field where General Reynolds Fell. Battle-Field of Gettysburg."[14] In the caption to this plate, number 37, Gardner identified the soldiers as "our own men" and transformed the majority of them from devilish monsters of decomposition to "those who wore a calm and resigned expression, as though they had passed away in the act of prayer." The caption continues in this reassuring vein: "Others had a smile on their faces, and looked as if they were in the act of speaking. Some lay stretched on their backs, as if friendly hands had prepared them for burial. . . . The faces of all were pale, as though cut in marble, and as the wind swept across the battle-field it waved the hair, and gave the bodies such an appearance of life that a spectator could hardly help thinking they were about to rise to continue the fight." Instead of a photograph that denies the dead burial and binds us to decomposing corpses, suddenly we have one, thanks to a new placement of the camera, that would have them all but buried respectfully were it not for the fact that they are really not so dead after all, their bodies continuing to exhibit "such an appearance of life," like many subjects of postmortem photography.

Here is counterfeiting, not in the sense of copying, but in the sense of defrauding, as the counterfeiter hopes to pass off sham currency as real. Here is another sham, like the Devil's Den sharpshooter, another instance of flagrant manipulation that belies Gardner's straight-faced, sanctimonious assertion on the first page of the *Sketch Book*: "Verbal representations of such places, or scenes, may or may not have the merit of accuracy; but photographic presentments of them will be accepted by posterity with an undoubting faith." In light of his shamming, one wonders whether Gardner had just finished talking with P. T. Barnum as he winked at the "undoubting faith" of posterity.

But is the fakery in Gardner's captions for "A Harvest of Death" and "Field where General Reynolds Fell" the same as that in "The Home of a Rebel Sharpshooter, Gettysburg"? For one thing the deceptions of the former are verbal, whereas those of the latter are visual. Moving the camera 135 degrees clockwise from one angle to another is not the same thing as moving a body forty yards to a new location. In the moment of moving the camera, there was not necessarily an intention

to deceive, as there most certainly was in the moment of moving the body. The deception came two years later with the writing of the caption, and as even Frassanito has conceded, it "may have been a lapse of memory on Gardner's part."[15] After taking and developing so many hundreds of photographs over several years, is it not possible that Gardner had failed to note, and subsequently forgotten, the relationship of the two photographs? Despite his concession to this possibility, Frassanito has added his opinion that the explanation is unlikely ("More likely it was deliberate"), and he may well be correct.

Even if he is right, however, "A Harvest of Death" remains unshakably true in at least one way, one that a sentence in Gardner's caption glosses accurately: here are the dreadful details. Whether the corpse in the foreground was that of a Confederate or U.S. soldier, O'Sullivan and Gardner made a black-and-white image of what decomposition looked like under the conditions of July 1863 in southern Pennsylvania. They may have chosen an angle from which to photograph; they may have been at the mercy of the conditions of sunlight and humidity, which affected the image produced. But there are no telltale signs of human manipulation. The bodies in the photograph have not been gathered in neat rows, like those of Confederates at the southwestern edge of Rose Woods or in front of Battery Robinett in Corinth, Mississippi; there is no sign of any of Gardner's signature props, such as the rifle he placed in other photographs. The shadowy horseman in the distance suggests the presence of authority that would not have looked kindly on civilians carrying the bodies to new locations. With the best technology available to them at the time, O'Sullivan and Gardner made an image that still stands behind everything I hear or see or read or learn about the Civil War. This is a picture of what lies at the end of the chain of links that begin with competing interests, reflected in divisive, intransigent politics, and continue through propaganda, jingoism, saber rattling, brinkmanship, mobilization, deployment, maneuver, and engagement. This is the endpoint, the omega, mostly unspoken and unseen. Because of my own commitment to the study of words, their histories, their uses, their artful arrangements, I am not comfortable with the tired old saw "One picture is worth a thousand words," to which I always want to respond, "It depends on whose picture and whose words." But in the case of "A Harvest of Death," in its relation to the billions of words written by participants in and narrators of the Civil War, I know one picture can haunt them all.

1. Alexander Gardner, *Gardner's Photographic Sketch Book of the Civil War* (New York: Dover, 1959), plate 36; originally published as *Gardner's Photographic Sketch Book of the War*, 2 vols. (Washington, D.C.: Philp and Solomons, 1865–66) in two editions, the first in 1865, the second in 1866. The Dover edition has this photograph on its cover.

2. William A. Frassanito, *Gettysburg: A Journey in Time* (New York: Scribner's Sons, 1975), 226.

3. Joseph Prahlow, *Forensic Pathology for Police, Death Investigators, Attorneys, and Forensic Scientists* (New York: Humana Press, 2010), 170–71.

4. William A. Frassanito, *Antietam: The Photographic Legacy of America's Bloodiest Day* (New York: Scribner's Sons, 1978), 17.

5. Editors of *American Heritage, The American Heritage Picture History of the Civil War* (Garden City, N.Y.: Doubleday [for American Heritage Publishing], 1960). The photographs from the Dunker Church and Hagerstown Pike appear on 208 and 231 respectively, those from Gettysburg, referred to subsequently, on 333 and 338.

6. Frassanito, *Gettysburg*, 203–4.

7. E. M. Forster, *Room with a View* (1908; reprint, New York: Vintage, n.d.), 60.

8. "The Home of a Rebel Sharpshooter, Gettysburg" is plate 41 in Gardner's *Sketch Book*. For Gardner's manipulation of the soldier's body, see Frassanito, *Gettysburg*, 186–92. For examples of postmortem photography, see Stanley B. Burns, *Sleeping Beauty: Memorial Photography in America* (Altadena, Calif.: Twelvetrees Press, 1990); Jay Rubin, *Secure the Shadow: Death and Photography in America* (Cambridge, Mass.: MIT Press, 1995); and Stanley B. Burns, *Sleeping Beauty II: Grief, Bereavement, and the Family in Memorial Photography, American and European Traditions* (New York: Burns Archive Press, 2002). Ric Burns's documentary film *Death and the Civil War* (2012), which is based on Drew Gilpin Faust's book *This Republic of Suffering: Death and the American Civil War* (New York: Knopf, 2008), contrasts examples of postmortem photography with photographs of Civil War dead.

9. For photographs taken at Spotsylvania and Petersburg, see William A. Frassanito, *Grant and Lee: The Virginia Campaigns, 1864–1865* (New York: Scribner's Sons, 1983), 109–12, 345–64. For Nicholas Brown's photographs of Confederate dead at Battery Robinett, see the Library of Congress Web site http://www.loc.gov/pictures/search/?q=dead%20corinth%20mississippi (accessed July 18, 2013). I am grateful to Gary Gallagher for calling my attention to Brown's photographs.

10. Wallace Stevens, "Sunday Morning," *Collected Poems of Wallace Stevens* (New York: Knopf, 1974), 66–70.

11. These translations come, respectively, from C. Day Lewis, *The Aeneid of Virgil* (Oxford: Oxford University Press, 1952); Allen Mandelbaum, *The Aeneid of Virgil* (Berkeley: University of California Press, 1971); Robert Fitzgerald, *Virgil's Aeneid* (New York: Random House, 1983).

12. David Greene and Richmond Lattimore, *Greek Tragedies*, vol. 1 (Chicago: University of Chicago Press, 1960), 196.

13. Tony Horwitz, *Confederates in the Attic* (1998; reprint, New York: Vintage, 1999), 7–8.

14. Frassanito, *Gettysburg*, 222.

15. Ibid., 228.

Stephen Cushman

Colonel William P. Rogers and His Comrades

Postmortem at Corinth, Mississippi, October 1862

T. MICHAEL PARRISH

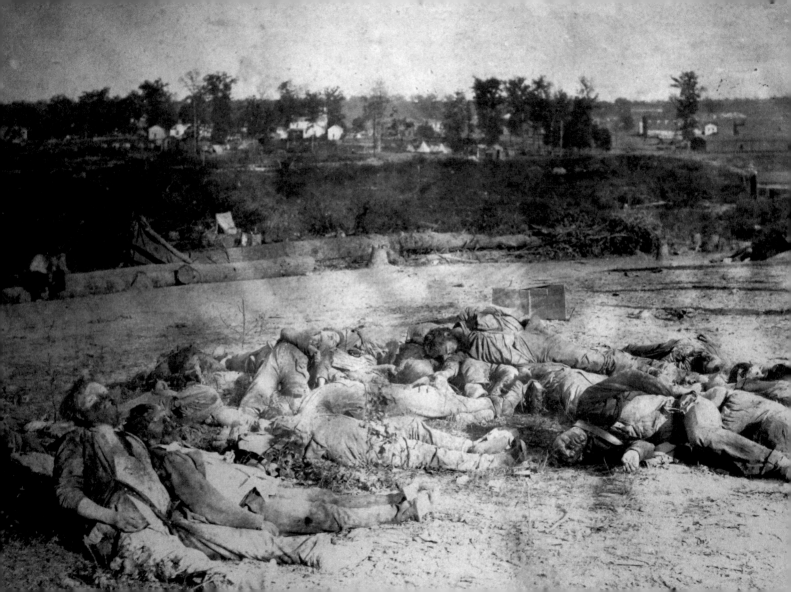

ONE OF THE grisliest photographs of the Civil War depicts Colonel William P. Rogers, commander of the Second Texas Infantry, along with a dozen or so fellow Confederates, dead on the field after the Battle of Corinth, Mississippi, in October 1862. Other than the famous death portrait of another Confederate hero, Brigadier General Turner Ashby, it is the only photograph showing a dead Civil War soldier who is actually identified, and it is only one of three showing dead soldiers in the Western Theater. I display a slide in my Civil War and Texas history classes at Baylor, as well as in frequent public presentations, in order to emphasize the brutality and human cost of the war, especially to the Confederacy, which lost disproportionate numbers of talented field officers like Rogers and simply could not replace them. My audiences are always rather stunned, at least momentarily, at seeing it.

I first encountered the image when I was a boy. It jolted me at the time, and it has haunted me ever since. Reproduced sharply and dramatically in Francis Trevelyan Miller's ten-volume masterpiece, *The Photographic History of the Civil War*, the picture bears a brief caption: "Before the Sod Hit Them."[1] The caption's crassness made the scene all the more disturbing to me. It shows a bearded Colonel Rogers in the foreground at left, his head and shoulders propped against a tree stump, his face appearing sad and tortured, and his eyes wide open, unfocused, and staring upward. His uniform, except for the trousers, had been stripped off by Yankee soldiers, who also looted his pistol, sword, belt, and boots. Shirtless, he wore long underwear unbuttoned down the front, exposing his chest and abdomen well below the waist, almost to the crotch. The other dead Confederates sprawling nearby received similarly crude treatment. In the background the little town of Corinth, seemingly peaceful, presented a stark contrast to the picture's raw carnage.

The image was almost certainly made by George Washington Armstead (1835–1912), a photographer from Columbus, Ohio.[2] Operating with partners under various business names (including Armstead & White and Armstead & Taylor), Armstead established a studio at Corinth in northeastern Mississippi after Union forces besieged and occupied the town during the spring of 1862. The two-day Battle of Corinth, October 3–4, 1862, culminated a futile and costly effort by Major General Earl Van Dorn's Confederate army to recapture Corinth from Major General William S. Rosecrans's Federal occupation troops. A vital railroad crossroads, Corinth was also a key to the Union's grand strategy: to push farther south, capture Vicksburg, and take control of the Mississippi River Valley.[3]

Armstead probably made the photograph on October 5, the day after the battle, taking advantage of the plentiful light of a bright midday sun. Like other Civil War battlefield photographers, he arranged the various corpses to achieve dramatic effect, positioning Colonel Rogers's body in the foreground next to another officer, whose identity remains unknown. The picture was actually the third in a trio made by Armstead. The first showed an unidentified dead Confederate in the foreground and allegedly Rogers's rather indistinct body near his horse, both lying in the background near Battery Robinett, one of several small earthen fortifications ringing the outskirts of Corinth. The second photograph, which is extremely rare, was a variant of the image of Rogers and his dead comrades. Armstead clearly made the second picture before the well-known third one. In the second, Rogers's torso was exposed even more immodestly, his right hand lay behind his back, and the left arm of the man on the far right concealed his face. At left in the near background, several local boys, gawking and even smiling at the spectacle, managed to squeeze into the scene, apparently with Armstead's approval. In contrast to the second picture, the third showed Rogers's underwear pulled up to make his torso less visible, his right hand rested on his thigh, and the arm of the man on the far right was pulled back to reveal his face. As a result, the third picture was the best composed of the three and was the one most widely reproduced.

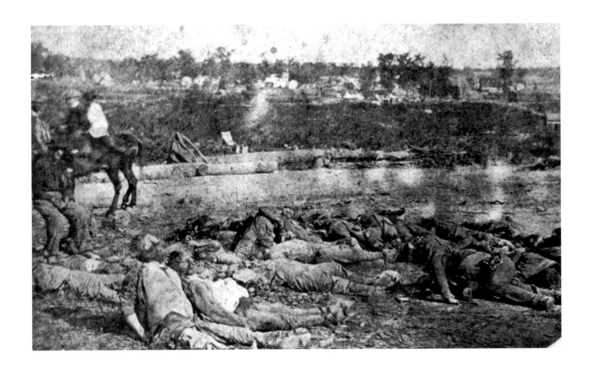

T. Michael Parrish

Armstead enjoyed a profitable business at Corinth for about a year and a half during 1862 and 1863, producing countless four-by-two-and-a-half-inch carte de visite portraits (paper photographs mounted on card stock) of Union soldiers. Occasionally, however, he produced larger, outdoor scenes, including the one of Colonel Rogers and his dead comrades. Miller's *Photographic History* praised Armstead for his remarkable skill: "George Armstead was a wonderful photographer, rivaling Brady at his best." Miller also featured a picture of the "Armstead & White Photograph Gallery." But Miller did not attribute the image of Rogers and his dead comrades to a particular photographer.[4] Most scholars of Civil War photography since, however, have cited Nicholas Brown of St. Louis as the photographer, probably because Brown made and sold second-generation copies, including cartes de visite, but he did not give Armstead credit.[5] Obviously, Brown could not have traveled the more than three hundred miles from St. Louis to Corinth quickly enough to make the photographs himself; the decomposing corpses would have been buried long before his arrival. Armstead's original image of the famous picture, a paper "salt print" from a glass negative, measuring six by eight inches and mounted on stiff paperboard, survives in copies owned by several institutions, including the Alabama Department of Archives and History and the Mississippi Department of Archives and History (MDAH). The MDAH copy is in an oval frame and features an elaborate decorative border that pays homage to Colonel Rogers and the Lost Cause. Another copy, at the San Francisco Museum of Modern Art, specifies George Armstead as the photographer.

The Confederacy could not afford to lose effective officers like William Peleg Rogers. Born in Georgia in 1819, he grew up in Mississippi and studied medicine and law. In 1840 he married Martha Halbert of Tuscaloosa, Alabama, and practiced law in Aberdeen, Mississippi. During the Mexican-American War, he commanded a company in Colonel Jefferson Davis's First Mississippi Regiment. In the early 1850s, Rogers moved his family to Texas, where he became a prominent attorney at Washington-on-the-Brazos in Washington County, one of the wealthiest slaveholding cotton-growing areas in the entire South. From 1857 to 1859, he taught in the Law Department at Baylor University at nearby Independence. All of Rogers's six children eventually became Baylor graduates. Rogers had brought his family to Texas in part to be near his favorite first cousin, Margaret Lea Houston, the wife of Sam Houston, who was then a U.S. senator. Rogers soon became a close friend of Senator Houston and served as his personal attorney. Originally a Whig and strong Unionist, Rogers became a proslavery Democrat and secessionist after moving to Houston in 1859. Sam Houston, a diehard Unionist and governor of Texas, disagreed passionately with Rogers. Elected a delegate from Harris County to the Texas secession convention in Austin in early 1861, Rogers served on the committee that informed Governor Houston that he would be removed from office unless he supported Texas's secession and accepted Confederate authority. Houston refused defiantly and was ousted from office.[6]

Early in the war, Rogers was commissioned a lieutenant colonel and made second in command of Colonel John C. Moore's Second Texas Infantry. The regiment

first saw combat at Shiloh in April 1862.[7] "The gallantry of our regiment is spoken of by all," Rogers wrote to his wife: "The last charge on Sunday evening and two on Monday were truly grand. These I led in person, on Monday carrying our battle flag." Promoted to colonel and given command of the regiment, Rogers referred to the Second Texas as the "Star Reg[iment] of the army of the West." A fervent believer in the Confederate cause, Rogers wrote to a friend that "duty to my oppressed and bleeding country is superior to the claims of wife and children, for it is for their sakes, for the peace and quiet of my own home as well as others that I am here."[8]

Rogers and his regiment joined Major General Earl Van Dorn's attempt during the autumn of 1862 to dislodge William Rosecrans's occupation force from Corinth. There on October 3, the first day of the battle, Rogers led the Second Texas as part of Brigadier General John C. Moore's brigade (Major General Dabney H. Maury's division, Major General Sterling Price's corps). Carrying out Van Dorn's orders to advance aggressively, Rogers seemed almost eager for extreme peril by leading several charges against entrenched troops.[9]

The next day Rogers led the Second Texas, together with a large detachment from the Forty-Second Alabama, in another series of assaults against the enemy's heavy artillery and infantry barricaded behind Battery Robinett. "We were met by a perfect storm of grape, canister, cannon balls, and minie balls," wrote one of Rogers's men. "Oh, God! I have never seen the like! The men fell like grass."[10] Another recounted, "Colonel Rogers, unsheathing his sword, cried 'Forward Texans!'"[11] The regiment responded, met heavy resistance, fell back, and charged again. Faltering yet again, the men saw a wounded color bearer drop the regimental flag. Rogers reached down from his horse, picked up the flag, and ordered another charge. Attaining the deep ditch in front of Battery Robinett, he rode directly into the ditch, dismounted, and led the men up the steep embankment. "They never halted," observed a Union soldier facing the onslaught. "Rogers, with a flag in one hand and a revolver in the other, led them straight into one of the awful death-traps of the war. Hundreds of them crossed the ditch, climbed into the fort, and their muskets clubbed the men at the [artillery] guns."[12] A Confederate recalled, "I heard the shout of 'Victory! Victory!' and I thought we had won the day."[13] Suddenly Union reinforcements arrived and fired a heavy volley into the Rebels. Colonel Rogers shouted, "Men, save yourselves or sell your lives as dearly as possible!"[14] According to a soldier with him, Rogers "in defiance hurled his empty revolver at the foe." Then a flurry of musketry riddled his body, killing him instantly. "Oh, we were butchered like dogs," lamented a fortunate survivor.[15]

Van Dorn's army had failed badly. The Second Texas lost more than half its men in casualties. Union soldiers quickly looted Rogers's body, and later they probably helped George Armstead move it to the spot where he made his famous photograph. "I saw the body of Rogers, the bravest of the brave, lying there," a Yankee soldier noted. "He was in his white-stocking feet. Some vandal had robbed him of his boots. He lay on his back, his face to the foe."[16] Later, a woman from Corinth, Sarah Cave Carter, having already attended to many of the wounded, turned her attention to Rogers's body. Gently taking her handkerchief, she wiped the blood from his mouth and covered his face with the handkerchief.[17]

In an act of simple respect, a Federal officer placed Rogers's body under a shade tree and covered it with an overcoat. Surveying the battle's aftermath, General Rosecrans asked to see Rogers's body. "He was one of the bravest men that ever led a charge," remarked Rosecrans. "Bury him with military honors and mark his grave, so his friends can claim him."[18] Such a burial of an enemy soldier was usually reserved for general officers only. Nearly two years later his family was still mourning for him. "Even the dearest consolation of religion did not, for a time, give comfort to our grief-stricken hearts," his wife Martha admitted to a friend. "But how kind and merciful is our Heavenly Father."[19]

True to Rosecrans's order, William P. Rogers's grave was located near the spot where he fell. Rather than claiming his body, Rogers's family allowed it to remain interred at Corinth as a parcel of sacred ground for battlefield visitors paying homage to the Lost Cause. For fifty years, it was cared for by local residents and the United Daughters of the Confederacy (UDC). In 1912, the UDC placed a tall white marble obelisk monument over the grave site. Several of Rogers's descendants attended the dedication ceremony. A great-grandson, young John Austin Sanders, saluted the monument with a sword that had once belonged to Rogers.[20] Words spoken on that occasion echoed the tribute by Earl Van Dorn in his official report of the battle in 1862: "The name of Rogers will be revered and honored among men. He fell in the front of battle, and died beneath the colors of his regiment, in the very center of the enemy's stronghold. [There] he sleeps, and glory is his sentinel."[21]

After the war George W. Armstead returned to Columbus, Ohio, and continued in business as a photographer. He and his wife, Charlotte, had twelve children. In the early 1880s his eyesight began to fail, and in 1885 he relocated his family to Nebraska to help several of his sons secure homesteads. In North Bend, Nebraska, he established another photography studio, "Armstead & Son." Completely blind by the 1890s, he turned the business over to two sons. When Armstead died in 1912, his obituary noted that he was survived by his wife, nine children, twenty-three grandchildren, and a great-grandchild. "He was the soul of good cheer despite his affliction, and his ready laugh and smile were always inspirations," stated the obituary. "His simple, upright life left its impress upon the community in which he lived so long."[22]

NOTES

1. Francis Trevelyan Miller, ed., *The Photographic History of the Civil War*, 10 vols. (New York: Review of Reviews, 1911), 2:145.

2. Floyd Rinhart and Marion Rinhart, *The American Daguerreotype* (Athens: University of Georgia Press, 1981), 380. See also the brief entry on Armstead in John S. Craig, "Craig's Daguerreian Registry: The Acknowledged Resource on American Photographers, 1839–1860," http://craigcamera.com/dag/a_table.htm.

3. The best study of the Battle of Corinth is Timothy B. Smith, *Corinth 1862: Siege, Battle, Occupation* (Lawrence: University Press of Kansas, 2012); see also Peter Cozzens, *The Darkest Days of the War: The Battles of Iuka and Corinth* (Chapel Hill: University of North Carolina Press, 1997), and Steven Nathaniel Dossman, *Campaign for Corinth: Blood in Mississippi* (Abilene, Tex.: McWhiney Foundation Press, 2006).

4. Miller, *Photographic History*, 2:151.

5. For example, see Bob Zeller, *The Blue and Gray in Black and White: A History of Civil War Photography* (Westport, Conn.: Praeger, 2005), 86–87.

6. T. Michael Parrish, "Rogers, William Peleg," in *Handbook of Texas Online* (published by the Texas State Historical Association), http://www.tshaonline.org/handbook/online/articles/fro64, accessed September 2, 2013.

7. See Joseph E. Chance, *The Second Texas Infantry: From Shiloh to Vicksburg* (Austin, Tex.: Eakin, 1984).

8. Eleanor Damon Pace, ed., "The Diary and Letters of William P. Rogers, 1846–1862," *Southwestern Historical Quarterly* 32 (April 1929): 287–94.

9. Cozzens, *Darkest Days of the War*, chap. 20.

10. Oscar L. Jackson, *The Colonel's Diary* (N.p., 1922), 71.

11. J. L. Mayo, "Col. William P. Rogers," *Confederate Veteran* 4 (February 1896): 57–58.

12. Samuel H. M. Byers, "How Men Feel in Battle," *American History Illustrated* 22 (April 1987): 13.

13. J. A. McKinstry, "With Col. Rogers When He Fell," *Confederate Veteran* 4 (July 1896): 220–22.

14. "Monument to Colonel Rogers," *Confederate Veteran* 21 (March 1913): 102.

15. Jackson, *Colonel's Diary*, 86–87.

16. Byers, "How Men Feel in Battle," 14.

17. Mrs. Don Watkins, "Sisters Search Battlefield after Bloody Conflict," in *The Civil War and the Battles of Corinth and Shiloh* (Corinth, Miss.: Daily Corinthian, Special Civil War Centennial Souvenir Edition, 1961), 5–6.

18. John Crane to Mr. Brownson, November 27, 1906, quoted in Lizzie George Henderson, "United Daughters of the Confederacy," *Confederate Veteran* 15 (June 1907): 245–46.

19. Thomas Jewett Goree, *The Thomas Jewett Goree Letters*, ed. Langston James Goree (Bryan, Tex.: Family History Foundation, 1981), 221.

20. "Monument to Colonel Rogers," 102.

21. U.S. War Department, *The War of the Rebellion: A Compilation of the Official Records of the Union and Confederate Armies*, 127 vols., index, and atlas (Washington, D.C.: GPO, 1880–1901), ser. 1, vol. 17, pt. 1, 381.

22. Angie Millar, "George W. Armstead's Obituary: G. W. Armstead Answers the Last Call," http://boards.ancestrylibrary.com/localities.northam.usa.states.nebraska.counties.dodge/402/mb.ashx (requires a membership).

T. Michael Parrish

"Eye of History"

Looking at Civil War Prisoners of War

JUDITH A. GIESBERG

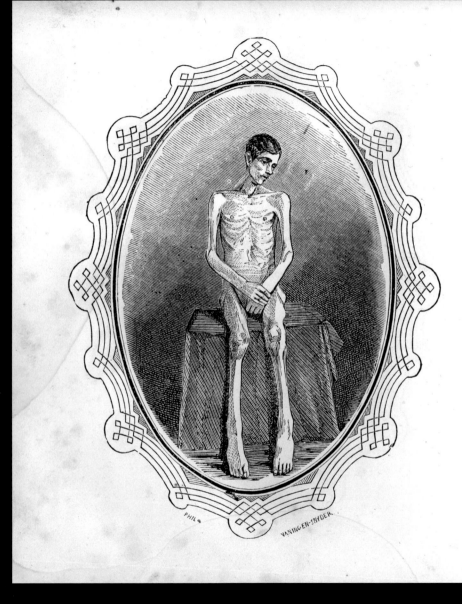

"Private John Q. Rose, Company C, 8th Kentucky Volunteers. Admitted per Steamer New York, from Richmond, Va., May 2, 1864. Died May 4, 1864, from the effects of treatment while in the hands of the enemy." Report of the Joint Committee on the Conduct of the War, Washington, May 5, 1864.

ON JUNE 18, 1864, the two most popular illustrated weeklies published images on their front covers that they hoped would shock their readers. Just released from Belle Isle Prison in Richmond, Virginia, and under treatment at a Baltimore hospital, the POWs were skeletal, their tortured bodies and haunted faces damning evidence of what the papers called "rebel atrocities." Unable to stand or to hold up their heads, the naked men sat slumped in chairs or propped up by pillows and stared with vacant eyes. *Harper's Weekly* pictured two POWs on its cover, one man sitting alone, covering his midsection with his hands and averting his gaze, and another, covered partly by a sheet, gently supported and tended to by a physician. *Frank Leslie's Illustrated Newspaper* devoted the entire front page to the story, publishing images of eight men, some who had already died by the time the paper was published and others who were undergoing treatment. For readers who knew the men—or who thought they might have—*Frank Leslie's* decision to include the names and regiments of the men, alongside their pictures, must have served as a shock. But even for readers for whom the men were strangers, the names and regiments worked against the urge to dismiss the images as fake, a newspaper trick. Seeing the men in person, Walt Whitman found it hard to believe. "Can these be men," he asked, "these little, livid brown, ash-streaked, monkey-looking dwarfs? Are they really not mummied, dwindled corpses?"[1]

I use POW images in my Civil War class to talk about the turn to hard war and to explain the consequences of a broken prisoner-exchange cartel. Snapshots of men so consumed by war relieve students of the notion of a "brothers' war" in which everyone knew the rules and played by them. I came across the complete set of these images in 2006 while I was researching an article on Benjamin Butler. Besides the friends and relatives of the men portrayed, perhaps no one was more disturbed by the POW pictures than Benjamin Butler. In 1863–65, Butler had served as commissioner of prisoner exchanges.[2] Overseeing the exchange of prisoners during the critical years when conditions at Southern POW camps deteriorated rapidly and overcrowding became epidemic, Butler was unable to effect a system of regular prisoner exchanges, and the Massachusetts general remained deeply sensitive to critics who held *him* responsible for allowing soldiers to starve to death.[3] Butler must have winced when he came across the June 18 copy of *Harper's Weekly*. Once published, it must have been hard for Butler—or anyone—to avoid seeing the images.

While the images are familiar enough to Civil War historians, they struck me with renewed force in the aftermath of the 2004 release of pictures documenting the

abuse of prisoners at Abu Ghraib prison in Iraq. With the digital pictures still on my mind, I stopped short when I came across the Belle Isle prisoner illustrations. The Abu Ghraib photographs first appeared on the Internet, and then they, too, seemed to be everywhere, daring us to look. There are many obvious and very important differences between these two sets of photographs and the experiences of looking at them, and I hope I will make these clear. But for just a moment, I wanted to think about what it meant for Civil War Americans to see *their* pictures—or more accurately, what it meant for them to look. Did it, as the papers hoped, confirm readers' opinions of Southerners as morally bereft slaveholders, so inured to the human suffering that surrounded them that they would intentionally starve U.S. soldiers to death? Did looking at the images make readers angry, and did they demand retaliation? Or did looking make readers wonder what the war had become? Did they assign responsibility for the suffering at Andersonville, Belle Isle, and Salisbury to the Union's policy of hard war, which in 1863 ended prisoner exchanges in order to deplete the Confederate ranks and to drive the enemy to desperation? Author Susan Sontag worried and wrote about wars and photographs for years, and inspired by her book titled *Regarding the Pain of Others*, which was published just before the Abu Ghraib revelations, this essay asks, "Why look?"

War photography was a new phenomenon during the U.S. Civil War. Sontag characterized the effort as "[t]he first full-scale attempt to document a war."[4] New as it was, by 1864 *Harper's* and *Leslie's* readers had some exposure to war photography. Photographer Alexander Gardner usually photographed conventional subjects, such as officers, soldiers, and military camps.[5] When Gardner exhibited a series of Antietam photographs in Mathew Brady's New York gallery in October 1862, Americans were exposed, for the first time, to pictures of corpses. Defending himself from critics who found the images shocking, Brady is supposed to have said, "The camera is the eye of history." Brady insisted that he and his photographers were merely recording what they saw. The quip might have been apocryphal, for we know that some of the pictures were staged—like "Home of Rebel Sharpshooter, Gettysburg," for instance, which portrays a dead Confederate soldier who was moved so that his corpse was artfully framed by a semicircle of boulders. The scene was completed when Gardner propped a rifle against the rocks, as if the dead man had left it there himself.

From the beginning, then, Civil War cameras were more than simply the "eye(s) of history"—photographers saw themselves as part of that history. Alexander Gardner and Brady's other photographers followed careful rules in photographing the conflict. Usually the dead were Confederates, and the bodies were most often intact. In keeping with the aesthetics of images like "Rebel Sharpshooter," photographs portrayed battlefield death gracefully rather than focus on bodies that showed obvious signs of injury (there were notable exceptions to this general rule). The message was that death was natural—injury, unnatural. Anticipating the temperament of his yet-untried audience, Brady "obscured the place of violence in history" and hid "the physical events of war that transform life into death."[6] Sparing his audience from the more gruesome scenes of war, Brady wanted his photographs to draw in onlookers,

and apparently they did. Despite his critics, New Yorkers flocked to the exhibit, hoping to take a look for themselves.[7] Commenting on the realism of Brady's photographs, one author insisted that Brady had "brought bodies and laid them in our door-yards and along the streets." He worried that someone might recognize a loved one among the dead, "a husband, son, or brother in the still, lifeless lines of the bodies, that lie ready for the gaping trenches."[8] Battlefield photographs offered a vivid and disturbing, though largely anonymous, look at the war's dead, one with which Americans had little experience and that ensured the photographs' significance in shaping the experience of war.

Daily newspapers and illustrated weeklies like *Harpers'* and *Frank Leslie's* did not yet have the technology to reproduce photographs, so images were reproduced as wood engravings. Through this medium, more Americans could get a closer look than those who might have attended Brady's studio. Most sketches reproduced photographs of traditional battlefield scenes—wrecked train tracks, ships engaged in battle, or soldiers convalescing in hospitals. Prisoner-of-war camps were also portrayed in magazine sketches, but the viewer was kept at a safe distance from the subjects, who were always dressed and often in the process of being exchanged, as in a December 5, 1863, *Harper's Weekly* sketch of prisoners from Belle Isle. The June 1864 POW images, on the other hand, were intimate, personal portraits of men. They represented a clear editorial departure.

The June POW story came to the papers by way of Secretary of War Edwin M. Stanton and Senate Republicans, who hoped it would shore up public support for the war. The original photographs resulted from an investigation conducted by the Joint Committee on the Conduct of the War (JCCW). In May 1864, in response to a request from Stanton, the JCCW visited army hospitals in Annapolis and Baltimore, where they interviewed and photographed POWs as part of their investigation. In their interviews, senators heard stories of men lying uncovered on the cold ground, suffering from smallpox and dysentery, with little or no food to eat and only their threadbare army uniforms to protect them. The chair of the committee, Senator Benjamin F. Wade of Ohio, explained the decision to photograph the men in this way: "Your committee, finding it impossible to describe in words the deplorable condition of these returned prisoners, have caused photographs to be taken of a number of them, [so] that their exact condition may be known."[9]

The committee prepared a report that combined the results of their investigation of POW abuse with their investigation of Confederate atrocities at Fort Pillow, Tennessee, scene of a notorious massacre on April 12, 1864, when black soldiers attempting to surrender were killed by Confederate troops. The Senate printed sixty thousand copies of the report, complete with photographs, in hopes that it would deliver a one-two punch to Northern war fatigue and stir up public anger against war critics and Southern sympathizers. *Harper's* and *Frank Leslie's* obliged, quickly turning the report into front-page news. "We hope not to be told that such pictures will make children shudder," *Harper's* warned its readers, continuing, "for we should certainly be amazed if they did not. Such pictures are for parents to ponder. This is the spirit which inspires the rebellion."[10] *Frank Leslie's* called the pictures "irrefragable proof of rebel

cruelties."[11] "Is it possible to conceive of demons exceeding the treatment which could reduce able, healthy men to such a frightful state?" *Leslie's* asked its readers, and answered, "And yet the authors of these barbarities have ever on their lips professions of piety and religion."

A recent study found that in four years of Civil War, 409,608 soldiers became prisoners of war, and many of them did not survive. Of 194,743 Yankees confined in Confederate prisons, 30,218 (15.5 percent) died. And of 214,865 Rebels who were incarcerated in Union camps, 25,976 (12.1 percent) did not survive. In all, 56,194 men died in captivity.[12] Neither army prepared for the responsibility of caring for POWs, and the result was that camps in both the North and the South earned their contemporary reputations as "death camps." Unable—or unwilling—to care adequately for the men in their camps, the two armies agreed to an exchange cartel in the summer of 1862, relieving pressure on both sides. But this relief proved transient, for by the next summer, Stanton began modifying the agreement, and the Confederate army refused to accept his terms. The cartel in default, prisons began to fill up quickly. Early in 1864, hundreds of prisoners were dying each day in overcrowded Union and Confederate prisons. By August 1864, the situation had become so desperate in the South that Jefferson Davis accepted Stanton's cartel revisions, but U. S. Grant stepped in to stop the resumption of prisoner exchanges. Prison commanders faced shortages of all sorts, many of them pleading with their superiors for relief. And the dying continued.

And the dissembling began immediately. The Union published "official histories" of their prisons, portraying the institutions as efficient and humane. Postwar Americans faced difficult questions coming to terms with these deaths, and the problem was complicated by a steady stream of strident and accusatory survivor memoirs, published first by Union veterans and then by Confederates. Long after other veterans had let go of their animosity for one another and clasped hands over the famous stone wall at Gettysburg, authors of prisoner memoirs continued to attack their former captors as inhumane. The earliest Confederate prisoner memoirs helped build the foundation for the Lost Cause memory of the Civil War.

Recently, historians who have not had to compete with memoirists have been more willing to spread the blame around. These works generally conclude that both armies were guilty of deliberately mistreating prisoners.[13] Presenting evidence of deliberate neglect high up the chain of command, recent studies can leave us with the sinking suspicion that the execution of Captain Henry Wirz for the abuse of Union POWs at Andersonville was part of a U.S. Army cover-up, one that we continue to be willingly deceived by today.

Frederick Law Olmsted, the general secretary of the U.S. Sanitary Commission, for one, was not so easily duped. In response to rumors of poor conditions in Union camps in the winter of 1863, Olmsted ordered a thorough inspection, the results of which proved to be damning. The army moved quickly to control the damage. Colonel William Hoffman, commissary general of prisoners, condemned the commission's report as unpatriotic and likely to give encouragement to our enemies. But the indefatigable Olmsted did not relent, defending

the report and insisting that the U.S. Army proceed "upon the ground that every rebel whose life is saved will increase the inducement presented to the rebel authorities to treat carefully all Union men who fall into their hands."[14] Abuse of POWS, Olmsted believed, cut both ways—a point reiterated more recently by former POW and presidential candidate John McCain in response to revelations of abuse at U.S. run prisons in Iraq.

But unlike McCain, Olmsted was not alone in refusing to give the Yankees a free pass to do with POWS what they might or in declining to lay the blame only at the feet of the Rebels. Indeed, *Harper's*—one of the two papers that helped to break the story of Rebel abuse—published a story seven months after the end of the war that made similar claims. Two weeks after Henry Wirz was executed—he was found guilty of "maliciously, willfully, and traitorously . . . combining, confederating and conspiring . . . to injure the health and destroy the lives of soldiers in the military service of the United States"—the paper appeared to offer an about-face. The author insisted that blame for prisoner brutality went further than Wirz. Pointedly, the author declined to implicate Jefferson Davis or any other high Confederate official for the parts they played in POW abuse, though there was much talk of putting Davis on trial at the very moment.[15] Instead, the author insisted it was the *nation's* fault that these prisoners were tortured and died. "The horrors of Andersonville were but the natural and inevitable result of the system of slavery which this country so long tolerated," the article concluded. "You can not deny natural rights to any man without becoming indifferent to those of every man. When man, under any circumstances, is systematically regarded and treated as a thing or a brute, the compensations of nature are so exquisite and perfect that humanity itself pays the penalty."[16]

What is particularly compelling here, it seems to me, is how the author scrupulously avoids placing blame on the usual suspects. He does not rail against slave owners, Confederate officers, or Southern civilians—all targets of extremely negative Northern popular sentiment at the time. He also carefully avoids the loaded antebellum language of sympathy—there is, for instance, no appeal to the long-suffering widows of dead soldiers.[17] Of sympathy, the late Susan Sontag said, "[S]o far as we feel sympathy, we feel we are not accomplices to what caused the suffering. Our sympathy proclaims our innocence as well as our impotence."[18] Here Sontag echoes the nineteenth-century newspaperman who, at the moment of the triumph of abolitionism, a movement built on the power of eliciting readers' sympathies, condemned those who would blame Confederates alone for the torture of POWS—or in more recent parlance, Abu Ghraib was the result of "a few bad apples." The reporter dismissed sympathy and condemned racism, referring to it as "the unclean devil which tortures this country." "[T]here will be no national health," he explained, "until it is utterly cast out."

What, it seems to me, *Harper's Weekly* was saying to its readers, more than a year after the magazine published startling and disturbing pictures of POW's, was look again—or perhaps, look differently. Let me explain. As long as looking at photographs of atrocities serves to reinforce the distance between *them* and *us*—that is, *them*, or those whom we choose to blame for the atrocities,

and *us*, or those whom we like to think of as bystanders, witnesses only—looking at these photographs seems to serve little purpose beyond confirming what we already know. Looking at photographs of atrocities in this way does not instruct, as Mathew Brady intended when he called his camera "the eye of history." Release of the images might have encouraged more people to look—though perhaps not to learn. A month after *Harper's* and *Frank Leslie's* published images of Union prisoners, for instance, an entrepreneur in Elmira, New York, site of a new and expansive Northern prison, opened an observatory offering townspeople the opportunity to "get a good peep at the rebel prisoners."[19] Months before the release of the Abu Ghraib pictures, Susan Sontag dared us to look, or more precisely, to look harder. "To set aside the sympathy we extend to others beset by war and murderous politics for a reflection on how our privileges are located on the same map of suffering," Sontag wrote in 2003, "is a task for which the painful, stirring images supply only an initial spark."

The images of prisoners from Belle Isle still speak to us—they *connect* us to those Civil War Americans who shook their heads and clenched their fists. Today, we shake our heads at the treatment of Americans in the hands of our enemies—and we wince when we see photos of Americans abusing our enemies. But these images also *separate* us from Americans 150 years ago. The original Civil War POW photographs were carefully staged, with the subjects sitting on pedestals, covered by sheets to protect their modesty—a pose borrowed from classical art, perhaps—the figures framed by an oval frame, similar to likenesses of loved ones sitting on a mantel in a Victorian home. The effect was to domesticate a distant scene of suffering that Civil War Americans could not understand—to *bring it home*.

The Abu Ghraib photographs were framed instead by celebration, thumbs-ups, high-fives, and other things that made it feel like we were already there. Ripped from the pages of "Girls Gone Wild" or a YouTube frat party video—on May 3, 2004, Rush Limbaugh compared the images to those from a "frat party," as kids "blow[ing] off some steam"—the Abu Ghraib photos seemed familiar. Looking at recent POW pictures reminds us of how close we are to the scenes depicted. How we, too, countenance a racism that can make some see in hard war merely a college prank. Pressed to make a statement, President Bush said on May 6, 2004, that he was "sorry for the humiliation suffered by the Iraqi prisoners," but, he added, he was "equally sorry that people seeing these pictures didn't understand the true nature and heart of America."

The caveat to his apology echoed claims made about the Belle Isle images, only in reverse. The skeletal survivors of the Confederacy's prisons, Senate investigators had insisted, revealed the Rebels' true nature. Neither of these claims is correct, of course, but there is some truth in both. Both claim and disclaimer remind us that we continue to assign great power to pictures, as eyes of history, perhaps, or as being worth a thousand words. Although pictures help us to remember, when we privilege photographs over other forms of remembering then perhaps we don't understand as much as we think. Looking at the photograph turned lithograph of Private John Q. Rose's wasted body, two days before his death, does not tell us as much about the experience of Civil War prisoners as reading the released prisoners'

testimonies, and it offers no window into the soul of the Southern slaveholder. Neither does the iconic Abu Ghraib image of the hooded man on the box, with outstretched arms (attached to wires), reveal an intimate map of American attitudes toward the Iraq war or their opinion of Iraqis. Instead, these photographs of individuals consumed by war "haunt us."[20] They follow us around, daring us to look and making it nearly impossible not to—to think about our privileges and where to locate them on the map of suffering that is war.

NOTES

1. Walter Lowenfels, ed., *Walt Whitman's Civil War* (New York: Knopf, 1961), 216.

2. Both Secretary of War Edwin M. Stanton and General Ulysses S. Grant strongly resisted returning Confederate POWs who would be conscripted into the Confederate army. Butler's Confederate counterpart was not authorized to deal with Butler because President Jefferson Davis had put a reward on Butler's head in response, in part, to the Federal general's General Order No. 28, issued while he commanded in New Orleans in 1862 (the order stated that Confederate women who mistreated or insulted United States soldiers would be treated as prostitutes). For an excellent discussion of this POW controversy, see Charles W. Sanders Jr., *While in the Hands of the Enemy: Military Prisons of the Civil War* (Baton Rouge: Louisiana State University Press, 2005), chap. 8.

3. Sanders, *While in the Hands of the Enemy*, 161–275.

4. Susan Sontag, *Regarding the Pain of Others* (New York: Farrar, Straus and Giroux, 2003), 51. In an earlier work, Sontag wondered if the public outcry in response to "the photographs of ill-clad, skeletal prisoners" was in part "due to the very novelty, at that time, of seeing photographs" (*On Photography* [New York: St. Martin's, 1973], 17).

5. Or, more accurately, the two weeklies exposed readers to photographs taken by Alexander Gardner and Timothy O'Sullivan.

6. Timothy Sweet, *Traces of War: Poetry, Photography, and the Crisis of the Union* (Baltimore: Johns Hopkins University Press, 1990), 110.

7. "Brady's Photographs," *New York Times*, October 20, 1862.

8. Ibid.

9. U.S. Congress, Joint Committee on the Conduct of the War, *Returned Prisoners* (Washington, D.C.: By the Committee, 1864), 3–4. The committee heard testimony on May 6. Woodcuts of eight photographs accompanied the report, including one of John Q. Rose.

Returned Prisoners was bound together with the committee's more famous report on the massacre at Fort Pillow; each was paginated separately.

10. "Rebel Cruelty," *Harper's Weekly*, June 18, 1864, 387.

11. "Of the Rebels," *Frank Leslie's Illustrated Newspaper*, June 18, 1864, 199.

12. Sanders, *While in the Hands of the Enemy*, 2–3.

13. Ibid., 5.

14. Olmsted quoted in ibid., 176. For the USSC's involvement in the POW crisis, see Margaret Humphreys, *Marrow of Tragedy: The Health Crisis of the American Civil War* (Baltimore: Johns Hopkins University Press, 2013), 248–67.

15. Although Davis spent about two years in prison after the war, the U.S. government never brought him to trial.

16. "Henry Wirz," *Harper's Weekly*, November 25, 1865, 738–739.

17. In his own evasion of responsibility for the abuse of Union POWs, Benjamin Butler blamed all of these groups and dramatically appealed to Congress to arrange special pensions for widows of starved Union POWs.

18. Sontag, *Regarding the Pain of Others*, 102.

19. "The Rebel Prisoners from the Upper Observatory," *Elmira (New York) Daily Advertiser*, September 6, 1864. For a full discussion of the observatory that opened in July 1864, see Michael P. Gray, *The Business of Captivity: Elmira and Its Civil War Prison* (Kent, Ohio: Kent State University Press, 2001), 23–27. Within a few weeks, there were two such towers in Elmira, each offering tourists the chance to "peep." Between the two stands, local residents sold spectators lemonade, beer, and other refreshments (24).

20. Sontag, *Regarding the Pain of Others*, 89.

A Dead Horse

JAMES I. ROBERTSON JR.

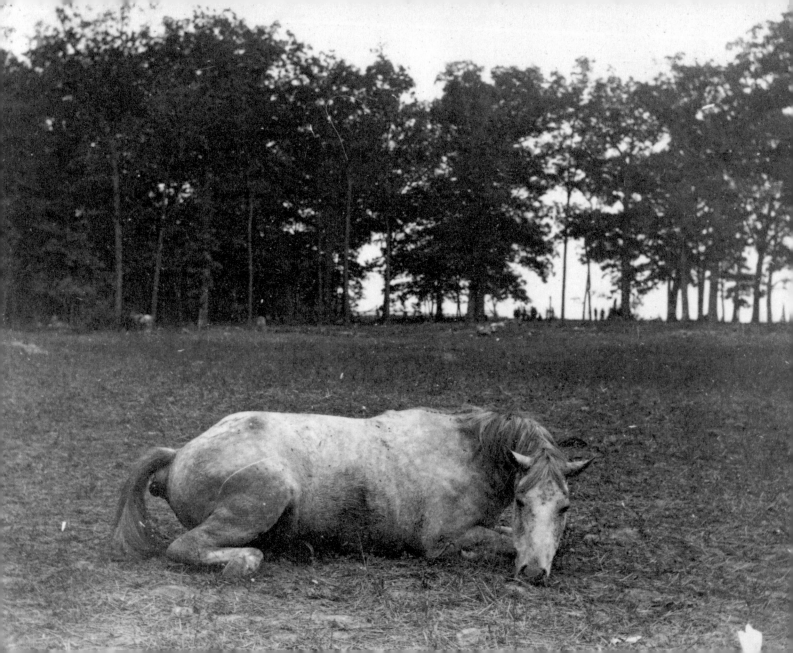

ONE WHO loves animals may want to bypass this chapter.

In my early career as a historian, I spent much time poring through picture files at such depositories as the National Archives, Library of Congress, Virginia Historical Society, and Museum of the Confederacy. Visual images (as modern-day PowerPoint attests) can provide a more realistic picture than the printed word.

All was going well and productively in my evolution as a researcher. Suddenly one day I stumbled upon a photograph of a dead horse all alone on a battlefield. It hit hard, for I freely confess that I have had a lifelong love affair with four-legged animals. The piteous spectacle of that horse provoked a number of thoughts: of innocent creatures caught in the crossfire of human destruction, how death in battle can be slow and cruel, whether the dying horse was looking for aid that never came, if anyone at the time paused to mourn its passing, what kind of burial—if any—the horse received.

A half century after discovering the photograph, the image and some of those initial thoughts still linger. Often, when Civil War history comes to mind, my first image is of that horse seemingly staring at me.

The basic facts behind the photograph are well documented. Its owner was Henry B. Strong. Born in Scotland around 1821, Strong immigrated to America and was working as a clerk in New Orleans when civil war began. On June 5, 1861, he entered Confederate service as a captain in the Sixth Louisiana Infantry. By the summer of 1862, Strong was colonel of the regiment. While not the most inspiring of officers, he was easily recognizable by his cream-colored stallion.

Wednesday, September 17, 1862, was the bloodiest day in American history. Two powerful armies fought viciously along the banks of Antietam Creek in western Maryland. When the thirteen hours of carnage began, the Sixth Louisiana and sister units of Brigadier General Harry T. Hays's brigade were posted behind the main line to the east of the Hagerstown Pike. Heavy waves of Federals soon fought their way through a cornfield on the Confederate left flank. Major General Thomas J. "Stonewall" Jackson ordered his second line forward to meet the threat.

The Louisiana brigade charged across David R. Miller's farm and collided with Brigadier General George L. Hartsuff's mostly Massachusetts brigade. Hartsuff fell seriously wounded; most of his six hundred casualties that day came in the morning fight.[1] However, a member of the Thirteenth Massachusetts Infantry boasted to his father, "I fired between forty and fifty rounds and had a good mark to aim at every time. I did not waste my ammunition, I can assure you."[2]

Henry Strong was killed in one of the first exchanges of gunfire. His horse, mortally wounded by the same blast, sank to the ground on all fours and turned his head as if falling asleep. The Confederates were forced back. A Louisiana comrade who sought to recover valuables from Strong's body was hit four times by bullets. Federals stripped the dying horse of its saddle and tack. The animal was ignored as battle raged until sundown brought an end to the slaughter. [3]

For at least two days the horse lay in a lifelike pose of helplessness. The unusual sight attracted attention. Union brigadier general Alpheus S. Williams wrote his daughters: "One beautiful milk-white animal had died in so graceful a position that I wished for its photograph. His legs were doubled under and its arched neck gracefully turned to one side, as if looking back to the ballhole in its side."[4]

Lieutenant Oliver Wendell Holmes Jr., a future Supreme Court justice, was among others struck with compassion by the sight of the dead animal.[5] On September 19, Alexander Gardner rode into the area. A Scottish immigrant, Gardner was then an assistant to pioneering photographer Mathew Brady. The energetic Gardner took some seventy pictures at Antietam. Most of them were of the battleground in the Dunker Church sector. One of the images was of the now-purging horse. Gardner likely made the photograph because of its unique nature. If so, such was a major misconception.

Without horses, no major battle could have occurred in the Civil War. That fact, overlooked by most historians, is incontestable. Horses and mules provided the bulk of transportation in the nineteenth century. Symbolically, the first casualty of the Civil War was a horse killed during the bombardment of Fort Sumter. Four-legged beasts pulled and carried armies that otherwise would have been stationary.

Naturally, cavalry would be nonexistent because of the absence of mounts. Each rider in the war needed three remounts yearly. Hence, demand was constant. A single six-gun artillery battery required seventy-two horses for full efficiency. Infantry was the main component of an army, yet it was inoperable without wagon trains. The Napoleonic standard at the time called for twelve wagons per one thousand men. Four horses lugged a wagon containing about 2,800 pounds of supplies. (A six-mule team was able to haul 4,000 pounds on good roads— but roads were seldom good.) At the time of Gettysburg, the Army of the Potomac was utilizing 4,000 wagons and 1,100 ambulances. Quartermaster Rufus Ingalls had the dauntless responsibility of obtaining and maintaining more than twenty thousand draft animals for that most famous campaign of the war.[6]

How far an army traveled, and what it accomplished on a march or in a battle, was contingent upon the presence and the quality of horses. Major General William T. Sherman was aware of that logistic. "Every opportunity at a halt during a march," he directed, "should be taken advantage of to cut grass, wheat, or oats and extraordinary care be taken of the horses upon which everything depends."[7]

Tragically, few participants in the Civil War possessed Sherman's incisiveness. The main reason may have been that just as we today take drinking water for granted anywhere, Civil War generations considered horses to be readily available. It certainly seemed that way at the outset of hostilities. In 1861 the North had 3.4 million horses; in the Confederacy were 1.7 million steeds.

This inventory was surely sufficient for the short contest everyone expected. Yet what followed were four years of marches, battles, deaths, sufferings, trials, and tribulations never envisioned. The most unimaginable hardships fell upon army horses and mules.

Most soldiers knew little about caring for mounts and draft animals. So they used them and abused them with pitiless disregard. They treated the animals as if they were at least indefatigable and at most indestructible. Long-distance movements in all kinds of weather wore down thousands of animals. In the Western Theater, horses traveled over nine states. One of Brigadier General John Hunt Morgan's cavalry raids involved horses pushed to cover 1,100 miles in less than a month. While cavalrymen could sleep in the saddle, their mounts were in continual motion.

An estimated 2.3 million horseshoes were annual necessities for every sixty thousand animals. Yet neither shoes nor farriers were always where they were needed. Lameness was epidemic.[8]

Sheer exhaustion overcame horses on prolonged movements. Brigadier General James H. Wilson recalled of the Union pursuit of John Bell Hood's Confederate army in December 1864: "It was cold and freezing during the nights, and followed by days of rain, snow, and thaw. The country . . . had been absolutely stripped of forage and provisions by the march of contending armies. . . . The poor cavalry horses faced still worse than their riders. Scarcely a withered corn blade could be found for them, and thousands, exhausted by overwork, famished with hunger, or crippled so that death was a mercy, with hoofs dropping off from frost and mud, fell by the roadside never to rise again."[9]

Worn-down animals in some cases were shot rather than allowed to recover and fall into enemy hands. Major General Philip H. Sheridan admitted after a retreat that he slaughtered five hundred of his mounts. The commander of the Confederate pursuit put the number at two thousand animals.[10]

The most constant problem faced by wartime horses was lack of water and food. Dehydration, malnutrition, and starvation were the most prevalent equine killers. Army regulations stipulated that each horse daily was to receive three pounds of oats and fourteen pounds of hay. Such standards were seldom met. One brigadier must have provoked laughter when he routinely asked for eight hundred thousand pounds of grain and hay *per day* for the horses in his command. Short rations were worse for the animals than for the soldiers. Indeed, in the later stages of the war, hungry men ate the corn allotted for starving horses. Finding sufficient forage was an almost hour-by-hour problem. Gathering food for man and beast was certainly a factor in Lee's 1863 decision to invade the North.

It was a crippled army that stopped the Confederate advance at Gettysburg. Federal horses had been without forage for three days. Several thousand of them collapsed and died in the Gettysburg–Frederick, Maryland, segment of Meade's postbattle movements. Ironically, the forage those animals so badly needed comprised a large percentage of the fifty-seven wagonloads of supplies that Lee took back to Virginia.

Insufficient attention was also paid to the content and quality of rations given the horses. When hay was not available, the horses would be fed only grain. Because horses are grazing animals, they require a considerable

amount of roughage in their diet. Lack of hay could lead to either of two deadly diseases: colic, a gastrointestinal infection usually fatal, and laminitis, an inflammatory foot condition that can be permanently crippling. Pasturage was a poor substitute for army rations. It has only a third of the nutritional value of oats and hay.[11]

Photographs of long wagon trains belie their contents. Many vehicles were carrying bales of hay and sacks of grain. As official campaign dispatches repeatedly made clear, never enough feed existed for dwindling numbers of animals still struggling to keep pace.

On July 2, 1863, at the climactic moments of both Vicksburg and Gettysburg, the Confederate Quartermaster Department announced that the sources for acquiring horses and mules were "well-nigh exhausted." A serious question now existed on "how the animals necessary for the future equipment of our armies in the field are to be obtained."[12] Within a year, Lee was eliminating artillery batteries because horses could not be found to pull the cannon and caissons. The retreat to Appomattox was a death march for both soldiers and animals. "The poor horses," a Richmond artillerist observed, "were giving out, and by the time Amelia Court House was reached, the teams were so broken down by hard marching and want of rest . . . that the caissons were abandoned and destroyed."[13] Lee thus was without artillery for the last five days of his army's existence.

The number of horses killed in combat will never be known. Commanding officers, even cavalry leaders, rarely mentioned equine casualties in their communiqués. However, some statistics emerged in official reports of Gettysburg. Losses in Colonel Henry Cabell's artillery battalion were 26 men, plus 67 horses killed and 13 disabled.[14] At least 881 artillery horses in the Army of the Potomac were slain in the three days of fighting. The day after Gettysburg concluded, Quartermaster Ingalls wrote Meade: "The loss of horses in these several battles has been great in killed, wounded and worn down by excessive march. . . . I think I shall require 2,000 cavalry and 1,500 artillery horses as soon as possible to recruit the army." Ingalls revised his figures the next day to 5,000 horses.[15]

A major factor in Meade's slow pursuit of Lee after the battle was the poor condition of cavalry and draft animals. Too few were present and asked to do too much. The army stalled as a result.[16]

Mahatma Gandhi once declared: "You can judge a people by the way they treat their animals." Throughout my career, in reading thousands of soldiers' letters, diaries, and reminiscences, I have always been on the alert for their comments about army horses and mules. Horses were wherever any component of an army was, so every soldier saw them at various times. Nevertheless, they received little attention from Johnny Rebs and Billy Yanks. Those men who did mention the animals generally were expressing revulsion or pity at what they beheld. In mid-April 1862, a Maine adjutant stationed at Harpers Ferry classified teamsters "as a class the most depraved of any in the Army. They have no mercy for their beasts, are the very personification of selfishness and malevolence, stupidity physical and moral They know less than the beasts they drive. Today I heard an unusual hub-bub and looking out saw a wretched abortion of humanity, pounding the noses of two mules and trying to make them back up against the railroad tracks."[17] George Hitchcock of the

Twenty-First Massachusetts Infantry stared out at the Fredericksburg battlefield two days after the fighting. The saddest sight, he wrote, "was that of a wounded horse fastened to an artillery wagon, which had been shot somewhere in the hindquarters. From time to time it would raise itself up on its forward feet, look toward us in a most imploring way, appealing for help with a groan like a human being—most heart-rending; then falling back in exhaustion, slowly dying by pain, starvation and thirst."[18]

Sprinkled throughout Civil War literature are instances of the bravery and endurance of individual mounts. At Gettysburg, Captain Chester Parsons of the First Vermont Cavalry was riding "a gentle sorrel, scarred and stiff with long service." Yet in an open-field attack on Major General James E. B. "Jeb" Stuart's Confederate cavalry, the horse "sprang into the charge!" The animal bounded over fences and broken country. A bullet struck Parsons, and he slumped in the saddle. "How gently he carried me from the field, although blood spurted from his side at every step. . . . And when I was lifted down into unconsciousness, my last recollection was of his great eyes turned upon me as in sympathy and reproof."[19]

Today's well-read students are familiar with the mounts of outstanding generals. Lee's Traveller, U. S. Grant's Cincinnati, Jackson's Little Sorrel, Sheridan's Rienzi. Those horses were in a far better class than the millions of their four-legged army comrades. Commanders' horses live still in equestrian statues on battlefields and in cities. In contrast, the average Civil War horse has a single monument.

Whenever I am riding on North Boulevard in Richmond, I habitually look at the front lawn of the Virginia Historical Society. There stands a bronze sculpture, created by Tessa Pullan and dedicated by Paul Mellon in 1997. The metal figure depicts a broken-down, skeletal horse, head bent low as if in the final seconds of life. It is not part of a proud army passing in review or a dramatic participant in a battle scene. The bronze horse instead is the silent embodiment of the phrase "faithful unto death."

That lone statue, as well as the Antietam photograph, are inadequate tributes. More than 1.5 million horses and mules did not live to enjoy the national pasture that came in 1865 with peace. Not one received a decent burial. Another million horses hobbled home permanently impaired. History remembers them all only as necessary costs in a great nation-molding conflict. They deserve a better title: "The Unsung Heroes of the Civil War."

NOTES

1. U.S. War Department, *The War of the Rebellion: A Compilation of the Official Records of the Union and Confederate Armies*, 127 vols., index, and atlas (Washington, D.C.: GPO, 1880–1901), ser. 1, vol. 19, pt. 1, 190 [hereafter cited as *OR*; unless otherwise stated, all references are to ser. 1]). Hays's brigade lost 257 men in the hour's fight (813).

2. Terry L. Jones, "The Dead at Antietam," *New York Times*, September 24, 2012.

3. Confederates retrieved Strong's body the following day and buried it in a hollow south of the Dunker Church; see William A. Frassanito, *Antietam: The Photographic Legacy of America's Bloodiest Day* (New York: Scribner's Sons, 1978), 124. The remains now lie in Rose Hill Cemetery, Hagerstown, Maryland.

4. Alpheus S. Williams, *From the Cannon's Mouth: The Civil War Letters of General Alpheus S. Williams*, ed. Milo M. Quaife (Detroit: Wayne State University Press, 1959), 120.

5. Oliver Wendell Holmes Jr., "My Hunt after the Captain," *Atlantic Monthly* 10 (December 1862): 748; Regimental Committee, *History of the 125th Pennsylvania Volunteers, 1862–1863* (Philadelphia: Lippincott, 1906), 68, 172; John M. Gould, *History of the First-Tenth-Twenty-ninth Maine Regiment: In Service of the United States from May 3, 1861, to June 21, 1866* (Portland, Me.: Stephen Berry, 1871), 253.

6. *OR* 27, pt. 1, 222–23; pt. 3, 521, 523.

7. Quoted in Deborah Grace, "The Horse in the Civil War," *O'Reilly's Battery Newsletter* (July 2000): 1. See also *OR* 39, pt. 3, 713–14.

8. J. William Jones and others, eds., *Southern Historical Society Papers*, 52 vols. (Richmond, Va.: The Society, 1876–1959), 8:428–29 [cited hereafter as *SHSP*].

9. Robert Underwood Johnson and Clarence Clough Buel, eds., *Battles and Leaders of the Civil War*, 4 vols. (New York: Century, 1887–88), 4:471 [cited hereafter as *B&L*]. Wilson was commanding a division of twelve thousand horsemen. Another three thousand cavalrymen had been left behind because of a lack of horses (467).

10. J. M. Bowen, "Horses—The Other Casualty of War," in James I. Robertson Jr., ed., *Military Strategy in the American Civil War* (Richmond: Virginia Sesquicentennial of the American Civil War Commission, 2012), 90.

11. Confederate artillery battalion chief David McIntosh lost more horses (thirty-eight) than men (twenty-four) in the Gettysburg Campaign. Overreliance on pasturage to sustain animals had heavily reduced horsepower and, to McIntosh, was a factor in the Southern defeat. See *SHSP* 10:137; 36:152.

12. *OR*, ser. 4, vol. 2, 615.

13. *SHSP* 27:326.

14. *OR* 27, pt. 2, 378.

15. Ibid., pt. 3, 524, 543.

16. Ibid., pt. 1, 86; pt. 3, 736.

17. John M. Gould, *The Civil War Journals of John Mead Gould, 1861–1866*, ed. William B. Jordan (Baltimore: Butternut and Blue, 1997), 116.

18. George A. Hitchcock, *From Ashby to Andersonville: The Civil War Diary and Reminiscences of George A. Hitchcock, Private, Company A, 21st Massachusetts Regiment, August 1862–January 1865* (Campbell, Calif.: Savas, 1997), 54.

19. *B&L* 3:396. In an 1861 fight in Missouri, the horse of a captain allegedly was shot thirteen times but managed to get its rider safely back to camp before it fell to the ground dead; see Charles Brackett, *Surgeon on Horseback* (Carmel, Ind.: Guild, 1998), 44.

PART 5
PLACES

City Point, Virginia

The Nerve Center of the Union War Effort

ELIZABETH R. VARON

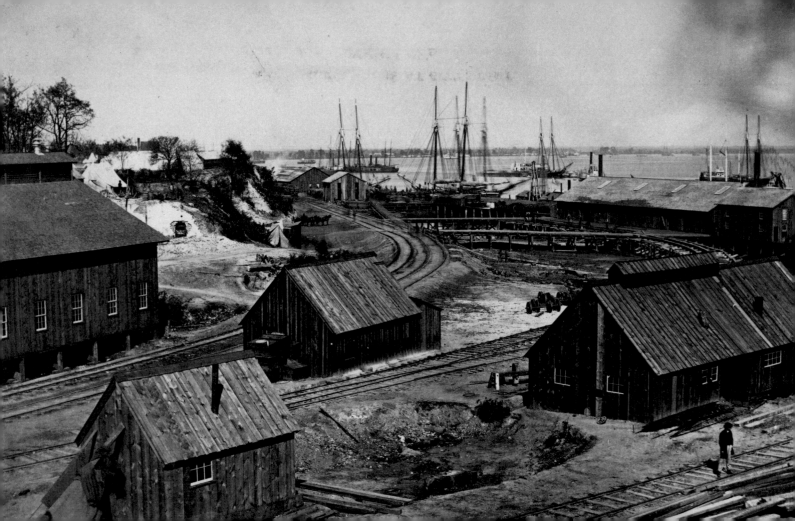

THIS IS A photograph of the main railroad depot at City Point, Virginia, Grant's headquarters and primary supply base for military operations against Petersburg (which lay eight miles away, to the southwest) from June 1864 until the end of the war. In order to appreciate the significance of the image, one must situate it in two different before-and-after pairings. Before the Union occupied it on May 5, 1864, City Point, a river landing at the confluence of the James and Appomattox Rivers, connected to Petersburg by rail, was a modest hamlet, home to roughly one hundred inhabitants. But within a few months of the Union occupation, City Point had been transformed into one of the world's busiest ports. Grant set up his headquarters there at Appomattox Manor, an estate owned by a Confederate cavalry officer, Richard Eppes, whose family had fled to Petersburg in 1862 (and whose slaves had fled to Union lines). The once-sleepy village was soon studded with wharves and warehouses, hospitals and barracks, railroad lines, engine houses and locomotives, water tanks and repair shops. On an average day one thousand barges, seventy-five sail vessels, and forty steamboats plied the waters of the James, bringing supplies from the North to the port; mail service and passenger service to Washington, D.C., was available daily. The Union's railroad construction corps built up and extended the rail line so that supplies could be whisked to the army in the trenches: 25 locomotives and 275 railroad cars were shipped in by barge. The army stored nine million meals at City Point on an average day; the camp bakery daily produced one hundred thousand rations of bread. City Point had 110 hospital buildings; the sprawling Depot Field Hospital, covering some two hundred acres, treated as many as ten thousand wounded soldiers a day.[1]

In short, City Point not only supported the troops at the front—it also symbolized the Union army's logistical, technological, and industrial might. But City Point's heyday was short, corresponding to Grant's ten-month siege. So we must situate this image in a second before-and-after pairing, in which we contrast City Point in 1864–65 with its postwar aspect. In the wake of the Union victory, the military buildings at City Point were taken down. Grant's cabin was sent to the citizens of Philadelphia and erected in Fairmount Park as a tourist attraction. By March 1866, Appomattox Manor was once again in the hands of Richard Eppes, who had taken an oath of amnesty and purchased the structures the Union army left behind, only to raze them. The bustling city soon reverted into a quaint village: in 1870, roughly three hundred people lived there. Modern day visitors to City Point (now part of the town of Hopewell,

and of Petersburg National Battlefield Park) can visit Grant's cabin, which was returned to its original location in 1983 and restored after falling into disrepair. The site is beautiful and serene—but in this case, it is less evocative than the photographic record. Only photographs can convey the teeming landscape and clanging soundscape of siege-era City Point.

Because City Point was "one of the few readily accessible subjects available to photographers during much of the siege of Petersburg," William Frassanito, a leading authority on Civil War photography, notes it is featured in more than a hundred photographic scenes intended for consumption by the Northern public and officialdom. Photographers recorded views of Grant's headquarters, portraits of his staff, and scenes of the wharves and railroad depot. This image is by official army photographer Captain Andrew J. Russell, who was assigned to the U.S. Military Railroad Construction Corps. Russell is an unsung hero of Civil War photography, overshadowed by Mathew Brady and Alexander Gardner; indeed, his photographs have frequently been misattributed to them. A New York artist, Russell was mustered into the 141st New York Infantry in September 1862. In March 1863, he was detached from his regiment to work as a government photographer based in Alexandria, Virginia, at the main terminus of the U.S. Military Railroads. He made frequent trips to the front, beginning with a photographic apprenticeship during the Chancellorsville Campaign. His role was to document not the human faces of the war but instead the technology, infrastructure, and transportation systems that supported the troops. Reporting to Union quartermaster general Montgomery C. Meigs, Russell "took more than a thousand negatives in two and

a half years, and his prints were distributed to generals, congressmen, foreign dignitaries, and to the president to illustrate the effectiveness of the war department," as the scholar Susan E. Williams has explained. His photographs stand out for their stark realism and lack of sentimentality.[2]

City Point has not only been effaced from the land but from our collective memory, too: it is not, for modern Americans, a "household name," like the great battlefields of Gettysburg, Antietam, and so on. But in 1864 and 1865, City Point was at the center of Americans' consciousness of the war. During the siege of Petersburg, Northerners received through their newspapers daily reports with the dateline "City Point," sent in by war reporters such as the *New York Herald*'s Sylvanus Cadwallader. Cadwallader's memoirs recount how he set up a messenger line between the Union headquarters and the New York offices, with correspondents crowding onto government steamers that departed City Point for Washington, D.C., and Baltimore: "an hour or two before the mail boat leaves they gather around it, like flies around a molasses barrel," he wrote. Soon the other major Northern dailies established their own lines of communication. Confederate dailies also printed regular updates from City Point, under headings such as "latest news of the enemy."[3]

Indeed, City Point furnished a panorama of the Union war effort. When we use other sources to supplement the scores of documentary images of City Point's built environment, we can see the site as rich in human drama, on both the grand and intimate scale. The most familiar City Point tableaux are Lincoln's: the president traveled to the front in June 1864 and solidified his

partnership with his general in chief. Lincoln "regaled Grant and his staff with his endless fund of stories" and soaked up the atmosphere at headquarters, coming away reassured that Grant's strategy would, in the end, bring victory. Lincoln returned to City Point on March 24, 1865, aboard the steamer *River Queen*, to confer with Grant about the prosecution of the final campaigns and to reiterate, in a storied March 28 meeting on shipboard, his liberal reconstruction policy. It was at City Point, in April 1865, that Lincoln waited anxiously for confirmation of Lee's surrender, and there that he had a chilling dream: a premonition of his own assassination.[4]

The most dramatic City Point story is a tale of sabotage. In August 1864, Captain John Maxwell, a member of the Confederate secret service, insinuated himself through the Union pickets and entered City Point, carrying a package in which was concealed a time bomb. He foisted the package on an unwitting worker on the ship *General Meade*, and the bomb detonated, sparking a conflagration at the nearby ammunition stores. An estimated 58 people were killed and another 126 wounded; Grant himself, who was seated at his headquarters tent, narrowly escaped injury. "Every part of the yard used as my headquarters is filled with splinters and shells," he observed of the fallout from the explosion. Although shocking, the act of sabotage did not fulfill the Confederate objective of interfering with the brisk traffic at the port. Union forces quickly reconstructed the damaged wharf and transferred the main ammunition depot to a new, safer wharf.[5]

Equally fascinating, if more difficult to bring into view, are the countless stories of exertion and sacrifice made on behalf of the Union by the mass of soldiers, laborers, hospital workers, and reformers at City Point. A construction corps of two thousand to three thousand men worked alongside more than a thousand carpenters, blacksmiths, teamsters, wheelwrights, clerks, and laborers to build, maintain, and extend its vast facilities. Hundreds of hospital workers staffed the seven hospitals at City Point and earned the Depot Field Hospital a reputation as the finest such facility in the land; consisting of 1,200 tents and 90 log barracks, the depot was described by Lieutenant Colonel Theodore Lyman of Meade's staff as a "huge canvas town." The workers toiling there included the indefatigable New Jersey Quaker Cornelia Hancock, the "Florence Nightingale of America," who left behind a rich collection of letters detailing life at City Point. On June 29, 1864, she wrote her mother that she had 180 patients to look after. "I work all day long and at night fall right down and sleep," she confessed, adding, "[T]he cannonading is perfectly deafening even at this distance" from the Petersburg front. It is "sickening when you know what a scene it must bring to us," she wrote of the artillery barrage.[6]

Scores of African Americans who fled from slavery, dubbed "contrabands" by the Union authorities, sought refuge at the Union headquarters. They acted as laborers, cooks, laundresses, nurses, and scouts for the Federal forces; indeed, it is likely that most of those killed in the 1864 wharf explosion were African American dockworkers. City Point was a magnet for Northern civilians working with the U.S. Sanitary Commission to supply the troops and lift their morale; these included teachers who offered instruction to the freedpeople and to the U.S. Colored Troops (USCT) soldiers in the camp. U.S. Christian Commission agents saw City Point as

a field for missionary work; they erected prayer tents and kept the camp abuzz with religious revivals. It was a magnet too for an altogether different sort of service to the troops: "an entire village of prostitutes, lining three parallel streets about four blocks long, flourished near the wharves," explains historian A. Wilson Greene. "In addition to dispensing sexual favors," he notes, some of these enterprising women would "write letters home for illiterate soldiers." The lure of City Point gave rise to an illicit traffic in the army passes soldiers needed as proof of their permission to leave the front for social visits to the headquarters.[7]

City Point was a transit point for a great throng of Confederates as well as Unionists. Hundreds of prisoners of war were brought there in flag-of-truce boats for exchange in the prison cartel system. City Point also drew scores of Confederate refugees from Richmond and Petersburg, and hundreds of deserters from the Rebel army, "fast leaving the sinking ship," as a *New York Times* article put it in March 1865. Deserters were often driven by hunger. They could not but contrast the dire conditions in besieged Petersburg with the "mountains of supplies flowing to the Union lines through City Point," Greene has observed. The price for provisions was loyalty: only those deserters who took an oath of allegiance to the Union were issued rations and granted passage on government steamers to points north.[8]

My own fascination with City Point and with its remarkable photographic record began as I researched the life of Elizabeth Van Lew, the intrepid spymaster who headed the Unionist "Richmond Underground" and funneled strategic and tactical intelligence to Grant during the last year of the war.

Van Lew's interracial network of agents and couriers kept up regular communications with City Point via five stations positioned along the thirty-five-mile stretch from the Rebel capital to the Union headquarters. Their route snaked its way east and then south of Richmond to the banks of the James directly across from City Point. Van Lew's couriers used resourceful if primitive spy tradecraft: posing as ordinary civilians selling farm produce, they hid letters, maps, and plans, written in invisible ink and a crude cipher, in the hollowed-out soles of their shoes and in dummy eggshells hidden among real eggs. The reminiscences of Grant's military secretary, Adam Badeau, permit us to conjure up how Richmond intelligence was received at City Point. "[W]hen night came, all the officers on duty at the head-quarters were accustomed to gather round the great camp fire," wrote Badeau, "and the circle often numbered twenty or thirty soldiers. Grant always joined in, with his cigar, and from six or seven o'clock till midnight, conversation was the sole amusement. The military situation in every quarter of the country was of course the absorbing theme; the latest news from Sheridan or Sherman, the conditions of affairs inside of Richmond, the strength of the rebel armies, the exhaustion of the South; the information extracted from recent prisoners, or spies, or from the rebel newspapers."[9] Reports from the underground of the increasing desolation inside Richmond emboldened and sustained Grant and his staff.

In short, to view the photographs of City Point is to see the Union triumph take shape. In the eyes of Northerners, City Point was a symbol of both their efficiency and of their righteousness. This was the message

of an August 6, 1864, letter written at City Point by a soldier (identified by the initials T.S.W.) in the First USCT to the Philadelphia-based African Methodist Episcopal newspaper the *Christian Recorder*. Reporting with pride on the role black troops were playing in the Petersburg Campaign, the soldier concluded, "I will now tell you something about the scenery around here. The birds are singing upon the trees, and every thing, animate and inanimate, is a beacon to us, that there is a God." The Union's remarkable city on the James, in the heart of Rebel territory, was proof that there would be no turning back.[10]

NOTES

1. William A. Frassanito, *Grant and Lee: The Virginia Campaigns, 1864–1865* (New York: Scribner's Sons, 1983), 268–71; David W. Miller, *Second Only to Grant: Quartermaster General Montgomey C. Meigs* (Shippensburg, Pa.: White Mane, 2000), 233; National Park Service, Cultural Resources, "Grant's Headquarters: City Point, Virginia," http://www.cr.nps.gov/logcabin/html/cp.html; "City Point," http://www.nps.gov/pete/historyculture/city-point.htm.

2. Frassanito, *Grant and Lee*, 27, 49–51, 276; Andrew J. Russell, "City Point R.R. Depot, looking toward Petersburg," Library of Congress, http://www.loc.gov/pictures/item/2005689624; Susan E. Williams, "'Richmond Again Taken': Reappraising the Brady Legend through Photographs by Andrew J. Russell," *Virginia Magazine of History and Biography* 110 (2002): 437, 440, 447, 458–59.

3. Sylvanus Cadwallader, *Three Years with Grant* (1955; reprint, Lincoln: University of Nebraska Press, 1996), 237–40.

4. Jean Edward Smith, *Grant* (New York: Simon & Schuster, 2001), 376, 393.

5. Emmanuel Dabney, "City Point during the Civil War," *Encyclopedia Virginia*, http://www.EncyclopediaVirginia.org/City_Point_During_the_Civil_War; Frassanito, *Grant and Lee*, 271.

6. Cornelia Hancock, *Letters of a Civil War Nurse* (Lincoln: University of Nebraska Press, 1998), 116; Theodore Lyman, *Meade's Army: The Private Notebooks of Lt. Col. Theodore Lyman*, ed. David W. Lowe (Kent, Ohio: Kent State University Press, 2007), 229.

7. Miller, *Second Only to Grant*, 233; A. Wilson Greene, *The Final Battles of the Petersburg Campaign: Breaking the Backbone of the Rebellion* (Knoxville: University of Tennessee Press, 2008), 54, 57; Greene, *Civil War Petersburg: Confederate City in the Crucible of War* (Charlottesville: University of Virginia Press, 2006), 224; Dabney, "City Point"; National Park Service, Petersburg National Battlefield, "African-Americans at City Point, 1864–1865," http://www.nps.gov/pete/historyculture/upload/African-Americans-at-City-Point-for-web-3.pdf; *Christian Recorder* (Philadelphia, Pa.), June 18, November 26, 1864.

8. *New York Times*, March 27, 1865; *Christian Recorder*, September 24, 1864; *Charleston (South Carolina) Mercury*, March 11, 1864.

9. Elizabeth R. Varon, *Southern Lady, Yankee Spy: The True Story of Elizabeth Van Lew, a Union Agent in the Heart of the Confederacy* (New York: Oxford University Press, 2003), 163, 174–75.

10. *Christian Recorder*, August 20, 1864.

City Point, Virginia

The Book or the Gun?

STEPHEN BERRY

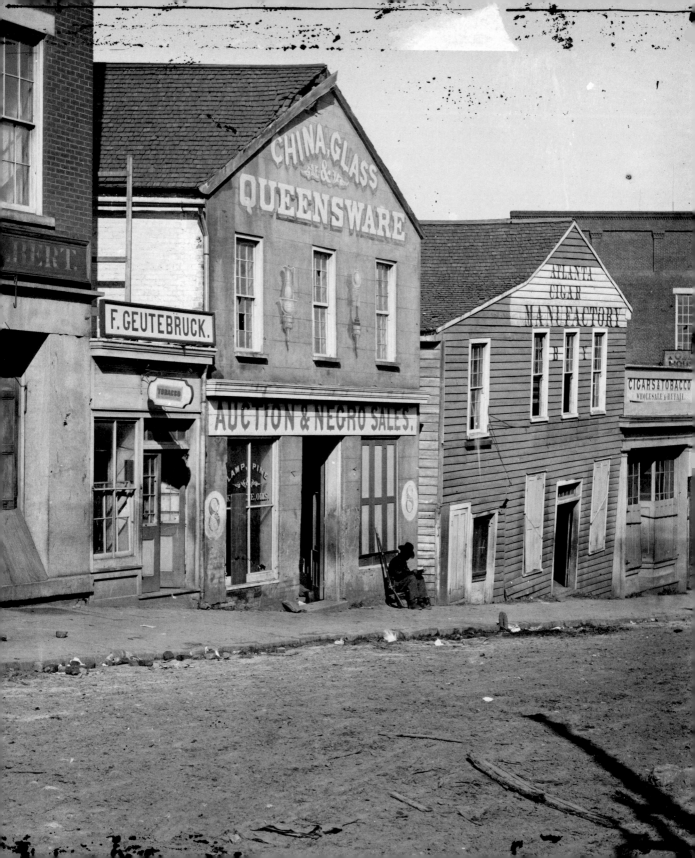

IN EARLY SEPTEMBER 1864, General William Tecumseh Sherman ordered Union army photographer George N. Barnard to report to Atlanta. The city had fallen, and the general was elated. "Atlanta was . . . the 'Gate-City of the South,'" Sherman would later recount in his memoir. "And I knew that its capture would be the death-knell of the . . . Confederacy."[1]

Before putting the city to the torch, Sherman wanted Atlanta to be photographed. So Barnard wandered its streets for days, laboriously setting up his camera and snapping pictures of buildings that were about to be destroyed.

My favorite of these Barnard photos captures the storefronts of several Atlanta businesses—cigar manufactories, a china shop, a store that sold lamp oils—all situated at the foot of Whitehall Street at what is now the Five Points station of the Metropolitan Atlanta Rapid Transit Authority (MARTA). At the center of Barnard's frame is an "auction house," plastered with the banner "Auction & Negro Sales." Two businesses operated from the building in its heyday. The top floor housed Thomas R. Ripley's crockery and china emporium. The bottom floor was the auction house of Crawford, Frazer & Co., which traded in a variety of goods, including human beings. In 1863, the company was making a killing supplying the Confederate army. But by 1864

Thomas Frazer had sold out or bugged out, and Robert A. Crawford was in sole control of the business. Crawford was the city's leading slave trader, boasting, as he said, the "most extensive Negro depot in the Confederacy." Most of his "stock" was penned a few doors down and across the street, in a yard between two other businesses. But at auction, the slaves were brought to this building, into the large downstairs room ringed by benches, where they could be coffled and chained. As one witness noted, prospective buyers paced the inside of the ring and "made their selections just as they would have a horse or mule at a stockyard."[2]

Throughout the war, Crawford's business had been "brisk." As late as May 1864, he was still assuring customers that his stock was being "constantly replenished." "For those who want them—and some still do—slaves can be purchased from several auctioneers," the city paper reported, "the most prominent of whom is Robert A. [Crawford]." "My extensive acquaintance and long experience in the business secure speedy and satisfactory sales," Crawford boasted. "Parties sending me Negroes by Railroad will find my old and trusty porters, 'Andrew' and 'Anthony,' about the train as usual."[3]

The most arresting thing about the image, however, is the lone figure at the center. Though reprinted often, it wasn't until the photograph was digitized and blown

up that it became widely recognized that the soldier is African American. His rifle is leaning against the building, and two rocks have been drawn up to serve as his chair as he reads from a book. We will probably never know his name, but we can certainly guess what it meant to him to be sitting in uniform, gun at hand and reading, outside an auction house that had just a few weeks before been actively engaged in buying and selling members of his race.

I would love to believe that the photograph is candid. I would love to think that Barnard came around a corner and found himself as captivated by the scene as I am. For here is the whole of the war in a single tableau—a war fought so that men capable of thinking and reading and dreaming might never be sold as things.

But my every historical instinct tells me that this photograph is staged. First: How did this soldier come to be here? There were no United States Colored Troops operating in Atlanta, and Sherman was not a fan of blacks in uniform. Before the war, he had not favored abolition. "I would not if I could abolish or modify slavery," he had written his wife in 1859 while superintending the Louisiana State Military Academy. "Negros in the great numbers that exist here must of necessity be slaves." Once the Union had broken over the issue, Sherman wanted slavery destroyed as a political irritant, but he was still no egalitarian. "A nigger as such is a most excellent fellow," he told a friend from St. Louis, "but he is not fit to marry, to associate, or vote with me, or mine." Given these racial attitudes, it is not surprising that Sherman refused to have colored troops in his army. The week this photograph was taken, Sherman had written to his superior, Henry Wager Halleck: "I have had the question put to me often: 'Is not a negro as good as a white man to stop a bullet?' Yes, and a sand-bag is better; but can a negro do our skirmishing and picket duty? Can they improvise roads, bridges, sorties, flank movements, &c., like the white man! I say no. Soldiers must and do many things without orders from their own sense. . . . Negroes are not equal to this. I have gone steadily, firmly, and confidently along, and I could not have done it with black troops."[4]

It is vaguely possible that the soldier belonged to another command. There were detachments of USCT at Chattanooga, and even at Dalton, and there are some good reasons a single soldier might have needed to visit the main army in Atlanta.

But let's consider the scene. No African American soldier can have decided on a whim to sit and read beneath a "negro auction" sign. Even assuming he had, surely he would have noticed a cameraman across the street, setting up equipment? And surely this would have caused him to move his head, thereby ruining the exposure? Now maybe the soldier did sit here of his own accord, reading and drinking in the delicious ironies. And maybe Barnard did capture the moment. But it seems unlikely.

It is also vaguely possible that the soldier was posted to this position. But, if so, what was he guarding? The city has clearly gone to seed—"battered and honey-combed," according to a witness, and awaiting the torch. Moreover, under high magnification, another soldier can be seen in the doorway. He is seated with his legs drawn under him, coffee pot nearby, looking almost precisely as if he has been asked to clear the frame for a moment while a picture is being taken.[5]

Evidence and instinct, then, suggest that this photograph was probably posed. How far did Barnard go to get the shot? Did he ask a handy USCT soldier to sit for him? Or did he create a USCT soldier by throwing a borrowed corporal's uniform around a cook, a teamster, or an assistant? And whose idea was the book? And if it was Barnard's idea, what did he mean by it? And why was he so subtle, photographing his figure from so far off that most viewers have never even noticed the richness of the symbols?

In many ways, these questions don't matter. Certainly the image draws strength from the juxtaposition of the auction house and the black figure, hunkered over a book like Rodin's *Thinker*. But the signage alone bespeaks the banalities, even the absurdities, of evil. The thought of buying cigars, lamp oil, and a few people in the same shopping run seems creepy and strange. The soldier's quiet presence only underlines the fact that those days are over. The ramshackle auction house is gutted, defunct, kaput; whatever power it once held, whatever authority kept its doors open, has fled. Power now belongs to the soldier *because he is present*, and it matters little how he came to be there or even if he *is* a soldier. He's an African American sitting without repercussion next to a dead symbol of his racial oppression. We can wish, in the great American soldier's tradition, that he had given the camera the thumbs-up, or given the establishment the middle finger, but however you pose it, this looks like *victory*.

Gone with the Wind exaggerates the drama of Atlanta's burning. (For one thing, the town had been evacuated by Sherman's order before it was put to the torch.) Still, the conflagration proved quite a spectacle. "In a day and a night [Atlanta] was made a Carthage," remembered Adin Underwood of the Thirty-Third Massachusetts Infantry. "All there was left of the . . . city was scientifically demolished. . . . Powder and fire reduced the great depots, store-houses and public buildings to piles of tottering walls, and gaunt chimneys. The foundries and machine shops that had been kept running night and day, casting cannon shot and shell, went down, and with them hotels, theatres and negro markets, the latter never to be set up again. . . . By a turn of the kaleidoscope . . . strong walls and proud structures [were reduced to] heaps of desolation."[6]

Every old photograph reeks of mortality. Staring into it, we vaguely understand that time has claimed everything in it and will claim us too eventually. But time claimed everything in this photograph almost immediately. In a matter of days, in a turn of Sherman's kaleidoscope, the "most extensive Negro depot in the Confederacy" was gone with the wind.

Its traces remain, however, not on the Atlanta streetscape but in legacies and effects that light us down to the latest generation. And this is the thing I like best about the photograph: its core tension—between the soldier and the auction house—is rooted in the past, but its subtler tension—between the book and the gun—plagues us still.

"The book or the gun?" It is a question that has hung over the heads of African Americans from 1609 to the present. The book represents education, spirituality, nonviolence, striving, succeeding—the dream of a country where artificial weights are lifted from all shoulders and all men get to run as fast as their legs can bear them in the "race of life." The gun represents the consistent

betrayal of that dream—the militant rage and wretched vengefulness turning inward and out—the sense that, sometimes, what is deserved must be taken by force.

After the Civil War, America would consistently present "the book or the gun" as a discrete choice to African Americans. It would reward (barely) those who chose the book. It would punish (terribly) those who chose the gun. And it would misunderstand (massively) that virtually every gain African Americans have made, they have made through the strategic use of both.

THE BOOK

In his famous autobiography, Frederick Douglass claimed that beating up the slave breaker Edward Covey marked the "turning-point" in his career as a slave. Repelling "by force the bloody arm of slavery," Douglass felt intoxicated by the physicality of his defiance, and he boldly declared that the next white man who expected to succeed in whipping him must also succeed in killing him. But such a scene seems like something out of *Django Unchained.* Surely Douglass knew violence was a poor prescription for the millions in bondage. Most slaves who rose up died. Nat Turner. Denmark Vesey. Gabriel Prosser. All tried to break the slave breaker. All were broken. And in beating up Covey, Douglass was lucky not to join them. The next white man who succeeded in whipping him probably would have succeeded in killing him.[7]

No, there has always been something off about this section of Douglass's autobiography. I do not dispute that the altercation occurred or that it was exhilarating. I do dispute that it marked Douglass's "turning point" as a slave, and my authority for contradicting Douglass is Douglass himself. For, unconsciously, he knew the truth. The fight, he said, "rekindled" his "embers of freedom," "revived" his manhood, and "recalled" his self-confidence. This is a lot of "re-" words for a short passage, and it forces us to ask: When, then, was the original kindling and calling, the original turning point? For this we must return to the beginning, to the moment when his master had assayed all the evils that would follow upon his learning to read. "[His] words sank deep into my heart," Douglass said, "stirred up sentiments within that lay slumbering, and called into existence an entirely new train of thought. It was a new and special revelation, explaining dark and mysterious things, with which my youthful understanding had struggled . . . in vain. I now understood what had been to me a most perplexing difficulty—to wit, the white man's power to enslave the black man." An "entirely new train of thought"—*this* is the fist that Douglass beat Covey with. The white man's power lay not merely in jailing the body but in jailing the mind. And reading would set it free.[8]

The freedmen certainly understood that. In her memoir of her family in slavery and freedom, Pauli Murray recalled the "first glorious months after Appomattox when the colored people had seen the coming of the Lord, had left the crops untended, the kitchens and nurseries deserted, had clogged the roads and flocked into the cities." But soon enough hunger and homelessness had driven them "to doubt the reality of their triumph." "Freedom was not something you could hold in your hands and look at it," Murray noted. "It was something inside you which refused to die, a feeling, an urge, an impelling force; but it was other things, too, things you did not have and you had to have tools

to get them. Few freedmen had tools in 1865; only the feeling, the urge."[9]

Had Thomas Jefferson lived, he would have been staggered to discover that his slaves' deepest urge was not for revenge but for education, for the tools they had been denied. Jefferson had famously trembled for his country when he remembered that "God is just, that his justice will not sleep forever." But when freedom came, African Americans were giddy, not retaliatory, and they set about their self-education with a determination that staggered even their advocates. "The Freedmen have started a school of their own," a Bureau worker goggled upon arriving in the South, "and employ at their own expense a colored teacher. A similar movement is commencing among the Freedmen in several other places, evincing a thirst for knowledge and a desire for improvement that finds *no parallel* among that numerous and degraded class, the 'poor whites.'" In his first report from the field, another bureau worker was equally impressed with the rapidity with which the freedmen organized themselves: "We have just emerged from a terrific war; peace is not yet declared. There is scarcely the beginning of reorganized society at the south; and yet here is a people long imbruted by slavery, and the most despised of any on earth, whose chains are no sooner broken than they spring to their feet and start up an exceeding great army, clothing themselves with intelligence. What other people on earth have ever shown . . . such a passion for education?"[10]

"The northern men had never seen anything quite like it," Pauli Murray remembered her grandfather saying, "ragamuffins coming out of the fields and swarming to whatever place had a teacher. They brought with them old scraps of newspaper, a page from the Bible, a leaf torn from a young master's spelling book, a ragged almanac, a piece of broken slate—anything they thought would help them to learn. They wept tears of joy when they could recite the alphabet or read a line from the Bible or write their names."[11]

Skeptics said the freedmen would never stick it out. Blacks weren't looking for an education, it was said, they were looking for a magic bullet, and as soon as they discovered that literacy didn't immediately translate into a house of gold, they would give it up.

Except that they didn't. School enrollments soared until, in urban areas, there were fifty students to a classroom and it was impossible to keep up with the demand for teachers, textbooks, and schoolhouses. "They believed, as perhaps no other people had believed so fervently, that knowledge would make them truly free," Murray said of her grandfather's generation. "As Booker T. Washington said later, 'It was a whole race trying to go to school. Few were too young and none were too old to make the attempt to learn.' This almost universal desire for education among the freedmen was the most inspiring thing to emerge from the bitterness and misery of war." Schoolteacher Laura Towne agreed. "Their steady eagerness to learn is just something amazing," she noted in 1877. "To be deprived of a lesson is a severe punishment. 'I got no reading to-day,' or no writing, or no sums, is cause for bitter tears. This race is going to rise."[12]

THE GUN

And so the racist white majority rose up to knock the freedmen back down. Long before the Winchester became the "gun that won the West," it was the gun that

won the South. Schools were firebombed, teachers set to flight or killed. What the Klan sought to destroy was what Martin Luther King would come to call the "some-bodiness" of African Americans, their ability to conjure and conduct "new trains of thought."

And thus, with uncanny precision, did Richard Wright have to repeat the steps of Frederick Douglass's racial awakening a hundred years earlier. A menial laborer in the South, the future *Native Son* and *Black Boy* author happened to read a "furious denunciation of [H. L.] Mencken" in the Memphis *Commercial Appeal*. Figuring, like Douglass, that what the white world assayed as an evil bore investigation, Wright tricked a librarian into lending him one of Mencken's books. And that night, in his rented room, while the hot water ran over a can of pork and beans in the sink, Wright experienced the turn-ing point in his career as a "slave." Because as he read, Wright was "jarred and shocked" to find that Mencken wrote like a "raging demon, slashing with his pen, con-sumed with hate, denouncing everything American, extolling everything European or German, laughing at the weaknesses of people, mocking God, authority." "What was this?" Wright asked himself. "I stood up, try-ing to realize what reality lay behind the meaning of the words. [Mencken] was using words as a weapon, using them as one would use a club. Could words be weapons? Well, yes, for here they were. Then, maybe, perhaps, I could use them as a weapon."[13]

Before he acquired his surreptitious library card, Wright's impulse to dream had been "slowly beaten out of" him by experience. Now it "surged up again," and he hungered for books, thirsty, like Douglass, for "new ways of looking and seeing." "I now knew what being a Negro *meant*," Wright explained. "I could endure the hunger and I had learned to live with hate. But to feel that there were feelings denied me, that the very breath of life itself was beyond my reach—that [hurt] more than anything else. . . . My reading had created a vast sense of distance between me and the world in which I lived and tried to make a living."[14]

Such distances are hard to endure. The uncloseable gulf between "who I am" and "where I find myself" becomes a kind of existential rage, an impotence so pro-found that when you see it whole it feels like despair.

"Occasionally in life one develops a conviction so precious and meaningful that he will stand on it till the end," Martin Luther King said. "This is what I have found in nonviolence." He was shot in the face. "There's a new deal coming in," Malcolm X said. "There's new thinking coming in. There's new strategy coming in. It'll be Molotov cocktails this month, hand grenades [the] next. . . . It'll be liberty, or it will be death." It was death. To be sure, neither man was surprised to find himself cut down. "Like anybody, I would like to live a long life," King said on the day he was assassinated. "Longevity has its place. But I'm not concerned about that now. I just want to do God's will." Malcolm made a similar commitment: "It has always been my belief that I, too, will die by violence," he said. "I have done all that I can to be prepared." Both men knew what it meant to draw word weapons on a system that resented their somebodiness.[15]

Teamster or soldier, the man in this photograph is *somebody*. Posed or reposed, he dreams of *something*. And it should shame us to the core that he would never have dreamed that 150 years after his photograph was taken,

members of his race would still be locked in an "airtight cage of poverty" where men are as likely to shoot themselves or their fellows in the face as to develop the word weapons of Richard Wright.

In the end, I am glad this soldier isn't grinning or giving the camera a thumbs-up or giving the auction house the middle finger. Because the truth is, there *is* no victory. There is only vigilance. In an 1859 letter, Abraham Lincoln warned Americans that when they lazily treated their founding principles as "glittering generalities" and not as active political commitments, they became the "vanguard—the miners, and sappers—of returning despotism." The forces of class, caste, and hate are abroad in the land. Let us be here dedicated to the unfinished work that remains: let us build a country that sustains *all men* in their reading.[16]

NOTES

The author wishes to thank the volume coeditor, Matthew Gallman, for conceiving such a great idea for this book and for encouraging me to participate; John Inscoe for steering me through the rich field of southern autobiography; and the graduate students of HIST 8111—Ashley Allred, Monica Blair, Katie Fialka, Jonathan Hepworth, Luke Manget, James Owen, and Kaylynn Washnock—for giving me their "reads" of the photograph and helping me to sharpen my own.

1. William Tecumseh Sherman, *Memoirs of William T. Sherman* (1875; reprint, with notes by Charles Royster, New York: Library of America, 1990), 573.

2. Franklin M. Garrett, *Atlanta and Environs: A Chronicle of Its People and Events*, 2 vols. (Athens: University of Georgia Press, 1969), 1:586.

3. Ibid.

4. William Tecumseh Sherman to Henry Wager Halleck, September 4, 1864, in U.S. War Department, *The War of the Rebellion: A Compilation of the Official Records of the Union and Confederate Armies*, 127 vols., index, and atlas (Washington, D.C.: GPO, 1880–1901), ser. 1, vol. 37, pt. 5, 793.

5. Adin Ballou Underwood, *The Three Years' Service of the Thirty-third Mass. Infantry Regiment* (Boston: Williams, 1881), 240.

6. Ibid., 240–41.

7. Frederick Douglass, *Narrative of the Life of Frederick Douglass, an American Slave, Written by Himself* (Boston, 1845).

8. Ibid.

9. Pauli Murray, *Proud Shoes* (New York: Beacon, 1999), 169–70.

10. Ronald E. Butchart, *Schooling the Freed People: Teaching, Learning and the Struggle for Black Freedom, 1861–1876* (Chapel Hill: University of North Carolina Press, 2010), 2–6.

11. Murray, *Proud Shoes*, 170 (quoting Washington's *Up from Slavery*).

12. Butchart, *Schooling the Freed People*, 1.

13. Richard Wright, *Black Boy* (1945; reprint, New York: Harper Perennial Modern Classics, 2008), 244–49.

14. Ibid.

15. Martin Luther King Jr., *Where Do We Go From Here? Chaos or Community?* (New York: Harper and Row, 1967), 63–64; Malcolm X, "The Ballot or the Bullet," April 3, 1964, in George Breitman, ed., *Malcolm X Speaks: Selected Speeches and Statements* (New York: Grove, 1965), 23–44; Martin Luther King Jr., "I've Been to the Mountaintop," April 3, 1968; Alex Haley, *The Autobiography of Malcolm X* (New York: Grove, 1965), 1.

16. Abraham Lincoln to Henry L. Pierce and others, April 6, 1859, in Abraham Lincoln, *The Collected Works of Abraham Lincoln*, ed. Roy P. Basler, 9 vols. (New Brunswick, N.J.: Rutgers University Press, 1953–55), 3:375–76.

From Home Front to Ruins

The Fredericksburg Destruction

WILLIAM A. BLAIR

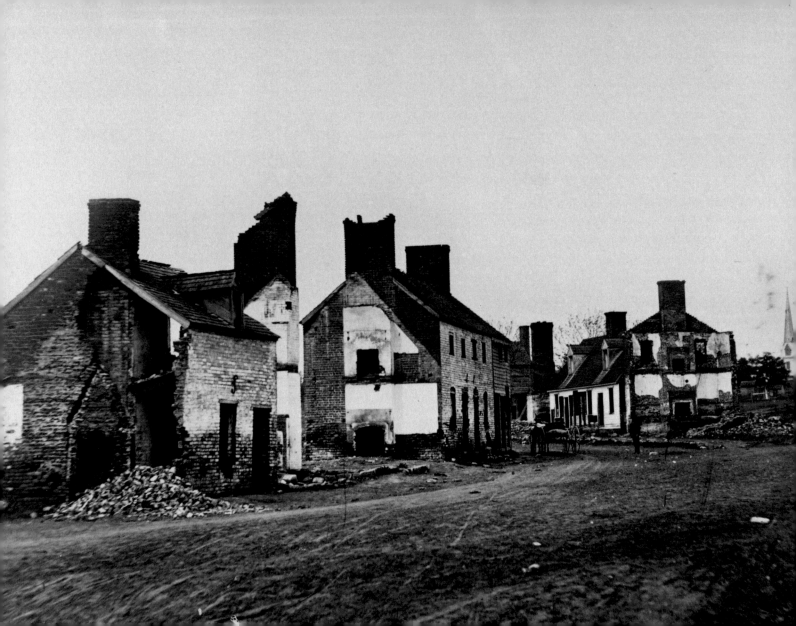

THE IMAGE conjured World War II and the kind of damage one might find in a European village. Various structures, presumably houses, wore scars from the shelling. One building in particular featured a collapsed wall, with bricks that spewed from it forming a pile of rubble nearby. A lone cart made its way through the dirt street. It was a somber scene, evidence of the destructive side of war and the possible outcome whenever civilians find themselves in the way of armies. But this was not Europe of the 1940s; it was a photograph of buildings in Fredericksburg, Virginia, damaged by artillery fire during the Union army's bombardment in late 1862.

Whenever I see this illustration, it resurrects memories of twenty-some years ago when a field started to congeal and my own career waited to blossom. It also reminds me how the field of Civil War studies has changed. Since I became intimately acquainted with this image in the early 1990s, the Internet has exploded with such images, making them more accessible and less surprising. The home front has matured as a framework for providing new insights into the conflict, and historians have shifted focus to the destructive war in an attempt to deromanticize the conflict. The "home front" now has become more complicated with scholars describing different experiences by civilians according to region and racial background. Additionally, scholars now ask different kinds of questions about how nineteenth-century Americans understood the meaning of the ruins left by the U.S. Civil War.

My encounter with this photograph came in the early 1990s, while preparing an essay for a book on the Fredericksburg Campaign, published in the series Military Campaigns of the Civil War.[1] In 1990, Ken Burns had demonstrated the power of images to expose this side of the conflict in his multipart PBS series on the Civil War. The damaged Fredericksburg buildings made a cameo appearance in episode four. When this image came onto the screen, the narration tied it not to the shelling of the town but to its pillaging by Union soldiers. The narration was correct. Soldiers stacked arms, entered homes, defaced walls, defecated on possessions, destroyed a piano, and paraded in the street in women's clothing while sporting parasols—this last gesture a signal that Confederate men could no longer protect their women. Although still somewhat overshadowed by the military side of the conflict, images such as the Fredericksburg ruins were attracting more attention from scholars. They signaled a different dimension to how the war had been depicted in prior decades, especially during the centennial, which had continued the celebration of generals, soldiers, and military topics.

Although known to historians from published volumes such as *The Photographic History of the Civil War*, the visual culture of that war remained less accessible than now. It is stunning to realize that when Burns's documentary aired, the Internet as we know it did not exist and only assumed its user-friendly face in 1991. Google did not form as a company until 1998. There was no such thing as Wikipedia. Shortly, websites on the conflict proliferated, demonstrating an explosion of interest in this seminal period of America's development. One of the earliest to capture my interest was the American Civil War Homepage, developed by George Hoemann, who was then at the University of Tennessee.[2] Debuting in 1995, the website contained links to a host of images, including the National Archives and the Library of Congress, which I eagerly mined for presentations to undergraduates in classrooms. While featuring many of the familiar faces (generals and politicians) as well as bodies on battlefields (lesson: don't march into cornfields or deep farm roads), the site exposed viewers to a wider range of still photography, including the damage caused to buildings and the landscape. Today, those images that struck me as fresh in the early 1990s are almost passé because of the rich material culture that can find its way onto the computer of anyone who can click a mouse.

The early 1990s represented a moment when historians began consciously to study the Civil War home front. As I was finishing my dissertation on the engagement of Virginia's civilians with such things as Confederate identity and the strains of mobilization, I worked on the essay on the two occupations of Fredericksburg by Union soldiers. This occurred roughly in 1994. Scholarship had started to produce books on the so-called nonmilitary aspects of the war. Part of this shift from the battlefield occurred because it seemed as if something could be learned by studying who sustained the conflict, how they did so, and whether the position of noncombatants had an equal effect on the outcome as the warriors in the army. This line of questioning was informed by our struggles in Vietnam, when it became apparent that God did not always lie on the sides of the heaviest battalions, but that a determined enemy with greater stakes in the cause might hold off a superpower until its people tired of the effort.

Other changes in American life influenced the course of Civil War studies. After World War II, Congress created the GI Bill, allowing a broader segment of American society access to college. The trend toward democratic admissions continued, fed by a booming economy, until by the 1960s and 1970s universities were populated with women, minorities, and white males who hailed from other than the elite ranks of society, with many representing the first generation of their families to attend institutions of higher learning. Interests naturally swung toward social history—from concentrating on leaders to trying to recover the stories of everyday people. For the Civil War, this inspired work on the common soldier, especially his motivations for fighting. But the changing demographics in the academy and the evolution of interests stimulated more nontraditional topics (as then considered) such as women and war, mobilization, opposition to Lincoln, and economic challenges. Soon, books started to appear with the "home front" as part of their titles. Today, Fordham University Press has dedicated a portion of its list to a series on the Northern home front in the Civil War. With my own studies of the civilian side

of the Fredericksburg occupation, and the research that became *Virginia's Private War*, I counted myself happily among the scholars who pursued an understanding of life beyond the battlefield.[3]

It must be admitted, though, that the term "home front," as much as I am a fan and a practitioner, speaks more to our time than the 1860s. It was not part of the lexicon of the nineteenth century. The *Oxford English Dictionary* indicates that "home front" first appeared around World War I and gained greater purchase because of World War II. For the latter, the idea found popular expression in the notion of Rosie the Riveter, or the women who filed into industrial jobs to keep the war machine going during the war against fascism. It suggested that there were two domains to war making: the military and the civilian, with the latter sustaining the fight through economic production, bond drives, propaganda, and more. In its more modern interpretation, the home front inevitably led to the notion of total war. By identifying the infrastructure that sustained wars, military leaders justified strikes—as the U.S. did in World War II—against factories, roads, railroads, and other materiel that helped the enemy, a practice that inevitably brought civilians into harm's way. Consequently, the term always has worn two faces: one that described separate fields of home front and battlefront, and the other that maintained how integral the two were for winning a war or defeating an enemy.

Given that fact, it is natural that the home front has come under questioning as a descriptive device, especially for the Confederate side of the war. In a thought piece that appeared as part of a forum in the *Journal of the Civil War Era*, Anne E. Marshall discussed this very subject. Historians of gender in particular have eradicated the line in the sand between battlefronts and home fronts. And they make a good point. Looking at guerrilla warfare, even in the border states, one cannot help but see that Confederate women sustained irregular warfare through hiding men, supplying them, and encouraging them. Scholars of the occupied Confederacy have encountered the same phenomenon. As Marshall has observed, historians focusing on gender in particular have shown that "groups of people (white and black free women or slaves, for example) [whom] historians traditionally considered 'civilians' on the southern home front were actually full-fledged combatants."[4]

Where a home front arguably existed was the North, in the upper regions that experienced no combat. To buttress this point I offer as evidence *Little Women*, by Louisa May Alcott. It remains among the best Civil War novels written about the Northern home front—or a segment of it. Those familiar with the text might wonder about this claim because it would seem, at first, that little of the war appears in the novel. And that is precisely the point. For the March girls, the war existed on the fringes of their lives. Father returned home a sick man from Fredericksburg, where he had ministered to the troops. Laurie Laurence, the boy next door who ends up marrying Amy, endured pressure to enlist in the Union army. Those are solid war issues. But for page after page in this novel, written shortly after the conflict, the Civil War remains an afterthought. That perspective, one of insular nonengagement, perhaps is too extreme to describe the times. As James Marten has demonstrated, the war did make a profound impact on children.[5] Families even in regions untouched by combat experienced more

loss than featured in the novel and followed events on the battlefield more attentively. But there were places in both North and South—isolated portions of Texas, the Upper Peninsula of Michigan, central Maine, and mountainous Arkansas—where the war remained somewhat, but not totally, present. It offered an element of concern, made its impact felt when loved ones died, featured itself in bond drives, became personal through collisions with draft and impressment officers, but it may not have dominated daily life at all times.[6]

This was not the case for the citizens of Fredericksburg in 1862. They experienced the full force of what some historians have called the Destructive War.[7] This was not a war felt in all areas of the Confederacy, but it did come home to the town of George Washington's mother. Union artillery opened fire because Confederate snipers had targeted engineers trying to build a pontoon bridge across the Rappahannock River. The shelling created the damage that appears in the photograph accompanying this essay. At the time, the shelling prompted quite a stir because it occurred when Confederates had not realized how far the Union might go to save the nation. The bombardment of Fredericksburg was not unique and was not by any means the worst. During the conflict, the Union tried to bombard other towns into submission, such as Charleston and Vicksburg. Richmond and Columbia, South Carolina, also suffered extensive damage, leaving behind charred ruins captured in photographs.

The extent of destruction in the Civil War—and the analysis of such photographs at the Fredericksburg ruins—has created interpretive battles among historians as well as new ways of using material culture. The Destructive War, which focuses on the aggressive measures applied against civilians, has expanded to include guerrilla warfare and greater recognition of atrocities that took place. Studies of rape have started to appear, with one promising work in the offing.[8] One scholar has termed this an era of New Revisionism, which features an antiwar perspective that exposes "the myriad cruelties" that the North in particular resorted to in order to defeat the Confederacy.[9] A counter to this position exists, and the South did commit its own atrocities, but for the moment the field remains settled on this path.[10]

Historians also have examined how Civil War–era Americans used ruins such as the shelled buildings at Fredericksburg to construct meaning from the destruction. They were in awe of war's waste. In *Ruin Nation*, Megan Kate Nelson recovers how frequently ruins provoked references in letters, diaries, battle reports, newspapers, and so on. A Union soldier who visited Fredericksburg after the war found the experience "humiliating" and terrible "to see an American city battered in this way," and "this too, by Americans." As such, people at the time often saw the ravages left by war as an example of the savagery inherent in human beings.[11] Work forthcoming by K. Stephen Prince suggests that Northerners also could see in this destruction vindication of their cause. The ruins supplied tangible evidence of the superiority of Northern political, labor, and military systems, as well as evidence of divine sanction. In this case, ruins were a good thing, although not without troubling considerations by Northerners.[12]

Two decades after featuring this image in an essay, the field has changed, as has my career. The home front has grown from a relatively new child to a more mature

adult historians try to improve, if not push beyond. Since the mid-1990s I have gone from an assistant professor at the University of North Carolina at Greensboro to a full professor at the Pennsylvania State University, but I always remember—especially when helped by a certain photograph—a time when I was a graduate student struggling to find my way and hoping that an essay on Fredericksburg might help the cause. The Destructive War as exemplified in the scarred buildings along the Rappahannock River has left a personal impact.

NOTES

1. William A. Blair, "Barbarians at Fredericksburg's Gate: The Impact of the Union Army on Civilians," in Gary W. Gallagher, ed., *The Fredericksburg Campaign: Decision on the Rappahannock* (Chapel Hill: University of North Carolina Press, 1995), 142–70.

2. The American Civil War Homepage, http://sunsite.utk.edu /civil-war/, accessed August 20, 2013.

3. See, for instance, J. Matthew Gallman, *The North Fights the Civil War: The Home Front* (Chicago: Dee, 1994); J. Matthew Gallman, *Northerners at War: Reflections on the Civil War Home Front* (Kent, Ohio: Kent State University Press, 2010); Paul A. Cimbala and Randall M. Miller, eds., *Union Soldiers and the Northern Home Front: Wartime Experiences, Postwar Adjustments* (New York: Fordham University Press, 2002).

4. Anne Marshall, "The Southern Home Front," *Journal of the Civil War Era* 2 (March 2012): 7; Stephen Berry, "Forum: The Future of Civil War Era Studies," http://journalofthecivilwarera.com /forum-the-future-of-civil-war-era-studies.

5. James Marten, *The Children's Civil War* (Chapel Hill: University of North Carolina Press, 1998).

6. For a similar point, see Drew Gilpin Faust, "The Civil War Homefront," in *Rally on the High Ground: The National Park Service Symposium on the Civil War*, http://www.cr.nps.gov/history/online _books/rthg/chap6.htm.

7. See, for instance, Charles Royster, *The Destructive War: William Tecumseh Sherman, Stonewall Jackson, and the Americans* (New York: Knopf, 1991).

8. E. Susan Barber and Charles F. Ritter, "'Physical Abuse . . . and Rough Handling': Race, Gender, and Sexual Justice in the Occupied South," in LeeAnn Whites and Alecia P. Long, eds., *Occupied Women: Gender, Military Occupation, and the American Civil War* (Baton Rouge: Louisiana State University Press, 2009), 49–66; Crystal N. Feimster, "Rape and Justice in the Civil War," *Opinionator* (blog), *New York Times*, April 25, 2013, http://opinionator.blogs.nytimes.com /author/crystal-n-feimster.

9. Yael Sternhell, "Revisionism Revisited: The Antiwar Turn in Civil War Scholarship," *Journal of the Civil War Era* 3 (June 2013): 243.

10. For a rebuttal to the notion of total war and unlimited warfare, see Mark E. Neely Jr., "Was the Civil War a Total War?" *Civil War History* 50 (December 2004): 434–58, and Neely, *The Civil War and the Limits of Destruction* (Cambridge, Mass.: Harvard University Press, 2007).

11. Megan Kate Nelson, *Ruin Nation: Destruction and the American Civil War* (Athens: University of Georgia Press, 2012), 2–3.

12. K. Stephen Prince, "The Burnt District: Southern Ruins and the Meaning of Reconstruction," in Gregory Downs and Kate Masur, eds., *Reconstruction* (Chapel Hill: University of North Carolina Press, forthcoming 2015).

George N. Barnard, "Charleston, S.C.
View of ruined buildings through porch of the
Circular Church (150 Meeting Street)," 1865.

MEGAN KATE NELSON

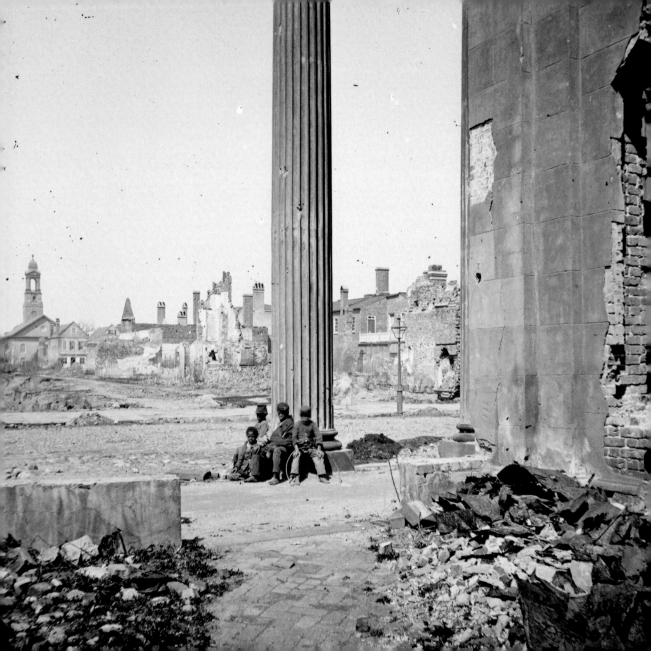

THE PHOTOGRAPH'S caption is meticulous. "Charleston, S.C.": the Cradle of the Confederacy. The birthplace of secession. "View of ruined buildings": an aesthetic rendering of urban destruction, an argument for ruins as something worth seeing. "Through porch of the Circular Church": the eye moves through space, from interior to exterior. "(150 Meeting Street)": the image situated in place, the street at the center of South Carolina's vital port city and home to its most significant civic and religious buildings. "1865": the end of the war. The Union saved, the Confederacy in ruins.

The caption is comprehensive. But it is also indefinite; it could describe any number of views taken from this vantage point at 150 Meeting Street. And it makes no mention of the actual subject of the photograph and its most striking feature: four black boys, gathered together at the base of a ruined column that at one time supported the portico of the Circular Church. That they are boys is evident from their small size and the fact that one of them has a hoop resting across his knees. One imagines the photographer (George N. Barnard, following William Tecumseh Sherman's troops through South Carolina in the winter and spring of 1865) stopping these boys as they were running down Meeting Street, keeping pace with the hoop they were urging along with a stick. He would have asked them to sit for his camera. Perhaps they seated themselves or Barnard arranged them. Their bodies curve around the left (south) side of the pillar, tracing its shape while leaving the right (north) side of the base visible. Three of them sat still for Barnard, waiting for the photographer to expose the film. The other, the boy with the hoop, was clearly restless; his facial features and upper body are blurred. The boys sit close together (one is on the ground, his hand resting on another's knee), and despite the angles of their bodies, they have all turned their heads and are looking the viewer in the eye.

Whether Barnard's camera was already set up to take this shot when the boys came along, we cannot know. It is likely, for this particular "view of ruined buildings" was aesthetically pleasing in and of itself. Barnard stood on south side of the building, along its ruined exterior wall, right before that wall curved out in the circular shape for which the church was named. From that angle he could capture part of a gaping hole in the church wall, where a window (one of twenty-six) had melted or exploded. The open air exposed the building's materials: walls of brick covered by a thin stone skin. Barnard trained his camera lens on one of the church's six remaining columns; it soars upward, bisecting the image, its Ionic capital out of the frame. Someone had cleared the rubble

from this side of the church, creating a pathway. It is an ocular thoroughfare, leading the eye from the foreground of the shot to the boys at the base of the pillar to the uneven street behind them and then to the ruins beyond.

"View of ruined buildings" is one of a series of Barnard's war pictures of cities destroyed in 1864 and 1865 as part of Sherman's campaign in Georgia and the Carolinas; he included images of Charleston as well as Columbia and Richmond in his *Photographic Views of the Sherman Campaign* (1866). The Civil War gave American artists like Barnard a range of ruined landscapes to depict. Scenes of urban destruction began to appear in newspapers, magazines, and photographic exhibits and albums as early as the summer of 1861. However, Barnard's extensive coverage of Charleston's urban rubble is unusual within the oeuvre of war landscape photography, in which images of battlefields, fortifications, and army camps predominate. And although many Americans were familiar with images of ruins—landscape paintings or illustrations of the Roman Campania, or lithographs of the great urban fires of the antebellum period—these views of war-torn cities and towns were something new.

While "View of ruined buildings" might have been a novel scene, the photograph is in many ways a traditional landscape image. There is a slightly elevated prospect—Barnard may have been standing on a mound of rubble or part of the church's low cemetery wall—creating a literal "view." The horizontal lines (the top of the wall in the foreground, the curbs of the street in the middle ground) give a sense of space, while the vertical lines (the church wall that frames the right side of the image and the column in the center, the "lone chimneys" of the urban ruins in the background) convey both height and—given the location—a sense of spirituality. The eye follows a diagonal line, however, moving slightly right to left from the pathway to the boys at the base of the pillar and then taking a sharper left down a road toward an intact church in the left background. All of these lines, which are formal elements of most landscape paintings in the Western tradition, work together to suggest movement, energy, and instability in three dimensions.

Ruins have long been part of this aesthetic, providing contrasts between light and shadow (chiaroscuro) and between linear and curving shapes; such disparities are pleasing to the eye. Crumbling walls and pillars began to appear frequently in religious paintings during the Renaissance, but it was not until the French artist Claude Lorrain began to paint landscapes as subjects (rather than as setting) in the mid-seventeenth century that ruins moved from the background into the middle and foreground of art. The American painters of the Hudson River School took up this established landscape style, although they did not have many American ruins to depict in their works (John Gadsby Chapman's *The Ruins of Jamestown* [1835] is a rare exception). Many decamped to Italy in order to paint crumbling edifices, while others created imaginary ruins to convey broader metaphorical narratives.

"View of ruined buildings" makes gestures to these artistic conventions and to the American landscape painter Thomas Cole's *The Course of Empire: Desolation* (1836). Cole's series of five paintings depicts the rise and fall of an imagined city from its initial site as a hunting ground for "savages" to its imperial apex to its violent

destruction. *Desolation*, the last painting in the series, portrays the city many years after its fall, overgrown with verdure. A single column, with its elaborate Corinthian capital, looms up in the foreground and dominates the scene. The column is the ultimate symbol of failure, an architectural remnant whose original function has been destroyed; its capital is exposed to the air and has become a nest for birds.

The Circular Church column evokes this sense of failure. It also dramatizes the disjunction that all ruins symbolize: the contrast between the past and the present. The Charleston of the past was a vibrant port city, the second largest in the South during the antebellum period. Although it was not the political capital of South Carolina, it was its cultural epicenter and the locus of its manufacturing and shipping power. When a small-pox scare prompted legislators to flee from Columbia in December 1860, they went directly to Charleston, where they voted overwhelmingly in favor of secession—in the building next door to the Circular Church. Barnard set up his camera in the space between these two structures. Although Institute Hall is not the subject of the shot or referenced in the caption, its jagged and roofless walls hover on the margins. Here are the ruins of secession, proof of the Union's victory, ordained by God.

And what of the four boys sitting among the rubble? Their inclusion is also part of the long history of landscape aesthetics. Religious and historical figures (Mary and the baby Jesus, most prominently) dominated the paintings of the Renaissance, while shepherds and farmers wandered through Claude Lorrain's ruined landscapes. But the boys' presence in "View of ruined buildings" suggests that at this moment the past of slavery has turned into the present of emancipation. They are free to run down Meeting Street, chasing their hoop. They are free to pose for Union photographers. And they are free to look the viewer in the eye. Their direct gaze is unusual within Civil War ruin images. Most other figures in Barnard's photographs of urban rubble look contemplatively into the distance or turn away from the camera to gaze at the ruins in their midst. When these boys look directly at the viewer, it is a challenge. What kind of future is in store for them? What kind of new world will be made out of the ruins of the South?

The impact of "View of ruined buildings" depends on the viewer's reading of Charleston's ruins and the boys' freedom as inextricably linked, the belief that the Union army's destruction of the city made emancipation possible. But the Circular Church and Institute Hall were not reduced to rubble during the Union siege and bombardment of the city, which began in the summer of 1863. They were burned to the ground during the most destructive fire in Charleston's history, which tore through the city over the course of two days in December 1861.

It was late in the evening when the fire started, in a sash and blind factory on Hasell Street fronting the Cooper River. A strong wind blowing to the southwest sent the flames on a diagonal course through the city streets, devouring more than six hundred buildings before burning itself out on the banks of the Ashley River in midafternoon on December 12. The wind showered "sparks & flakes around or [bore] them far aloft in the air," wrote Charleston resident Emma Holmes, "where they floated like falling stars."[1] Just after midnight on the twelfth, the fire had reached Meeting Street and the Circular Church was burning. Around 3:00 a.m., part

George N. Barnard, "Charleston, S.C."

of its steeple collapsed in giant flaming shards. The loss of this building was a shock to residents; the church site and burial ground had been in constant use since the seventeenth century, and the sanctuary had been designed by prominent Charleston architect Robert Mills in 1804. The 182-foot-high steeple was added in 1838. Holmes had a personal connection to the church, for it was where "all [her] ancestors worshipped and are buried for 175 years." Her Uncle James ran into the building before it was consumed by the flames and "saved the Bible & Hymn Book."[2]

Charleston was no stranger to urban conflagrations. From 1700 to 1865, the city experienced more than fifteen major fires that destroyed significant sections of the city. To protect private and public property, city officials assigned policemen to fire details and called for volunteers to form fire companies. By December 1861, however, the city's fire companies had been depleted by the war effort; the vast majority of their members had already departed with their regiments to fight for the Confederacy in the Eastern and Trans-Mississippi Theaters. Those who remained rushed to the scene of the fire that night but could not do much to control it. Among those who battled the flames were a significant number of Charleston's free blacks and slaves.[3]

Biracial fire companies were not a wartime exigency. Since the 1810s the city had been paying slaves—most of them already licensed by their owners to hire out their time—and free blacks twenty-five cents each to help fight fires (their white counterparts were paid fifty cents). By 1837 they manned sixteen of Charleston's fire engines, under white supervision. On the night of December 11, they hurried into the burning streets, and their efforts, according to Emma Holmes, were "superhuman." The *Charleston Mercury* lauded their work, crowing that "one of the most gratifying incidents of the fire of Wednesday night, was the zeal manifested by our slaves, in their efforts, as firemen and laborers."[4]

White Charlestonians took comfort in reports of slaves' heroic efforts to save their city, for they had lived in nearly constant fear of slave insurrection since the discovery of Denmark Vesey's plot in 1822.[5] However, before the flames died down there were already rumors of three different origin points, which suggested that the destruction was the work of "incendiaries." Moses Henry Nathan, chief of the city's fire department, also suspected arson and thought the fire might have been the work of William P. Russell, the owner of the sash and blind factory. Nathan had done some investigating and determined that 70 percent of all urban fires "occurred in stocks of goods"—which businessmen later claimed on insurance forms. Russell publicly proclaimed his innocence and blamed "country Negroes" living in a shed next to his factory.[6] Charleston resident Elizabeth Frost did not believe Russell and noted in a letter to her brother that the factory owner had received several warnings about the safety of his building "but to no purpose." Although the fire may have started due to Russell's carelessness, Frost admitted, "a good many persons think it was helped by the negroes and some think by Yankee emissaries."[7]

Nathan ultimately concluded that debris from an upper floor of Russell's factory "drifted down into the furnace on the lower floor" and then high winds prevented firefighters from containing the blaze.[8] But the rumors about a slave conspiracy persisted. When the

New York Times reported on the fire a few days later, the editors acknowledged that such tales were likely false. However, they wrote, if "the conflagration be really the work of slaves in insurrection, the fact brings a terrible completeness into the logic of the event. Although special pains have been taken by the Southern leaders and journals to represent the blacks as showing no disposition to revolt, yet many denotements have of late appeared to show that the slaves are catching the contagion of fury from their masters."[9] The insurrectionary actions taken in Institute Hall, the *Times* seemed to suggest, may have provoked the desire and created an opportunity for slaves to revolt against whites in Charleston, to destroy the material foundations of a Confederacy built upon the right to trade in and own black bodies.

Such an interpretation frames the great fire of December 1861 as an act of providence of the retributive sort: the city burned as vengeance for slavery, for secession, and for war itself. "If any place could deserve such a doom," the *New York Times* editors wrote, "it is the cursed city by the sea, in whose harbor the ensign of the Republic received its first wound, in being lowered to armed ingrates, their country's parricides."[10] White Charlestonians understood the fire differently, of course. To many of them, the conflagration was God's will—but of the benevolent sort. It was a test of the community's will to survive. And after aid money poured in from several different states, the fire was seen as a confirmation of Confederate unity. Emma Holmes firmly believed "that God has permitted this to unite us still more closely than before & to prepare and purify us through suffering for the great position he means for us to occupy."[11]

For white Charleston residents, this vision of imperial destiny was confirmed in the city's ruins. In the days after the fire, the residents of Charleston wandered through the wreckage. Emma Holmes was particularly captivated by the ruins of the Circular Church, its walls "perfect and part of the steeple still standing." She rambled down Meeting Street in the evening, and "with the moonlight streaming through the windows & the monuments gleaming beyond, the effect was beautiful & reminded us of the Coliseum," she wrote in her diary. "While the front view, with the row of Ionic columns standing as if to guard the sanctuary, brought the ruins of the old Grecian temples vividly before us."[12] For Holmes, the ruins forged a link between present and past and rendered the Confederacy an heir to the ancient empires of Greece and Rome.

But Charleston's black residents also wandered through the ruins in late December 1861 and in the days and years following. Despite the money that came to residents in the weeks after the fire, funds dried up and Charleston's officials, businessmen, and home-owners could not afford to rebuild the structures in the burnt district. When Sherman's soldiers marched through the fallen city in February 1865—led by a black regiment—they found an urban wilderness overgrown with weeds, an American Pompeii. And here, not at the Battery (where most of the Union shells had fallen in the siege of 1863–65), was where George Barnard spent most of his time taking photographs of "war scenes."

Barnard saw no need to mention the great fire of 1861 in the captions for his photographs of Charleston. His motives were likely both aesthetic and political. The

George N. Barnard, "Charleston, S.C."

ruins themselves were impressive landscapes, and they photographed beautifully. All of those hard edges and sharp angles, all of that light and shadow. When he pulled those black boys off the street and into his image, he very likely intended to create a redemptive narrative of the war's destruction, an image of the U.S. Army's victory in the name of Union and emancipation. True, "View of ruined buildings" is not a war view if we define war views as images depicting destruction brought about by battle or bombardment. But this photograph is a war view in the sense that it dramatizes the struggle at the heart of the Civil War: the fight over what constituted liberty and property, the rights of man. "View of ruined buildings" evokes the past, the present, and the future of that struggle, in all of its rage and its terrible completeness.

NOTES

1. Emma Holmes Diary, December 16, 1861, quoted in John F. Marszalek Jr., ed., "The Charleston Fire of 1861 as Described in the Emma E. Holmes Diary," *South Carolina Historical Magazine* 76 (April 1975): 61.

2. "A Brief History of the Circular Church," circularchurch.org; Emma Holmes Diary, December 16, 1861, quoted in Marszalek, "Charleston Fire of 1861," 63.

3. Marie Ferrara, "Moses Henry Nathan and the Great Charleston Fire of 1861," *South Carolina Historical Magazine* 104 (October 2003): 264.

4. Ferrara, "Moses Henry Nathan," 264, 273–74; Emma Holmes Diary, December 16, 1861, quoted in Marszalek, "Charleston Fire of 1861," 62; Brian Hicks, "Charleston at War: Charleston Beaten Down by Great Fire," *Charleston Post and Courier*, January 30, 2011; updated, March 23, 2012, www.postandcourier.com.

5. Ferrara, "Moses Henry Nathan," 265.

6. Hicks, "Charleston at War"; Ferrara, "Moses Henry Nathan," 269–70, 274–75.

7. Elizabeth Frost to Dr. Frank Frost, December 14, 1861, as quoted in Ferrara, "Moses Henry Nathan," 275.

8. Ferrara, "Moses Henry Nathan," 276.

9. "Charleston in Ashes," *New York Times*, December 16, 1861.

10. Ibid.

11. Ferrara, "Moses Henry Nathan," 259, 277; Emma Holmes Diary, December 16, 1861, quoted in Marszalek, "Charleston Fire of 1861," 60, 66.

12. Emma Holmes Diary, December 17, 1861, quoted in Marszalek, "Charleston Fire of 1861," 66–67.

Megan Kate Nelson

The Grand Review

STEVEN E. WOODWORTH

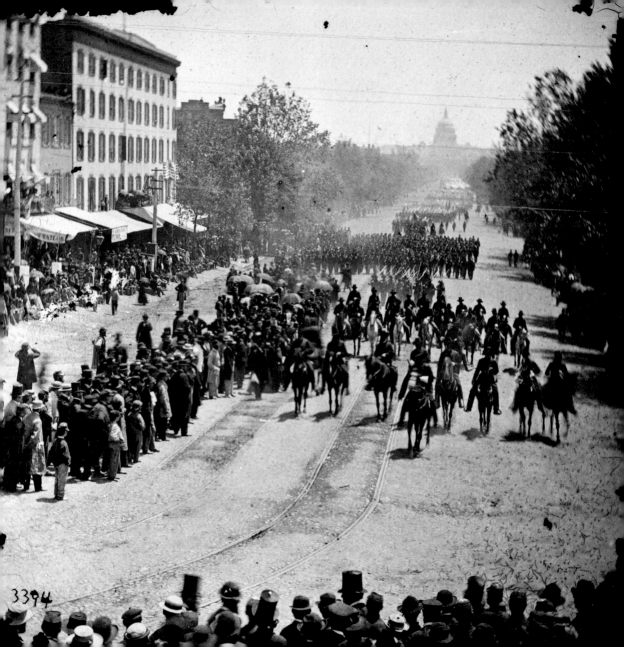

3394

IT WAS HARD for me to choose a single photograph as my favorite image of the Civil War. There are quite a number of pictures I could have selected and could reasonably have called my favorite. I finally decided on this one, not for any particular artistic merit (I wouldn't be the one to judge artistic merit anyway), but rather for what it depicts. This is a photograph of Union troops marching down Pennsylvania Avenue in an event known as the Grand Review of the Armies. The scene has somewhat the appearance of a celebration, and one might well ask, what is there to celebrate about a war? Well, first of all, its end, and, second, victory. Those were just what the Grand Review was celebrating.

During the spring of 1865, the conflict had moved rapidly toward its conclusion. On April 2, Richmond fell, and a week later General Robert E. Lee surrendered the remnant of the Army of Northern Virginia at Appomattox. On April 18, General Joseph E. Johnston opened negotiations with Major General William Tecumseh Sherman for the surrender of the Confederate army in North Carolina, and eight days later soldiers in gray and butternut uniforms laid down their arms at Durham Station. On May 4, Lieutenant General Richard Taylor surrendered the remaining Confederate forces east of the Mississippi River to Major General Edward R. S. Canby at Citronelle, Alabama. By then it was clear that the remaining Rebels west of the Mississippi would not keep up the fight much longer. On May 10, President Andrew Johnson declared the rebellion officially over.

Already plans were underway for the great victory parade that would be called the Grand Review. Not all of the Union troops could take part. Many units were elsewhere around the country, performing various necessary duties such as chasing down the last Confederates, maintaining order in the formerly rebellious states, or putting the fear of the United States into French emperor Napoleon III, who was conducting an ongoing adventure in imperial expansion in Mexico. If not doing indispensable work at the far-flung stations, tens of thousands of bluecoats were at least too far from the capital to reach it in time for the May 23–24 event. Participation in the parade was not necessarily a matter of fairness or choice but rather of the happenstance of proximity.

Two units were the beneficiaries of their proximity. The first, obviously, was the Army of the Potomac. Based near the national capital and charged with protecting it, that army had remained within 150 miles of Washington throughout the war. It had no trouble reaching the capital in time for the Grand Review. The other Union force destined for the great parade was Sherman's group of western armies—the Army of the Tennessee and the Army of Georgia. Most of these troops hailed

from what is now known as the Midwest, and they had started their war from bases such as Louisville, Kentucky, and Cairo, Illinois, but their success had carried them through Vicksburg, Atlanta, Savannah, and the capitals of five Rebel states. When hostilities ended, they had been marching north on their way to join Grant near Petersburg and Richmond to finish off Lee. Their help had turned out to be unnecessary for that task, but the march had put them just 225 miles from the national capital by the time of Johnston's surrender. That was still a good piece of countryside to cover on foot, but the western armies prided themselves on their marching ability. Indeed, some of their officers took rather too much pride in that ability and caused a number of heat-exhaustion casualties as they raced their units northward through the sultry late-spring weather in Virginia. At any rate, they were encamped on the outskirts of Washington in time for the Grand Review. Together, the Army of the Potomac, the Army of the Tennessee, and the Army of Georgia numbered about 150,000 men.

Their parade through the capital city was scheduled for two days. The Army of the Potomac would march through on Tuesday, May 23, and the western armies the following day. The twenty-third dawned clear and pleasant with light breezes. Major General George G. Meade rode alone at the head of the Army of the Potomac as it crossed the Long Bridge from its camps on the Virginia side of the river into the District of Columbia, then up Capitol Hill and down Pennsylvania Avenue where President Johnson, General in Chief Ulysses S. Grant, and other dignitaries sat in a reviewing stand not far from the White House. Washington was decked out in celebration. The black crepe and other signs of public

mourning that had been on display everywhere one looked for more than a month in honor of the slain Abraham Lincoln were now removed, to be replaced by what seemed to be thousands of flags and thousands of yards of bunting. Most striking, though, were the crowds. People lined the sidewalks four or five deep, when not more, and sometimes spilled into the streets. Many watched from windows and balconies. Soldiers remembered the ladies waving handkerchiefs or throwing flowers. And of course there was the cheering as the thousands of spectators shouted themselves hoarse during the six hours it took the army to pass by any given point on the parade route.

The next day came the turn of the western armies. They had been encamped on the heights of Arlington, Virginia, for the past two days, from which they could gaze across the river at the capital city with all the wonderment of country boys seeing it for the first time, which most of them were. One noted that he could make out all the important sights—the Washington Monument, the Capitol, the White House, and the lunatic asylum.

May 24 dawned as fair as the day before, and Sherman's men were up early. They marched across the Long Bridge and then up to the foot of Capitol Hill, where they formed up on Pennsylvania Avenue and waited for the signal cannon, as Meade's men had done the day before. It came precisely at 9:00 a.m., and the column stepped off. Sherman rode at the head, as Meade had done the day before, and he worried that his men would not march well. It was not a question of ability; they had done plenty of drilling over the years. The question was one of motivation. Would the veterans of the Georgia and Carolina Campaigns think they ought to march

carefully in step down Pennsylvania Avenue? He might have put his mind at ease if he had known that some of his men had gone into town on their own the day before to watch the Army of the Potomac parade and had come back to camp assuring their comrades that they could outmarch the paper-collar easterners. The westerners were determined to do it.

Down the avenue they strode now, past banners that read "Welcome to Our Western Boys" and "Hail to Sherman's Army." As they had the day before, women threw flowers in amazing quantities, especially at the regimental bands, which began to look like "moving flower gardens."[1] As they reached the Treasury Building, the position shown in this photograph, Sherman ventured to turn in the saddle and look to see how his boys were marching. As he gazed up Pennsylvania Avenue toward the Capitol, "the sight was simply magnificent. The column was compact, and the glittering muskets looked like a solid mass of steel, moving with the regularity of a pendulum."[2]

With Sherman rode the recent Army of the Tennessee commander, Major General Oliver O. Howard, lately transferred to head up the Freedmen's Bureau. Behind them rode their staffs, then the current Army of the Tennessee commander, Major General John A. Logan, followed by his staff. Then came the infantry. Leading the column was the 100th Indiana Infantry. In its ranks, nineteen-year-old soldier Theodore Upson stole a sidelong glance at the comrades in line. "Every man had his eyes front," Upson later remembered. "Every step was perfect, and on the faces of the men was what one might call a *glory look*." As it passed the reviewing stand, each regiment crisply moved from "right shoulder shift" to "carry arms," the marching salute. The dignitaries on the reviewing stand lifted their hats, and the crowds cheered again. As his regiment marched beyond the stand and smartly brought its rifles up to a right shoulder, Upson thought, "My, but I was proud of our boys."[3]

The Army of the Tennessee marched by the reviewing stand for three hours, and then came the Army of Georgia, led by its commander, Major General Henry W. Slocum, followed by his staff. They are the horsemen who appear in the photograph, with the Army of Georgia's infantry stretching out rank on rank behind them all the way to the Capitol. Like all of Sherman's troops, they marched precisely but with a certain swagger. One spectator was heard to remark, "They march like lords of the world!"[4]

The pride came not so much from being able to march in step down Pennsylvania Avenue as from having won the privilege of doing so in the previous three or four years of hard campaigning, both on the part of the Army of the Potomac and the western armies, as well as the many thousands of Union soldiers who could not be part of that parade. Together, their efforts had won the war, preserved the Union, vindicated self-government, and ended slavery. There had been much sorrow along the way, many hardships, many comrades buried in Southern soil or sent home maimed. There would be many trials and disappointments ahead, both in the soon-to-be-former soldiers' personal lives and in the national affairs of a country that still had a long way to go to achieve equality of rights under the law. "The coming of the Lord," of which so many soldiers and spectators had sung during those two days of marching as part of what seemed the favorite song of the review,

The Grand Review

"The Battle Hymn of the Republic," had been no more than figurative. They had not ushered in the millennium. The struggles of life would continue. But one very great struggle was over and won. The guns were silent. The wholesale killing had stopped. The slaves were free, and the Great Republic was saved. There was cause for celebration, cause for a parade and flowers and banners and bands.

And that is why I chose this as my favorite photograph of the Civil War.

NOTES

1. Theodore F. Upson, *With Sherman to the Sea: The Civil War Diaries, Letters, and Reminiscences of Upson*, ed. Oscar Osburn Winther (Bloomington: Indiana University Press, 1958), 177–78; Isaiah T. Dillon to "My Dear Wife Sarah," May 29, 1865, Isaiah T. Dillon Papers, Lincoln Library, Springfield, Illinois; Hosea W. Rood, *Story of the Service of Company E, Twelfth Wisconsin Regiment Veteran Volunteer Infantry in the War of the Rebellion* (Milwaukee: Swain and Tate, 1893), 447–48; Young J. Powell to Ellen Aumack, May 28, 1865, Ellen Aumack Papers, Perkins Library, Duke University, Durham, N.C.; Charles F. Hubert, *History of the Fiftieth Regiment, Illinois Volunteers in the War of the Union* (Kansas City: Western Veteran, 1894), 394–95; Aaron Dunbar, *History of the Ninety-third Regiment, Illinois Volunteer Infantry: From Organization to Muster*, ed. Harvey M Trimble (Chicago: Blakeley, 1898), chap. 12 available at the website Illinois in the Civil War, http://www.illinoiscivilwar.org/cw93-hist-ch12.html.

2. William Tecumseh Sherman, *Memoirs of William T. Sherman* (1875; reprint with notes by Charles Royster, New York: Library of America, 1990), 865–66.

3. Upson, *With Sherman to the Sea*, 177–78.

4. William B. Hazen, *Narrative of Military Service* (Boston: Ticknor & Co., 1885), 378; Jack K. Overmyer, *A Stupendous Effort: The 87th Indiana in the War of the Rebellion* (Bloomington: Indiana University Press, 1997), 168.

Steven E. Woodworth

Suggested Readings

THE PUBLISHED photographic record of the Civil War began the year after hostilities ended with two landmark collections of images. Scottish-born Alexander Gardner, perhaps most famous for his views of the battlefields of Antietam and Gettysburg, offered *Gardner's Photographic Sketch Book of the War*, 2 vols. (Washington, D.C.: Philp & Solomons, 1866), which included among its 100 plates not only some of his own best work but also that of other photographers such as Timothy H. O'Sullivan and George N. Barnard. That same year, Barnard presented 61 images in *Photographic Views of Sherman's Campaign, Embracing Scenes of the Occupation of Nashville, the Great Battles around Chattanooga and Lookout Mountain, the Campaign of Atlanta, March to the Sea, and the Great Raid through the Carolinas* (New York: n.p., [1866]), many of which are simply stunning in their complexity and beauty. Of the two, Gardner's reached by far the larger audience in the original edition, though modern students can find both in high-quality reprints.

Photographer A. J. Russell also created a scrapbook of 116 images, though he never published it. Charged with recording the railroad-construction accomplishments of the Union army in Virginia, Russell also created views of ruins, battlefields, entrenchments, and other subjects. Editors Joe Buberger and Matthew Isenberg made Russell's work available as *Russell's Civil War Photographs: 116 Historic Prints by Andrew J. Russell* (New York: Dover, 1982), a volume that merits a place alongside those by Gardner and Barnard.

Francis Trevelyan Miller's *The Photographic History of the Civil War*, 10 vols. (New York: Review of Reviews, 1911), published on the fiftieth anniversary of the outbreak of the war, stood as the standard work of its kind for nearly three-quarters of a century. Miller selected approximately 3,500 images and added a connecting text. Although many of the photographs lack sharpness and the narrative and captions are littered with errors, Miller's compilation remains worth consulting by all serious students of Civil War photography and easily can be found in several reprint editions of uneven quality.

The modern successors to Miller are two collections edited by William C. Davis: *The Image of War, 1861–1865*, 6 vols. (Garden City, N.Y.: Doubleday, 1981–84), and *Touched by Fire: A Photographic Portrait of the Civil War*, 2 vols. (Boston: Little, Brown, 1985–86). Containing more than four thousand and one thousand images respectively, these sets easily surpass Miller in terms of textual accuracy and crispness of the photographs, and together they constitute the beginning point for anyone seeking to build a library of Civil War images.

A trio of books by William A. Frassanito created a new genre of works devoted to photography during the conflict. In *Gettysburg: A Journey in Time*, *Antietam: The Photographic Legacy of America's Bloodiest Day*, and *Grant and Lee: The Virginia Campaigns of 1864–1865* (New York: Scribner's, 1975, 1978, 1983), Frassanito pioneered the technique of finding the precise locations of wartime photographs and duplicating the shots, to the extent possible, on the modern landscape. More than any other student of the war's photography, Frassanito corrected errors regarding where and when original photographs were taken while also demonstrating the degree to

which Alexander Gardner and others rearranged bodies and objects to achieve maximum impact.

Three general pictorial histories, all of which contain hundreds of photographs as well as other illustrative material, stand out among titles that introduce readers to the visual side of the conflict. *Divided We Fought: A Pictorial History of the War, 1861–1865*, edited by David Donald (New York: Macmillan, 1952), includes many full-page reproductions of iconic photographs. *The American Heritage Picture History of the Civil War* (Garden City, N.Y.: Doubleday, 1961), compiled by the editors of *American Heritage: The Magazine of History* and with a beautifully crafted text by Bruce Catton, likely attracted more readers to the Civil War during the centennial era than any other single book. *The Civil War: An Illustrated History* (New York: Knopf, 1990) was published in connection with Ken Burns's popular documentary *The Civil War* and combined high production values with a fine text by Geoffrey C. Ward. All three of these volumes, it is worth noting, contain a number of errors in the captions for photographs.

Among recent photographic books, three stand out. Bob Zeller's *The Blue and Gray in Black and White: A History of Civil War Photography* (Westport, Conn.: Praeger, 2005) provides a superb introduction to the subject, exploring technical details, discussing some of the most famous photographers, and reproducing important images. Christine Dee's *"Feel the Bonds That Draw": Images of the Civil War at the Western Reserve Historical Society* (Kent, Ohio: Ken State University Press, 2011) draws on one of the great collections of Civil War images, while *Landscapes of the Civil War: Newly Discovered Photographs from the Medford Historical Society*, edited by Constance Sullivan (New York: Knopf, 1995), uses extremely high-quality, full-page images to transport the reader into the world of the generation that experienced the conflict.

One last series deserves mention. In 1987, the University of Arkansas Press (Fayetteville) published *Portraits of Conflict:*

A Photographic History of Arkansas in the Civil War, by Bobby Roberts and Carl Moneyhon. Photographs of leaders, common soldiers and civilians, towns and villages, structures, naval vessels, and other subjects, all presented with great attention to quality and tied together by a fine text, set a very high bar. Over the next twenty-five years, nine more impressive volumes appeared, devoted to Louisiana (Roberts and Moneyhon, 1990), Mississippi (Roberts and Moneyhon, 1993), South Carolina (Richard B. McCaslin, 1994), Georgia (Anne J. Bailey and Walter J. Fraser Jr., 1996), North Carolina (McCaslin, 1997), Texas (Roberts and Moneyhon, 1998), Tennessee (McCaslin, 2007), Missouri (William Garrett Piston and Thomas P. Sweeney, 2009), and Alabama (Ben H. Severance, 2012).

These twenty-five titles should more than meet the needs of almost anyone interested in the photographic record of the war. Together with websites devoted to holdings at the Library of Congress ("Civil War Glass Negatives and Related Prints"), the American Memory project ("Civil War Treasures from the New-York Historical Society"), and the National Archives ("Pictures of the Civil War"), they go a long way toward conveying a sense of the immensely rich lode of wartime images.

These texts and websites provide substantial background on the history of photography and the significance of photographs during the Civil War. Readers who wish to pursue these topics from a broader theoretical perspective might wish to consult Susan Sontag, *On Photography* (New York: Farrar, Straus and Giroux, 1977); Roland Barth, *Camera Lucida: Reflections on Photography* (New York: Hill and Wang, 1981); Alan Trachtenberg, *Reading American Photographs: Images as History, Mathew Brady to Walker Evans* (New York: Hill and Wang, 1989); and J. Matthew Gallman, "Snapshots: Images of Men in the United States Colored Troops," *American Nineteenth Century History* 13, no. 2 (2012): 127–51.

Contributors

Stephen Berry is Gregory Professor of the Civil War Era at the University of Georgia. He is the author or editor of four books on nineteenth-century America, including *Weirding the War: Stories from the Civil War's Ragged Edges* (University of Georgia Press, 2011). His work has been supported by fellowships from the National Endowment for the Humanities, the American Council of Learned Societies, and the Mellon Foundation, among others.

William A. Blair is a liberal arts research professor and director of the Richards Civil War Era Center at the Pennsylvania State University. He is the author of, among other books, *With Malice toward Some: Treason and Loyalty in the Civil War Era* (University of North Carolina Press, 2014), and the founding editor of the *Journal of the Civil War Era.*

Stephen Cushman is Robert C. Taylor Professor of English at the University of Virginia. He has written several volumes of poetry and literary criticism, as well as *Bloody Promenade: Meditations on a Civil War Battle* (University Press of Virginia, 1999), which focuses on the Battle of the Wilderness. His book *Belligerent Muse: Five Northern Writers and How They Shaped Our Understanding of the Civil War* (University of North Carolina Press, 2014) examines the narrative artistry of Abraham Lincoln, Walt Whitman, William T. Sherman, Ambrose Bierce, and Joshua Lawrence Chamberlain.

Gary W. Gallagher is the John L. Nau III Professor in the History of the American Civil War at the University of Virginia

and past president of the Society of Civil War Historians. His recent books include *The Union War* (Harvard University Press, 2011) and *Becoming Confederates: Paths to a New National Loyalty* (University of Georgia Press, 2013).

J. Matthew Gallman is professor of history at the University of Florida. The author of several books and articles on the Northern home front, he has recently completed *Defining Duty in the Civil War: Personal Choice, Popular Culture, and the Union Home Front* (University of North Carolina Press, 2015).

Judith A. Giesberg is professor and director of graduate studies in the Department of History at Villanova University. Her books include *Civil War Sisterhood: The United States Sanitary Commission and Women's Politics in Transition* (Northeastern University Press, 2000), *"Army at Home": Women and the Civil War on the Northern Home Front* (University of North Carolina Press, 2009), *Keystone State in Crisis: Pennsylvania in the Civil War* (Pennsylvania Historical Association, 2013), and *Emilie Davis's Civil War: The Diaries of a Free Black Woman in Philadelphia, 1863–1865* (Penn State University Press, 2014). She is researching the sexual culture of Union military camps during the Civil War.

Joseph T. Glatthaar is the Stephenson Distinguished Professor at the University of North Carolina–Chapel Hill. He is author of numerous books and articles, including *The March to the Sea and Beyond: Sherman's Troops in the Savannah and Carolinas Campaigns* (NYU Press, 1985), *Partners in Command: Relationships between*

Civil War Leaders (Free Press, 1994), and *General Lee's Army: From Victory to Collapse* (Free Press, 2008).

Thavolia Glymph is an associate professor of history and African and African American studies at Duke University, where she teaches courses on slavery, the U.S. South, emancipation, Reconstruction, and African American women's history. She is the author of *Out of the House of Bondage: The Transformation of the Plantation Household* (Cambridge University Press, 2008), which won a Philip Taft Labor History Award, and a coeditor of volumes 1 and 3 of *Freedom: A Documentary History of Emancipation, 1861–1867* (Cambridge University Press, 1985, 1990).

Earl J. Hess holds the Stewart W. McClelland Chair in History at Lincoln Memorial University and has authored nearly twenty books on Civil War military history. His recent publications include *Into the Crater: The Mine Attack at Petersburg* (University of South Carolina Press, 2010), *The Civil War in the West: Victory and Defeat from the Appalachians to the Mississippi* (University of North Carolina Press, 2012), and *Kennesaw Mountain: Sherman, Johnston, and the Atlanta Campaign* (University of North Carolina Press, 2013).

Harold Holzer is chairman of the Abraham Lincoln Bicentennial Foundation and Roger Hertog Fellow at the New-York Historical Society. He is the author, coauthor, or editor of forty-six books on Lincoln and the Civil War, including a number of volumes on art, photography, and popular prints. Among his many awards are a second-place Lincoln Prize for *Lincoln at Cooper Union* and the National Humanities Medal in 2008.

Caroline E. Janney is a professor of history at Purdue University and president of the Society of Civil War Historians. She is the author of *Burying the Dead but Not the Past: Ladies' Memorial Associations and the Lost Cause* (University of North Carolina

Press, 2008) and *Remembering the Civil War: Reunion and the Limits of Reconciliation* (University of North Carolina Press, 2013).

James Marten is professor of history at Marquette University and past president of the Society of Civil War Historians. Among his books are *The Children's Civil War* (University of North Carolina Press, 1998), *Sing Not War: The Lives of Union and Confederate Veterans in Gilded Age America* (University of North Carolina Press, 2011), and *America's Corporal: James Tanner in War and Peace* (University of Georgia Press, 2014).

Kathryn Shively Meier is an assistant professor of history at Virginia Commonwealth University. Her first book, *Nature's Civil War: Common Soldiers and the Environment in 1862 Virginia* (University of North Carolina Press, 2013), explores how Civil War soldiers adapted to the mental and physical challenges of their wartime environments using survival techniques and informal networks of care.

Megan Kate Nelson is a freelance writer and historian. She has written for *Disunion* (a *New York Times* blog) and *Civil War Times*, and is the author of *Ruin Nation: Destruction and the American Civil War* (University of Georgia Press, 2012) and *Trembling Earth: A Cultural History of the Okefenokee Swamp* (University of Georgia Press, 2005).

Susan Eva O'Donovan is associate professor of history at the University of Memphis. She is a former editor of the Freedmen and Southern Society Project, coeditor of volumes 1–2 of Series 3 of *Freedom: A Documentary History of Emancipation, 1861–1867* (University of North Carolina Press, 2008, 2013), and author of *Becoming Free in the Cotton South* (Harvard University Press, 2007), which won the James A. Rawley Prize of the Organization of American Historians. She coedits the journal *American Nineteenth Century History* and is currently investigating the political lives of slaves.

T. Michael Parrish is Linden G. Bowers Professor of American History at Baylor University and former president of the Society of Civil War Historians. His books include *Richard Taylor: Soldier Prince of Dixie* (University of North Carolina Press, 1992) and *Brothers in Gray: The Civil War Letters of the Pierson Family* (with Tom Cutrer; Louisiana State University Press, 1997). He edits the series Conflicting Worlds: New Dimensions of the American Civil War at LSU Press.

Ethan S. Rafuse is a professor of history at the U.S. Army Command and General Staff College. His publications include *McClellan's War: The Failure of Moderation in the Struggle for Union* (Indiana University Press, 2005), *Robert E. Lee and the Fall of the Confederacy, 1863–65* (Rowman and Littlefield, 2008), and *Guide to the Richmond-Petersburg Campaign* in the U.S. Army War College Guide to Civil War Battles series (University Press of Kansas, 2014).

Carol Reardon is the George Winfree Professor of American History at the Pennsylvania State University. She is the author of several books on Civil War and American military history, including *Pickett's Charge in History and Memory* (University of North Carolina Press, 1997), *Launch the Intruders: A Naval Attack Squadron in the Vietnam War, 1972* (University Press of Kansas, 2005), and *A Field Guide to Gettysburg* (with Tom Vossler; University of North Carolina Press, 2013). She served as president of the Society of Military History from 2005 through 2009.

James I. Robertson Jr. is Alumni Distinguished Professor Emeritus and founding executive director of the Virginia Center for Civil War Studies at Virginia Tech. A prolific scholar, his books include *The Stonewall Brigade* (Louisiana State University Press, 1963), *A. P. Hill: The Story of a Confederate Warrior* (Random House, 1987), *Soldiers Blue and Gray* (University of South Carolina Press, 1988), and *Stonewall Jackson: The Man, the Soldier, the Legend* (Macmillan, 1997).

Jane E. Schultz is professor of English and director of literature at Indiana University–Purdue University–Indianapolis, where she teaches courses in American literature and culture and the medical humanities. Her books include *Women at the Front* (University of North Carolina Press, 2004), a finalist for the 2005 Lincoln Prize, and *This Birth Place of Souls: The Civil War Nursing Diary of Harriet Eaton* (Oxford University Press, 2011). A project in progress on Civil War medicine, *Lead, Blood, and Ink*, focuses on soldiers.

Aaron Sheehan-Dean is the Fred C. Frey Professor of Southern Studies at Louisiana State University. He is the author of *Why Confederates Fought: Family and Nation in Civil War Virginia* (University of North Carolina Press, 2007) and the *Concise Historical Atlas of the U.S. Civil War* (Oxford University Press, 2009), as well as the editor of several books. He teaches courses on nineteenth-century U.S. history, the Civil War and Reconstruction, and southern history.

Brooks D. Simpson is ASU Foundation Professor of History at Arizona State University, teaching at Barrett, the Honors College as well as the School of Historical, Philosophical, and Religious Studies. A historian of nineteenth-century American history, he has written, cowritten, edited, or coedited several books on the period of the Civil War and Reconstruction. Most recently he edited the Library of America's *The Civil War: The Third Year Told by Those Who Lived It* (2013).

Daniel E. Sutherland, Distinguished Professor of History at the University of Arkansas, is the author or editor of fifteen books about nineteenth-century U. S. history, among them *Guerrillas, Unionists, and Violence on the Confederate Home Front* (University of Arkansas Press, 1999), *A Savage Conflict: The Decisive Role of Guerrillas in the American Civil War* (University of North Carolina Press, 2009), and *American Civil War Guerrillas: Changing the Rules of Warfare* (Praeger, 2013).

Emory M. Thomas is Regent's Professor of History Emeritus at the University of Georgia. His many books include *The Confederate Nation, 1861–1865* (Harper & Row, 1979), *Bold Dragoon: The Life of J. E. B. Stuart* (Harper & Row, 1986), *Robert E. Lee: A Biography* (Norton, 1995), and *The Dogs of War, 1861* (Oxford University Press, 2011).

Elizabeth R. Varon is Langbourne M. Williams Professor of American History at the University of Virginia. Her books include *Southern Lady, Yankee Spy: The True Story of Elizabeth Van Lew, a Union Agent in the Heart of the Confederacy* (Oxford University Press, 2003); *Disunion! The Coming of the American Civil War, 1789–1859* (University of North Carolina Press, 2008); and *Appomattox: Victory, Defeat, and Freedom at the End of the Civil War* (Oxford University Press, 2013).

Joan Waugh, a professor in the Department of History at UCLA, researches and writes about nineteenth-century America, specializing in the Civil War, Reconstruction, and Gilded Age eras. She has published many essays and books on Civil War topics, including *The Memory of the Civil War in American Culture* (with Alice Fahs; University of North Carolina Press, 2004) and *U. S. Grant: American Hero, American Myth* (University of North Carolina Press, 2009).

Steven E. Woodworth is professor of history at Texas Christian University. He is the author, coauthor, or editor of thirty-three books, including *Jefferson Davis and His Generals: The Failure of Confederate Command in the West* (University Press of Kansas, 1990), *Davis and Lee at War* (University Press of Kansas, 1995) *While God Is Marching On: The Religious World of Civil War Soldiers* (University Press of Kansas, 2001), and *Nothing but Victory: The Army of the Tennessee, 1861–1865* (Knopf, 2005).

Credits for Photographs

Pages ii, iii, and 142. Library of Congress, Prints and Photographs Division, reproduction number LC-DIG-cwpb-00218.

Page 8. Library of Congress. Prints and Photographs Division, reproduction number LC. O-77.

Page 18. Dementi Studios. Richmond. Va.

Page 26. Library of Congress, Prints and Photographs Division, reproduction number LC-DIG-ppmsca-35236.

Page 34. Library of Congress, Prints and Photographs Division, reproduction number LC-DIG cwpb-07546.

Page 42. Library of Congress, Prints and Photographs Division, reproduction number LC-DIG-cwpb-01131.

Page 52. Library of Congress, Prints and Photographs Division Washington, LC-DIG-stereo-1s02859.

Page 60. Library of Congress, Prints and Photographs Division, reproduction number LC-DIG-cwpb-07136.

Page 70. Library of Congress, Prints and Photographs Division, reproduction number LC-DIG-cwpb-01402.

Page 78. Virginia Historical Society.

Page 86. Library of Congress, Prints and Photographs Division, reproduction number LC-DIG-cwpb-01451.

Page 94. Cowan's Auction House, Cincinnati, Ohio.

Page 102. Library of Congress, Prints and Photographs Division, reproduction number LC-DIG-cwpb-04324.

Page 112. Library of Congress, Prints and Photographs Division, reproduction number LC-DIG-cwpb-01663.

Page 115. Library of Congress, Prints and Photographs Division, reproduction number LC-DIG-cwpb-01666.

Page 122. Courtesy of U.S. Army Military History Institute, Carlisle Barracks, Pa.

Page 124. Linus P. Brockett and Mary C. Vaughan, *Woman's Work in the Civil War* (Philadelphia: Zeigler, McCurdy, 1867), 747.

Page 125. Courtesy of Michigan State Archives, Lansing.

Page 134. Nebraska State Historical Society, RG3323.PH6-12.

Page 152. Library of Congress, Prints and Photographs Division, reproduction number LC-DIG-ppmsca-11747.

Page 160. Library of Congress, Prints and Photographs Division, reproduction number LC-DIG-ppmsca-11747.

Page 168. Library of Congress, Prints and Photographs Division, reproduction number LC-B8184-7964-A.

Page 178. Library of Congress, Prints and Photographs Division, reproduction number LC-DIG-ppmsca-3545.

Page 180. Collection of the Museum Division, Mississippi Department of Archives and History.

Page 186. "Private John Q. Rose, Company C, 8th Kentucky Volunteers. Admitted per Steamer New York, from Richmond, Va., May 2, 1864. Died May 4, 1864, from the effects of treatment while in the hands of the enemy." *Report of the Joint Committee on the Conduct of the War, Washington, May 5, 1864.* Harvard Medical Library Rare Books Collection (33.Ah.1864.4).

Page 196. Library of Congress, Prints and Photographs Division, reproduction number LC-DIG-ppmsca-34150.

Page 206. Library of Congress, Prints and Photographs Division, reproduction number LC-DIG-ppmsca-08248.

Page 214. Library of Congress, Prints and Photographs Division, reproduction number LC-DIG-cwpb-03351.

Page 224. Library of Congress, Prints and Photographs Division, reproduction number LC-DIG-ppmsca-32890.

Page 232. Library of Congress, Prints and Photographs Division, reproduction number LC-DIG-cwpb-03049.

Page 240. Library of Congress, Prints and Photographs Division, reproduction number LC-DIG-cwpb-02943.

Index

Perry (Robert E. Lee's manservant), 79

Petersburg, Battle of, 171

Petersburg, Virginia, 153–57; and City Point, Virginia, 207–8; and Robert E. Lee, 19–23

pets as mascots, 118–19

Philadelphia, Pennsylvania, 116, 207

photographs and photography: of African Americans, 135–36; of the dead, defended by Mathew Brady, 189, 192; identified pictures of the dead, 179; manipulation of, 163, 171–74; and posing, 10, 46–47, 216–17, 233; spirit photographs, 165; staged photographs, 189; technology and innovation, 1, 19–20, 28, 46, 157, 190

Plato, *The Republic*, 173

Pollard, Edward A., *Lee and His Lieutenants*, 37

Pope, John, 44

postage stamps, commemorative, 31

pregnancy, in camp, 117

Prince, Stephen K., 228

prisoners of war, 87–91, 135, 187–93, 210; exchange cartel, 89, 190; numbers of, 190

Prosser, Gabriel, 218

prostitutes, 210

Pullan, Tessa, 201

Quantrill, William Clarke, 95

racial composition of the United States, 123, 131

Rappahannock River, 143–47, 228; crossing, 136

Ream, Vinnie, 13

Reardon, Carol, 21

Reardon, Catharine Gordon, 106

Reardon, Daniel, 106

refugees, African American, 135–39, 143–47; Confederate, 210

religious revivals, 210

Revolutionary War, women in, 114

Rice, A. T., 12

Rice, Spottswood, 147

Richmond, Virginia, 44; fall of, 241; funeral of Stonewall Jackson, 56; population, 73; and Robert E. Lee, 19–23, 80. *See also* Belle Isle Prison

Richmond Examiner, 37

Rienzi (Philip Sheridan's horse), 201

River Queen (steamer), 209

Robinson, Cary, 79, 81–82

Robinson, Conway, 82

Robinson, William, 82

Roche, Thomas C., 155–57, 171

Rogers, William P., 179–83; family of, 181

Rose, John Q., 192

Rosecrans, William A., 179, 182–83

Royster, Charles, 56

Russell, Andrew J., 162–65, 208, 236

sabotage, 209

Salisbury Prison (North Carolina), 188

Sallie (bull terrier), 118

Sanders, John Austin, 183

Schoolcraft, Jane Johnston (Baamewaawaagizhigokwe), 125

sculpture, 14

Second Bull Run, Battle of, 106, 129, 143

Second Manassas, Battle of. *See* Second Bull Run, Battle of

Sedgwick, John, 162

Seven Days' Battles, 54, 106

Seward, William H., 45

Shenandoah Valley campaign, and Stonewall Jackson, 54

Sheridan, Philip H., 31, 199, 201

Sherman, William Tecumseh: in Atlanta, Georgia, 215; campaign in Georgia and the Carolinas, 234; in Charleston, South Carolina, 237; and Grand Review, 242–43; health, 63; on horses, 198; and Joseph Johnston's surrender, 241; portrait by Mathew Brady, 61–65; and Ulysses S. Grant, 28, 31; views on black soldiers, 216

Sherman's March, 63–64

Shiloh, Battle of, 71

slavery, 75, 88, 143, 145–46, 136, 209, 215, 218–20; children in camps, 118

Slocum, Henry W., 243

Smith, Tim, 89

soldiers: attitudes toward horses, 200–201; in camp, 71, 113–19; Confederate, 88–91

Sontag, Susan, 191, 192, and *Regarding the Pain of Others*, 188

Sophocles, *Antigone*, 172–73

Southern Illustrated News, 35, 54, 56

Southern Literary Messenger, 54

spies, 210

spirit photographs, 165

Spotsylvania Court House, Battle of, 21, 30

Stanton, Edwin M., 30, 89, 104; and prisoners of war, 189–90; and William Tecumseh Sherman, 64

Stevens, Thaddeus, 35

Stevens, Wallace, 171

Story, George Henry, 14

St. Paul's Episcopal Church, Richmond, Virginia, 79

Strong, Henry B., 197–98

Stuart, James Ewell Brown "Jeb," 35–39, 55; and Robert E. Lee, 81

Sutherland, Elihu J., 100

Sutherland, William "Billy," 95–96, 100

Index

257

UnCivil Wars

———— ◆ ————